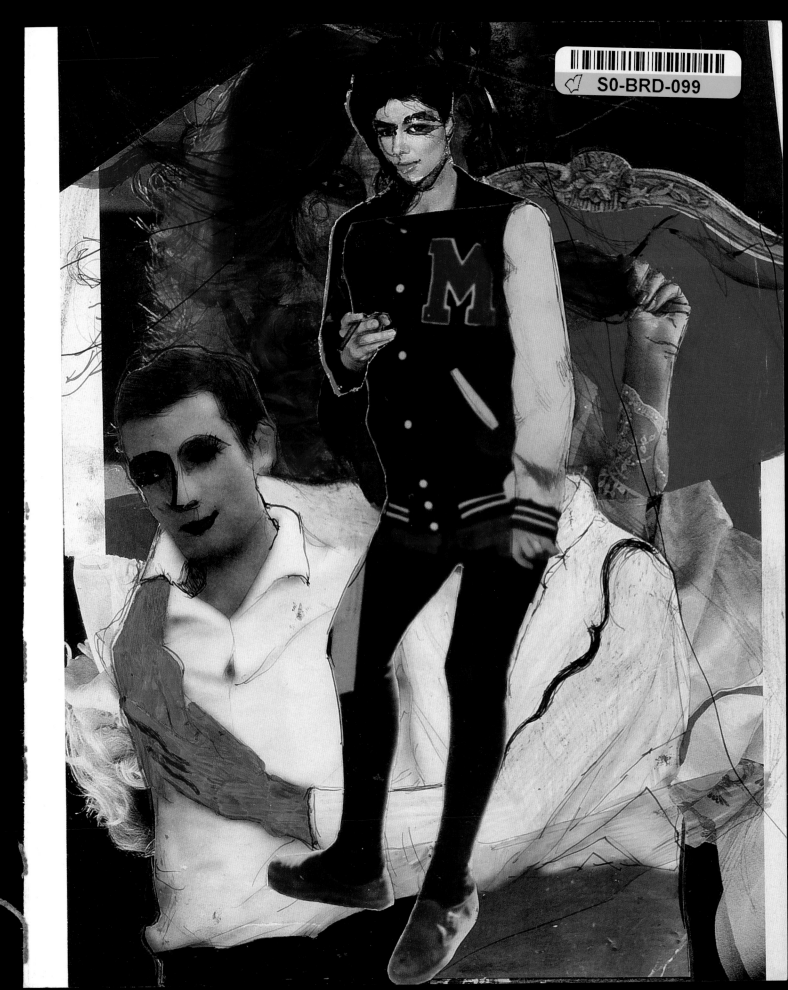

DIE PARKETT-REIHE MIT GEGENWARTSKÜNSTLERN / THE PARKETT SERIES WITH CONTEMPORARY ARTISTS

Book Series with contemporary artists in English and German, published twice a year. Each volume is created in collaboration with artists who contribute an original work specially made for the readers of Parkett. The works are reproduced in the regular edition and available in a limited and signed Special Edition.

Buchreihe mit Gegenwartskünstlern in deutscher und englischer Sprache, erscheint zweimal im Jahr. Jeder Band entsteht mit Künstlern oder Künstlerinnen, die eigens für die Leser von Parkett einen Originalbeitrag gestalten. Diese Werke sind in der gesamten Auflage abgebildet und zusätzlich in einer limitierten und signierten Vorzugsausgabe erhältlich.

PARKETT NR. 89 ERSCHEINT IN COLLABORATION MIT • MARK BRADFORD, CHARLINE VON HEYL, OSCAR TUAZON, HAEGUE YANG • WILL BE COLLABORATING ON PARKETT NO. 89.

JAHRESABONNEMENT (ZWEI NUMMERN) / ANNUAL SUBSCRIPTION (TWO ISSUES) SFR. 95.– (SCHWEIZ), € 72 (EUROPA), US$ 78 (USA AND CANADA ONLY)

ZWEI- UND DREIJAHRESABONNEMENTPREISE SIEHE BESTELLKARTE IM HEFT / FOR TWO & THREE YEAR RATES, PLEASE CONSULT ORDER FORM. (S./p. 264)

Zürichsee Druckereien AG (Stäfa) Satz, Litho, Druck / Copy, Printing, Color Separations

PARKETT-VERLAG AG ZÜRICH MARCH 2011 PRINTED IN SWITZERLAND ISBN 978-3-907582-48-0 ISSN 0256-0917

HEFTRÜCKEN / SPINE 88–91: ERNST CARAMELLE

Cover / Umschlag: DAS INSTITUT, GOOD SMILE VARIABLE FROM DI WHY RELAX!, 2009, Swiss Spa ca va Series, silkscreen on mylar, 39 ³/₈ x 51 ¹/₈".
Back Cover / Rückseite: STURTEVANT, DUCHAMP CINÉ, 1989 / DUCHAMP NU DESCENDANT UN ESCALIER, 1967, installation video.
(PHOTO: PIERRE ANTOINE - MUSÉE D'ART MODERNE DE LA VILLE DE PARIS/ARC 2010)
Cover Flap / Umschlagklappe: PAUL CHAN, OPUS AND THE GREAT NOON, mixed media on paper, 17 x 14".
Inside cover flaps: PAUL CHAN, 3rd ~~LIGHT~~, installation view.
Page 1: ANDRO WEKUA, FRIENDS, 2009, collage, ball pen, color pen, illustration, pencil, photograph, spray paint, crayon on paper 8 ¹/₄ x 10 ³/₄".
(All images slightly cropped / Alle Bilder leicht beschnitten.)

PARKETT Zürich New York

Bice Curiger Chefredaktorin/Editor-in-Chief; **Jacqueline Burckhardt** Redaktorin/Senior Editor; **Mark Welzel** Redaktor/Editor; **Jeremy Sigler** Redaktor USA / Associate Editor US; **Hanna Willamson · Simone Eggstein** Graphik/Design, **Trix Wetter** Graphisches Konzept/Founding Designer (–2001); **Catherine Schelbert** Englisches Lektorat/Editorial Assistant for English; **Claudia Meneghini Nevzadi & Richard Hall** Korrektorat/Proofreading

Beatrice Fässler Vorzugsausgaben, Inserate/Special Editions, Advertising; **Nicole Stotzer** Buchvertrieb, Administration / Distribution, Administration; **Mathias Arnold** Abonnemente/Subscriptions; **Andrea Urban** Vorzugsausgaben, Inserate und Abonnemente USA / Special Editions, Advertising, and Subscriptions US; **Zaily Keiffer** Praktikant / Intern

Jacqueline Burckhardt – Bice Curiger – Dieter von Graffenried Herausgeber/Parkett Board;
Jacqueline Burckhardt – Bice Curiger – Dieter von Graffenried – Walter Keller – Peter Blum Gründer/Founders

Dieter von Graffenried Verleger/Publisher

www.parkettart.com

PARKETT-VERLAG AG, QUELLENSTRASSE 27, CH-8031 ZÜRICH, TEL. 41-44-271 81 40, FAX 41-44-272 43 01
PARKETT, NEW YORK, 145 AV. OF THE AMERICAS, N.Y. 10013, PHONE (212) 673-2660, FAX (212) 271-0704

Bewegte Bilder

Das Titelblatt dieser Ausgabe von *Parkett* verkündet ganz dezidiert Vitalität – doch welche Art von Lebendigkeit ist hier gemeint? Die Bewegung, das Pulsierende, aber auch das Nicht-festhalten-Können oder der plötzliche Stillstand, genauso wie die Scheinbewegung und die Hyperaktivität spielen bei den hier vorgestellten Künstlerinnen und Künstlern eine zentrale Rolle.

Kerstin Brätsch – von ihr und Adele Röder stammt das Bild auf dem Cover – mimt in ihren Bildern und «Bildprodukten» die Aufgeregtheit und exzessive Buntheit der Warenwelt und gleichzeitig rufen ihre Arbeiten die Kunstgeschichte auf. Und die zweite Collaboration-Künstlerin, Sturtevant, verkündet: «Meine Arbeiten widerspiegeln unsere Cyberwelt der Exzesse, Hemmnisse, Grenzüberschreitungen und Verschwendung.» (S. 123)

Paul Chan lässt in seinem Werkzyklus, THE 7 ~~LIGHTS~~, alle Dinge dieser Welt in sanfter Bewegung dem Himmel zuschweben, was den Autor Boris Groys (S. 71) veranlasst, diesem vertikalen Entfliehen etwas anderes gegenüberzusetzen, nämlich die horizontal ausgerichtete Bewegung des Fortschritts menschlicher Geschichte.

In Andro Wekuas Universum ist die Erinnerung der Hauptakteur, sie glüht in ganz eigenen Farben. Die süss-giftige Präsenz von unwiederbringlich Vergangenem nimmt sich jedoch wie der Klammergriff des Stillstands aus – zwischen Traumbild und Trauma, Abstossung und Sehnsucht. In den neuen Werken wird, wie es Douglas Fogle formuliert, «eine Art Schauplatz des Verbrechens aufgedeckt», wie auf einer «leeren Bühne, wo alle darauf warten, dass etwas passiert». (S. 168/169)

Auch im Insert (S. 217) dieser Ausgabe lässt Silke Otto-Knapp Bewegung als Thema buchstäblich «paradieren». Das gleiche Motiv einer Gruppe von Tänzerinnen wird in der multiplizierten Wiederholung – nur angedeutet durch minimale farbliche Veränderungen – paradoxerweise in Bewegung versetzt.

Und hier sei noch eine redaktionelle Neuerung erwähnt: *Parkett* ändert den Erscheinungsrhythmus und wird nun zwei Mal im Jahr in erweiterter Dimension publiziert. Auch wir lassen uns von der Bewegung erfassen.

4

Moving Pictures

One might say that the current cover of *Parkett* flaunts vitality—but of what kind? What is intended? On one hand, movement, pulsating activity, the inability to hang on, and the impact of coming to a sudden halt; on the other, counterfeit movement and hyperactivity: these all play a crucial role in the work of the artists presented in this issue.

Kerstin Brätsch—it is her work, done in collaboration with Adele Röder, that is seen on the cover—produces pictures and products that mimic the excitement and colorful excesses of consumerism and yet clearly take their cue from art history, while Sturtevant, our second collaboration artist, declares that "My pieces reflect our CyberWorld of excess, of fetters, transgression, and dilapidation. (p. 118)

In his cycle THE 7 ~~LIGHTS~~, Paul Chan shows the things of this world gently floating overhead, which leads Boris Groys to draw an illuminating conclusion: he contrasts their vertical escape with the horizontal movement of progress in the history of humankind. (p. 66)

The main protagonist in Andro Wekua's universe is memory; it is aglow in colors all its own. But the poisonous, cloying presence of an irrevocable past is rudely arrested—between dream and trauma, repulsion and longing. Speaking about Wekua's recent work, Douglas Fogle trenchantly notes that "what's unveiled is a crime scene of sorts" like "an empty stage where everybody is waiting for something to happen." (p. 162)

In her insert (p. 217), Silke Otto-Knapp literally "parades" movement. The same motive of a group of dancers, its repetition underscored by minimal modifications in color, is multiplied and paradoxically generates motion.

The rhythm of *Parkett* has undergone a change as well, with two expanded issues now appearing annually. We too are swept up in movement.

Bice Curiger

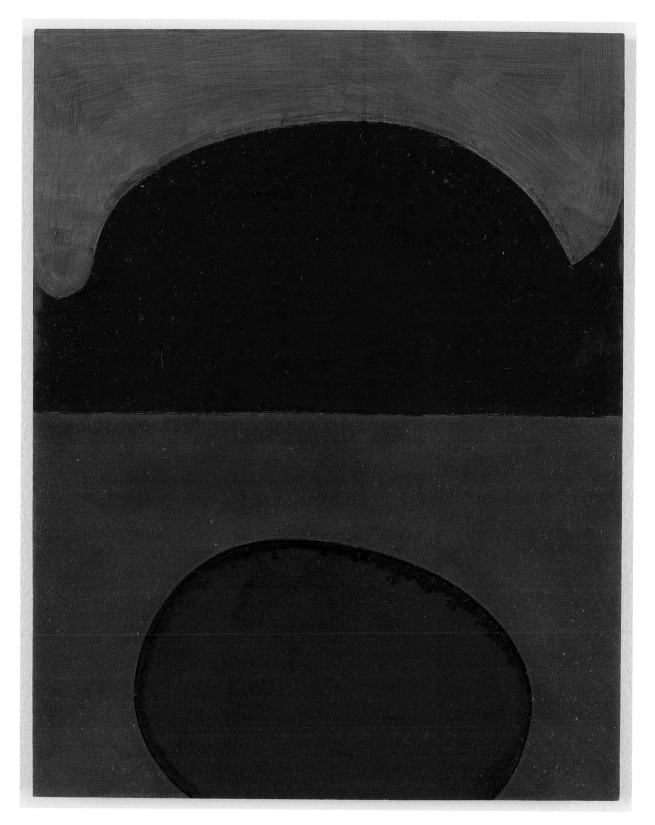

SUZAN FRECON, COMPOSITION IN FOUR COLORS 1, 2009, oil on linen, 2 panels, each 54 x 87 ³/₈ x 1 ¹/₂", overall 108 x 87 ³/₈ x 1 ¹/₂" / KOMPOSITION IN VIER FARBEN 1, Öl auf Leinen, 2 Tafeln, je 137,2 x 221,9 x 3,8 cm, total 274,3 x 221,9 x 3,8 cm. (ALL PHOTOS COURTESY OF THE ARTIST AND DAVID ZWIRNER, NEW YORK)

Chatter About Art Is Almost Always Useless

Paul Cézanne

A Conversation between Mother and Daughter

As I arrive, a little late, only forty-five minutes, Suzan Frecon admonishes me not to spill tea on my own computer. She was in the middle of ironing some watercolors in her other studio at the Elizabeth Foundation. I had been standing in front of the locked door of her old one, baffled, wondering where at that moment she could possibly be.

MARCELLA DURAND: Let's begin with a quote from Cézanne that you've often referred to: "Art is a harmony that runs parallel to nature."
SUZAN FRECON: Cézanne is very important to me as everyone knows or maybe knows and that phrase struck home with me. I was always trying to figure out, vis-à-vis my own work, why nature is so overwhelmingly important to me. It's vital, but I don't try to copy or illustrate it.

MARCELLA DURAND is a poet whose most recent collections are *Deep Eco Pré* (Little Red Leaves, 2009), *Traffic & Weather* (Futurepoem, 2008), and *AREA* (Belladonna Books, 2008).
SUZAN FRECON currently lives and works in New York.

MD: Are art and nature such a binary, truly running parallel?
SF: It seems true to me. Human beings evolved in the fabric of the natural world. It's obviously harmful to all life to be brutalized by the degradations of nature all around us. I feel uncomfortable in this low chair.
MD: You're supposed to be uncomfortable.
SF: I'm going to sit here.
MD: Then I can't see you.
SF: I feel unnatural on this side. I want to look at my paintings and think about them. I usually sit on that stool you're sitting on.
MD: Do you have another stool?
SF: Do you want to sit in this low chair?
MD: No, then I can't reach the computer. I want to see your face. I'll move to this side.
SF: Why don't I give you a smaller table and I'll sit on the stool?
MD: No, you can have the smaller table, with a smaller chair.
SF: I'm getting tired.
MD: This is ridiculous.

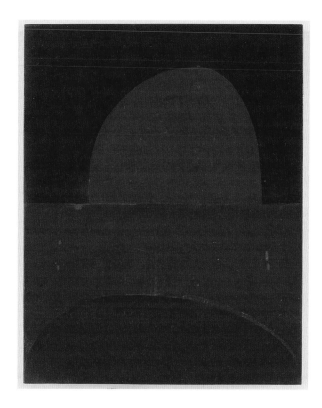

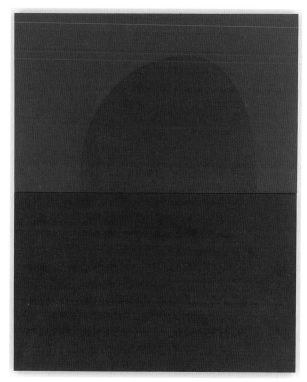

SUZAN FRECON, EMBODIMENT OF RED, VERSION 5,
TRIAL, 2006, oil on wood panel, 10 x 8 x 1" / VERKÖR-
PERUNG VON ROT, VERSION 5, VERSUCH, Öl auf Holz-
tafel, 25,4 x 20,3 x 2,5 cm.
SUZAN FRECON, SOFOROUGE, 2009, oil on linen, 2 pan-
els, each 54 x 87 ³/₈ x 1 ¹/₂", overall 108 x 87 ³/₈ x 1 ¹/₂" /
Öl auf Leinen, 2 Tafeln, je 137,2 x 221,9 x 3,8 cm, total
274,3 x 221,9 x 3,8 cm.

Suzan leaves the studio. I look at her windowsill,
upon which is a plastic case filled with bird feath-
ers, rocks, two green plums, a pencil on top of some
notes about things to build, a book open to a page on
the origins of cathedrals—*Monet's Cathedral* (1990) by
Joachim Pissarro. I find a bag of empanadas and eat
one. Suzan comes back.

MD: So tell me about the reverse curve, which ap-
pears in one of your newer paintings.
SF: The reverse curve first captivated me in a film
about the rebuilding of an ancient Chinese rainbow
bridge. It stayed with me and I finally found a way to
make it work in one of my paintings, COMPOSITION
IN FOUR COLORS (2009). I worked out the composi-
tion on graph paper as I do in preparation for trans-
fer to the large-format canvases. I worked out the re-
lationships of curves asymmetrically throughout the
painting so that each curve plays off the balances,
tensions, and dissonances of the other curves in the
painting. These are indicated in pencil line on the
graph paper drawings, but they indicate what will be
areas of color, which, as you look at the paintings,
can be either figure or ground, or what I prefer to
call "empty space and full space."
MD: When you say areas of color rather than line,
what do you mean?
SF: I don't want my paintings to look like drawings. I
want them to be paintings.
MD: I noticed at the opening of your show there was
a man who seemed a bit troubled by the shiny part
of the paintings bleeding into the matte. Why do you
think that troubled him?
SF: It surprised me the first time it happened and I

thought I would have to correct it. I had a matte indigo next to a red pigment mixed with cold pressed linseed oil, which had bled into the indigo. But I looked at it again, and I realized it added another dimension; it picked up the light in a beautiful way, so I let it stand. My decisions are, finally, all visual decisions.

MD: What is a visual decision?

SF: My most important obligation is to build the work into a v i s u a l work of art, rather than a work where the story is the carrying point. If the work doesn't hold together as visual art, then the content that aspires to be inherent in it falls by the wayside. But you know words are not my tools. I already feel uncomfortable trying to explain what normally one would s e e. It really is inexplicable. If I have to provide a long explanation for a painting, even if it's an interesting explanation, that doesn't mean the painting is going to be worth looking at. I look and look a lot to see where I'm going, over a long period of time. I constantly visualize the colors and compositions, which are the bedrock of the painting, and these compositions build on knowledge of mathematics, art, architecture, literature, science, astronomy, and on and on.

MD: Is there a universal visual grammar?

SF: Probably painting came before language…

MD: Grr.

SF: No one will ever know the explanation behind ancient cave paintings, but there is a visual communication. Take Islamic calligraphy. I don't understand what it is saying, but it has the power of art for me. Successful art has an enigmatic power. It is ungraspable. That's why I find that art and religion are similar. I am not a religious person, but the spiritual and the physical seem integral to both my art and other art.

MD: Regarding the cave paintings, when you say a visual communication, what precisely in the paintings is so provocative to you?

SF: We're getting too didactic. In fact, I really like it when someone looks at my paintings and can't say they look like anything. One time when you were little, you walked into my studio and said, oh, that makes me feel like a rainy day. I thought that was an honest reaction.

MD: How about when your sister-in-law thought your paintings were exercise mats?

SF: I liked that, too. She asked if my studio was a ballet studio and what were those red mats hanging on the wall. She sensed that it wasn't correct as soon as she said it. Once when a friend—Keiko (Prince)—looked at an early large red painting, she said it caused her to experience the same feelings she had when she went on a Shinto ritual up a mountain in Japan. She then went on to describe the Shinto music and ceremony. The ultimate reward is the experience of the viewer. That's why I very rarely sell a painting before it is exhibited.

MD: A lot of the art you refer to was actually intended to illustrate, to symbolize the divine. So how do you reconcile, say, with a Cimabue in which every element was meant to evoke God?

SF: Who knows what Cimabue was really thinking? His primary endeavor was to make a great work of art. It's evident to me that that superseded all else. His work looks very abstract to me. In the crucifixes, the outside form generates and holds—formally—the rest. It holds the art. Supposedly the magnificent artist Fra Angelico, for example, was very religious. But then there's someone like Filippo Lippi, who supposedly was not, though his paintings were religious in subject. I read about his escaping from the monastery and carousing with women, drinking, etc. Not much is written on Mary Benson, but her work manifests a vital connection to nature. She would recognize that when the light slanted a certain way, it was time to gather the materials for her baskets. The baskets of the Pomo weavers were their cathedrals. The finished works came directly from the natural, physical world (and they never destroyed their source by depleting it). Yet, the baskets are very, very abstract. Timeless, powerful works of art are carried by their form, with its inherent virtuosity and expertise. Bill Traylor didn't start working until he was in his 80s, but he had an innate skill and very strong sense of composition. As a result, his work lasts beyond illustration.

MD: How about someone like Robert Grosvenor, who is very difficult visually? His piece in the Whitney Biennial this year was silver (aluminum) and red (flocking)—two colors and materials that wouldn't seem harmonious. How does he play with this idea of uni-

versal visual grammar we were discussing? How about that piece of his that looks like a suburban patio with wheels on it?

SF: He is probably one of my favorite contemporary artists. I doubt that he thinks "universal visual grammar" when he is working. You would have to ask him and I don't think he would explain it to you. I love the experience of walking into a show of his work and having no idea of where I am, except for a strong feeling that it's art!

MD: What makes it art?

SF: You tell me. I walk around his work. I look at it from different angles. There are subtleties that keep revealing themselves. He uses contrary materials that normally wouldn't be pleasing: aluminum paint, cinder blocks, industrial, refuse-like materials. He pulls off a tour de force in being able to turn these unpleasant materials that get in our way into art. I wouldn't presume to explain it.

MD: Let's talk about ugly materials. Most of your inspiration seems pretty highfalutin, so to speak. Are you ever inspired by what's regarded as trashy or throwaway?

SF: I wouldn't call it inspiration. I would call it common denominators—materials I am drawn to that are also, incidentally, used in many other cultures throughout time. Earth-red pigments come from the earth. They are not highfalutin at all. Linseed oil is not highfalutin. I like art for what it is, whether it's a bark cloth painting or a Bellini. It's for everyone. It takes me somewhere I haven't been, beyond my own perimeters. This is knowledge.

MD: I still want to know more what underlies your art and what you think makes art. Math? Nature? Geometry? Spirituality?

SF: I do too! I always felt math to be one of my tools, but I don't have a deep enough knowledge of it. The golden ratio has been used in diverse cultures throughout time. It's found in nature too, so nature has generated math. Math came from farmers and astronomers trying to understand the weather and the planets.

MD: But using the golden ratio is not a guarantee of great art. What animates the math?

SF: It's how it's used. When you think of it as a vital component of human awareness, it's very exciting.

The golden mean has been proven through time by artists, architects and scientists to be a visually pleasing ratio. It can give a composition strength and beauty. It can. It doesn't mean it will. Math is a foundation for my compositions. My measurements also come from the human scale. The foot of twelve inches leads to the nine-foot-high painting determined by a human in contact with it.

MD: Could you talk a little more about asymmetry?

SF: My compositions are based on asymmetry because I find that it can make them more interesting and unpredictable, even dissonant, taking the viewer beyond what they have already seen and know. What about your poetry? My tool is a brush. I mix the paint and apply it to the canvas. You wrote a poem in a treehouse by hand, unusual for you, and it turned into a visual thing. But when I read it, it came across complete in itself as literature. What are your tools? Keyboard, word processor, pen in hand?

MD: I like the portability of writing. I can write a poem on a bus, using pen and paper. Or I can whisper a poem into someone's ear. It's ephemeral, nomadic. So that's the physical making of the poem, the when, where and how—maybe the least interesting part. The mental making of a poem depends on all sorts of things. The French poet Michèle Métail told me, "First I find the form, which crystallizes the sense." That's not quite true for me, as I tend to write also from the intent of content, but I think about what underlies form—the mathematic and rhythmic structures.

SF: Math is part of all human knowledge. And all fields of knowledge are integral to each other. Vitruvius relates that the artist or architect needs to know about medicine, mathematics, philosophy, science, music, literature, and so on. All comes into the work.

MD: OK, we talked about math, but what about nature?

SF: Well, what about your interest in nature? It seems to be integrated into your work in a vital way. Your planet poems come to mind; and *Traffic & Weather* (2008), as well as many others.

MD: I love nature, but I'm also interested in ecology—how systems connect. And I'm particularly interested in how humans are also wilderness. I want to rework the concept of wilderness, in that it no longer

exists, or really never did. Yet the idea of a place where "we" are not seems to be necessary to being "we." And here, I want to bring in that you grew up in a particular kind of human-influenced nature. I've thought a lot in my own work about the pré, or meadow, which is an interim phase between human and nature. You grew up in an orchard, which is a human-tended, espaliered sort of nature.

SF: When I was a child, I couldn't wait to leave my family's farm, but it wasn't because of nature. It was because of my family. We never conversed, we only yelled. Later, from a more mature perspective, the farm became more precious to me. At the same time that there is such a terrible abuse of nature going on in the orchard, it is also incredibly beautiful. They inundate trees and land with poisons and pesticides. It's all a terrible waste of fuel and a brutalization of nature. But it's beautiful to see the way the orchard is organized, and the light in spring, the tender greens, the scents of the blossoms. In summer, there's the lush fullness, the colors and taste of the fruit, and in fall, the light angles and becomes more golden. They stop spraying so you can walk through the orchard and not smell pesticides and the migrating songbirds start to come through again.

MD: But your attraction to Cézanne's quote perhaps goes back to this—this primal experience of a forced, espaliered nature, almost like a bonsai, painful. An apple tree is pruned and not entirely natural, but visually compelling. If nature and art are parallels, how can nature be part of art?

SF: I don't know the answers. Cézanne painted from nature. But the reality of the paintings was what mat-

tered to me! At the same time the beauty of a real French landscape is powerful in a parallel way. His paintings are their own reality. They are a painting first and foremost.

MD: In Paris once, you showed me Uccello's THE BATTLE OF SAN ROMANO (1435–1460) and told me it was one of your favorite paintings. To me at first it looked like some dingy (because the Louvre takes such bad care of its art) thing and I didn't understand why you liked it so much. I had no doorway into it. Then you pointed out how you could see the very human eyes of one of the horse riders in the middle of what seemed to me an inhuman composition. That opened the painting up to me and allowed me to understand it so much more. It's now one of my favorites, but it raises the question of the relationship between figurative and abstract—or at least how you see the two.

SF: I started my education in abstract expressionism and minimalism. But I felt I was just skimming the surface of what painting was about, so I spent time looking at older paintings. I visited the Prado, and saw Bosch and Goya and Velázquez. I was more drawn to Bosch and Brueghel because I could understand the subjects. However, little by little, I started to be more interested in Velázquez and Goya, even though their paintings were mostly of aristocrats. The paint was more interesting. I started to see painting for what it really is: paint and how it's applied. Then later I became more involved in how to structure my own paintings. I was totally interested in the stroke, but I needed stronger compositions to hold it. I became aware later, much later of Uccello. His compositions are very structured and mathematical. I wanted to uncover the secrets of how he could achieve a painting like THE BATTLE OF SAN ROMANO.

MD: To go back to the cave paintings, when I visited the Font de Gaume cave in France, the

guide showed us the drawing of an arrow, and said they thought this was the first instance of a symbol, or symbolic language. For me as a writer, it was incredibly moving to see this abstract thing that carried other meaning.

SF: Why was the arrow abstract? To me that's figurative. It was a depiction of an arrow. All you can say is what you felt and what was meaningful. You can't say for sure whether it was a symbol or non-symbol. To me the reality of the paintings, done so many years ago, was the physical painting. I looked at how they used the bulges in the wall to add dimension to the paintings, and wondered at how difficult it must have been to paint them so high on the cave walls, with very little light to see what they were doing. As I looked at them I felt that they had put everything they could possibly muster, physically and spiritually, into achieving these paintings. Was it called art at that time? We have no idea, but it is. I always thought human beings evolved into higher intellects. When I saw these paintings, I thought we had, rather, regressed.

MD: Let's talk a little about your watercolors.

SF: The large paintings are the core of my work. The watercolors spin off them. They are the same ingredients, only they are not measured. It's the paper that generates the facts of the watercolors. I experiment more in the watercolors while the oil paintings are more resolute. But they are all part of the same unity.

MD: That echoes Mondrian's flower studies, a sort of necessary parallel activity where the connection is not immediately evident.

SF: I like oil paint better than watercolor. I can manipulate the material nuances of the paint more and I like that tangibility.

MD: Why do you do watercolors then?

SF: It's perhaps comparable to being a musician, experimenting with tunes, finding tunes, and then composing a symphony. There are so many more components and elements in finishing an oil painting. Sometimes I fill in with doing watercolor. Oil has a long drying time. If I employ orange watercolor I can see what it looks like immediately. With oil, I have to build up layers, work out the composition. I don't see what I have until after it has fully evolved, sometimes two or three years later. Oil paint teaches patience,

but with that, I think one can go into a much deeper dimension than with watercolors. That doesn't mean that watercolors are inferior.

MD: Do you use the same pigments in both?

SF: Pretty much. Different mediums: gum arabic for watercolors and linseed oil for paintings.

MD: You used to use gallons of turpentine.

SF: Don't remind me.

MD: And you used cadmiums.

SF: I was painting in thin, matte layers, so I was using a lot of thinner. Gradually I wanted to have the more physical characteristics of oil paint. But I stand by some of those early paintings.

MD: I understand the earth reds now, but I don't understand why you were interested in the cadmiums.

SF: Just for the colors. They glowed. Vermilions were also poisonous. I didn't know that they contained mercury when I was using them years ago. I'm not so keen on cadmiums now. They are usually too bright for my purpose. But I don't rule them out. I use them if I need them. I think maybe tube colors are developed for artificial lighting and maybe that's why I like to make my own colors, which work in my paintings, with daylight.

MD: What about indigo? I would think that would be a hard color to use.

SF: Indigo has many colors within it—light blue, black, red tones. It's a plant-based dye and I always thought it was a beautiful, fascinating color.

MD: What about blues in general?

SF: The blue pigments I use are more transparent and have less body. So I use them accordingly, relative to what I need in the total organic composition of the painting. Reds seem more difficult. They can end up being really ugly or extremely beautiful. I find blues easier to resolve. I am drawn to and obsessed by the infinite red earth color combinations. They take me further out because I have to work harder to find their solutions. Earth reds are the core to the existence (regarding color) of my paintings. But I will also continue searching for resolutions inspired and generated by many other colors. Remember when you quoted that line from the *Wen Xuan* (1982) to me about the "purple forbidden enclosure?" I was inspired to immediately begin a series of paintings based on that line!

Das Gerede über Kunst ist so gut wie nutzlos

Paul Cézanne

Ein Gespräch zwischen Mutter und Tochter

Als ich etwas verspätet eintreffe, nur fünfundvierzig Minuten, ermahnt mich Suzan Frecon, keinen Tee über meinen Computer zu verschütten. Sie war dabei, in ihrem anderen Atelier in der Elizabeth Foundation einige Aquarelle zu glätten. Ich hatte vor der verschlossenen Tür ihres alten Ateliers gestanden und mich verwirrt gefragt, wo sie gerade sein könnte.

MARCELLA DURAND: Beginnen wir mit einem Zitat von Cézanne, das du häufig angeführt hast: «Die Kunst ist eine Harmonie parallel zur Natur.»

SUZAN FRECON: Wer mich kennt, weiss, oder weiss vielleicht, dass Cézanne mir sehr wichtig ist, und dieser Satz traf für mich ins Schwarze. Ich versuchte in Bezug auf meine Arbeit immer herauszufinden, warum die Natur für mich von so grosser Bedeutung ist. Sie ist zentral, doch ich versuche nicht, sie zu kopieren oder zu illustrieren.

MARCELLA DURAND ist Dichterin. Ihre jüngsten Gedichtsammlungen sind *Deep Eco Pré* (Little Red Leaves, 2009), *Traffic & Weather* (Futurepoem, 2008) und *AREA* (Belladonna Books, 2008). *SUZAN FRECON* lebt und arbeitet zurzeit in New York.

MD: Sind Kunst und Natur wirklich derart exakte Parallelen?

SF: Für mich stimmt das. Die Menschen sind aus dem Stoff der natürlichen Welt hervorgegangen. Offensichtlich ist es für jegliches Leben schädlich, von der Naturzerstörung um uns herum brutal in Mitleidenschaft gezogen zu werden. Ich fühle mich unwohl in diesem niedrigen Sessel.

MD: Du sollst dich unwohl fühlen.

SF: Ich setze mich hierher.

MD: Da kann ich dich nicht sehen.

SF: Es ist für mich unnatürlich auf dieser Seite zu sitzen. Ich will meine Bilder anschauen und über sie nachdenken. Gewöhnlich sitze ich auf dem Hocker, auf dem du jetzt sitzt.

MD: Hast du noch einen solchen Hocker?

SF: Willst du in diesem tiefen Sessel sitzen?

MD: Nein, dann komm ich nicht an meinen Computer. Ich will dein Gesicht sehen. Ich gehe auf diese Seite.

SF: Weshalb gebe ich dir nicht einen kleineren Tisch und ich setze mich auf den Hocker?

MD: Nein, du kannst den kleineren Tisch haben, mit

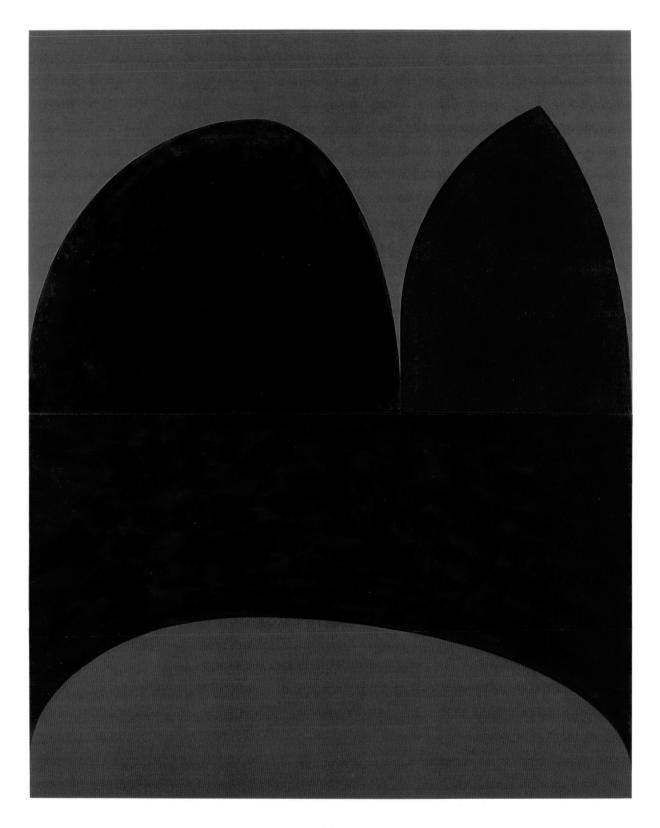

SUZAN FRECON, CATHEDRAL SERIES, VARIATION 6, 2010, oil on linen, 2 panels, each 54 x 87 ³/₈ x 1 ¹/₂″, overall 108 x 87 ³/₈ x 1 ¹/₂″ / KATHEDRALEN SERIE, VARIATION 6, Öl auf Leinen, je 137,2 x 221,9 x 3,8 cm, total 274,3 x 221,9 x 3,8 cm.

einem kleineren Stuhl.

SF: Mir langt's allmählich.

MD: Das ist lächerlich.

Suzan verlässt das Atelier. Ich schaue auf ihren Fenstersims, da steht ein Plastikbehälter gefüllt mit Vogelfedern, Steinen und zwei grünen Pflaumen, ein Kugelschreiber auf einigen Notizen über irgendwelche zu bauenden Dinge, ferner ein Buch, aufgeschlagen an einer Stelle über den Ursprung der Kathedralen – *Monet's Cathedral* (1990) von Joachim Pissarro. Ich finde einen Sack mit Krapfen und esse einen. Suzan kommt zurück.

MD: Erzähl mir von der Doppelkurve in einem deiner neueren Bilder.

SF: Die Doppelkurve faszinierte mich erstmals in einem Film über die Rekonstruktion einer alten chinesischen Regenbogenbrücke. Sie liess mich nicht mehr los und schliesslich fand ich einen Weg, sie in einem meiner Bilder einzubauen, COMPOSITION IN FOUR COLORS (Komposition in vier Farben, 2009). Ich habe die Komposition auf Millimeterpapier erarbeitet, wie ich es zur Vorbereitung der Übertragung auf grossformatige Leinwände immer tue. Ich habe die Verhältnisse zwischen den asymmetrischen Kurven im ganzen Bild ausgearbeitet, sodass jede Kurve die Gleichgewichte, Spannungen und Unstimmigkeiten der anderen Kurven im Bild ausspielt. Sie sind als Bleistiftlinien auf den Millimeterpapier-Zeichnungen eingetragen, aber sie bezeichnen eigentlich Farbflächen, die beim Betrachten der Bilder entweder als Figur oder Hintergrund fungieren können, oder wie ich es lieber nenne: «leerer Raum und gefüllter Raum».

MD: Was meinst du, wenn du von Farbflächen im Gegensatz zu Linien sprichst?

SF: Ich will nicht, dass meine Bilder wie Zeichnungen aussehen. Ich will, dass es echte Malerei ist.

MD: Bei der Eröffnung deiner Ausstellung schien sich ein Mann daran zu stören, dass die glänzenden Bildpartien in die matten Flächen ausbluten. Weshalb hat ihn das gestört, was denkst du?

SF: Als es das erste Mal passierte, dachte ich selbst, ich müsse es korrigieren. Ich hatte ein mattes Indigoblau neben einem roten Pigment, angerührt mit kaltgepresstem Leinöl, das ins Indigo hineingelaufen war. Aber dann schaute ich noch einmal genau hin und sah, dass dadurch eine neue Dimension hinzukam; es nahm das Licht sehr schön auf, also liess ich es so. Meine Entscheidungen sind letzten Endes immer visuelle Entscheidungen.

MD: Was ist eine visuelle Entscheidung?

SF: Mein oberstes Ziel ist es, aus meiner Arbeit ein v i s u e l l e s Kunstwerk zu machen und nicht ein Werk, bei dem die Geschichte das tragende Element ist. Wenn ein Werk nicht als visuelles Kunstwerk funktioniert, wird auch sein Inhalt hinfällig. Aber du weisst, Worte sind weniger mein Ding. Ich fühle mich schon unwohl, wenn ich etwas erklären soll, was man normalerweise s i e h t. Es lässt sich eben nicht erklären. Wenn ich zu einem Bild eine lange Erklärung liefern muss, selbst wenn sie interessant ist, bedeutet das noch lange nicht, dass das Bild sehenswert ist. Ich schaue sehr lange immer wieder ganz genau hin, um zu sehen, wohin es geht. Ich stelle mir die Farben und Kompositionen – die Grundlagen des Bildes – ständig bildlich vor, und diese Kompositionen beruhen unter anderem auf mathematischem, künstlerischem, kunstgeschichtlichem, architektonischem, literarischem, naturwissenschaftlichem und astronomischem Wissen.

MD: Gibt es eine visuelle Universalgrammatik?

SF: Die Malerei gab es wahrscheinlich vor der Sprache …

MD: Grrr …

SF: Niemand wird je die urzeitlichen Höhlenmalereien erklären können, aber es gibt so was wie visuelle Kommunikation. Nimm beispielsweise die islamische Kalligraphie. Ich verstehe nicht, was diese Schriften bedeuten, aber sie haben für mich die Macht der Kunst. Gute Kunst verfügt über eine rätselhafte Macht. Sie ist ungreifbar. Deshalb denke ich, dass Kunst und Religion verwandt sind. Ich bin kein religiöser Mensch, aber das Spirituelle und das Physische scheinen ein integraler Bestandteil meiner und jeder anderen Kunst zu sein.

MD: Wenn du im Hinblick auf die Höhlenmalerei von visueller Kommunikation sprichst, was ist an diesen Malereien für dich eigentlich so provokativ?

SF: Jetzt geraten wir ins Didaktische. Tatsächlich mag ich es, wenn jemand meine Bilder betrachtet und

nicht sagen kann, sie sähen aus wie irgendwas. Als du klein warst, bist du einmal in mein Atelier gekommen und meintest: «Oh, das gibt mir das Gefühl, dass es draussen regnet.» Ich hielt das für eine ehrliche Reaktion.

MD: Und als deine Schwägerin dachte, deine Bilder wären Übungsmatten?

SF: Das gefiel mir auch. Sie fragte, ob mein Atelier ein Ballettstudio wäre und was diese roten Matten an der Wand wären. Schon als sie es aussprach, merkte sie, dass es nicht so war. Einmal hat eine Freundin, Keiko (Prince), eines der frühen roten Bilder betrachtet und meinte, es wecke in ihr dieselben Gefühle, die sie empfunden habe, als sie zu einem Shinto-Ritual auf einem Berg in Japan gegangen sei. Dann beschrieb sie die Shinto-Musik und die Zeremonie. Der schönste Lohn ist das Erlebnis des Betrachters. Deshalb verkaufe ich sehr selten ein Bild, bevor es ausgestellt war.

MD: Ein grosser Teil der Kunst, auf die du Bezug nimmst, sollte ursprünglich das Göttliche illustrieren oder symbolisieren. Wie bringst du das in Einklang mit, sagen wir, einem Cimabue, in dem jedes Element dazu da war, Gott zu beschwören?

SF: Wer weiss, was Cimabue wirklich dachte? Sein oberstes Ziel war es, ein grosses Kunstwerk zu schaffen. Für mich liegt es auf der Hand, dass dies absoluten Vorrang hatte. Seine Kunst wirkt auf mich sehr abstrakt. Bei seinen Kruzifixen erzeugt und umfasst die äussere Form – formal – alles andere. In ihr ist die Kunst enthalten. Man nimmt beispielsweise an, dass der grossartige Künstler Fra Angelico sehr religiös gewesen ist. Aber dann gibt es auch jemanden wie Filippo Lippi, auf den das vermutlich nicht zutrifft, obwohl seine Gemälde religiöse Themen behandeln. Ich habe von seiner Flucht aus dem Kloster gelesen, von seinen Zechereien und Besäufnissen mit Frauen und so weiter. Über die indianische Künstlerin Mary Benson ist nicht viel geschrieben worden, aber ihr Werk verrät eine tiefe Naturverbundenheit. Sie wusste genau, bei welchem Sonnenstand der richtige Zeitpunkt gekommen war, um das Material für ihre Körbe zu sammeln. Die Körbe der Pomo-Flechter waren ihre Kathedralen. Die fertigen Arbeiten kamen direkt aus der natürlichen physischen Welt (und sie zerstörten ihre Rohstoffquellen nie durch

Übernutzung). Und doch sind diese Körbe extrem abstrakt. Zeitlose, starke Kunstwerke werden von ihrer Form getragen, in ihr steckt die ganze Virtuosität und Sachkunde ihrer Erzeuger. Bill Traylor begann erst mit über 80 Jahren zu arbeiten, aber er war ein Naturtalent und hatte ein sehr starkes Gespür für Komposition. Folglich ist sein Werk mehr als blosse Illustration.

MD: Wie steht es mit jemandem wie Robert Grosvenor, der visuell sehr schwer verständlich ist? Seine Arbeit an der diesjährigen Whitney Biennial war silbern (Aluminium) und rot (Stoffpolster) – zwei Farben und Materialien, die nicht zusammenzupassen scheinen. Wo ist er anzusiedeln im Hinblick auf die Idee einer visuellen Universalgrammatik, von der wir sprachen? Und was hältst du von jener Arbeit von ihm, die aussieht wie eine Vorstadt-Veranda auf Rädern?

SF: Unter den heutigen Künstlern mag ich ihn vielleicht mit am besten. Ich bezweifle, dass er an so etwas wie eine «visuelle Universalgrammatik» denkt, wenn er arbeitet. Du müsstest ihn schon selbst fragen und ich glaube nicht, dass er es dir erklären würde. Ich mag das Gefühl, eine seiner Ausstellungen zu betreten und keine Ahnung zu haben, wo ich mich befinde, abgesehen von der tiefen Überzeugung, dass es sich um Kunst handelt!

MD: Was macht es zu Kunst?

SF: Sag du's mir. Ich gehe um seine Arbeit herum. Ich betrachte sie aus verschiedenen Blickwinkeln. Man entdeckt laufend neue Feinheiten. Er verwendet gegensätzliche Materialien, die normalerweise nicht ansprechend wirken: Aluminiumfarbe, Blöcke aus Schlackenbeton, industrielle Materialien, die nach Abfall aussehen. Er vollbringt eine Meisterleistung, indem er diese unangenehmen Materialien, die uns nur im Weg sind, in Kunst verwandelt. Ich würde mich nie erdreisten, das zu erklären.

MD: Reden wir über hässliches Material. Deine Inspirationen scheinen meist ziemlich, sagen wir, hochgestochen. Hast du dich auch schon von etwas inspirieren lassen, was als Müll oder Abfall gilt?

SF: Ich würde das nicht Inspiration nennen. Ich würde es als gemeinsame Nenner bezeichnen – Materialien, zu denen ich mich hingezogen fühle, die im Lauf der Geschichte zufällig auch in vielen anderen Kulturen Verwendung fanden. Rote Erdfarben

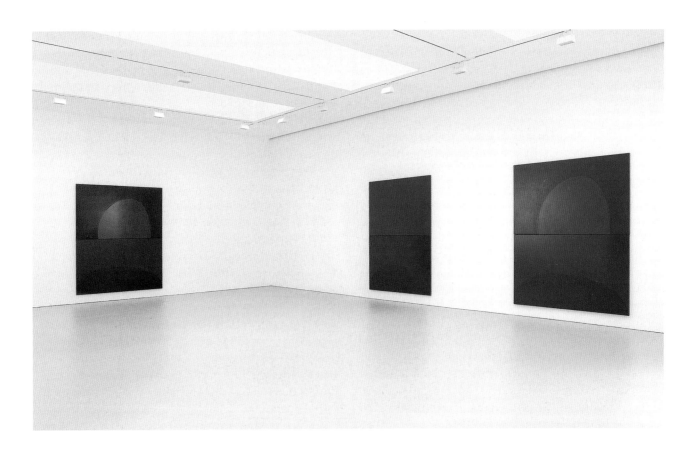

stammen aus der Erde. Sie sind ganz und gar nicht hochgestochen. Auch Leinöl ist nicht hochgestochen. Ich liebe Kunst um ihrer selbst willen, ob es sich um ein Bild auf Rindentuch oder einen Bellini handelt. Kunst ist für alle. Sie versetzt mich an einen Ort, wo ich noch nicht war, sie trägt mich über meine eigenen Grenzen hinaus. Das ist Erkenntnis.

MD: Ich möchte trotzdem mehr darüber wissen, was deiner Kunst zugrunde liegt und was deiner Meinung nach Kunst ausmacht. Mathematik? Natur? Geometrie? Spiritualität?

SF: Das möchte ich auch! Ich hielt die Mathematik immer für eines meiner Werkzeuge, aber meine mathematischen Kenntnisse reichen nicht tief genug. Der Goldene Schnitt ist im Lauf der Geschichte in verschiedenen Kulturen verwendet worden. Er kommt auch in der Natur vor, also hat die Natur zur

Mathematik geführt. Die Mathematik kam von Bauern und Astronomen, die das Wetter und die Planeten zu verstehen suchten.

MD: Aber die Anwendung des Goldenen Schnitts ist keine Garantie für grosse Kunst. Was haucht der Mathematik Leben ein?

SF: Es kommt darauf an, wie man sie einsetzt. Wenn man sie als zentralen Bestandteil der menschlichen Erkenntnis betrachtet, wird es extrem spannend. Dass der Goldene Schnitt ein visuell angenehmes Verhältnis ist, wurde im Lauf der Geschichte von Künstlern, Architekten und Naturwissenschaftlern wiederholt bewiesen. Er kann einer Komposition Strenge und Schönheit verleihen. Er kann. Das heisst nicht, dass es so sein muss. Mathematik ist e i n e Grundlage meiner Kompositionen. Meine Masse entsprechen auch dem menschlichen Massstab. Der Fuss zu zwölf

Inches führt zum neun Fuss hohen Gemälde, definiert durch die Masse des Menschen, der damit in Berührung kommt.

MD: Kannst du etwas mehr über Asymmetrie erzählen?

SF: Meine Kompositionen beruhen auf Asymmetrie, weil ich denke, dass sie dadurch interessanter und unberechenbarer, ja sogar unstimmiger werden, da sie den Betrachter über das bereits Gesehene und Vertraute hinausführen. Wie wär's mit Poesie? Mein Werkzeug ist ein Pinsel. Ich mische die Farbe und trage sie auf die Leinwand auf. Du hast in einem Baumhaus ein Gedicht geschrieben, von Hand, was für dich ungewöhnlich ist, und es wurde zu etwas Visuellem. Doch als ich es las, kam es als ein in sich geschlossenes Stück Literatur herüber. Was sind deine Werkzeuge? Tastatur, Textverarbeitungssystem, der Stift in deiner Hand?

MD: Ich mag die leichte Transportierbarkeit des Schreibens. Ich kann ein Gedicht mit Stift und Papier in einem Bus schreiben. Oder ich kann jemandem ein Gedicht ins Ohr flüstern. Es ist flüchtig, nomadisch. Das ist die physische Entstehung eines Gedichts, das Wann, Wo und Wie – vielleicht der uninteressanteste Teil. Die geistige Entstehung hängt von allen möglichen Dingen ab. Die französische Dichterin Michèle Métail erzählte mir: «Zuerst finde ich die Form, die dann den Sinn zur Kristallisation bringt.» Für mich trifft das nicht ganz zu, da ich eher auch aus einer inhaltlichen Absicht heraus schreibe, aber ich denke darüber nach, was der Form zugrunde liegt – die mathematischen und rhythmischen Strukturen.

SF: In jedem menschlichen Wissen steckt Mathematik. Und alle Wissensgebiete sind ineinander enthalten. Vitruv schreibt, dass der Künstler oder Architekt in Medizin, Mathematik, Philosophie, Naturwissenschaften, Musik, Literatur und so weiter bewandert sein muss. Alles fliesst ins Werk ein.

MD: Okay, über die Mathematik haben wir gesprochen, aber wie steht's mit der Natur?

SF: Tja, wie steht's mit deinem Interesse an der Natur? Sie scheint ein lebenswichtiges Element deines Werks zu sein. Ich denke dabei an deine Planetengedichte, aber auch an *Traffic & Weather* (2008) und viele andere.

MD: Ich liebe die Natur, aber ich bin auch ökologisch interessiert – wie Systeme zusammenhängen. Und ich interessiere mich ganz besonders dafür, inwiefern auch die Menschen ein Teil der Wildnis sind. Ich möchte den Begriff der Wildnis neu fassen, in der Überzeugung, dass es sie nicht mehr gibt beziehungsweise nie wirklich gegeben hat. Und doch scheint es, dass die Vorstellung von einem Ort, an dem «wir» nicht sind, für unser «Wir-Sein» notwendig ist. Und hier möchte ich einflechten, dass du in einer besonderen Art von menschlich beeinflusster Natur aufgewachsen bist. Ich habe in meinen Arbeiten viel über *la pré* oder die Wiese nachgedacht, die ein Zwischenstadium zwischen Mensch und Natur darstellt. Du bist auf einer Obstplantage aufgewachsen, also in einer vom Menschen gehegten, spalierförmigen Natur.

SF: Als Kind konnte ich es nicht erwarten, von der Farm meiner Familie wegzukommen, aber nicht wegen der Natur. Es war wegen der Familie. Wir redeten nie miteinander, wir schrien nur. Später, aus einem etwas gereiften Blickwinkel betrachtet, gewann ich die Farm wieder lieber. Obwohl auf der Obstplantage tatsächlich ein schrecklicher Missbrauch der Natur stattfindet, ist sie gleichzeitig unglaublich schön. Die Bäume und das Land werden mit Giften und Pestiziden überschwemmt. Das Ganze ist eine schreckliche Treibstoffverschwendung und eine Vergewaltigung der Natur. Aber es ist schön, zu sehen, wie die Obstplantage angeordnet ist, und das Licht im Frühling, die zarten Grüntöne, die Blütendüfte. Im Sommer herrscht üppige Fülle, da sind die Farben und der Geschmack der Früchte, und im Herbst fällt das Licht flacher ein und wird golden. Es wird nicht mehr gespritzt und man kann durch die Plantage spazieren, ohne Pestizide zu riechen, und die ersten Sing-Zugvögel sind wieder da.

MD: Aber deine Vorliebe für das Zitat von Cézanne geht darauf zurück – auf diese Urerfahrung einer erzwungenen Spaliernatur, fast wie Bonsai, schmerzhaft. Ein Apfelbaum wird beschnitten und ist nicht ganz natürlich, aber visuell anziehend. Wenn Natur und Kunst Parallelen sind, wie kann dann die Natur Teil der Kunst sein?

SF: Ich kenne die Antworten nicht. Cézanne malte nach der Natur. Aber mir kam es auf die Realität der Bilder an! Gleichzeitig ist die Schönheit einer

Kerstin
Brätsch

KERSTIN BRÄTSCH, UNTITLED 13, 2007, Psychic Series, oil and crayon on paper, 110 x 72" / OHNE TITEL, Öl und Pastellkreide auf Papier, 279,4 x 182,9 cm.

MASSIMILIANO GIONI

Notes on Abstraction

For Kerstin Brätsch, painting is merely one tile in a mosaic of languages that range from drawing to performance, sculpture to design, by way of theater and fashion. Brätsch sees a painted work as a single link in a system of production and distribution. Perhaps it is the hidden influence of Franz West and his *Passstücke*—sculptures that can be used as strange theatrical props—or a return to the experimental fluidity of the 1960s, in the footsteps of Robert Rauschenberg, painter, dancer, and choreographer; unquestionably, Brätsch thinks of her work as an exercise in constant lateral shifts through which a painting can become a book, a sculpture, the set for a performance, or even turn into a phantom image of itself. And the artist's identity seems to follow a similar path, moving freely from the personal to the collective, from Kerstin Brätsch to DAS INSTITUT.

There is the echo of a great deal of twentieth-century abstract painting in Brätsch's work, and she knows how to digest entire stylistic vocabularies with the same ease, processing them into a unique mixture. There is no referentialism or historical obsession in her work; if anything, there is a pride in seeming absolutely contemporary and of the moment. With the awareness, however, that the era we live in is also based on the synchronicity and permeability of languages, as if every style were always on hand, within reach, but never completely assimilable.

MASSIMILIANO GIONI is Associate Director at the New Museum in New York and Artistic Director of the Trussardi Foundation in Milan. He recently curated 10,000 Lives, the 8th Gwangju Biennale, where Kerstin Brätsch presented a selection of her paintings.

Painting in the age of Wikipedia: a surfeit of information, maximum superficiality, minimum knowledge—history as assemblage.

Among the artists whose traces and memories are to be found in the works of Kerstin Brätsch, one could list, almost at random: René Daniels, Hilma Af Klint, Emma Kunz, František Kupka, Sonia Delaunay, Bridget Riley, Rudolf Steiner. And this legacy is also encrusted with the enticements of much more prosaic visual languages: old advertisements, worn photocopies, decorative motifs, computer graphics, patterns from cheap fabric, photographs from mail-order catalogues.

Kerstin Brätsch's painting seems to strive for a precarious balance between diverging impulses and attitudes. It is no coincidence that many of her paintings and drawings have an irresolute way of occupying space: hung from magnets, stretched out like bedsheets in the wind, suspended on wooden frames, or left on the ground like clothes torn off in the heat of an amorous encounter. Brätsch's painting is environmental and spatial, but often takes a marginal position within the exhibition space, off to the side, as if it were somewhat insecure: her painting is first and foremost an attitude, not a style, a way of inhabiting space.

When forms become attitudes.

Brätsch's objects and artworks often trigger actions or generate other objects and products, as in a chain reaction.

Perhaps Brätsch's art is interested not so much in abstraction as in a form of obstruction, concealment, and dissimulation. She seems stubbornly determined not to be just a painter, even though painting is her vocation. In all of her work, one can sense an effort to escape from the narrow confines of painting, to instead create a form of art that cannot be immediately traced to a single genre.

In this centrifugal movement, outside the limits of painting, Brätsch's work is connected to an entire tradition of minor and decorative arts. Especially in the series of works created under the pseudonym DAS INSTITUT—a sort of fictional collective made up of Kerstin Brätsch and Adele Röder—one can feel the echo of Bauhaus, and even before that, of the Arts & Crafts Movement, but somehow debased and corroded by a new sense of urgency and immediacy, even by a certain cheapness that is very much of our present time.

DAS INSTITUT is Bauhaus by way of the sweatshops of the Far East.

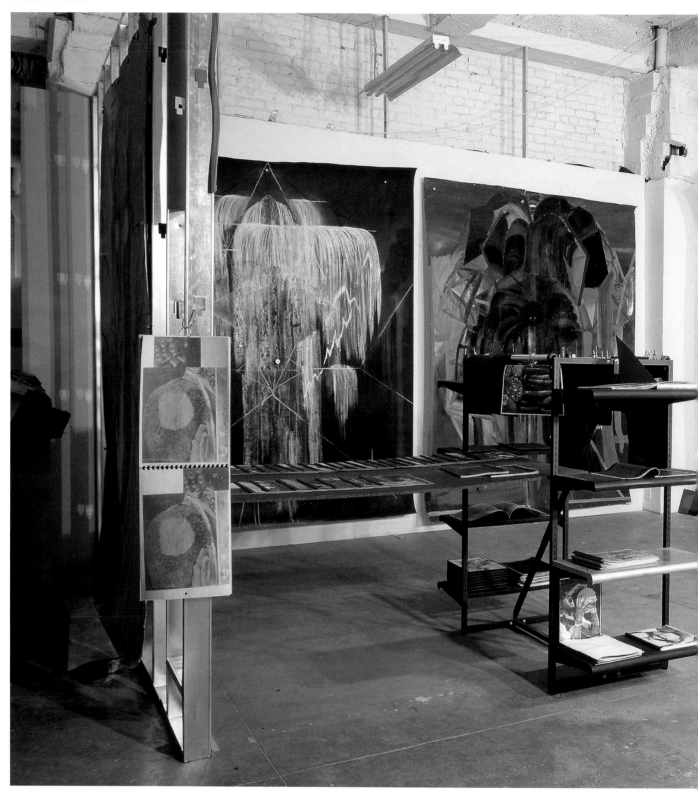

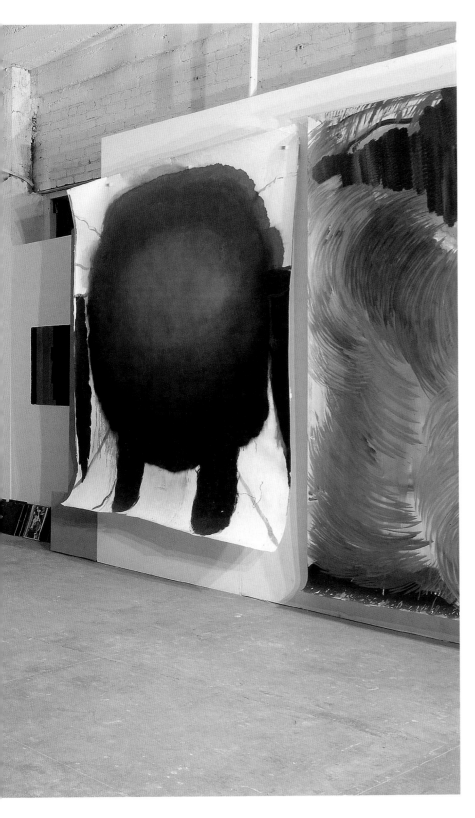

KERSTIN BRÄTSCH, *paintings from Psychic Series, thesis show, 2007, and* BOOK SHELVING UNIT, *selfmade books and booklets from unlimited edition / Gemälde aus der Psychic Serie, Diplomausstellung und* BÜCHERREGAL EINHEIT, *selbstgemachte Bücher und Broschüren aus unlimitierter Edition.*

(ALL PHOTOS: COURTESY OF THE ARTIST AND BALICE HERTLING, PARIS, UNLESS OTHERWISE INDICATED)

DAS INSTITUT is Bauhaus meets disco design.

This tendency to mix the loftiest languages with the most hackneyed styles crops up in many of Brätsch's paintings. In the *Psychic Series*, for instance, she combines theosophy with spirituality straight out of a self-help manual. Abstract painting as a vehicle towards the absolute is one of the most burdensome legacies of the century just behind us. In the large works on paper of the *Psychic Series*, Brätsch seems to be looking for a way to deal with the sublime without falling into the snare of kitsch. The paintings in the *Psychic Series* are not aura portraits or the projections of some kind of obscure force; rather, they are an attempt to open up a pictorial space in which the absolutist urges of visionary painting can coexist with much lighter, more contemporary forms of notation. Strange, vaguely larval forms loom out of these large drawings: here and there, once can glimpse the oval of a face, the shape of a head. Elsewhere one finds large, wide-open, oddly animal eyes. These are paintings that swarm with protocellular life, or whose planes of color ripple like television static. The faces that sometimes float up to the surface have the gaseous substance of a revelation. These are contemporary icons—icons in the sense of religious paintings and of computer graphics. The sublime is now.

Many of Kerstin Brätsch's paintings live a double life. They exist as themselves and as ghosts of their former being. Painted on sheets of mylar and plastic, the works that Brätsch calls "ghosts" are copies of pieces the artist has painted before: the same motifs, shapes and colors that she used in her works on paper are repeated on transparent backgrounds. This repetition and dematerialization of painting is a process that demystifies and critiques Brätsch's work from the inside, as if through these transparent copies, the artist wanted to strip her previous paintings of all weight, rendering them lighter, volatile. Moreover, Brätsch's phantom copies are not faithful reproductions of the originals, but rather variations on a theme. Actually, one could say that all of Brätsch's work rests on the very negation of any difference between original and copy. All of her paintings are originals and all are copies, to the point that many of Brätsch's abstractions actually derive from patterns drawn on the computer by Adele Röder: in other words, her abstract paintings are reproductions of computer-generated graphic motifs that Brätsch diligently enlarges and reproduces on paper. Through these repetitions and endless translations across media, Brätsch—like many artists of her generation—seems to take painting to a new level of inflation, as though it were to compete with the industry of digital imaging.

In the Brätsch system, every object is interchangeable, and the borders between painting, design, sculpture are equally fluid, to the extent that for some paintings, Brätsch and DAS INSTITUT have even come up with a series of posters and commercials to promote the works as if they were commodities or design products.

Kerstin Brätsch's goal is probably to no longer be considered a painter, to finally be seen as the owner of a conceptual import/export agency, a trader in the market of pure information, an aesthete of communication.

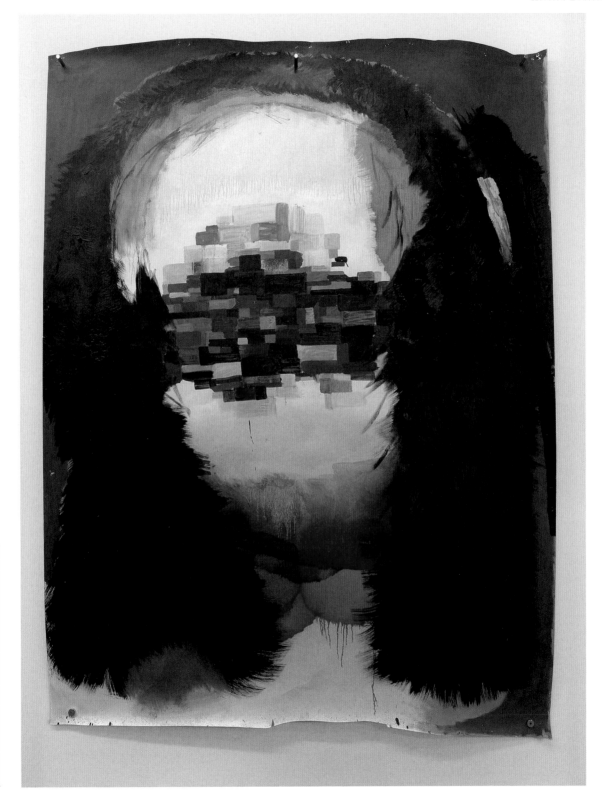

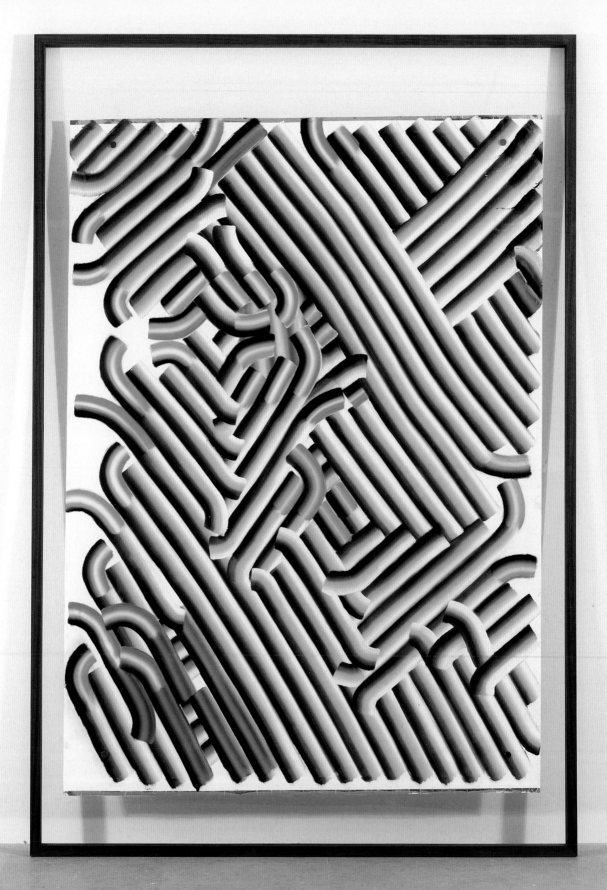

KERSTIN BRÄTSCH *for DAS INSTITUT, HE WANTS TO BE A WASP, 2010,*
Broadwaybrätsch Corporate Abstraction Series, oil on paper, wooden frame, magnets, 110 x 72" /
ER WILL EIN WEISSER ANGELSÄCHSISCHER PROTESTANT SEIN, Öl auf Papier,
Holzrahmen, Magnete, 279,5 x 182,9 cm. (PHOTO: JASON MANDELLA)

Anmerkungen zur Abstraktion

MASSIMILIANO GIONI

Malerei ist für Kerstin Brätsch lediglich ein Stein in einem Mosaik von Sprachen, das von der Zeichnung und Plastik über das Theater und die Mode zu Performance und Design reicht. Brätsch betrachtet ein gemaltes Werk als einzelnes Glied in einem System der Produktion und Verbreitung. Vielleicht ist es der versteckte Einfluss von Franz West und dessen *Passstücken* – Plastiken, die sich als seltsame Bühnenrequisiten verwenden lassen – oder eine Rückkehr zu den fliessenden Grenzen der experimentellen 60er-Jahre, in den Fussstapfen von Robert Rauschenberg, Maler, Tänzer und Choreograph; ohne Frage versteht Brätsch ihr Werk als eine Übung in unentwegten Verschiebungen, im Zuge derer ein Gemälde zu einem Buch, zu einer Plastik oder zur Kulisse für eine Performance werden oder sich gar in ein trügerisches Abbild seiner selbst verwandeln kann. Und die Identität der Künstlerin scheint einen ähnlichen Weg zu nehmen, da sie sich nach Belieben vom Persönlichen aufs Kollektive, von Kerstin Brätsch auf DAS INSTITUT verlagert.

Es gibt in Brätschs Werk Anklänge an jede Menge abstrakter Kunst des 20. Jahrhunderts, und sie weiss mit gleichbleibender Leichtigkeit ganze stilistische Vokabulare zu verarbeiten und zu einer einzigartigen Mischung aufzubereiten. Es gibt in ihrem Werk keinen Referentialismus und keine Geschichtsbesessenheit, sondern, wenn überhaupt, nur Stolz darauf, ganz und gar heutig und jetzig zu wirken. Allerdings in dem Bewusstsein, dass das Zeitalter, in dem wir leben, ebenso auf der Gleichzeitigkeit und Durchlässigkeit von Sprachen beruht, so, als wäre jeglicher Stil jederzeit verfügbar, scheinbar griffbereit, jedoch nie vollständig assimilierbar.

MASSIMILIANO GIONI ist Associate Director am New Museum in New York und künstlerischer Leiter der Fondazione Nicola Trussardi in Mailand. Er hat kürzlich 10.000 Lives, die 8. Gwangju Biennale, kuratiert, im Rahmen derer Kerstin Brätsch eine Auswahl ihrer Gemälde zeigte.

Malerei im Zeitalter von Wikipedia: Informationsübersättigung, ein Höchstmass an Oberflächlichkeit, minimales Wissen – Geschichte als Assemblage.

Die Künstler, von denen Erinnerungsspuren in den Arbeiten von Kerstin Brätsch auszumachen sind, lassen sich geradezu wahllos aufzählen: René Daniëls, Hilma Af Klint, Emma Kunz, František Kupka, Sonia Delaunay, Bridget Riley, Rudolf Steiner. Dieses Vermächtnis ist zudem überkrustet mit den Lockungen von ausgesprochen prosaischen Bildsprachen: alte Werbeanzeigen, abgegriffene Photokopien, dekorative Motive, Computergraphiken, Schnittmuster von billigen Stoffen, Abbildungen aus Versandkatalogen.

Die Malerei von Kerstin Brätsch strebt, so scheint es, ein prekäres Gleichgewicht zwischen unterschiedlichen Impulsen und Haltungen an. Nicht zufällig wirken ihre Malereien und Zeichnungen vielfach unentschlossen in der Art und Weise, wie sie Raum einnehmen: Mal hängen sie an Magneten, mal sind sie aufgespannt wie Bettlaken im Wind, an Holzgerüsten aufgehängt oder wie in der Hitze eines erotischen Rendezvous auf dem Boden liegen gelasse Kleidungsstücke. Brätschs Malerei hat Environmentcharakter, ist räumlich angelegt, doch oft nimmt sie im Ausstellungsraum eine Randposition ein, zur Seite hin, so, als sei sie ein wenig unsicher: Ihre Malerei ist zuerst und vor allem eine Haltung und kein Stil, eine Art und Weise, sich im Raum einzurichten.

Wenn Formen Haltungen werden.

Brätschs Objekte und Kunstwerke lösen vielfach wie in einer Kettenreaktion Handlungen aus oder generieren andere Objekte und Produkte.

Vielleicht ist die Kunst von Kerstin Brätsch nicht so sehr am Abstrakten interessiert als vielmehr an einer Form von Versperrung, Verbergung und Kaschierung. Sie ist offenbar hartnäckig entschlossen, nicht nur Malerin zu sein, obwohl das ihr erlernter Beruf ist. In ihrem Werk ist immer wieder das Bemühen spürbar, aus den eng gesteckten Grenzen der Malerei auszubrechen und stattdessen eine Kunst zu schaffen, die sich nicht sofort auf eine einzige Gattung zurückführen lässt.

In dieser zentrifugalen Bewegung jenseits der Grenzen der Malerei knüpft Brätschs Werk an eine ganze Tradition der Klein- und Gebrauchskunst an. Insbesondere bei den unter dem Pseudonym DAS INSTITUT entstandenen Werkgruppen – DAS INSTITUT ist eine Art fiktives Kollektiv, bestehend aus Kerstin Brätsch und Adele Röder – lässt sich der Nachhall des Bauhauses und, noch davor, der Arts-and-Crafts-Bewegung heraushören, nur irgendwie verwässert und zersetzt durch einen neuen, ganz und gar heutigen Geist der Dringlichkeit und Unmittelbarkeit, ja sogar durch eine gewisse Billigkeit.

KERSTIN BRÄTSCH for DAS INSTITUT, Broadwaybrätsch Corporate Abstraction Series, 7 paintings /
7 Gemälde; ADELE RÖDER for DAS INSTITUT, men's shirts / Männerhemden; both works /
beide Arbeiten: Cc: Corp AB Series, Art Basel Statements, 2010. (PHOTO: BALICE HERTLING)

DAS INSTITUT ist Bauhaus unter dem Vorzeichen der Sweatshops des Fernen Ostens.

DAS INSTITUT ist Bauhaus trifft Disko-Design.

Diese Tendenz, die gehobensten Sprachen mit den trivialsten Stilarten zu vermischen, zeigt sich in zahlreichen Gemälden von Kerstin Brätsch. So verbindet sie bei den Arbeiten der *Psychic Series* Theosophie mit unmittelbar einem Selbsthilfebuch entnommener Spiritualität. Die Vorstellung, man könne über abstrakte Malerei zum Absoluten gelangen, ist eine der schwersten Erblasten des unmittelbar hinter uns liegenden Jahrhunderts. Bei den grossformatigen Arbeiten auf Papier der *Psychic Series* scheint Brätsch nach einer Möglichkeit zu suchen, sich mit dem Erhabenen auseinanderzusetzen, ohne in die Kitschfalle zu gehen. Die Malereien der *Psychic Series* sind keine Aura-Darstellungen oder Projektionen irgendeiner Art

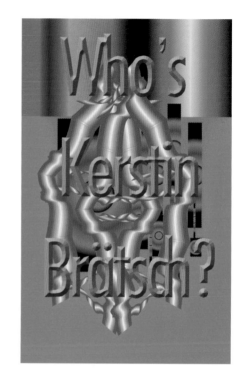

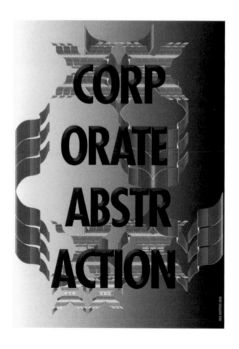

DAS INSTITUT, Cc: Corp AB Series, 2010, title posters, size variable, digital prints on archival paper, series of 16 posters, Art Basel Statements / Titelplakate, Masse variabel, Digitaldruck auf Archivpapier.

von dunkler Kraft, sondern vielmehr der Versuch, einen Bildraum zu erschliessen, in dem der absolutistische Drang visionärer Malerei neben wesentlich leichteren, eher heutigen Darstellungsformen existieren kann. Sonderbare, irgendwie larvenartig anmutende Formen treten uns aus diesen grossformatigen Zeichnungen entgegen: Hier und da ist flüchtig das Oval eines Gesichtes, die Form eines Kopfes zu erkennen. Anderswo trifft man auf grosse, weit geöffnete, seltsam tierische Augen. Es sind Gemälde, in denen es von protozellulärem Leben nur so wimmelt oder deren verschiedene Farbebenen wie TV-Störbilder Wellen werfen. Die Gesichter, die manchmal an die Oberfläche treiben, haben die gasartige Substanz einer Offenbarung. Dies sind zeitgenössische Ikonen – Ikonen im Sinne von religiösen Gemälden und Computergraphik. Das Erhabene ist jetzt.

Eine Vielzahl der Gemälde von Kerstin Brätsch führt ein Doppelleben. Sie existieren als sie selbst und als Geister ihrer früheren Existenz. Die auf Mylar- und Plastikfolien gemalten Arbeiten, die Brätsch als «Geister» bezeichnet, sind Kopien von Arbeiten, die bereits existieren: Die gleichen Motive, Formen und Formen, die sie bei ihren Arbeiten auf Papier verwendet hatte, werden auf transparentem Grund wiederholt. Diese Wiederholung und Entmaterialisierung der Malerei ist für Brätsch ein Weg, ihr Werk von innen her zu entmystifizieren und zu hinterfragen, so, als wollte sie mittels dieser transparenten Kopien ihren früheren Gemälden jegliches Gewicht entziehen und sie so leichter, flüchtiger machen. Brätschs Phantomkopien sind zudem keine originalgetreuen Reproduktionen, sondern eher Variationen über ein Thema. Man könnte tatsächlich behaupten, dass das gesamte Schaffen von Kerstin Brätsch gerade auf der Negierung jedweden Unterschieds zwischen Original und Kopie beruht. Alle ihre Gemälde sind Originale u n d Kopien: Eine Vielzahl ihrer Abstraktionen geht tatsächlich auf Vorlagen zurück, die von Adele Röder am Computer gezeichnet wurden. Das heisst, ihre abstrakten Gemälde sind Reproduktionen von computergenerierten zeichnerischen Motiven, die Brätsch sorgfältig vergrössert und auf Papier reproduziert. Mittels dieser Wiederholungen und endlosen Übertragungen über verschiedene Materialien und Techniken hinweg führt Brätsch, wie viele Künstler ihrer Generation, die Malerei zu einem neuen Niveau der Inflation, so, als würde sie mit der digitalen Bildverarbeitungsindustrie konkurrieren.

Im Brätschschen System ist jedes Objekt austauschbar und die Grenzen zwischen Malerei, Design und Plastik sind ebenso fliessend. Das geht sogar so weit, dass Brätsch und DAS INSTITUT eine Reihe von Plakaten und Werbespots entwickelt haben, um für die Werke zu werben, als wären sie Verbrauchsgüter oder Design-Erzeugnisse.

Kerstin Brätschs Ziel ist es wohl, nicht mehr als Malerin, sondern endgültig als Eigentümerin einer konzeptuellen Import-Export-Agentur, als Händlerin auf dem Markt der reinen Information, als Ästhetin der Kommunikation angesehen zu werden.

(Übersetzung: Bram Opstelten)

BEATRIX RUF

Kecke Schale, komplexer Kern

So umwoben waren wir wohl noch nie, keine Informationsaneignung, kein Genuss, keine geistige oder körperliche Betätigung, keine Arbeit oder Freizeit ohne Werbebanner, Sideclick, Pop-up, Umhüllung mit Marken, Konsummöglichkeiten, Customizing und Identitätsprojektionen. Egal welches Medium wir nutzen, egal in welcher Realität oder Virtualität wir uns bewegen, egal welche Wahl wir treffen, eine allgegenwärtige, und nebenbei meist schlecht gestaltete, Buntheit verspricht uns ein «So soll es sein», «Das willst Du», «Das kannst Du haben», «Das bist Du» als reale Möglichkeit. Realität und Fiktion, Unerreichbares und Erwerbbares, Vorher und Nachher, Vergangenheit und Zukunft, Mangelhaftes und Perfektes scheinen darin zu verschmelzen und das Unvereinbare dieser Kategorien wird in Bild- und Text-Collagen mit Absicht, aber ohne erkennbaren Geschmack oder Stil zusammengezwungen.

Kerstin Brätsch agiert in ihrer Kunst mit einer ähnlich präsenten Buntheit der Mittel und Referenzen: Mit der Anlehnung an die Warenhaftigkeit von Bildern und durch einen Prozess kontinuierlicher Variation wird die Aufmerksamkeit für ihre grossflä-

chigen Kunst-Banner immer wieder reaktiviert. Diese ungewöhnlich grossen Papiergemälde (meist 300 x 200 cm) und die überlangen bemalten Mylarfolien sind entweder auf schrillen Plexiglasplatten in den Raum gestellt, an der Wand verankert wie Werbefahnen oder sie sind mit mörderisch starken Magneten auf das Glas eigentlicher «Kunstrahmen» montiert oder hängen drapiert wie Stoffe auf diversen Trägermaterialien im Raum.

Die Arbeiten von Kerstin Brätsch basieren auf der Kreativität eines medial forcierten Kollektiven, das die Gleichzeitigkeit der Originale mit den unüberschaubaren Parallelexistenzen von Reproduktionen und der medialen Verbreitung von Bildern als gegeben akzeptiert und uns diesen Realitätszustand in ihren Werken kritisch erlebbar macht. In einem von der Künstlerin verfassten 103 Punkte umfassenden *Psychischen Atlas* heissen Punkt 22 «Malerei ist performativer Realismus (Ich bekenne, ich zweifle)», Punkt 30 «Ein Raum mit Theaterrequisiten und gleichzeitig eine V.I.P. Lounge», 58 «Gedankenformen/Emma Kunz» und 59 «Picabia».

Brätschs Gemälde sind von vielen Historien, Geschichten, Originalen durchzogen: der Romantik, der Frühmoderne, dem Deutschen Expressionismus,

BEATRIX RUF ist Direktorin der Kunsthalle Zürich.

KERSTIN BRÄTSCH for DAS INSTITUT, Broadwaybrätsch Corporate Abstraction, 2010, Art Basel Statements, installation view / Installationsansicht.

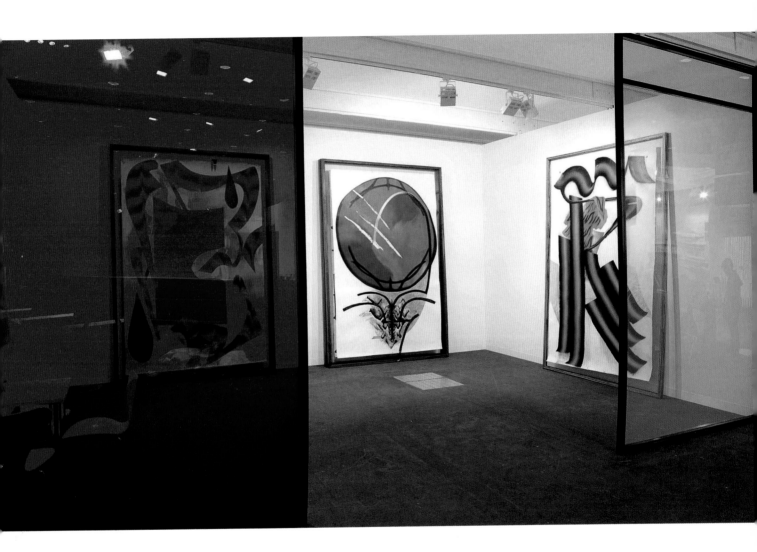

KERSTIN BRÄTSCH for DAS INSTITUT, Broadwaybrätsch Corporate Abstraction, 2010, Art Basel Statements, installation view / Installationsansicht.

dem Abstrakten Expressionismus, aber auch Francis Picabia spielt eine Rolle, die Malerei der 50er-Jahre und Martin Kippenberger, Sigmar Polke, Albert Oehlen, die 80er-Jahre insgesamt – Okkultismus, Esoterik und Warentrash. Generationskollegen wie Josh Smith und Seth Price, deren malerische und mediale Arbeiten Themen des Originals, der Handschrift, des medialen Vertriebs und der dadurch veränderten Bedeutungsproduktion berühren, klingen mit – und selbstverständlich ist die Werbeästhetik roter Faden,

durchdringendes Element und Leitidee ihrer auf das Display und die Präsentationsform reflektierenden Installationen.

Caterina Riva und Joshua Simon formulieren in ihrer Einleitung zum Dialog «Die Sprache der Dinge» im Showroom in diesem Dezember in London:

Als Karl Marx im Kapital den Warenfetischismus beschrieb, führte er aus, dass der Ware jenseits ihres Handels- und Nützlichkeitswertes ein dritter Wert eigen ist: «Eine Ware scheint auf den ersten Blick ein selbstverständliches,

triviales Ding. Ihre Analyse ergibt, dass sie ein sehr vertracktes Ding ist, voll metaphysischer Spitzfindigkeit und theologischer Mucken.» (Das Kapital, Der Fetischcharakter der Ware und sein Geheimnis) In den seither vergangenen hundertfünfzig Jahren ist die Ware zu einem historischen Subjekt in der Gegenwartskultur geworden. Fast jedes Objekt betritt die Welt als Ware und als solches fühlt es sich in ihr sehr zu Hause (man denke zum Beispiel an IKEA ...). Durch verschiedene Strategien der Komposition, Appropriation und Re-Kontextualisierung unterschiedlicher Waren versuchen Künstler heutzutage Kunst zu machen und zu verstehen. Von einer Assemblage von Produkten bis zu einem abstrakten Gemälde, könnte man argumentieren, dass einige Waren Kunstobjekte sind, aber alle Kunstobjekte schlussendlich Waren: Die Ware geht nicht nur der Warenhaftigkeit des Kunstwerks im Kunstmarkt voraus, sondern

dem Kunstwerk selbst. Es ist das Material alller Materialien. Es ist die fundamentale Technik jeder Technik, das Medium aller Medien.[1]

Metaphysische Spitzfindigkeiten und theologische Mucken durchdringen auch das Werk Kerstin Brätschs. Die so offensichtlich im Warensinn durchdeklarierte Präsentation und Distribution der Arbeiten bietet Testfälle für Vermutungen, Erwartungen, Möglichkeiten, Spekulationen erweiterter Werte der Kunst an.

Zusammen mit Adele Röder hat sie folgerichtig 2007 die nicht minder aufgeputzt genannte Firma DAS INSTITUT gegründet. Eine Import/Export Agency, die in einem unauflösbaren Hinein und Hinaus von Original und Variation, Individualisierung und Multiplikation, Authentifizierung und Analyse

KERSTIN BRÄTSCH, left COME BYE – GHOST; right GIVE ME STRENGTH – GHOST, New Images – Unisex Series; exhibition view "Buybrätschwörstghosts" at Hermes und der Pfau, Stuttgart, 2009 / links KOMM AUF WIEDERSEHEN – GEIST, rechts GIB MIR KRAFT – GEIST, Ausstellungsansicht. (PHOTO: BERNHARD KAHRMANN)

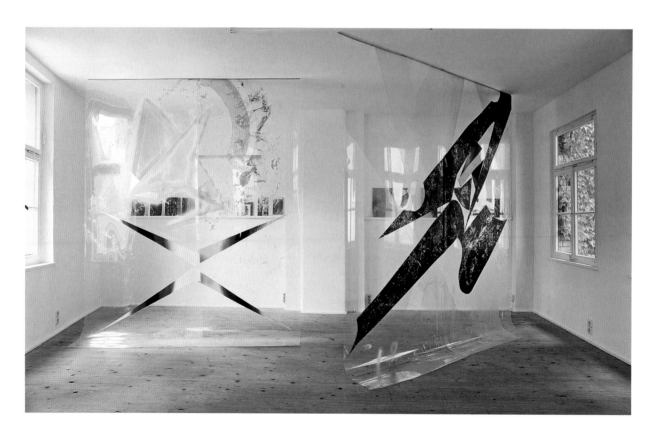

KERSTIN BRÄTSCH for DAS INSTITUT,
GIVE ME STRENGTH, 2009,
New Images – Unisex Series, oil on paper, 72 x 110" /
GIB MIR KRAFT, Öl auf Papier, 182,9 x 279,4 cm.

ausstellungen (I) und was es sonst noch so zum Vertrieb geben kann. Geister und Parasiten der Kunst in allen möglichen Erscheinungsformen, alles «zertifiziert» durch einen Firmennamen. Die grandiose Namensgebung federt die Wägbarkeiten individuell-subjektiver Äusserungen ab, sie steht für alle Forschungs- und Bildungsanstalten der Erkenntnis- und Güterwelt – entlarvt sich aber auch selbst polemisch, humorvoll und kritisch als strategisches Schachzug- und Versicherungsmodell.

HEY DU KUNST, HEY KERSTIN BRÄTSCH – die Titel der Arbeiten und das, was die Künstlerin an Text in ihren Werken zur Sprache bringt, setzen das absichtsvoll Aufreizende und das immer haarscharf an der Bedeutungsfrage schlingernde Werben der Arbeiten in grandioser Ambivalenz ins Bild: New-Images-UNISEX-SERIES; PSYCHICS SERIES; ÄTSCH BRÄTSCH; MR. EYE GIVES YOU A DEAL; MADE IN CHINA; WER ICH WIRKLICH BIN, JA HALLO?, HELLO, YES HELLO!; DOUBLE DEBO; GIB MIR KRAFT; ARE YOU GAME?; FÜRST FÜRST SERIES; BUYBRÄTSCHWÖRST; DI WHY RELAX! SWISS SPA CAVA SERIES; GENRES, PERHAPS, OR TACTICS, MAYBE?, STARS AND STRIPES SERIES; LA TECHNIQUE DE BRÄTSCH SERIES; BROADWAY-BRÄTSCH_CORPORATE ABSTRACTION (II); KERSTIN KOPY KOMMERZIAL; WHO'S KERSTIN BRÄTSCH?, WHEN YOU SEE ME AGAIN IT WON'T BE ME ... Pompöse Fragen an die Identität, pompöse Erwartungsansprüche der Kunst, pompös benutzerfreundliche Produktionen. (III)

Bei Kerstin Brätsch und bei DAS INSTITUT ist die Erscheinungsform eines Kunstwerks immer eine Möglichkeit von vielen, Identität eine von vielen möglichen und sogar das Authentizität verheissende handgemalte Original der technikvirtuosen Kerstin Brätsch kann zahlreiche «Geister» evozieren und produzieren.

2009 hat Brätsch in zwei zeitgleichen Ausstellungen die Originale und die Geister gezeigt: In der Pariser Galerie Balice Hertling fand «BUYBRÄTSCHWÖRST» statt und in der Stuttgarter Galerie Hermes und der Pfau sah man sämtliche Exponate der Pariser Ausstellung als Variationen, Mutationen und Übertragungen unter dem Titel «BUYBRÄTSCHWÖRSTGHOSTS». Auch DAS INSTITUT hat seine Geister produziert und in Stuttgart die Schwarzweiss-Kopien der farbigen

von Identität, der Verwertung der Bildmotive beider Künstlerinnen dient.

Brätsch und Röder produzieren mit/für/durch DAS INSTITUT sowohl individuelle wie kollaborative Arbeiten. Ihre Bilder durchwandern im INSTITUT multiple Variationen von Erscheinungsformen, sie werden zu Stoffmustern, Strickmode, Modekollektionen, Diaprojektionen, Piktogrammen, Bühnensets, Indexlisten und Gebrauchsgegenständen, zu Aufklebern und Abziehbildern, zu Büchern und Kunst-

Hefte präsentiert, die in der Galerie Balice Hertling Kerstin Brätschs Ausstellung dokumentierten.

Kerstin Brätsch und Adele Röder bemühen mit ihrem INSTITUT absichtsvoll etwas ausgeleierte Vorstellungs- und Erwartungsbereiche und gelangen so zu möglichen neuen Spannungsmodellen. Dies tun sie nicht im Sinne einer Erweiterung künstlerischer Aktivitäten und Formulierungen aus der Kunst hinein in die Welt, das Design, den Gebrauch, so wie es etwa in den 90er-Jahren als Erweiterung der Produktions- und Bedeutungsbedingungen der Kunst realisiert und thematisiert wurde. Stattdessen geht es ihnen um Problematisierungen der Authentifizierung von Kunst in einer durchkommodifizierten Weltoberfläche, um Performanzen von Dingen und ihren Bedeutungen, um mögliche Instrumente zur Abstraktion, aber auch um das, was Kunst, Mode, und Design im Rahmen einer Produktwelt insgesamt an Modellen, Information und Sinnübertragungen leisten können – sie nennen das für die Vorgehensweise des INSTITUTS: Design, Werbung, Distribution.

I: In zwei Ausstellungen «Thus! Unit # 1-3» im Ausstellungsraum New Jerseyy in Basel und «Thus! Unit # 4» in der Ausstellung Greater New York, P.S.1 in New York (beide 2010) spielen die Künstlerinnen das gesamte Repertoire ihrer Zusammenarbeit durch: «Originale» von Kerstin Brätsch finden ihre digitalen Doppelgänger als Textilien von Räder und erscheinen wiederum von Brätsch gemalt in Variationen als «authentische» Papiergemälde an der Wand. Bildmotive von Adele Röder sind als Stoffdrucke am Boden auf den Ingredenzien der Präsentationsformen von Malerei ausgelegt (Holzrahmenelemente und Glas etwa), aber sie kommen auch als Stoffe, Kleider, Gebrauchsobjekte vor. Ineinanderverwobene Motive beider Künstlerinnen, hängen als Drapagen von Prints auf Werbefolien von Stangen wie auch weitere Stoffdrucke von Röder und handgemalte Mylargeister-Brätscher-Bilder. Für die Ausstellungen haben die beiden Künstlerinnen auch eine Werbekampagne entwickelt, in der beide vor ihren Arbeiten zu sehen sind, beide halten eine Schrifttafel hoch, auf denen die Initialen der Firma «DI», DAS INSTITUT, eher als «ID», Identity gelesen werden kann.

II: Auch bei BROADWAYBRÄTSCH_CORPORATE AB-STRACTION, Kerstin Brätsch für DAS INSTITUT, gezeigt in den Art Statements der Art Basel (2010), dekliniert Kerstin Brätsch Präsentationsformen der Kunst mit Vermarktungsmodellen und Mode. Ihre Präsentation bestand aus einer grossen Gruppe von sieben Papiergemälden, die gestapelt präsentiert wurden, im jeweiligen Wechsel, sodass jeweils drei Bilder sichtbar waren, die grossformatigen Papiere waren wie immer mit Magneten auf die Vorderseite der Gläser in massiven Holzrahmen fixiert. Die gemalten Bilder enthielten Motive zahlreicher früherer Gemälde Brätschs, in einer grandiosen Mischung entstand ein Remix von eigenen Arbeiten und Evokationen von abstrakten Werken der Kunstgeschichte. In der täglichen Neumischung der Bilder zueinander wurde zudem eine Ausstellungssituation als permanenter Remix von Bildern in erweiterter Form geschaffen (Punkt 22. «Malerei ist performativer Realismus (Ich bekenne, ich zweifle)»). DAS INSTI-TUT hatte Werbeposter mit einem Motivmix beider Künstlerinnen und Stoffdrucke hergestellt, die als Wandposter (DAS INSTITUT, 2010)und als Hemden der Galeristen (Adele Röder für DAS INSTITUT, 2010) ebenso im permanenten Wandel die Gesamtinstallation in einen beschleunigten Zirkus der Begriffsdeflationen verwandelte: Was ist die Kunst? Wer vermarktet? Wer performt? Wo ist das Original? Who is Kerstin Brätsch?

III: In ihrer neuesten Werkgruppe nehmen die beiden Künstlerinnen sich selbst als Material und machen das, was man ein photographisches «Porträt» nennen könnte. Mit Malerei, Modeaccessoires, mit Drucken, Stoffen und anderen Produktionen von DAS INSTITUT und individuellen Arbeiten der beiden Künstlerinnen schaffen sie ein graphisches, alles verwebendes Gesamtprodukt Mensch.

1) «The Language of Things», in The Showroom, 4. Dezember 2010, ein Gespräch mit Luigi Fassi, Stefano Harney, Julia Mortiz, Andrea Phillips und Joshua Simon. http://www.theshowroom.org/programme.html?id=101,355

DAS INSTITUT, *"Greater New York," exhibition view PS 1, New York, 2010 / Ausstellungsansicht.*
(PHOTO: LUKAS KNIPSCHER)

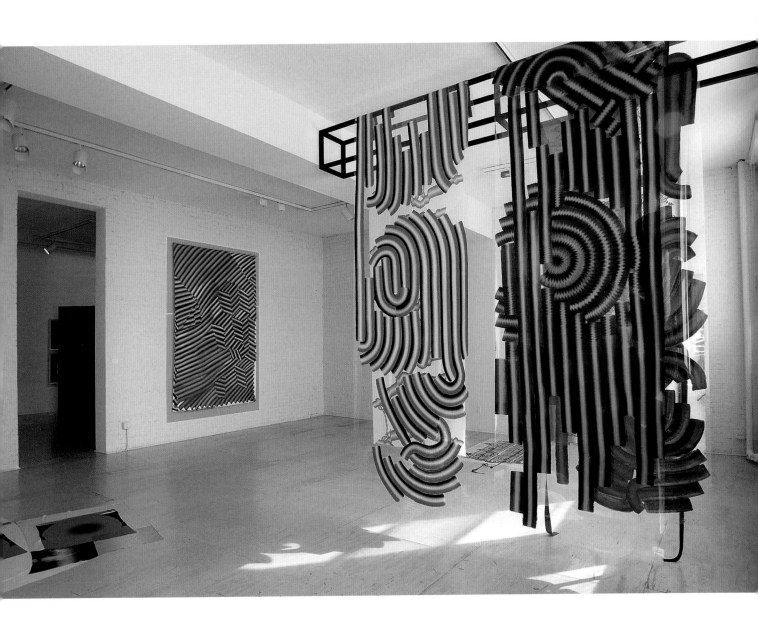

BEATRIX RUF

Alluring Appearance, Complex Core

Never have we been so wantonly wooed. No quest for information, be it for business or pleasure, work or leisure, comes without a banner ad, a sideclick, a pop-up, a barrage of brand names and consumer temptations, customization and projected identities. No matter what medium we use, real or virtual, no matter what choice we make, there is an omnipresent and often shoddily designed parade of all things bright and shiny telling us how life could be, how much we want this or that, how readily something is within our grasp, that we can be whoever we want to be, or are told we want to be. Reality and fiction, the unattainable and the obtainable, before and after, past and future, inadequacy and perfection all seem to fuse in collages of text and image, forcibly uniting the incompatible, with great purpose, but with no discernible taste or style.

Kerstin Brätsch deploys a similarly motley mix of media and references in her art. Exploiting the status of the visual image as a marketable commodity, and using a process of continuous variation, the allure of her large-scale art banners is constantly reactivated. These extraordinarily large paper paintings (most of them 300 x 200 cm) and extra-long sheets of painted mylar are either installed on the floor of the gallery, on strident Plexiglas panels, anchored to the wall like advertising banners, mounted with super-strong magnets on the glass panes of bona-fide "art frames," or draped like swathes of fabric over a variety of objects in the gallery space.

Kerstin Brätsch's works draw upon the creativity of a media-driven collectivity that accepts, as given, the simultaneity of the original with the inevitable parallel existence of reproductions and the media dissemination of images, and they reveal this state of reality to us both critically and tangibly. In her 103-point *Psychischer Atlas* (Psychic Atlas), the artist lists Point 22 as "Painting is performative realism. (I declare that I doubt)," Point 30 as "A theatre-requisite room and a V.I.P. Lounge at the same time," Point 58 as "Thought Forms/Emma Kunz," and Point 59 as "Picabia."

Brätsch's paintings are teeming with histories, stories and originals: Romanticism, Early Modernism, German Expressionism, Abstract Expressionism, and even Francis Picabia all play a role, as does the painting of the 1950s, and the 1980s in general, from Martin Kippenberger, Sigmar Polke, and Albert

BEATRIX RUF is the director of the Kunsthalle Zürich.

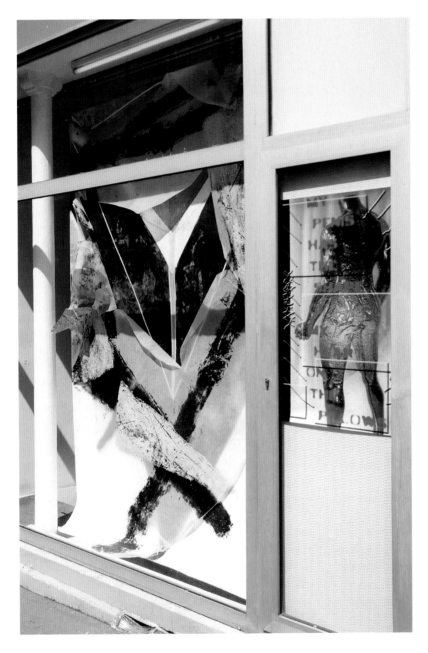

DAS INSTITUT, WHO I REALLY AM, 2009,
title poster, digital print on archival paper,
39 ³/₈ x 27 ¹/₂" / WER ICH WIRKLICH BIN,
Titelplakat, Digitaldruck auf Archivpapier,
100 cm x 70 cm.

KERSTIN BRÄTSCH *for* DAS INSTITUT, MY PENIS HAS THE SHAPE
OF MY HEART ON THE PILLOWS, 2009, *painting and poster, exhibition view*
"Buybrätschwörst," Balice Hertling Paris / MEIN PENIS HAT DIE FORM
MEINES HERZENS AUF DEM KISSEN, *Gemälde und Plakat, Ausstellungsansicht.*

DAS INSTITUT, MADE IN CHINA, 2009,
title poster, digital print on archival paper,
39 ³/₈ x 27 ¹/₂" / Titelplakat, Digitaldruck
auf Archivpapier, 100 cm x 70 cm.

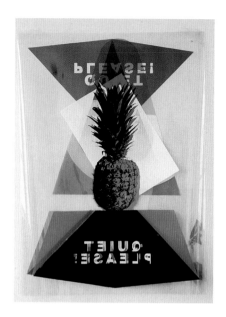

DAS INSTITUT, EAT AND DRINK VARIABLE FROM
DI WHY RELAX!, 2009, Swiss Spa ca va Series,
silkscreen on mylar, each 39 ³/₈ x 51 ¹/₈" /
ISS UND TRINK VARIABEL VON DI WARUM ENTSPANNUNG!,
Siebdruck auf Mylarfolie, je 100 x 130cm.

DAS INSTITUT, QUIET PLEASE VARIABLE FROM
DI WHY RELAX!, 2009, Swiss Spa ca va Series,
silkscreen on mylar, each 39 ³/₈ x 51 ¹/₈" /
RUHE BITTE VARIABEL VON DI WARUM ENTSPANNUNG!,
Siebdruck auf Mylarfolie, je 100 x 130cm.

Oehlen to the occult, the esoteric, and consumer trash. The work of her own contemporaries, such as Josh Smith and Seth Price, whose paintings and media-based works address issues relating to the original, the hand of the artist, media distribution, and the way these affect the production of meaning, are also referenced—and, needless to say, the aesthetics of advertising runs like a red thread throughout, a leitmotif permeating her installations reflecting on aspects of display and presentation.

Caterina Riva and Joshua Simon, in their introduction to the dialogue "The Language of Things" at the Showroom, London, in December 2010, state:

When Karl Marx described commodity fetishism in Capital (1867), he mentioned that beyond its exchange and use values, the commodity has a third implied quality, or as he put it: "A commodity appears, at first sight, a very trivial thing, and easily understood. Its analysis shows that it is, in reality, a very queer thing, abounding in metaphysical subtleties and theological niceties." Since the past 150 years the commodity has become the historical subject in contemporary culture. Almost every object enters the world today as
a commodity and as such it feels most at home in this world (think of IKEA …). Through various strategies of composition, appropriation and re-contextualization of different commodities, artists try to make and understand artworks today. From an assemblage of consumer products to an abstract painting, one could argue that some commodities are art objects, but all art objects are commodities. The commodity not only precedes the commodification of artworks in the art market, but it precedes the artwork itself. It is the material that is in all materials. It is the basic technique of every technique, the fundamental medium of all mediums.[1]

Metaphysical subtleties and theological niceties also permeate the work of Kerstin Brätsch. The presentation and distribution of her works are so obviously and explicitly informed by the spirit of commodification that they provide test cases for the assumptions, expectations, possibilities, and speculation relating to the expanded values of art.

In 2007, true to form, she and Adele Röder founded the suitably ostentatiously named company DAS INSTITUT as an import/export agency serving to promote the visual motifs of both artists in an inex-

tricable to and fro of original and variation, individualization and multiplication, and authentication and analysis of identity.

Brätsch and Röder produce both individual and collaborative works with, for, and through DAS INSTITUT. Within DAS INSTITUT, their images undergo multiple variations of appearance and form, becoming textile patterns, knitwear, fashion collections, slide shows, pictograms, stage sets, index lists, functional everyday objects, stickers and transfers, books, and art exhibitions (I)—and indeed, just about anything else that might lend itself to distribution. The ghosts and parasites of art appear in every conceivable form, all duly certified, as it were, by a brand name. The grand title buffers the ponderables of individual subjective statements, standing as it does for all the research and educational institutes that

DAS INSTITUT, "Non-Solo Show, Non-Group Show,"
Swiss Spa ca va, installation view / Installationsansicht,
Kunsthalle Zürich, 2009.
(PHOTO: STEFAN ALTENBURGER)

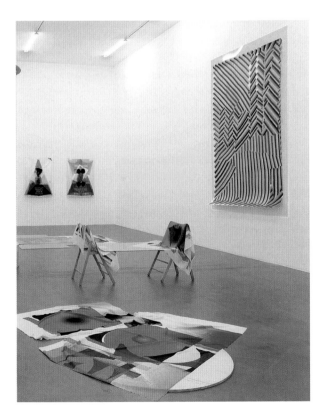

KERSTIN BRÄTSCH for DAS INSTITUT, UNTITLED, 2010,
spraypaint, New York Times advertisements, Plexiglas, metal
clamps, each 19 $^3/_3$ x 27 $^1/_2$,", exhibition view "Rien Rien!,"
Parc Saint Léger / OHNE TITEL, Sprühfarbe, New York Times
Reklamen, Plexiglas, Metallklammern, je 50 x 70 cm,
Ausstellungsansicht. (PHOTO: PARC SAINT LÉGER)

populate the world of knowledge and commodities. At the same time, it is a strategic move and a form of insurance that is as polemical and critical as it is witty.

HEY DU KUNST, HEY KERSTIN BRÄTSCH—the titles of the works and what the artist expresses in them highlight, with grandiloquent ambiguity, the deliberate allure of the works and their oblique yet pertinent allusion to questions of meaning: UNISEX SERIES; PSYCHICS SERIES; ÄTSCH BRÄTSCH; EYE GIVES YOU A DEAL; MADE IN CHINA; WER ICH WIRKLICH BIN, JA HELLO, HELLO, YES HELLO; DR. DEBRO; GIB MIR KRAFT; ARE YOU GAME?; FÜRST FÜRST SERIES; BUY-BRÄTSCHWÖRST; DI WHY RELAX! SWISS SPA CAVA SERIES; GENRES, PERHAPS, OR TACTICS, MAYBE?; STARS AND STRIPES SERIES; LA TECHNIQUE DE BRÄTSCH SERIES; BROADWAYBRÄTSCH/CORPORATE ABSTRACTION (II); KERSTIN KOPY KOMMERZIAL; WHO'S KERSTIN BRÄTSCH?; WHEN YOU SEE ME AGAIN IT WON'T BE ME ... Pompous questioning of identity, pompous expectations of art, pompously user-friendly productions. (III)

In the oeuvre of Kerstin Brätsch and DAS INSTITUT the outward appearance of the artwork is invariably only one of many possibilities; its identity is one of many possible identities and even the promise of authenticity embodied in the hand-painted original by an artist as technically skilled as Kerstin Brätsch can invoke and produce many "ghosts."

In 2009, Brätsch mounted two simultaneous exhibitions featuring originals and their ghosts. All the works in her "BUYBRÄTSCHWÖRST" exhibition at the Balice Hertling gallery in Paris were presented in her "BUYBRÄTSCHWÖRSTGHOSTS" show at the Hermes und der Pfau exhibition space in Stuttgart in the form of variations, mutations, and transpositions. Ghosts were also produced by DAS INSTITUT: the color brochures documenting Kerstin Brätsch's exhibition at Balice Hertling in Paris were available in Stuttgart in the form of black-and-white copies.

With DAS INSTITUT, Kerstin Brätsch and Adele Röder trawl through hackneyed areas of imagination and expectation to dredge up potentially new and highly-charged forms. They do not do so in the sense of expanding artistic activities and formulae from the world of art into the world of design and use, the way artists did in the 90s, by creating or addressing, for instance, the conditions by which the production and meaning of art are expanded. Instead, they focus on the problems of the authentication of art in a thoroughly commodified world, on possible instruments of abstraction, and also on what art, fashion, and design are capable of achieving within the world of products in terms of creating models, spreading information, and conveying meaning. For the purposes of DAS INSTITUT, they describe this approach as design, advertising, and distribution.

I: In two exhibitions—"Thus! Unit # 1-3" at the New Jerseyy gallery in Basel and "Thus! Unit # 4" in the Greater New York exhibition at MoMA PS1 in New York (both 2010)—the artists play through the entire repertoire of their collaborative effort: originals by Kerstin Brätsch, computer-digitalized by *Räder*, appear in variations painted by *Brötsch* as "authentic" paper paintings on the wall, while motifs by Adele Röder are presented as textile prints on the floor, referencing the basic ingredients (such as wooden frames and glass) that are involved in the presentation of paintings, or taking the form of fabrics, clothing, or everyday objects. Interwoven motifs by both artists are hung from rails as draped prints on advertising banners, along with textile prints by Röder and hand-painted mylar ghosts of works by Brätsch. For the exhibitions, the two artists also developed an advertising campaign in which they can both be seen in front of their own works, holding up a sign on which the company initials DI (DAS INSTITUT) can be read as ID, in reference to identity.

II: In "Broadwaybrätsch/Corporate Abstraction," created for DAS INSTITUT and shown at Art Basel's Art Statements (2010), Brätsch used marketing models and fashion elements to systematically break down the presentational modes of art into their component parts. Her presentation consisted of a large group of nine paper paintings stacked in alternating order so that three different pictures were visible at any one time, and affixed to the front of the glass in solid wooden frames by her hallmark magnets. The paintings included motifs from several of Brätsch's earlier works, in a grandiose amalgam that formed a remix of her own oeuvre and evoked abstract works from art history. By changing the order of the paintings on a daily basis, she created an expanded form of exhibition involving a constant remix of images. Cf. Point 22: "Painting is performative realism (I declare that I doubt)." DAS INSTITUT had produced advertising posters featuring a mix of motifs by both artists and textile prints for shirts worn by the gallery staff. Together with the constantly changing images, these wall posters and shirts transformed the overall installation into an accelerated circus of conceptual deflation: What is art? Who markets it? Who performs it? Where is the original? Who is Kerstin Brätsch?

III: In their latest group of works, the two artists use themselves as material to create what might be described as a photographic "portrait." Using painting, fashion accessories, prints, fabrics, and other productions by DAS INSTITUT, as well as works by both artists, they create a graphic and all-inclusive image of the individual as product.

(Translation: Ishbel Flett)

1) "The Language of Things" in The Showroom, 4 December 2010, Conversation with Luigi Fassi, Stefano Harney, Julia Mortiz, Andrea Phillips, and Joshua Simon. http://www.theshowroom.org/programme.html?id=101,355

KERSTIN BRÄTSCH *for DAS INSTITUT, MY LIFE AS FRAU COW WILL SHOW YOU HOW TO CHEW THE LEFT OVER GRASS ON THE FIELDS, 2009, Fürst Fürst Series, oil on paper, 110 x 72" / MEIN LEBEN ALS FRAU KUH WIRD DIR ZEIGEN WIE DAS AUF DEM FELD ÜBRIGGEBLIEBENE GRAS ZU KAUEN IST, Öl auf Papier, 279,4 x 182,9 cm.*

FIONN MEADE

SEE REVERSE FOR CARE

The time of fashion, therefore, constitutively anticipates itself and consequently is always too late. It always takes the form of an ungraspable threshold between a "not yet" and a "no more".
—Giorgio Agamben, *What is an Apparatus?*[1]

To encounter a painting by Kerstin Brätsch is to enter into a space of exhibition design where images behave according to a tailored logic of distribution, mutation, and mischief. From the thick paper employed for the majority of Brätsch's outsized oil paintings to cousin paintings the artist refers to as "ghosts" (translations of previous works onto industrial sheets of mylar), the conventional material setting for painting is repeatedly sidestepped through choices of scale and surface. Often draped or hung by magnets, the paintings curl, warp, and unfurl from intermediary supports integral to the kinesthetic demands of

FIONN MEADE is Curator at SculptureCenter, NY, where recent group exhibitions include "Knight's Move," and "Leopards in the Temple." He received a 2009 Arts Writer Grant from Creative Capital and the Andy Warhol Foundation. He teaches at the Center for Curatorial Studies, Bard College, and in the MFA in Visual Arts Program at Columbia University.

Brätsch's presentation. Painting is provisional here, beta-like. Affixed to temporary freestanding walls, protruding sheets of colored plexiglass and lattice-like beam structures evocative of Minimalism, the paintings engage varying support structures to reiterate and underscore a compositional dictum of her own: "Question the wall itself."[2]

For a recent exhibition at Kunsthalle Zürich, this interrogative stance took the form of sheets of colored plexiglass inserted into the gallery wall at a perpendicular angle in order to suspend and frame Brätsch's *Stars and Stripes Series* (2010); murky void-like washes of oil paint striated with a surface geometry of American coins were countered by the stark detours of shifting, multicolored stripe compositions. While a group exhibition at SculptureCenter, New York, found works from the geometrically inclined *New Images/Unisex Series* (2009), adorning three temporary walls erected close together in the middle of the exhibition space. Both installations are examples of Brätsch pushing away from a pre-existing architectural context in order to compress and moderate the viewing experience of painting, referencing in the process not only the slideshow and preview functions of contemporary screen culture but also the rotating display structures of trade fairs and showrooms.

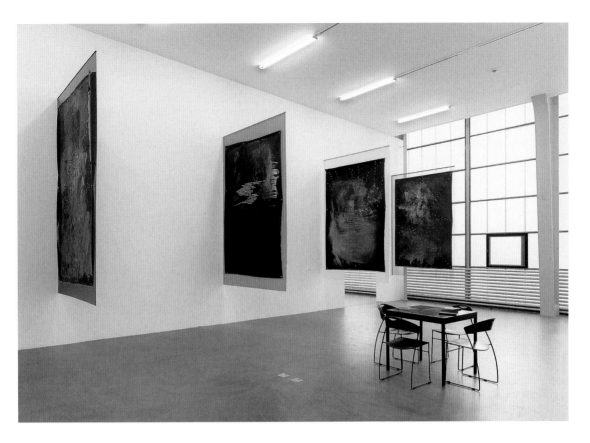

KERSTIN BRÄTSCH and DAS INSTITUT, "Non-Solo Show, Non-Group Show," Swiss Spa ca va, installation /
Installationsansicht, Kunsthalle Zürich, 2009. (PHOTO: STEFAN ALTENBURGER)

The support becomes part of the composition in
Brätsch's design, mimicking the placement, sorting,
and stand-in qualities of display products and digi-
tal imagery. As another of Brätsch's maxims indi-
cates, such strategies embrace "painting as perfor-
mance or as performative backdrop."[3] Indeed, her
solo exhibitions often deploy a re-shuffling of the
paintings themselves, as in her 2009 show "BUY-
BRÄTSCHWÖRST" at Galerie Balice Hertling, Paris,
and "BroadwayBrätsch/Corporate Abstraction" at
ArtBasel Statements 41. Sequencing is reconsidered,
juxtapositions are played with, and the perceptual
status of each painting is made contingent to a se-
ries of editorial decisions and performative gestures
within her restive mode of display. At Balice Hertling,
for instance, each of Brätsch's eighteen rough-hewn,
large-scale abstractions took turns hanging suspend-

DAS INSTITUT, HEAVY MÄDEL, 2009, title poster,
digital print on archival paper, 27 ¹/₂ x 39 ³/₈ " / Titel
Plakat, Digitaldruck auf Archivpapier, 70 cm x 100 cm.

ed in the main window of the storefront alongside a title poster featuring such appropriated or collapsed phrases as "SEE REVERSE FOR CARE" printed over an image of a bandaged hand or "HEAVY MÄDEL" atop a rudimentary digital abstraction. For the ArtBasel Statements presentation (also with Balice Hertling), a new series of Brätsch's large-scale abstractions was housed in wooden frames and plexiglass—the frames designed so as to provide a transparent margin around the paintings—that allowed the works to lean in two-deep stacks against the wall and rotate into visibility according to a pre-determined schedule.

Recalling to a certain extent the dismantling of the hierarchy of armature and support in the Support/Surfaces movement of early 1970s France, the uneasy role of abstraction in Brätsch's exhibition design also brings to mind El Lissitzky's "Demonstration Rooms" of the 1920s. Constructed by Lissitzky primarily with expo-type scenarios in mind, the rooms evinced a potential synthesis of architectural support and artwork via an encompassing design that took into account not only the corporeal movement and perceptual shifts of the viewer, but also the ma-

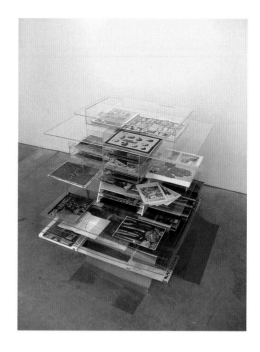

KERSTIN BRÄTSCH, UNTITLED, BOOK SHELVING UNIT 2, 2008, edition of selfmade and found books, xeroxed booklets, catalogs, acetate, Plexiglas, 60 x 60 x 66" / OHNE TITEL, BÜCHERREGAL EINHEIT 2, Edition aus selbstgemachten und gefundenen Büchern, Kataloge, kopierte Bücher, Acetat, Plexiglas, 152,4 x 152,4 x 167,5 cm.

DAS INSTITUT, UNTITLED, 2009, edition of selfmade books and booklets, marzipan fruits, metal boxes, Plexiglas folds, dimensions variable, installation view Kunsthalle Zürich / OHNE TITEL, Edition selbstgemachter Bücher und Broschüren, Marzipanfrüchte, Metallschachteln, Plexiglasstruktur, Masse variabel, Installationsansicht. (PHOTO: STEFAN ALTENBURGER)

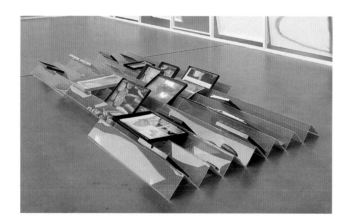

nipulation of the support structure itself. A not dissimilar emphasis upon the place of exhibition as a "transfer station," to borrow Lissitzky's own description of his initial PROUN ROOM (1923), is productive in considering the host of references and stylistic influences that inflect Brätsch's fast-paced, hybrid approach.[4] Indeed, viewers are often encouraged to

look through kiosk-like structures (as well as shelving units and poster racks) housing Brätsch's far-ranging interest in comic gesture, consumer lingo, pattern, and prefab surface materials. In BOOK SHELVING UNIT #1 (2008) and BOOK SHELVING UNIT #2 (2008), Brätsch's oblique humor steps forth in a vertical vitrine-like display archiving images of bratwurst and

hamburgers alongside images of men hunting and practicing archery, a book on Emma Kunz's abstraction, diagrammatic images of absurd hairstyles, and a self-help book titled *Treat Your Own Neck* (2008), among other items. Promoting a kind of "fair use" clause into her practice, Brätsch's version of a transfer station brings abstraction squarely into contact and contamination with a makeshift pop iconography that resurfaces throughout her practice.

Exposure to Brätsch's abiding interest in image-sourcing and branding strategies quickly moves an overall consideration of her work away from the endgame heritage of abstract painting or the totalizing motivations of a utopian model that would seek to envelop the viewer in a synthesis of support and surface. For Brätsch, demonstrative style has more to do with the mix-and-match borrowings of high fashion, DIY subculture, and the manufacturing of persona found in advertising and online viral campaigns, which is not to say that avant-garde tropes and the spectral desire for a collective aesthetic are left entirely behind. Rather, the untethered place of painting is shifted away from its most common territorial codes and introduced into a self-fashioned, recombinant method of distribution and wry fanfare. In making visible the various modes of production, applied techniques, image sources and surface materials at play, Brätsch asserts a kind of curatorial stance by donning and trading upon multiple guises, including her role as producer, performer, persona, exhibition designer and long-time collaborator with fellow German artist, Adele Röder.

Founded in New York in 2007 by Brätsch and Röder, DAS INSTITUT is the collaborative entity that receives and mediates the majority of Brätsch's production. Often described by the artists as a fictitious "import/export" company (readily encouraging the ironic connotations of trafficking in knockoff replica products, shady deals, etc.), the loose narrative conceit of DAS INSTITUT seems of less importance than the structuring of a network that adopts and articulates a visibility of production while emphasizing the techniques and applied expertise of its invited participants and contributors.[5] As the attribution of a given piece indicates, works are ascribed as being for use and presentation by DAS INSTITUT. WHEN YOU

SEE ME AGAIN IT WON'T BE ME (2010)—KERSTIN BRÄTSCH FOR DAS INSTITUT (2010), for example, evinces how authorship is simultaneously acknowledged yet displaced into the artists' brand. And though the collaboration can and often is extended to include other artists via invitation, DAS INSTITUT is first and foremost Brätsch and Röder, who likewise contributes her own digitally designed projections, posters, textile works, advertisements, and support designs to the exhibition platform that is DAS INSTITUT.

Here art historian and critic David Joselit's recent proposition that "Painting is beside itself" precisely in "practices in which painting sutures a virtual world of images onto an actual network composed of human actors, allowing neither aspect to eclipse the other," seems particularly resonant in considering DAS INSTITUT's method.[6] Through allowing and promoting a transitive potential whereby the body of painting becomes a form of translation once it is extended into a specific yet mutable network, painting can begin to resist or at least delay its assumed stance as the most readily collectible, reified art form. Existing not unlike a beta test for a new line of product, a Brätsch oil painting will often enter into the DAS INSTITUT circuit by taking up motifs from a digital image of Röder's only to be subsequently fragmented and transposed back onto a new textile design by Röder and then further corrupted and dispersed into a collaborative poster, zine, or kiosk display. *Starline Necessary Couture*—ADELE RÖDER FOR DAS INSTITUT (2009), for example, is an index of abstract digital imagery created by Röder for DAS INSTITUT that promotes just such a transitive dynamic. Made entirely in Adobe Photoshop without importing any source material, Röder's series of digital abstractions recall Constructivist and Futurist paintings and typographic design even as they are imbued with the limited sense of shadow and gradient possible within the parameters of a consumer-grade digital program. The longer you look, the more the layered abstractions seem to exist only on one plane, unable to pull you in or out of a convincing experience of depth— distorted instead into the unitary false mimesis of digital abstraction. Selected by Röder from a larger pool of images as a sampling source for Brätsch's

New Image/Unisex Series, the digital series oscillates between subtle, garish, minimal, busy, seductive, and overwrought—qualities that Brätsch then borrows freely from, translates, and often compresses into a single composition.

Brätsch's unique style of painterly distortion is perhaps even more evident in recent compositions. THE IF (2010), for example, from the *Broadway Brätsch/Corporate Abstraction* series, appears to introduce a figurative apparition toward the top of the painting in the form of an oval, forehead-like shape that emerges only to remain incipient. Undone by what appear to be brightly-hued, overlaid cutouts, a gestural grid-work is revealed upon closer inspection of the floating fragments, just as a thick granular application of paint builds up a competing ridge of attention along the right edge of the composition. With the undulant green pattern that intervenes between as yet another potential substratum, the various motifs repeatedly mis-register, fragment, and cancel each other, failing to achieve the implication of an allover effect. Similarly, WHO'S KERSTIN BRÄTSCH? (2010), from the same series, siphons from competing modes of abstraction—a swirling Op-Art effect of flesh tones, the welling up of black, cartoonish teardrops, and the noisy centrality of a pink geometric shape—all applied as if they were transposed from a hallucinatory clip-art file.

While Brätsch's paintings constantly reference past modes of advanced abstraction, they do so within the display network of DAS INSTITUT, embodying what Giorgio Agamben recently termed the "caesura of fashion" and its perpetual attempt (and inevitable failure) to demarcate what is in and out of style, the distinctive manner in which "fashion can therefore 'cite,' and in this way make relevant again, any moment from the past (the 1920s, the 1970s, but also the neoclassical or empire style). It can therefore tie together that which it has inexorably divided—recall, re-evoke, and revitalize that which it has declared dead."[7] The tacking nature of Brätsch's practice is under constant revision and alteration—exhibition-making as studio practice—and the caesura of fashion is repeatedly claimed, occupied, and then displaced. An advertisement for a recent exhibition in 2010 ("THUS!" DAS INSTITUT at New Jerseyy, Basel

featuring: La Technique de Brätsch/DI Why Relax! Raincoats & Röder Desert Capes in cooperation with a DAS INSTITUT My Favorite Artworks As Cakes Baking Workshop") makes the DAS INSTITUT process of citation quite clear. A photo features the two artists as models (Brätsch standing, Röder seated), paintings on the wall and floor behind, a hanging textile in between, and the artists up front, each holding a small monogram insignia for DI before them. A fashion shoot stripped bare, the network is up and running, authorship is dispersed, abstraction is corrupted, and the place of painting is on the move.

1) Giorgio Agamben, "What is the Contemporary?" in *What is an Apparatus?* (Stanford; Stanford University Press, 2009), p. 48.
2) Kerstin Brätsch, "My Psychic Atlas," artist writing (No. 66), 2008.
3) Ibid. (No. 29).
4) As Benjamin H. D. Buchloh remarks in his essay, "From Faktura to Factography," the installations that Lissitzky began in the 1920s eventually gave way to large-scale photographic displays that incorporated the perceptual shifts of his earlier experiments in abstraction with an iconographic repertoire of imagery more effective in relating politicized content to mass audiences—relegating the potential for a participatory, perceptual abstraction to State campaigns. "Already in 1923 in his PROUNENRAUM for the Grosse Berliner Kunstausstellung, Lissitzky had transformed tactility and perceptual movement still latent in Rodchenko's Hanging Construction into a full-scale architectural relief construction. For the first time, Lissitzky's earlier claim for his Proun Paintings, to operate as transfer stations from art to architecture, had been fulfilled." Benjamin H. D. Buchloh, "From Faktura to Factography," *October*, Vol. 30 (Fall 1984), p. 91.
5) While shades of Russian Productivism's laboratory aesthetic come to mind—along with the temporary exhibition designs of Lily Reich and Mies van der Rohe and the collaborative efforts of Hans Arp and Sophie Taeuber-Arp, including the couple's collaboration with Theo van Doesburg on Café de l'Aubette in Strasbourg, which opened in 1928—it should also be noted that there is an obvious response in Brätsch's work to German Expressionism and the related response of so-called "bad painting" (from Martin Kippenberger back to Sigmar Polke and forward to Albert Oehlen, etc.), just as Brätsch's practice is very much in dialogue with a wider circle of New York artists, including the installation tactics of Seth Price, Blake Rayne, and Cheyney Thompson, among others.
6) David Joselit, "Painting Beside Itself," *October*, No. 130 (Fall 2009), p. 125.
7) See note 2, p. 50.

KERSTIN BRÄTSCH for DAS INSTITUT, THE IF, 2010, Broadwaybrätsch Corporate Abstraction Series, oil on paper, wooden frame, magnets, 110 x 72" / DAS WENN, Öl auf Papier, Holzrahmen, Magnete, 279,4 x 182,9 cm.

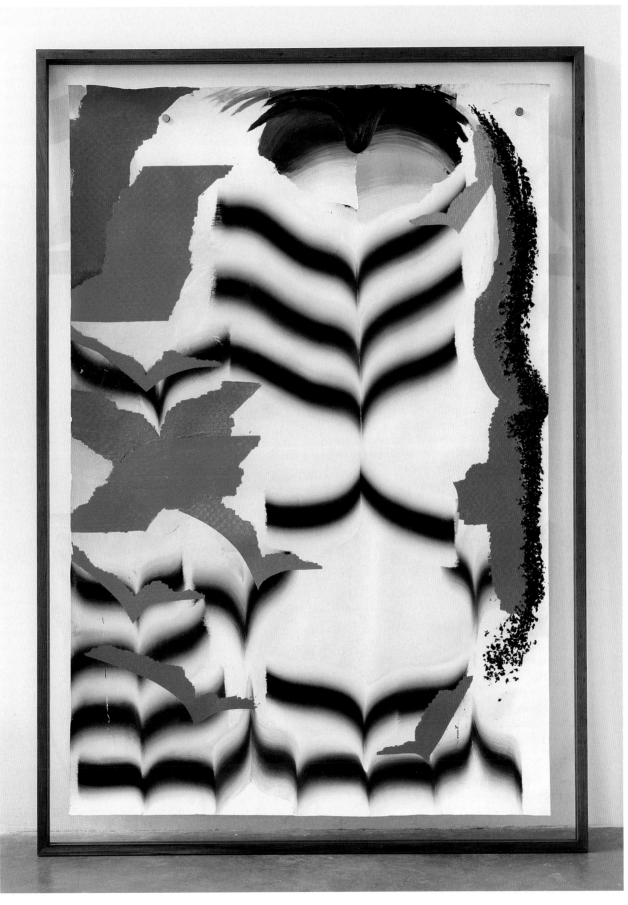

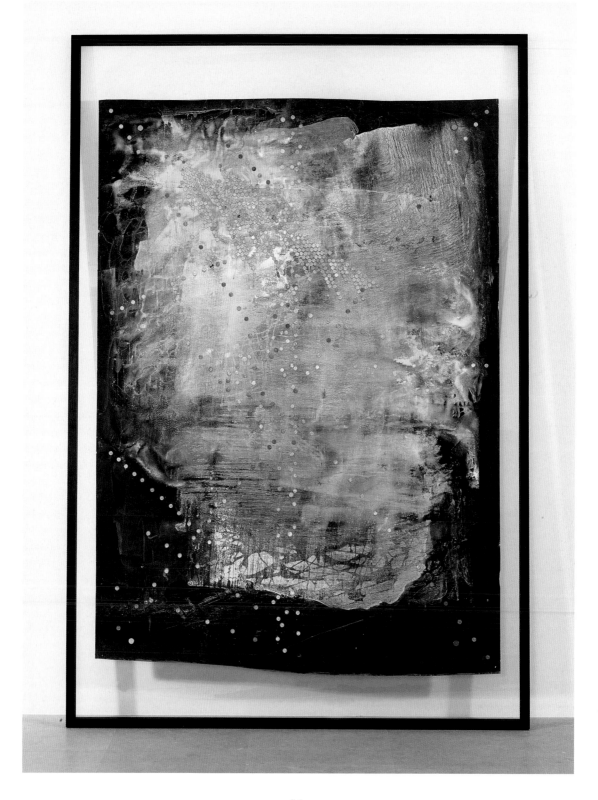

KERSTIN BRÄTSCH *for DAS INSTITUT, RETROSPECTIVE, 2010, Stars and Stripes Series, oil and coins on paper, wooden frame, magnets, 110 x 72" / Öl und Münzen auf Papier, Holzrahmen, Magnete, 279,4 x 182,9 cm. (PHOTO: EMMANUEL ROSETTI)*

FIONN MEADE

BITTE PFLEGE-ANLEITUNG BEACHTEN

*Aus diesen Gründen antizipiert sich die Zeit
der Mode dauernd und ist in der Folge immer zu spät.
Sie nimmt die Form einer unerreichbaren Schwelle an,
zwischen einem «noch nicht» und einem «nicht mehr».*
– Giorgio Agamben, *What Is an Apparatus?*[1]

Sich auf ein Gemälde von Kerstin Brätsch einzulassen heisst, ein Stück Ausstellungsdesign zu betreten, in dem Bilder einer präzisen Logik der Verteilung, Verwandlung und Hinterlist gehorchen. Von den grossflächigen Papierbögen der Ölmalereien bis zu den breiten Transparentfolien der «Geister», doppelgängerischen Repliken bereits entstandener Werke, wird die Malkonvention immer wieder zugunsten ungewöhnlicher Formate und Materialien umgangen. Die drapierten oder an Magneten hängenden Gemälde wellen, krümmen und entrollen sich von verteilten Befestigungspunkten gemäss der kinästhetischen

FIONN MEADE ist Kurator am SculptureCenter in New York; letzte Gruppenausstellungen waren «Knight's Move» und «Leopards in the Temple». Auszeichnungen von Creative Capital und der Andy Warhol Foundation (beide 2009). Er unterrichtet am Center for Curatorial Studies des Bard College und am MFA des Visual Arts Program der Columbia University.

Regie der Künstlerin. Wir erleben ein Provisorium, eine Beta-Version der Malerei. Stellwände, farbige Plexiglasscheiben, minimalistische Gitterstrukturen und andere Konstruktionen unterstreichen ein Grundprinzip von Brätschs Installationsdesign, «die Wand selbst infrage zu stellen».[2]

Bei einer Ausstellung kürzlich in der Kunsthalle Zürich nahm diese Kritik die Form farbiger Plexiglasscheiben an, die im rechten Winkel von der Wand ragten, als Träger und Rahmen für Brätschs *Stars and Stripes Series* (Serie Sterne und Streifen, 2010): Amorphen Öllasuren mit Konstellationen aus aufgeklebten US-Münzen standen Schichtungen aus farbigen, scharf konturierten Streifen gegenüber. Bei einer Gruppenausstellung im SculptureCenter, New York, errichtete sie für einige Arbeiten der geometrisierenden *New Images/Unisex Series* (Serie Neue Bilder/Unisex, 2009) drei Stellwände in der Mitte des Raums. Beide Installationen zeigen, wie Brätsch sich von der existenten Architektur abwendet, um die Erfahrung der Bildbetrachtung zu kontrollieren und zu komprimieren. Dabei verweist sie nicht nur auf die Vorschau- und Diashow-Funktionen der modernen Bild-

verarbeitung, sondern auch auf die Drehständer für Verkaufsräume und Messen.

Der Ausstellungsbau wird bei Brätsch Teil der Komposition. Die Faktoren Platzierung, Arrangement und Imitation spielen wie in der Computergraphik und Produktpräsentation eine Schlüsselrolle. Sie instrumentalisieren, wie ein weiteres Prinzip der Künstlerin fordert, die «Malerei als Performance oder als performative Kulisse».[3] Tatsächlich werden die Gemälde für jede Einzelausstellung neu aufgemischt, so etwa für «BUYBRÄTSCHWÖRST» (2009) in der Galerie Balice Hertling, Paris, und für «BroadwayBrätsch/Corporate Abstraction» (2010) im Rahmen der Art Statements der Art Basel. Brätsch überdenkt die Abfolge, spielt Kontrastmöglichkeiten durch und definiert den Wahrnehmungsstatus jedes Exponats mittels einer Serie kuratorischer Entscheidungen und performativer Gesten innerhalb ihrer

eigenwilligen Präsentationsstrategie. Während der Pariser Ausstellung wurde jede der achtzehn grossformatigen Abstraktionen abwechselnd in das Galerieschaufenster gehängt, neben einem Plakat mit Slogans oder Wortkombinationen wie «BITTE PFLEGEANLEITUNG BEACHTEN» auf dem Bild einer verbundenen Hand oder «HEAVY MÄDEL» auf einem digitalen abstrakten Kürzel. Für die grossformatigen Abstraktionen ihres Auftritts auf der Art Basel (ebenfalls mit Balice Hertling) fasste sie die Arbeiten in Holzrahmen mit Plexiglas, sodass zwischen Rahmen und Bild ein transparenter Streifen blieb. Je zwei dieser Werke lehnten hintereinander an der Wand und wurden nach einem festen Zeitplan dem Betrachter zugewendet.

Die widersprüchliche Rolle der Abstraktion in Brätschs Ausstellungsdesign erinnert nicht nur an die Auflösung der Hierarchie von Bildträger und

KERSTIN BRÄTSCH and DAS INSTITUT, from left to right, GIB MIR KRAFT, DEN MOCH MA!,
AND LET ME KNOW WHAT YOU THINK, exhibition view, "Leopards in the temple," SculptureCenter, New York, 2010 / von links nach rechts,
GIB MIR KRAFT, DEN MOCH MA! UND SAG MIR WAS DU DENKST, Ausstellungsansicht. (PHOTO: SCULPTURECENTER)

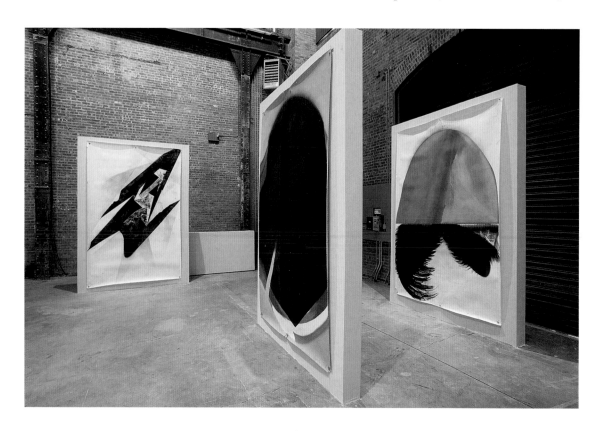

Bildoberfläche durch die französische Gruppe Support/Surfaces in den 70er-Jahren, sondern auch an El Lissitzkys «Demonstrationsräume» der 20er-Jahre. Primär für Schauzwecke konzipiert, deuten Lissitzkys Räume die Möglichkeit einer Synthese zwischen Rahmenarchitektur und Kunstwerk an. Sein umfassender Entwurf berücksichtigt Körperbewegungen und Positionswechsel des Betrachters ebenso wie Veränderungen der grundlegenden Raumstruktur. Die Sicht des Ausstellungsraums als «Umsteigestation», wie sie El Lissitzky für den ersten PROUNENRAUM (1923) formulierte, kann uns helfen, die Querverbindungen und stilistischen Einflüsse, die Brätschs energische, hybride Vorgehensweise prägen, in ihrer Vielfalt zu erfassen.[4] In der Tat sieht sich der Betrachter nicht selten gezwungen, durch kioskartige Aufbauten (oder Regale oder Plakatständer) zu blicken, in denen die Vorliebe der Künstlerin für Situationskomik, Werbejargon, Muster und Fertigteile zur Geltung kommt. So etwa in den Werken BOOK SHELVING UNIT #1 (Bücherregal-Einheit Nr. 1, 2008) und BOOK SHELVING UNIT #2 (Bücherregal-Einheit Nr. 2, 2008), in denen Brätschs schräger Humor sich in einer vertikalen Vitrine manifestiert, in der unter anderem Bilder von Bratwürsten, Hamburgern, Jägern und Bogenschützen, ein Buch über die Zeichnungen von Emma Kunz, Darstellungen absurder Frisuren und ein Selbsthilfebuch mit dem Titel *Treat Your Own Neck* (2008) untergebracht sind. Brätsch, die in ihrer Praxis spezifische Übertretungen des Urheberrechts sanktioniert, «kontaminiert» die Abstraktion in ihrer Version eines Umschlagplatzes mit einer improvisierten Pop-Ikonographie, die wiederholt in ihrer künstlerischen Produktion in Erscheinung tritt.

Wird man Brätschs konsequenter Beschäftigung mit Bildbeschaffungs- und Markenstrategien gewahr, verwirft man unverzüglich alle Assoziationen ihrer Kunst mit dem Endspiel der abstrakten Malerei oder mit den absoluten Ansprüchen eines utopischen Modells, das den Betrachter mit einer Synthese von Bildträger und Bildoberfläche vereinnahmen will. Ihre rigorose Ausdrucksweise nimmt freie Anleihen bei der Haute Couture und der Do-it-yourself-Subkultur wie auch bei der Identitätskonstruktion durch Werbung und virale Online-Kampagnen. Damit sei nicht gesagt, dass avantgardistische Zielsetzungen und das unterschwellige Verlangen nach einer verbindenden Ästhetik gänzlich wegfallen. Vielmehr driftet der unverankerte Ort der Malerei weg von den konventionellen territorialen Codes hin zu einer selbst erfundenen, rekombinanten Methode des Vertriebs und der gemischten Freuden. Indem sie die Produktionsweisen, Techniken, Bildquellen und Materialien ihres Prozesses sichtbar macht, nimmt Brätsch eine Art kuratorische Pose ein, in der sie ein Repertoire von Masken (unter anderem Produzentin, Performerin, Akteurin, Ausstellungsdesignerin und Langzeit-Atelierkollegin der deutschen Künstlerin Adele Röder) benutzt und vertauscht.

Brätsch und Röder gründeten 2007 in New York ihr Gemeinschaftsprojekt DAS INSTITUT, das den Grossteil von Brätschs Schaffen aufnimmt und vertreibt. Von den Künstlerinnen als Import-Export-Firma lanciert (man denkt bei diesem Namen wohl nicht ungewollt an den Handel mit Produktfälschungen und ähnlich dubiose Geschäfte), geht es bei diesem Projekt weniger um die Etablierung einer fiktiven Gesellschaft als um die Errichtung eines Netzes, das die Sichtbarkeit der Produktion gewährleistet und zugleich die Verfahren und Kenntnisse aller Mitwirkenden herausstellt.[5] Einzelne Arbeiten werden dem INSTITUT zur Weiterverwendung und -verwertung überschrieben. Ein Titel wie WHEN YOU SEE ME AGAIN IT WON'T BE ME – KERSTIN BRÄTSCH FOR DAS INSTITUT (Wenn du mich wieder siehst, bin ich eine andere, Kerstin Brätsch für Das Institut, 2010) nennt die Urheberin des Werks, nicht ohne sie sofort in die Künstlermarke zu überführen. Obwohl das Kollektiv häufig Einladungen an andere Künstler vergibt, ist und bleibt DAS INSTITUT primär eine Initiative von Brätsch und Röder (die gleichfalls ihre Digitalprojektionen, Plakate, Textilarbeiten, Werbeanzeigen und Präsentationsentwürfe der gemeinsamen Ausstellungsplattform überlässt).

Die Bemerkung des Kunsthistorikers und -kritikers David Joselit, die Malerei sei «ausser sich», speziell in «Praktiken, in denen die Malerei eine virtuelle Bildwelt in ein reales Netz menschlicher Akteure einschreibt, ohne dass ein Aspekt den anderen in den Schatten stellt», scheint für die Methodik des INSTITUTS besonders zutreffend.[6] Durch Kultivierung eines Übertragungspotenzials, das einen Korpus von

Malwerken, sobald dieser in ein spezifisches, doch flexibles Netz eingespeist wird, in eine Art Übersetzung verwandelt, kann die Malerei beginnen, ihren Status als Sammelobjekt par excellence und traditionell konkrete Kunstform abzulegen oder zumindest aufzuschieben. So kommt es zum Beispiel vor, dass ein Ölgemälde von Brätsch Motive einer Computergraphik von Röder aufnimmt und wie der Prototyp einer neuen Produktlinie in die Kanäle des INSTITUTS einfliesst, nur um sogleich wieder fragmentiert und nun von Röder für ein neues Textildesign verwendet zu werden, das dann weiter demontiert und modifiziert als Plakat, Magazin oder Kiosk des Kollektivs endet. STARLINE NECESSARY COUTURE (Starline Gebrauchs-Couture, 2009), ein Katalog abstrakter, von Röder für das INSTITUT entworfener Computergraphiken, folgt einer solchen Transfer-Dynamik. Ohne Vorlagen direkt in Photoshop erzeugt, erin-

nert Röders Kollektion an konstruktivistische und futuristische Gemälde und Typographien, obwohl das Computerprogramm nur einfache Schatteneffekte und Farbabstufungen zulässt. Je länger man sie betrachtet, desto mehr scheinen sie einzig in der Fläche zu existieren, ausserstande, eine überzeugende Tiefenwahrnehmung hervorzurufen, verzerrt zur falschen Mimese der digitalen Abstraktion. Die Graphiken, die Röder aus einem grösseren Bildfundus als Quellmaterial für Brätschs *New Images/Unisex Series* ausgewählt hat, oszillieren zwischen subtil, krass, minimal, überladen, verführerisch und exaltiert – Attribute, die Brätsch frei übernimmt, übersetzt und oft in einer einzigen Komposition konzentriert.

Brätschs Stil der malerischen Deformation macht sich in neueren Werken noch drastischer bemerkbar. So erscheint im oberen Bildbereich von THE IF (Das Wenn, 2010) aus der *BroadwayBrätsch/Corporate*

DAS INSTITUT, "Thus! La Technique de Brätsch, DI WHY RELAX! Raincoats and Röder Desert Capes," exhibition view / Ausstellungsansicht, New Jerseyy Basel, 2010. (PHOTO: EMMANUEL ROSETTI)

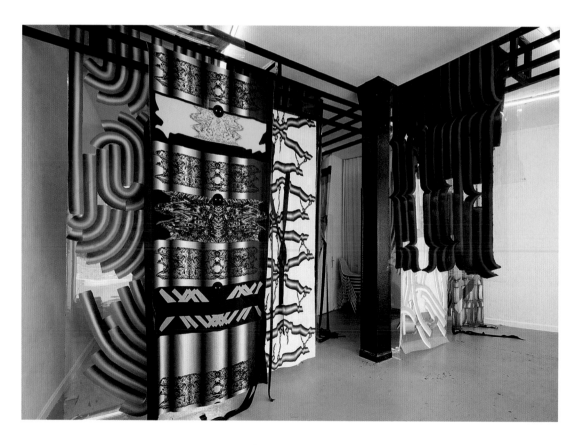

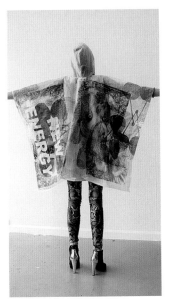

DAS INSTITUT, DI WHY RELAX!, 2010, silkscreened raincoats, edition / Siebbedruckte Regenmäntel, Edition.

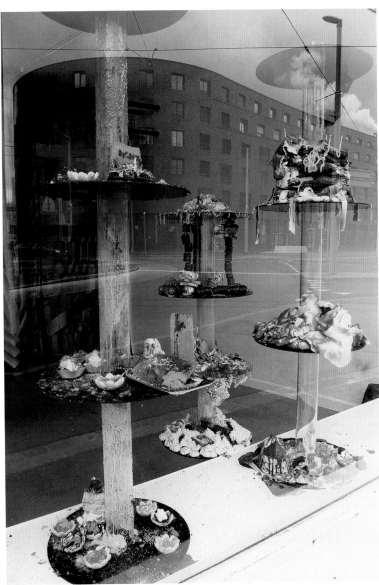

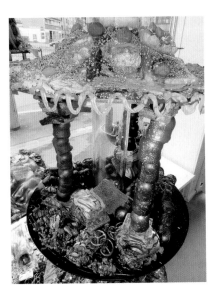

DAS INSTITUT, My Favorite Artworks as Cakes, baking workshop, installation view / Installationsansicht, exhibition view / Meine liebsten Kunstwerke als Kuchen, Back-Workshop, Ausstellungsansicht, New Jerseyy Basel, 2010.

Abstraction Series ein figurales Motiv, vielleicht das Oval einer Stirn, das jedoch nicht klar herausgearbeitet ist. Bei genauerer Betrachtung der schwebenden Bildelemente wird ein gestischer Raster sichtbar, über den grelle Farbinseln gelegt sind, die wie mit der Schere ausgeschnitten wirken. Entlang des rechten Bildrands verläuft ein körniges Impasto. Dazwischen schiebt sich als weiterer potenzieller Bildgrund ein grünes Wellenmuster. All diese Motive erzeugen Dissonanzen, Bruchstellen, wechselseitige Auslöschungen. Ein einheitlicher Gesamteindruck bleibt aus. WHO'S KERSTIN BRÄTSCH? (Wer ist Kerstin

ADELE RÖDER for DAS INSTITUT, STARLINE, 2010, slide projection, 160 slides,
dimensions variable, exhibition view "Rien, Rien!," Parc Saint Léger /
STARLINE, Diaprojektion, 160 Dias, Masse variabel, Ausstellungsansicht.

Brätsch?, 2010) aus derselben Serie lässt gleichfalls konkurrierende Schulen der Abstraktion gegeneinander antreten. Die Karambolage aus inkarnatfarbenen Op-Art-Girlanden, schwarzen Plakat-Tränen und der geometrischen Knallrosa-Form in der Bildmitte wirkt wie der Auszug einer halluzinatorischen Clipart-Datei.

Brätsch zitiert in ihren Gemälden laufend aus der Geschichte der abstrakten Avantgarde. Dass dies im Rahmen der Präsentationsplattform des INSTITUTS geschieht, steht im Zeichen dessen, was Giorgio Agamben die «Zäsur der Mode» nennt. Die Mode will ständig (wenngleich vergeblich) bestimmen, was «in» und was «out» ist, und «deshalb kann sie zitieren und jeden Moment zwischen den 20er- und 70er-Jahren (aber auch den Neoklassizismus und den Empire-Stil) wieder relevant werden lassen. Sie kann verbinden, was getrennt wurde und wiederbeleben, was für modisch tot erklärt wurde.»[7] Brätsch steuert einen wechselhaften Kurs, unterwirft ihre Kunst unablässig neuen Korrekturen und Änderungen – die Ausstellung als Atelierpraxis. Die Zäsur der Mode wird wiederholt eingefordert, besetzt und dann an eine andere Stelle verlegt. Die Anzeige für eine jüngste Ausstellung bei New Jerseyy in Basel ist exemplarisch für die Zitierkonvention des INSTITUTS. Sie zeigt das Künstlerinnenduo als Photomodelle, Brätsch stehend, Röder sitzend. Hinter ihnen Bilder an der Wand und auf dem Boden, zwischen ihnen ein hängendes Textilobjekt. Beide halten ein Abzeichen mit den Initialen DI vor die Kamera. Bares Minimum einer Photosession. Das Netz ist komplett, die Urheberschaft zerstreut, die Abstraktion korrumpiert und der Ort der Malerei in Bewegung.

(Übersetzung: Bernhard Geyer)

1) Giorgio Agamben, «What Is the Contemporary?», in *What Is an Apparatus?*, Stanford University Press, Stanford, 2009, S. 48. Aus dem Engl. übersetzt.

2) Kerstin Brätsch, «My Psychic Atlas», *artist writing* Nr. 66, 2008.

3) Ebd. Nr. 29.

4) Wie Benjamin Buchloh in seinem hochinteressanten Aufsatz «From Faktura to Factography» nachweist, ging El Lissitzky nach den Installationen der 20er-Jahre zu grossen Photoschauen über, in denen er die Wahrnehmungskritik der vorhergehenden abstrakten Experimente mit einem ikonographischen Bildrepertoire anreicherte, das besser zur massenhaften Verbreitung politischer Inhalte geeignet war. Die Möglichkeit einer partizipativen, perzeptuellen Abstraktion wurde der staatlichen Propaganda geopfert. «Schon im Jahr 1923, in seinem Prounenraum für die Grosse Berliner Kunstausstellung, hatte Lissitzky Taktilität und bewegte Wahrnehmung, die in Rodtschenkos Hängender Raumkonstruktion erst angedeutet waren, zu einem grossen Raumrelief ausgestaltet. Was Lissitzky für seine früheren Proun-Bilder in Anspruch genommen hatte, dass sie eine Umsteigestation von Malerei nach Architektur seien, war hier zum ersten Mal Wirklichkeit geworden.» Benjamin H. D. Buchloh, «From Faktura to Factography», *October* 30, S. 91.

5) Man denkt vor allem an die Laborästhetik des russischen Produktivismus, aber auch an das Ausstellungsdesign von Lilly Reich und Ludwig Mies van der Rohe sowie an die Gemeinschaftsprojekte von Hans Arp und Sophie Taeuber-Arp, etwa die Ausstattung der Strassburger Aubette (eröffnet 1928), an der auch Theo van Doesburg mitgewirkt hat. Zu erwähnen sind ferner Brätschs offensichtliche Reaktion auf den Expressionismus und auf das sogenannte «Bad Painting» (von Martin Kippenberger zurück bis Sigmar Polke und wieder vorwärts bis Albert Oehlen usw.) und ihr Dialog mit einem breiteren Kreis New Yorker Künstler, einschliesslich der Installationsstrategien von Seth Price, Blake Rayne und Cheyney Thompson.

6) David Joselit, «Painting Beside Itself», *October* 130 (Herbst 2009), S.125.

7) Siehe Fussnote 1, Agamben, 2008, S. 50. Aus dem Engl. übersetzt.

DAS INSTITUT, DI Advertisement, Kerstin Brätsch, Adele Röder, 2010. (PHOTO: JASON SCHMIDT)

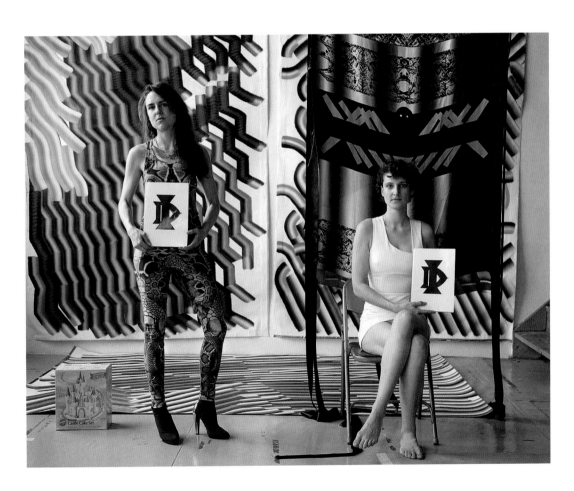

KERSTIN BRÄTSCH and DAS INSTITUT

PARASITE PATCH from Schröderline 2011
In 4 versions each with 4 design layers /
In 4 Versionen, jede in 4 Design Variationen:
NOTHING NOTHING / THUS / Ä / Ö

Knitted textile patch with 4 design layers,
made of custom dyed yarns, each layer: 15 x 12".
Designed by DAS INSTITUT (Kerstin Brätsch, Adele Röder).
Program and digital knitwear by Stoll, New York. Cotton yarn by
Filartex, Italy, silk/merino yarn by Cariaggi and Filpucchi, Italy.
To be individually attached to clothes with three snap buttons. The
Parasite Patch can be worn displaying each of the 4 different design layers.
Ed. 18 / X for each patch version, with signed and numbered certificate.

Gestricktes Textilobjekt mit 4 Design Variationen,
hergestellt aus gefärbtem Garn, jede Design Variation 38 x 30,5 cm.
Gestaltet von DAS INSTITUT (Kerstin Brätsch, Adele Röder). Programm und
digitale Umsetzung von Stoll, New York, Baumwollgarne von Filartex, Italien,
Seiden- und Merinogarn von Cariaggi und Filpucchi, Italien.
Zur individuellen Befestigung auf Kleidungsstücken mit drei Druckknöpfen.
Der Parasite Patch kann mit jeder der 4 Design Variationen getragen werden.
Auflage 18 / X für jede Version, mit signiertem und nummeriertem Zertifikat.

Parasite Patch „NOTHING NOTHING", Design layers / Design Variationen

Parasite Patch, Version „NOTHING NOTHING"

(For images of all 4 versions see p. 260 / 261 / Für Bilder aller 4 Versionen siehe S. 260 / 261)

Paul Chan

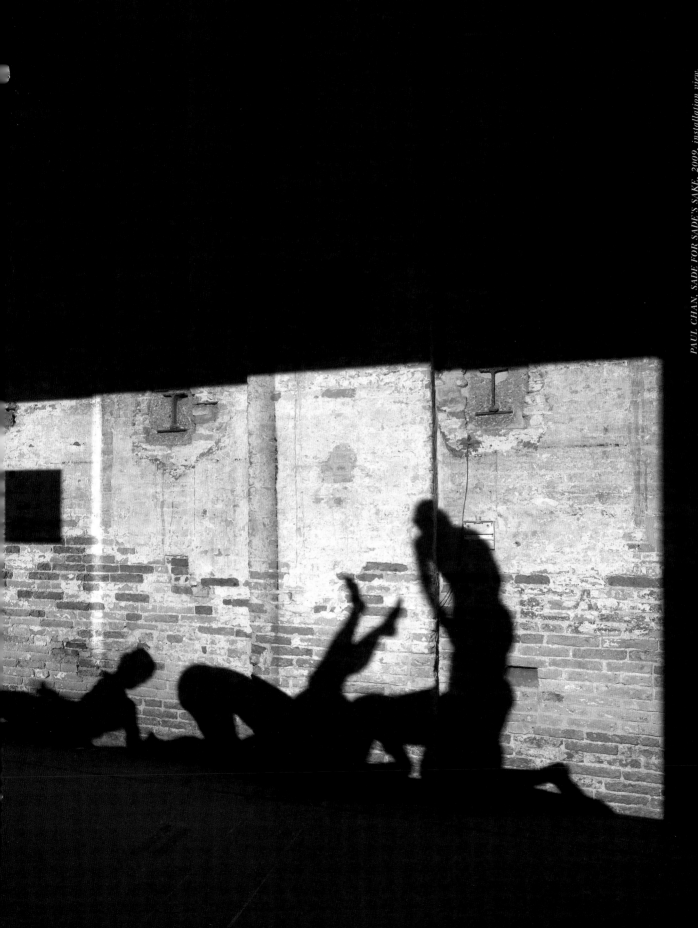

PAUL CHAN, SADE FOR SADE'S SAKE, 2009, installation view,
Venice Biennale / SADE UM SADES WILLEN, Installationsansicht.
(ALL PHOTOS COURTESY: PAUL CHAN AND GREENE NAFTALI GALLERY, NEW YORK)

Liberation in the Loop Paul Chan:

BORIS GROYS

The 7 ~~Lights~~.

In Plato's *Parmenides* one finds the following exchange between Parmenides and young Socrates. Parmenides asks: "Is there a form, itself by itself, of just, and beautiful, and good, and everything of that sort?" Socrates answers: "Yes." Parmenides then asks Socrates if he finds that not only human beings have a separate, ideal form, but also, as he says, "things that might seem absurd, like hair and mud and dirt, or anything else totally undignified and worthless." At that point, Socrates has to confess that questions of this kind trouble him, too, but that he tries to avoid them so that he does not "fall into some pit of nonsense." To which Parmenides says: "That's because you are still young, Socrates, and philosophy has not yet gripped you, as in my opinion, it will in the future, once you begin to consider none of the cases beneath your notice."[1]

This passage from *Parmenides* came to mind the first time I watched the videos in Paul Chan's installation, THE 7 ~~LIGHTS~~. In these videos, forms of the most ordinary objects are permanently moving upward, toward the heaven of pure ideas. And in the process of their ascension, they slowly begin to dissolve into a mass of fragments that appear so abstract that they are no longer recognizable. Thus, one can imagine the heavens being transformed by this slow yet interminable process into a kind of garbage pit—"some pit of nonsense," to use Plato's words. This pit would, in a somewhat paradoxical way, consist not of de-functionalized ordinary things themselves, but of their pure, abstract forms. In some of his interviews, Paul

BORIS GROYS is Professor at New York University and Senior Research Fellow at the Academy of Design, Karlsruhe, Germany. He has recently published *Art Power* (2008), *History Becomes Form: Moscow Conceptualism* (2010), and *Going Public* (2010).

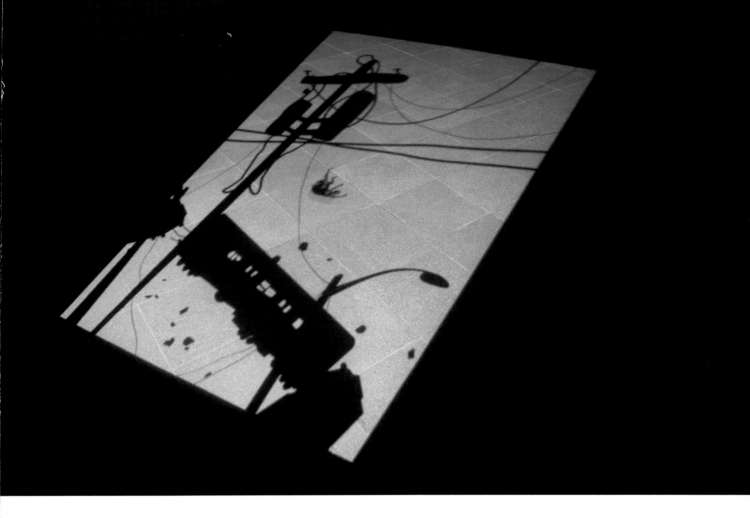

PAUL CHAN, 2nd ~~LIGHT~~, 2006, digital video projection, 14 min. / 2. ~~LICHT~~, digitale Videoprojektion, 14 Min.

Chan insists on the importance of the fact that in the title of the installation the word "light" is crossed out—like the word "being" in some of Derrida's texts. The light is understood here not as natural light—visually identifiable light having a certain equally identifiable natural source. Nor is it light in which we see natural things. Rather, ~~light~~ is understood by Chan as metaphysical, one might say—as divine light that gives us the capability to imagine and see pure, ideal forms. This metaphysical, "other" light is the light of the Byzantine icons—light without a source of light. It is also the light of Malevich's suprematist paintings, in which the abstract geometrical forms look as though they were caught by the eye of the painter at the moment of their slow movement upward and rightward. Chan substitutes these pure geometrical forms with "impure," trash-like forms of everyday life. And, at the same time, these impure forms are not moving upward and rightward, but rather strictly upward or upward and leftward—opposite, in any case, to the vector of progress that we tend to imagine as pointing from left to right.

Indeed, one gets the impression that all of these pure forms of things—or one might say souls of things—go strictly upward to escape the horizontal axis of progress—something that things themselves cannot escape. At least since Hegel we know that it is progress that makes things into things. In our civilization things are defined by their use. And their use is defined

by the projects of biological survival, economic growth, political stability, social justice, and military security—projects of change and improvement that are directed toward the future. This radical subjection of all objects to the objectives of progress does not spare human beings, which, in the era of modernity, are regarded as things among other things. In our civilization man is functionalized and instrumentalized, as is every other thing, in the name of progress. It is precisely this modern and contemporary equation between humans and things that is reflected in Chan's 7 ~~LIGHTS~~. The privileged position of humans vanishes and they escape the horizontal movement of the progress that enslaves them together with all other things—through the universal ascension of all forms, through the vertical movement that does not compromise the horizontal movement of history. And, of course, this form of escape is more difficult for humans than for the simple things of their everyday life, which is why in some of Chan's videos human figures are seen falling down while the figures of the things are seen moving upward. The dissolution of these things through their free fall upward can look idyllic. The Dionysian dissolution of the human form implied by the same movement looks tragic.

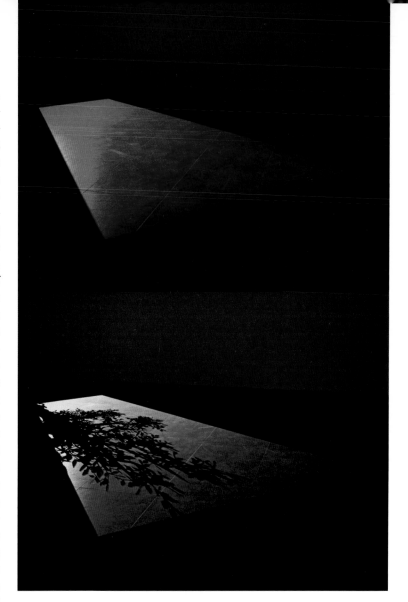

PAUL CHAN, 2nd ~~LIGHT~~, 2006, digital video projection, 14 min. /
2. ~~LICHT~~, digitale Videoprojektion, 14 Min.

The videos from 7 ~~LIGHTS~~ evoke cinematographic scenes of catastrophic explosions shown in slow motion, like the famous scene from Michelangelo Antonioni's *Zabriskie Point* (1970). Chan himself speaks of the power of recession, which is the dark side of the power of progress as well as the chance to escape progress by suspending it.[2] One is reminded here of Walter Benjamin's famous interpretation of Paul Klee's ANGELUS NOVUS (1920), according to which the constant winds of progress propel "the angel of history … irresistibly into the future to which his back is turned" as he stares in terror at the ruins that the movement of progress leaves behind.[3] It is easy enough to imagine Chan as a contemporary Angelus Novus, recording the destruction that the wind of progress inflicts on the bodies of things. But this interpretation obviously contradicts the meditative, serene atmosphere of the installation. Here we are not witnessing the suffering of material bodies, but the ascension of

their pure forms to the empty heaven of ideas. These forms move constantly upward as if a huge spiritual, anti-gravitational magnet has liberated them from their subjection to the law of utility, their enslavement by the power of progress, and set them free.

Nonetheless, these videos would merely function as another promise of radical liberation if they did not, at the same time, address the central characteristics of the medium of video itself as it is used in the context of the video installation—video's movement in a loop. Traditional film is the most radical and spectacular embodiment of the linear concept of time. The filmic narrative inexorably moves from a beginning to an end—and all attempts by a range of experimental filmmakers to reverse or stop this linear progression have never really succeeded. Video inherited from film this compulsive progression along the axis of linear time. But when film and video made their way into installations they began to run in loops—and this totally changed their reception. There is a huge difference between looking at a film from beginning to end and looking at the same film (or video) in a loop because the permanent return of the same in the latter radically destroys any illusion of linear time. The filmic narrative loses its power over the imagination if spectators know that all the elements of this narrative will keep returning to their field of attention. This makes the spectator feel like a Nietzschean Übermensch who grasped the law of the eternal return of the same. Ordinarily, films and videos shown in art installations ignore this radical change of reception since their makers, being mere humans and unaware of the distinction, believe that their work can be presented as a unique event, seen from beginning to end.

Today videos themselves frequently attempt to reflect the conditions under which a video is shown in a video installation. This reflection necessarily takes the form of repetition inside the video's narrative—to remove the gap between its own narrative structure and the installational, looped repetition to which it is subjected. Now, there is nothing as repetitive as the act of liberation. Radical (self-) liberation means escape from any kind of instrumentalization, commodification, and utilization, which, in turn, excludes the possibility to inscribe the liberated thing in a narrative, for that would imply its renewed subjugation to the laws of cause and effect, or its renewed involvement in the horizontal movement of progress. Every liberation is a final liberation, and cannot be turned into a new beginning. Yet, at the same time, it is like any other liberation; the specificity of any particular action stems exclusively from its integration into some historical, horizontal process. The forms of slavery are different, but all the liberations are identical. And this is precisely what we see in Chan's videos. One thing is liberated after another—and every thing is taken directly to heaven (or to hell), away from the horizontal axis of universal history. And while the liberated things may be different, the act of liberating them is always the same. The videos present movement, but this movement is in itself a permanent repetition of the same act of liberation. In this sense, the gesture that constitutes movement in Chan's videos is repetitive long before it is put in the loop. These videos demonstrate liberation as the eternal return of the same—liberation put into the loop.

1) Plato, "Parmenides," *Complete Works*, trans. Mary Louise Gill and Paul Ryan (Indianapolis: Hackett Publishing, 1996), pp. 130–131.
2) Paul Chan, "The Spirit of Recession," *October*, No. 129 (Summer 2009), pp. 3–12.
3) Walter Benjamin, "On the Concept of History" in *Walter Benjamin—Selected Writings*, 1938–1940 (Harvard University Press, 2003), p. 392.

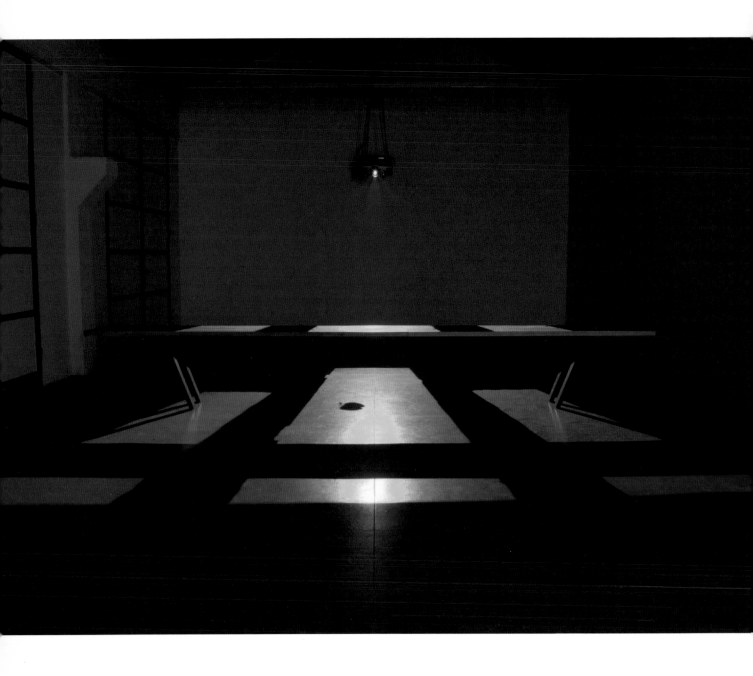

PAUL CHAN, 3rd ~~LIGHT~~, 2006, digital video projection and table, 14 min. / 3. ~~LICHT~~, digitale Videoprojektion und Tisch, 14 Min.

Befreiung in der Endlosschlaufe Paul Chans

BORIS GROYS

7 ~~Lights~~

In Platons *Parmenides* trifft man auf folgenden Wortwechsel zwischen Parmenides und dem jungen Sokrates. Parmenides fragt: «Nimmst du [...] eine für sich bestehende Idee des Gerechten, des Schönen, des Guten und alles anderen an, was dahin gehört?» Sokrates bejaht dies. Darauf fragt Parmenides, ob Sokrates denn auch glaube, dass es neben der für sich bestehenden Idee des Menschen auch eine solche des Feuers und des Wassers gebe und dass es sich mit Dingen, «bei denen es sogar lächerlich scheinen könnte, wie zum Beispiel Haar, Kot, Schmutz und was sonst recht verachtet und geringfügig ist», ebenso verhalte. An diesem Punkt muss Sokrates eingestehen, dass er darüber auch beunruhigt sei und er diesen Fragen jeweils lieber schnell den Rücken kehre, «aus Furcht, hier in einen wahren Abgrund der Albernheit zu versinken ...». Worauf Parmenides meint: «Du bist eben noch jung, Sokrates, und die Philosophie hat dich noch nicht so ergriffen, wie sie dich, glaube ich, einst noch ergreifen wird, wenn du keins dieser Dinge mehr geringschätzest.»[1]

An diese Stelle aus *Parmenides* musste ich denken, als ich die Videos in Paul Chans Installation 7 ~~LIGHTS~~ (7 ~~Lichter~~) zum ersten Mal sah. In diesen Videos gleiten unentwegt Formen ganz alltäglicher Gegenstände aufwärts in den Himmel der reinen Ideen. Und im Aufstieg verwandeln sich diese Formen allmählich in eine Masse aus Fragmenten, die derart abstrakt wirken, dass sie nicht mehr identifizierbar sind. Folglich kann man sich vorstellen, dass sich

BORIS GROYS ist Professor an der New York University und Professor für Kunstwissenschaft, Philosophie und Medientheorie an der Hochschule für Gestaltung in Karlsruhe. Zu seinen jüngsten Buchpublikationen gehören *Art Power* (2008), *History Becomes Form: Moscow Conceptualism* (2010) und *Going Public* (2010).

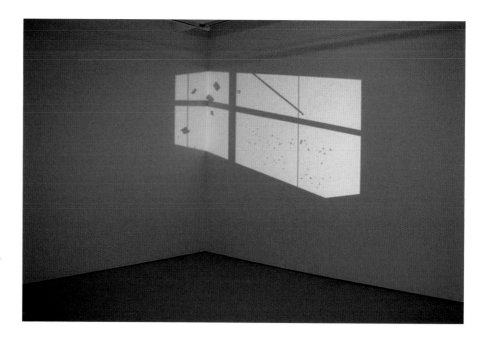

*PAUL CHAN, 4th ~~LIGHT~~, 2006,
digital video projection, 14 min. /
4. ~~LICHT~~, digitale Video-
projektion, 14 Min.*

der Himmel durch diesen langsamen aber endlosen Prozess in eine Art Abfallgrube verwandelt – «einen Abgrund der Albernheit» mit Platon gesprochen. Diese Grube bestünde paradoxerweise irgendwie nicht aus den entfunktionalisierten Dingen selbst, sondern aus ihren reinen abstrakten Formen. In einigen seiner Interviews unterstreicht Paul Chan die Bedeutung der Tatsache, dass im Titel der Installation das Wort «light» durchgestrichen ist – wie das Wort «Sein» in gewissen Texten Derridas. Licht meint hier kein natürliches Licht, also sichtbares Licht mit einer ebenso sichtbaren natürlichen Quelle. Es ist auch kein Licht, in dem wir natürliche Dinge sehen. Vielmehr versteht Chan sein ~~Licht~~ als, könnte man sagen, metaphysisches Licht ohne Lichtquelle – ein göttliches Licht, das uns die Fähigkeit verleiht, reine, ideale Formen zu sehen und uns vorzustellen. Dieses metaphysische, «andere» Licht ist das Licht der byzantinischen Ikonen – ein Licht ohne Lichtquelle. Dasselbe Licht finden wir in Malewitschs suprematistischen Gemälden, in denen die abstrakten geometrischen Formen wirken, als hätte sie das Auge des Malers im Lauf ihrer sachten Bewegung nach oben oder rechts eingefangen. Chan ersetzt diese reinen geometrischen Formen durch «unreine», müll- oder schrottähnliche Elemente aus dem Alltagsleben. Zudem bewegen sich diese unreinen Formen nicht nach oben oder nach rechts, sondern vielmehr senkrecht nach oben oder nach oben links – auf jeden Fall entgegen dem Fortschrittsvektor, den wir uns gern als von links nach rechts gerichtet vorstellen.

Tatsächlich gewinnt man den Eindruck, dass all diese reinen Formen von Dingen – man könnte auch sagen Seelen von Dingen – senkrecht nach oben streben, um der horizontalen Fortschrittsachse zu entfliehen – was den Dingen selbst nicht möglich ist. Spätestens seit Hegel wissen wir, dass es der Fortschritt ist, der die Dinge zu Dingen macht. In unserer Kultur sind die Dinge durch ihren Gebrauch definiert. Und ihr Gebrauch ist seinerseits definiert von den Projekten des biologischen Überlebens, des wirtschaftlichen Wachstums, der politischen Stabilität, der sozialen Gerechtigkeit und der militärischen Sicherheit – alles zukunftsorientierte Veränderungs- und Verbesserungsprojekte. Diese radikale Unterwerfung

aller Gegenstände unter die Ziele des Fortschritts macht nicht Halt vor den Menschen, die im Zeitalter der Moderne als Dinge unter anderen Dingen gelten. In unserer Kultur werden Menschen im Namen des Fortschritts funktionalisiert und instrumentalisiert wie alles andere auch. Und genau diese moderne, nach wie vor wirksame Gleichsetzung von Menschen und Dingen spiegelt sich in Chans 7 LIGHTS wider. Die privilegierte Stellung des Menschen löst sich auf und er entflieht der horizontalen Fortschrittsbewegung, die ihn zusammen mit allen anderen Dingen versklavt, in einem universalen Akt des Aufsteigens aller Formen, einer Aufwärtsbewegung, die keinen Kompromiss mit dem horizontalen Strom der Geschichte eingeht. Und natürlich gestaltet sich diese Art von Flucht für den Menschen schwieriger als für die einfachen Dinge des Alltags. Deshalb sieht man in einigen Videos von Chan menschliche Gestalten herunterfallen, während die Formen der Dinge aufsteigen. Die Auflösung der Dinge in ihrem freien Fall nach oben mag idyllisch wirken. Die durch dieselbe Bewegung in Gang gesetzte dionysische Auflösung der menschlichen Form wirkt dagegen tragisch.

Die Videos aus 7 LIGHTS rufen im Gedächtnis des Betrachters Filmszenen von in Zeitlupe gezeigten katastrophalen Explosionen wach – etwa die berühmte Szene aus Michelangelo Antonionis *Zabriskie Point* (1970). Chan selbst bezeichnet die Macht des Rückschritts als dunkle Seite der Macht des Fortschritts, die zugleich die Chance biete, dem Fortschritt zu entkommen, indem sie ihn ausser Kraft setze.[2] Man fühlt sich dabei an Walter Benjamins berühmte Interpretation von Paul Klees ANGELUS NOVUS (1920) erinnert.[3] Benjamin beschreibt den Angelus Novus als Engel, der mit dem Rücken zur Zukunft vom steten Sturm des Fortschritts unaufhaltsam rückwärts getrieben wird – den vor Schreck geweiteten Blick auf die Trümmer gerichtet, die der Fortschritt hinterlässt. Man kann sich Chan gut als zeitgenössischen Angelus Novus vorstellen, der den Schaden festhält, welcher der Sturm des Fortschritts an den Körpern der Dinge anrichtet. Aber diese Interpretation steht in klarem Widerspruch zur meditativen, heiteren Stimmung der Installation. Wir sehen hier nicht das Leiden konkreter Körper, sondern das Auffahren ihrer reinen Formen in den leeren Himmel der Ideen. Die Formen gleiten unaufhaltsam aufwärts, als hätte ein riesiger geistiger Antischwerkraftmagnet sie von der Unterwerfung unter das Gebot der Nützlichkeit und von ihrer Versklavung durch die Macht des Fortschritts erlöst und sie in die Freiheit entlassen.

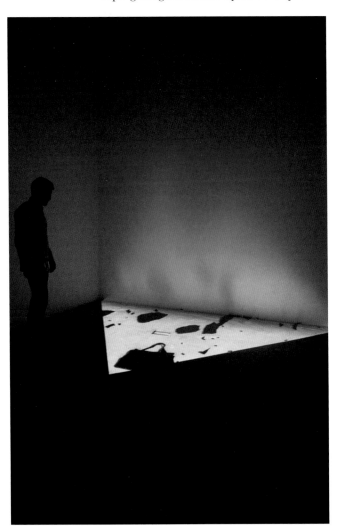

PAUL CHAN, 5th LIGHT, 2007,
digital video projection, 14 min. /
5. LIGHT, digitale Videoprojektion, 14 Min.

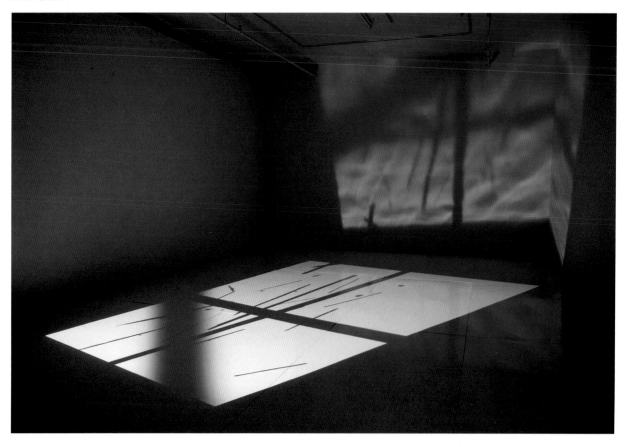

PAUL CHAN, 6th ~~LIGHT~~, 2007, digital video projection, 14 min. / 6. ~~LICHT~~, digitale Videoprojektion, 14 Min.

Dennoch wären diese Videos lediglich ein weiteres radikales Freiheitsversprechen, sprächen sie nicht gleichzeitig die zentrale Eigenschaft des Mediums Video selbst an, die im Kontext der Videoinstallation zum Tragen kommt – die zirkuläre Bewegung des Videos als Endlosschleife. Der traditionelle Film ist die radikalste und spektakulärste Verkörperung des linearen Zeitbegriffs. Die Filmhandlung entwickelt sich unaufhaltsam vom Anfang bis zum Ende – und sämtliche Versuche diverser experimenteller Filmemacher, diese lineare Entwicklung des Films umzukehren oder aufzuhalten, sind letztlich gescheitert. Das Video hat diese zwingende Vorwärtsbewegung entlang der linearen Zeitachse vom Film geerbt. Doch als man begann, Film und Video in Installationen einzusetzen und als Endlosschleife abzuspielen, hat das ihre Rezeption vollkommen verändert. Es ist ein gigantischer Unterschied, ob man einen Film (oder ein Video) von Anfang bis Ende oder als Endlosschleife sieht. Im letzteren Fall räumt die offensichtliche «ewige Wiederkehr des Gleichen» mit jeder Illusion einer linearen Zeit radikal auf. Die Filmhandlung verliert die Macht über unsere Vorstellungskraft, sobald wir wissen, dass alle Elemente der Geschichte immer wieder in unser Wahrnehmungsspektrum zurückkehren werden. Die meisten Filme und Videos, die im Rahmen von Kunstinstallationen gezeigt werden, vernachlässigen jedoch diese radikal veränderte Wahrnehmung. Der Betrachter oder die Betrachterin fühlt sich als Nietzscheanischer Übermensch, der das Ge-

setz der ewigen Wiederkehr des Gleichen begriffen hat, während die Filme- oder Video-macher gewöhnliche Menschen geblieben sind und nicht an dieses Gesetz dachten. Entspre-chend glauben sie nach wie vor, dass ihr Film oder Video in einmaliger Aufführung gezeigt und von Anfang bis Ende geschaut werden kann.

Mittlerweile haben wir zahlreiche Versuche gesehen, die Bedingungen, unter denen ein Video im Rahmen einer Videoinstallation gezeigt wird, im Video selbst zu reflektieren. Diese Reflexion nimmt notwendig die Form einer Wiederholung innerhalb der Handlung des Vi-deos selbst an – um die Kluft zu beseitigen zwischen seiner eigenen narrativen Struktur und der installationsbedingten Endloswiederholungsschleife, der es unterworfen ist. Nun, es gibt nichts Repetitiveres als den Akt der Befreiung. Radikale (Selbst-)Befreiung bedeutet einen Ausstieg aus jeder Art von Instrumentalisierung, Kommerzialisierung und Nutzbarkeit. Eine radikale Befreiung schliesst daher die Möglichkeit aus, das Befreite in irgendeine mögliche Geschichte zu integrieren, weil es dadurch erneut den Gesetzen von Ursache und Wirkung unterstellt oder erneut der horizontalen Fortschrittsbewegung unterworfen würde. Jede Be-freiung ist daher eine endgültige Befreiung und kann nicht in einen Neuanfang verwandelt werden. Gleichzeitig ist eine Befreiung wie die andere; der spezifische Charakter jeder beson-deren Handlung ergibt sich allein aus ihrer Integration in einen historischen, horizontalen Prozess. Die Formen der Sklaverei sind unterschiedlich, aber alle Befreiungen sind identisch. Genau dies sehen wir in Chans Video. Ein Ding nach dem anderen wird befreit – und jedes Ding kommt direkt in den Himmel (oder die Hölle), jenseits der horizontalen Achse der Weltgeschichte. Obschon die befreiten Dinge sich unterscheiden, ist der Akt ihrer Befreiung immer derselbe. Die Videos zeigen eine Bewegung, aber diese Bewegung ist per se eine ewige Wiederholung ein und dessel-ben Befreiungsaktes. In diesem Sinn ist die Geste, welche die Bewegung in Chans Videos erzeugt, repetitiv – lange bevor die Endlos-schleife ins Spiel kommt. Diese Videos führen Befreiung als ewige Wiederkehr des Gleichen vor – Befreiung in der Endlosschlaufe.

(Übersetzung: Suzanne Schmidt)

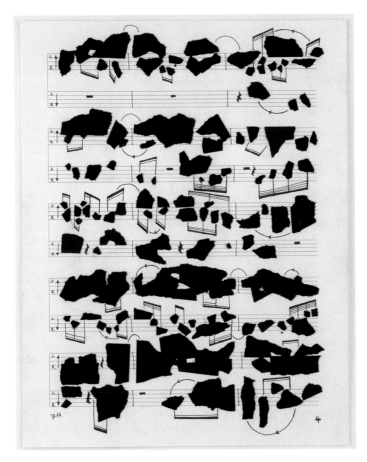

1) Platon, «Parmenides», zitiert nach Platon, *Sämtliche Werke*, Bd. 2, übers. v. Friedrich Schleiermacher et al., Lambert Schneider, Berlin 1940, Stephanus-Numme-rierung 130b–e.
2) Paul Chan, «The Spirit of Recession», *October*, Nr. 129 (Sommer 2009), S. 3–12.
3) Walter Benjamin, «Über den Begriff der Geschichte», in: ders., *Gesammelte Schriften*, Bd. I-2, Suhrkamp, Frank-furt am Main 1991, S. 697 (These IX).

Essentially Alien:

CARRIE LAMBERT-BEATTY

Notes from Outside Paul Chan's *Godot*

1.

In a way, it's not hard to describe what took place.[1] In November 2006, New York-based artist Paul Chan went to New Orleans to give a talk. The city was still devastated by Hurricane Katrina and like so many other visitors he was overwhelmed by the evidence of destruction, loss, and displacement. The very landscape—the Lower Ninth Ward reduced to a neo-rural wasteland—was hard to visually process. Then an aesthetic correlation pulled the scene into focus: "Standing there at the intersection of North Prieur and Reynes, I suddenly found myself in the middle of Samuel Beckett's *Waiting for Godot*." Back in New York, Chan connected with public arts non-profit Creative Time (whose director, Anne Pasternak, was hoping to launch a project in New Orleans) and the Classical Theatre of Harlem (which had just closed

an acclaimed, Katrina-inspired version of *Godot*), and they set about manifesting the vision: a free, public, site-specific *Waiting for Godot* performed at an intersection in the Lower Ninth Ward. Of course, almost as quickly as Chan recognized the aesthetic correctness of the image, he saw how wrong it could be ethically. Besides the usual questions about art's ability to make a difference, he'd be an outsider jetting in to a community now defined by disaster to offer a gift no one had asked for—a famously opaque, fifty-five-year-old play by a dead, white European no less—while families still needed homes to be rebuilt, facilities to be reopened, neighbors to return. The first step, then, was to ask people in New Orleans what they thought of the idea and how to make it meaningful in its context.

CARRIE LAMBERT-BEATTY is the John L. Loeb Associate Professor of the Humanities at Harvard University in the Department of History of Art and Architecture and the Department of Visual and Environmental Studies.

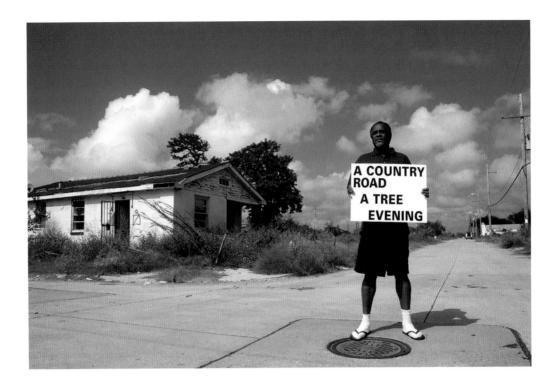

PAUL CHAN, WAITING FOR GODOT IN NEW ORLEANS, 2007, *performance photo* / WARTEN AUF GODOT IN NEW ORLEANS, *Szenenbild.*

The result was a massive, months-long endeavor. Chan relocated to New Orleans, volunteered to teach at Xavier University and the University of New Orleans, coordinated workshops and potlucks, and met with New Orleanians in their churches, community groups, studios, and homes. Inspired by a local friend's injunction to "do the time and spend the dime," Chan and Creative Time launched what he called the Shadow Fund, giving grants to local aid organizations in amounts that totaled, dollar for dollar, what was spent producing the play. He altered his initial vision so that *Godot* was performed in the diverse Gentilly neighborhood as well as the more infamously devastated—and disaster-tourist-attracting—Ninth Ward. Local flavor was added, with New Orleans food and music before the performances and Louisiana accents and references slipped into it. Thousands of people—local residents, evacuees, art fans—lined up for four performances, so many that a fifth was added by popular demand.

But the reception history of this project includes an audience beyond those present at the five performances, as must have been Chan's wish, for his documentation is both thorough and accessible. First online and now in the form of a book, he has made available everything from scrawled notes to performance props, newspaper clippings, and recorded interviews. His entire archive of the project was purchased by the Museum of Modern Art, with Chan stipulating that the museum preserve the organizing materials as well as the play's documents, and make both publicly accessible. An installation of archive material is on view at MoMA through September 2011. It is such documentary material that I've been mining—trying to figure out just what WAITING FOR GODOT IN NEW ORLEANS (2007) really was, or is; and meanwhile wondering whether an account from outside can sit respectfully alongside the many versions that have been produced by its participants, or whether it displaces the subject it is trying to serve.

PAUL CHAN, *double spreads from /*
Doppelseiten aus Waiting for Godot in New Orleans:
A Field Guide, 2010.

Creative Time has a shorthand for the questions that have plagued socially site-specific artworks, no matter how good their intentions. He calls it the "parachute problem." If the documentation of GODOT IN NEW ORLEANS shows anything, it is how seriously everyone involved struggled with, "in a nutshell, the riddle of how to work intensively, responsibly, and collaboratively in locales that are not your own."[3]

GODOT IN NEW ORLEANS gives an unexpected answer. You would think all that organizing work was aimed at embedding the project in its social environment, naturalizing it to its physical and social locales. But it's not clear that's what happened. Chan has said that what made his project successful wasn't the way Beckett's play adapted to the environment, but rather its "essential alienness."[4] Perhaps that's why elements like the pre-performance gumbo and the second-line jazz band seem such overtly clumsy attempts to blend in—the taped-together camouflage an alien might wear as he lands in New Orleans... in a parachute.

This is not to say the project failed; it's to say it successfully demonstrated the inadequacy of embeddedness as an ideal—either for what Chan did in New Orleans, or for what art does in society today.

2.

Could *Waiting for Godot* take place in New Orleans? Could a production of *Godot* reach out to exhausted New Orleanians rather than impose something on them? Would it divert funds and attention needed elsewhere in the city? Would it accomplish anything locally, or just enhance Chan's reputation back in the art world? In other words, could Waiting for *Godot* take place without taking t h e place?

The questions faced by Chan and his collaborators link his *Godot* project to a conversation that has been ongoing since the mid-1990s about community-based, or new public art—projects that are specific not only to their physical locations, but to the social and historical sites they engage.[2] Gavin Kroeber of

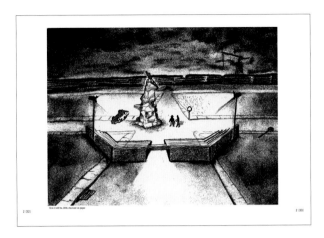

PAUL CHAN, *double spread from /*
Doppelseite aus Waiting for Godot in New Orleans:
A Field Guide, 2010.

3.

When the question of art's political potential is raised in contemporary art discourse (and sometimes it seems nothing else is), the main tendency since at least the 1990s has been to question the distinction between its two terms: to "blur the line between art and life," as the phrase goes. A political activist and an artist, Paul Chan might be the exemplary figure for the great blur—if he didn't spend all his time resisting it. As he puts it in an interview with George Baker, "the desire to bridge what we call art and politics is in fact a fear of both."[5]

4.

Chan does not pretend the idea of an outdoor *Godot* emerged out of the community's own needs or desires—in fact as you track Chan's movement between art schools, FEMA trailers, and bureaucrats' offices, it becomes clear that if there was any singular "community" involved in this project it is the one that he and his collaborators called into being. In fact, there is a distinctly visionary quality to his picturing of Vladimir and Estragon in the Lower Ninth Ward (Chan has also called it a hallucination), and it is his vision that recurs as the origin moment of the project in most all the narratives surrounding it. The artist

has a vision that he makes manifest: it's a model of inspiration, imagination, and imposition, as alien to the mode of socially engaged art-making from the last twenty years as Beckett's modernist play itself. Situating the play on the streets of New Orleans was "my way of reimaging the empty roads, the debris, and above all, the bleak silence as more than the expression of mere collapse." This artistic "reimaging" turned out to require teaching and meeting and donating, processes that happened at the same time as theater-specific activities like producing and rehearsing. I suspect that for the people involved in them they felt like—and so they were—part of a single process. But for us?

When an art work's genre is hard to name, the category of performance always obliges; perhaps, then, the Beckett play is essentially a prop in a piece of performance art, a now-classic work of literature serving as the occasion for all the possibilities of art in an expanded field. But I would resist calling GODOT IN NEW ORLEANS a performance—not because it wasn't theatrical, but because it was plural. It would be easy enough to call everything Chan did in New Orleans part of a singular work of art. But there's more to be gained by admitting that the relationship between his different activities is strange, and strained; that GODOT IN NEW ORLEANS is less a model artwork than a model of art's relationship to its social world.

5.

Footnotes. Illustrations. Indices. These are the add-ons, the extraneous parts of the textual apparatus that Jacques Derrida often focused on, finding the keys to literature and philosophy in elements seemingly external to "the text itself." They are also a few of Chan's favorite devices. His film BAGHDAD IN NO PARTICULAR ORDER (2003), for instance, has what he calls "online footnotes" on his website that explicate, relate to, or riff on its scenes. His recent essay in *October* has footnotes that are illustrations.[6]

Derrida was interested in these elements of texts because his basic intervention was in the pursuit of origin, purity, and presence in Western thought and, in particular, the way language is understood as supplemental to reality—outside and secondary to it. A supplement is a thing added on. But the oldest mean-

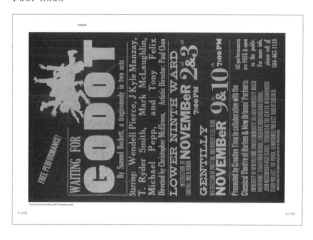

PAUL CHAN, double spreads from /
Doppelseiten aus Waiting for Godot in New Orleans:
A Field Guide, 2010.

ing of supplement is "something added to supply a deficiency."[7] Derrida argued that to supplement is always to admit the incompleteness of the thing supplemented. The supplement "adds only to replace. It intervenes or insinuates itself in-the-place-of; if it fills, it is as if one fills a void... the supplement is an adjunct, a subaltern instance which takes-(the)-place."[8] It seems important, then, that in many accounts of Chan's conversations with New Orleanians about the staging of *Godot*, his question took a particular form: "What else should we do?"

6.

Normally it is art that is considered the supplement, added on to and representing reality. But the narrative of GODOT IN NEW ORLEANS given in most every account of the project, including this one, reverses the terms. It is art—Beckett's modernist masterpiece or Chan's inspired siting of it—that gets supplemented. In fact, the whole structure of what took place in New Orleans is lacy with add-ons. Chan added Creative Time and the Classical Theatre of Harlem as producers. He added a second site to the site-specific work. He added lectures about contemporary art, master classes, and workshops as well as an organizing model borrowed from Saul Alinsky, and $55,000, gumbo, and a marching band. It makes

sense, in a way: the "parachute problem" is in part the fear that art will displace something more important. So it is as if Chan took the normal assumptions and reversed them. In this scenario, life is the supplement, and art the essential absence it reveals. This is why it is so tempting to wrap all the elements of the New Orleans project up together and call it an artwork. If we don't, if we admit that it has a structure of supplementation, we admit that art is not enough.

7.

Or is it asked to do too much? Chan's *Godot* and community-based art are false cognates. They look the same, and perhaps felt the same in the making, but out here in the aftermath they have different meanings and consequences. In describing the double nature of the supplement, Derrida also said that it "produces no relief." This makes a kind of double sense in the context of GODOT IN NEW ORLEANS. First, Chan did not fancy himself any kind of relief worker, in a city that had seen plenty of them (if not always in the right times and places). "To imagine that what we do could as a performance, as art, [could] provide an alternative to the actual basic nourishments for the city I think overplays the idea of what art can be."[9] Then, this overplay, the famous blurring of the line between politics and art, has to be resisted precisely because it c a n provide relief: when contemporary art acquiesces to an overriding ideology of interconnection and integration, what it produces, Chan writes, is a "numbing peace."

Another way to put it: Chan made a project using community organizing, teaching, and potluck dinners that defends, of all things, the autonomy of art.

8.

How to reinvent aesthetic autonomy in the twenty-first century: can that possibly be an appropriate question to pull from this project? I'm not sure. But what took place in New Orleans has two avenues into the future: memory and history. Memory's route is not available to me, or to most of you reading. But, displacing and replacing, our add-on reception helps shape its path, nevertheless, into textbooks and classrooms, galleries and archives, and the imaginations of those who find it there. And what I see moving forward is not a solution to art and politics, but an arguing, limping assemblage of the two.

1) Quotes in this section are from Paul Chan, "Waiting for Godot in New Orleans: An Artist's Statement" in *Waiting for Godot in New Orleans: A Field Guide*, ed. Paul Chan (New York: Creative Time, 2010), pp. 25–28, but my capsule description is distilled from many accounts given by Chan and others (most also included in the Field Guide). In some way, the project is a narrative. Am I recounting it objectively? Can I write without overwriting? Do you really have to ask?

2) Nato Thompson places the project in this lineage, while also suggesting its divergence from it, in his "Destroyer of Worlds," *Field Guide*, pp. 38–49.

3) Gavin Kroeber, "Producing Waiting for Godot in New Orleans," *Field Guide*, pp.138–147, 138.

4) In Claudia La Rocco, "An Interview" (interview of Paul Chan), *The Brooklyn Rail* (July/August 2010), pp. 22–26, 24.

5) George Baker, "An Interview with Paul Chan," *October*, No. 123 (Winter 2008), pp. 205–233, 216.

6) Paul Chan, "The Spirit of Recession," *October*, No. 129 (Summer 2009), p. 3–12.

7) Based on the definition of the word "supplement" from the Oxford English Dictionary Online: www.oed.com

8) Jacques Derrida, *Of Grammatology*, trans. Gayatri Chakravorty Spivak, Corrected Edition (Baltimore & London: Johns Hopkins University Press, 1998), p. 145.

9) Quoted in Zachary Youngerman, "Waiting for Godot in New Orleans," *Next American City*, 13 July 2010, www.americancity.org.

PAUL CHAN, double spreads from /
Doppelseiten aus Waiting for Godot in New Orleans:
A Field Guide, 2010.

Absolut fremd:

CARRIE LAMBERT-BEATTY

Periphere Anmerkungen zu Paul Chans *Godot*

1.

Was geschah, ist schnell erzählt.[1] Der New Yorker Künstler Paul Chan reiste im November 2006 für einen Vortrag nach New Orleans. Die Wunden, die der Hurrikan Katrina geschlagen hatte, waren noch nicht verheilt. Chan war wie so viele vor ihm vom Ausmass der Zerstörung, von der Not und Obdachlosigkeit erschüttert. Die Szenerie – Stadtviertel wie der Lower Ninth Ward lagen brach wie Ackerland – überwältigte das Auge. Dann bot sich überraschend ein ästhetischer Zusammenhang an, der das Gesehene fassbar machte: «An der Kreuzung North Prieur und Reynes Street fühlte ich mich plötzlich in Becketts *Warten auf Godot* versetzt.» Zurück in New York kontaktierte Chan Creative Time (einen Fonds

für Kunst im öffentlichen Raum, dessen Direktorin Anne Pasternak an einem Projekt für New Orleans interessiert war) und das Classical Theatre of Harlem (das eben eine von Katrina angeregte *Godot*-Inszenierung beendet hatte). Gemeinsam fassten sie einen Plan: eine kostenlose, ortsspezifische Produktion von *Warten auf Godot* an einer Kreuzung im Lower Ninth Ward. Natürlich erkannte Chan sofort die ethischen Risiken des Vorhabens, so treffend es in ästhetischer Hinsicht auch sein mochte. Abgesehen von der unvermeidlichen Frage, ob Kunst überhaupt etwas bewirken kann, würde er als ungebetener Fremder in ein Krisengebiet kommen, wo es noch immer eingestürzte Häuser, geschlossene Betriebe und menschenleere Viertel gab, mit nichts im Gepäck als dem

CARRIE LAMBERT-BEATTY ist John L. Loeb Associate Professorin of the Humanities des Instituts für Kunst- und Architekturgeschichte sowie des Instituts für Bild- und Umweltwissenschaft an der Harvard University.

kryptischen, fünfundfünfzig Jahre alten Schauspiel eines toten Schriftstellers – schlimmer noch, eines toten, weissen, europäischen Schriftstellers! Man musste zuallererst die Menschen in New Orleans fragen, was sie von der Idee hielten und unter welchen Bedingungen sie sich sinnvoll realisieren liess.

Dieser erste, ungemein schwierige Schritt nahm einen Monat in Anspruch. Chan zog nach New Or-

leans, unterrichtete ehrenamtlich an der Xavier University und der University of New Orleans, organisierte Workshops, Potlucks (Essen, bei denen jeder Gast eine Speise mitbringt) und besuchte Kirchen, Versammlungen, Werkstätten und Wohnungen. Den Ratschlag eines einheimischen Freundes befolgend, «weder Zeit noch Geld zu sparen», gründeten Chan und Creative Time den sogenannten «Shadow Fund»,

PAUL CHAN, WAITING FOR GODOT IN NEW ORLEANS, 2007, *performance photo /* WARTEN AUF GODOT IN NEW ORLEANS, *Szenenbild.*

der für jeden Dollar, der in die Produktion des Theaterstücks floss, einen weiteren Dollar an lokale Hilfsorganisationen überwies. Entgegen dem ursprünglichen Plan wählte man neben dem Ninth Ward, der mittlerweile zum Mekka des Katastrophentourismus aufgestiegen war, einen zusätzlichen Schauplatz im ethnisch gemischten Viertel Gentilly. Die Vorstellungen wurden mit ortstypischen Speisen und Musik eingeleitet und sowohl sprachlich als auch kontextuell dem Lokalkolorit angepasst. Tausende Besucher – Einheimische, Evakuierte, Kunstfreunde – standen für *Godot* Schlange. So gross war der Andrang, dass den vier Aufführungen eine fünfte hinzugefügt werden musste.

Doch die Wirkung des Projekts geht weit über diesen Rahmen hinaus. Chan hat es gründlich dokumentiert und alle Materialien – Notizen und Requisiten, Zeitungsausschnitte und Interviews – online und nun auch in Buchform veröffentlicht. Das Archiv befindet sich heute im Besitz des Museum of Modern Art in New York, das sich beim Ankauf verpflichtete, es in seiner Gesamtheit zu verwahren und allgemein zugänglich zu machen. Eine Installation des Archivs ist bis September 2011 im MoMA zu sehen. Ich durchsuchte diese Fundgrube nach einer Antwort auf die Frage, was damals bei WAITING FOR GODOT IN NEW ORLEANS (Warten auf Godot in New Orleans, 2007) wirklich geschah. Kann es mir als einer distanzierten Beobachterin gelingen, meine Betrachtungen respektvoll neben die Augenzeugenberichte der Be-

teiligten zu stellen, oder sind meine noch so gut gemeinten Versuche dazu verurteilt, ihren Gegenstand auszulöschen?

2.

Kann *Warten auf Godot* in New Orleans aufgeführt werden? Kann das Stück die leidgeprüfte Bevölkerung erreichen, ohne sich aufzudrängen? Verschlingt es Geld und Publicity, die anderswo nötiger wären? Ist das Projekt ein Gewinn für New Orleans oder für Chans Künstlerkarriere? Kurz, kann man ein solches Gastspiel aufführen, ohne sich wie ein ungebetener Gast aufzuführen?

Dieser Fragenkomplex entspringt einem Diskurs, der seit Mitte der 90er-Jahre im Zusammenhang mit neuer Kunst im öffentlichen Raum geführt wird, einer Kunst, die nicht nur die physischen, sondern auch die sozialen und historischen Bedingungen ihres Entstehungsorts reflektiert.[2] Das Risiko, dem sozialorientierte, ortsspezifische Projekte trotz guter Vorsätze ausgesetzt sind, nennt Gavin Kroeber von Creative Time lakonisch das «Fallschirmspringer-Problem». Wenn die Dokumentation zu GODOT IN NEW ORLEANS irgendetwas beweist, dann die unglaubliche Intensität, mit der alle Beteiligten das Rätsel zu lösen suchten, «an einem fremden Ort konsequent, verantwortlich und kooperativ zu arbeiten».[3]

GODOT IN NEW ORLEANS gibt eine überraschende Antwort. Man möchte erwarten, dass die gesamte Organisation und Planung darauf abzielte, das Projekt

PAUL CHAN, double spreads from /
Doppelseiten aus Waiting for Godot in New Orleans:
A Field Guide, 2010.

in sein materielles und soziales Umfeld einzubetten, einzupflanzen, einzubürgern. Ob dem tatsächlich so war, bleibt fraglich. Das Erfolgskriterium lag für Chan eben nicht in der Anpassung des Stücks an die örtlichen Gegebenheiten, sondern in seiner «absoluten Fremdheit».[4] Stimmungsmacher wie Gumbo oder Jazz zweiter Klasse wirkten womöglich gerade deshalb wie ein plumper Anbiederungsversuch, wie der schnell nach der Landung in New Orleans zusammengeflickte Tarnanzug – eines Fallschirmspringers.

Damit sei nicht gesagt, dass das Projekt ein Fehlschlag war. Vielmehr bestätigte es die Unangemessenheit der Anpassung an die Gegebenheiten als Ideal – für Chans Aktivitäten in New Orleans ebenso wie für jene der Kunst in der Gesellschaft.

3.

Wenn in der zeitgenössischen Kritik der politische Inhalt der Kunst angesprochen wird (und manchmal meint man, es gäbe kein anderes Thema), herrscht zumindest seit den 90er-Jahren eine Tendenz vor, die, wie es so schön heisst, für die «Aufhebung der Grenzen» eintritt. Ein politisch engagierter Künstler wie Paul Chan scheint prädestiniert für dieses Aufhebungsmanöver – wenn er sich nicht so vehement dagegen sträuben würde. Argumentierte er doch in

einem Interview mit George Baker, «der Wunsch, eine Brücke zwischen Kunst und Politik zu schlagen, ist nichts als die Furcht vor beidem».[5]

4.

Chan behauptet nicht, dass die Idee für den Freiluft-*Godot* aus bodenständigen Bedürfnissen und Anliegen erwuchs. Wer seinen Weg zwischen Kunstschulen, Notunterkünften und Ämtern nachzeichnet, wird entdecken, dass die einzig wirklich beteiligte «Gemeinschaft» jene war, die er und seine Partner spontan ins Leben riefen. Es gehört schon Phantasie dazu, Wladimir und Estragon in den Lower Ninth Ward hineinzudenken. Diese (wie manche meinen fast halluzinative) Kraft ist das auslösende Moment fast aller Erzählspuren des Projekts. Der Künstler verwirklicht seine Vision. Sein Ansatz, eine Kombination aus Inspiration, Vorstellungsgabe und Durchsetzungsvermögen, hat ebenso wenig mit der sozial engagierten Kunst der letzten zwanzig Jahre gemein wie Becketts modernistisches Schauspiel. Die Verlegung des Stücks in das Stadtbild von New Orleans war «mein Versuch, die leeren Strassen, die Trümmer und vor allem die dumpfe Stille nicht bloss als Überreste einer Katastrophe zu begreifen». Die übliche Theater- und Probenarbeit reichte dazu nicht aus. Es galt, Vorträge zu halten, Menschen zu treffen, Geldmittel zu spenden. Für die Akteure war das vermutlich ein einziger, organischer Prozess. Aber wir, welchen Eindruck gewinnen wir?

Wenn es schwerfällt, ein Kunstwerk einzuordnen, muss meist der Begriff «Performance» herhalten. Becketts Schauspiel wäre demnach nicht mehr als das Versatzstück einer Performance. Der klassische Text als Angelpunkt für die Entfaltung eines transdisziplinären Kunstwerks. Ich würde GODOT IN NEW ORLEANS allerdings keineswegs als Performance einstufen. Nicht, weil das Event nicht theatralisch gewesen wäre, sondern weil es seinem Wesen nach pluralistisch war. Man könnte durchaus so weit gehen und alles, was Chan in New Orleans getan hat, als Kunst bezeichnen, als komplexes Gesamtkunstwerk. Zielführender wäre es jedoch, die (gewiss reale) Hilfeleistung für die Einwohner von New Orleans als Zusatz und nicht als integralen Bestandteil des Kunstwerks zu werten. GODOT IN NEW ORLEANS erwiese

PAUL CHAN, *double spread from /*
Doppelseite aus Waiting for Godot in New Orleans:
A Field Guide, 2010.

sich dann weniger als Modell einer künstlerischen Position, sondern eher als Modell für die Beziehung zwischen Kunst und Gesellschaft.

5.

Anmerkungen. Illustrationen. Register. Dies sind die Zusätze, die Anhängsel des Textapparats, denen Jacques Derrida sich gerne zuwendet, vermeintlich extratextuelle Äusserlichkeiten, die dennoch einen Schlüssel zu Literatur und Philosophie bieten. Anmerkungen, Illustrationen und Register gehören auch zum festen Instrumentarium von Paul Chan. So verfügt sein Film BAGHDAD IN NO PARTICULAR ORDER (Bagdad ohne bestimmte Reihenfolge, 2003) über «Online-Fussnoten» auf seiner Webseite, die den Inhalt der Bilder erklären, untermalen oder weiterspinnen. Chans jüngster Aufsatz in der Zeitschrift *October* enthält Anmerkungen in Form von Illustrationen.[6]

Derrida prüfte diese Elemente im Zuge seiner Untersuchungen zur Entstehung, Reinheit und Präsenz des westlichen Denkens, speziell aber zu jener Sichtweise, die die Sprache als supplementär – extern und sekundär – zur Wirklichkeit setzt. Ein Supplement ist ein Zusatz, etwas das hinzugefügt wird, um einen Mangel zu beheben. Nach Derrida indiziert das Supplement stets die Unvollkommenheit der ergänzten Sache. Das Supplement «gesellt sich nur bei, um zu ersetzen. Es kommt hinzu oder setzt sich unmerklich an-(die-)Stelle-von; wenn es auffüllt, dann so, wie man eine Leere füllt. ... Hinzufügend und stellvertretend ist das Supplement ein Adjunkt, eine un-

tergeordnete, stellvertretende Instanz.»[7] Wenn das Supplement sonach nicht nur hinzufügt, sondern ersetzt, scheint bedeutsam, dass Chan in Gesprächen über sein *Godot*-Projekt vor Ort wiederholt die Frage stellte: «Was sollen wir sonst tun?»

6.

Zumeist ist es die Kunst, die als Supplement bezeichnet wird, als Zusatz zur Realität und als deren Spiegel. Dessen ungeachtet kehren so gut wie alle Berichte über GODOT IN NEW ORLEANS (so auch der vorliegende) den Sachverhalt um. Es ist die Kunst – Becketts Meisterwerk oder dessen kongeniale Verortung durch Chan –, die Ergänzung erfährt. Das Programm für New Orleans wimmelt nur so von Zusätzen: Creative Time und das Classical Theater of Harlem als Koproduzenten, ein zweiter Spielort für das ortsspezifische Projekt, Referate über zeitgenössische Kunst, Meisterklassen und Workshops, ein von Saul Alinsky geborgtes Organisationsmodell, 55000 Dollar, Essen, eine Blaskapelle. Irgendwie ergibt das alles Sinn: Das «Fallschirmspringer-Problem» ist zum Teil nichts als die Furcht, die Kunst könne etwas Wichtigeres ersetzen. Derrida charakterisiert das Supplement als «untergeordnete, stellvertretende Instanz». Chan stellt die westliche Anschauung auf den Kopf. In seiner Konfiguration dient das Leben als Supplement, das die Kunst ersetzt und deren fundamentale Abwesenheit enthüllt. Daher das Verlangen, alle Elemente des *Godot*-Projekts zur Einheit eines Kunstwerks zusammenzuführen. Wenn wir dies unterlassen, wenn wir zugeben, dass es sich um eine

offen erweiter- und ersetzbare Struktur handelt, müssen wir auch zugeben, dass die Kunst allein nicht ausreicht.

7.

Oder dass man zu viel von ihr erwartet. Chans *Godot* gehört nicht zum Genre «Kunst im öffentlichen Interesse». Es bestehen äusserliche Ähnlichkeiten und der Prozess hat sich, während er ablief, wohl so dargestellt. Im Rückblick auf das abgeschlossene Projekt treten indessen ganz andere Bedeutungen und Wirkungen hervor. In seiner Beschreibung der Doppelnatur des Supplements – Ergänzung und Ersatz – erklärt Derrida, dass aus ihm keine Erleichterung erwächst. Dies ist im Hinblick auf GODOT IN NEW ORLEANS zweifach relevant. Erstens verstand sich Chan nie als Helfer, von denen es ohnehin genug in der Stadt gab (wenn auch nicht immer zur richtigen Zeit am richtigen Ort). «Sich vorzustellen, dass das, was wir taten, als Performance, als Kunst ... eine Alternative zur Versorgung der Bewohner darstellen könne, übersteigt die Möglichkeit dessen, was Kunst sein kann.»[8] Zweitens darf die berühmte Aufhebung der Grenze zwischen Kunst und Politik nicht widerstandslos hingenommen werden, denn sie k a n n hilf-

reich sein: Wenn die zeitgenössische Kunst eine Ideologie akzeptiert, die beides als wechselseitig verbunden und einander zugehörig hinstellt, schreibt Chan, entsteht nichts als «hohler Frieden».

Anders formuliert: Chan organisierte für sein Projekt Versammlungen, Lehrveranstaltungen und Potlucks, um die Autonomie der Kunst zu verteidigen.

8.

Wiederherstellung der ästhetischen Autonomie im 21. Jahrhundert. Ist das die Quintessenz dieses Werks? Ich weiss es nicht. Von den Geschehnissen in New Orleans führen zwei Wege in die Zukunft: Erinnerung und Geschichte. Der erstere ist mir wie den meisten Lesern verwehrt. Ich kann nicht sagen, was Chans *Godot*-Projekt war. Aber ich kann mit diesem Text einen kleinen Beitrag dazu leisten, was es sein wird. Ich entlasse ihn somit in die Öffentlichkeit: in Lehrbücher, Klassenzimmer, Galerien und Archive wie auch in die Vorstellung all jener, die ihn dort antreffen werden. Nicht als Lösung des Problems von Kunst und Politik, sondern als deren zankende, humpelnde, zusammengestückelte Mischgestalt.

(Übersetzung: Bernhard Geyer)

PAUL CHAN, *double spread from /*
Doppelseite aus Waiting for Godot in New Orleans:
A Field Guide, 2010.

1) Zitate in diesem Abschnitt aus Paul Chan, «Waiting for Godot in New Orleans: An Artist's Statement», in: *Waiting for Godot in New Orleans: A Field Guide*, hrsg. von Paul Chan, Creative Time, New York 2010, S. 25–28. Mein Resümee ist verschiedenen Berichten von Chan und anderen Autoren entnommen (die grossteils im *Field Guide* wiedergegeben sind). In gewisser Weise ist das Projekt selbst ein Narrativ. Gebe ich es objektiv wieder? Kann ich schreiben, ohne zu überschreiben? Ist es wirklich notwendig, diese Fragen zu stellen?

2) Nato Thompson ordnet das Projekt diesem Genre zu, nicht ohne zugleich Abweichungen festzustellen. Nato Thompson, «Destroyer of Worlds», in: *Field Guide*, S. 38–49.

3) Gavin Kroeber, «Producing Waiting for Godot in New Orleans», in: *Field Guide*, S. 138–147, Zitat S. 138.

4) Claudia La Rocco, «An Interview» (Gespräch mit Paul Chan), *The Brooklyn Rail* (Juli/August 2010), S. 22–26, Zitat S. 24.

5) George Baker, «An Interview with Paul Chan», *October* 123 (Winter 2008), S. 205–233, Zitat S. 216.

6) Paul Chan, «The Spirit of Recession», *October* 129 (Sommer 2009), S. 3–12.

7) Jacques Derrida, *Grammatologie*, Suhrkamp, Frankfurt/M 1983, S. 250.

8) Zitiert nach Zachary Youngerman, «Waiting for Godot in New Orleans», *Next American City*, 13. Juli 2010, americancity.org.

4.

~~Remember the Bourgeoisie?~~ Their acreage comes closest to the ~~mobile phone.~~

~~The model is~~ new ~~and the ring renews the sting of~~ triumph. Like that dog.

28.

~~This morning's~~
~~string~~ theory
~~goes as~~ follows:

Light ~~is the inverse~~
~~of a slackening~~
~~made real~~.

~~Apply it~~ with malice
on ~~aching joints~~
~~and~~ floors.

29.

~~A life in~~ crime
must ~~cross that line~~
~~before the~~ point
left ~~by Xeno~~.

30.

~~The time to thug~~
always ~~comes~~
~~too soon~~.

~~You trap all day and~~
play all ~~night~~.
The clowns ~~meet~~
~~down the block~~.

As a precaution.

31.

Echo reconciles. ~~Ask the shadow of the tree.~~

~~Or~~ the ~~broken window about the slurry time that~~ bonds itself ~~in the thing.~~

4.

~~Erinnerst du dich an die~~
~~Bourgeoisie?~~ Ihre
Länderien gleichen am ehesten
dem ~~Mobiltelefon.~~

~~Das Klingeln des~~ neuen
~~Modells erneuert~~
~~den~~ Triumphstachel.
Wie der Hund da.

28.

~~Die String~~theorie
~~von heute Morgen~~
~~lautet wie~~ folgt:

Licht ~~ist die Umkehrfunktion~~
~~einer wahrgemachten~~
~~Verlangsamung.~~

~~Wende es~~ in böser Absicht
auf ~~schmerzende Gelenke~~
~~und~~ Böden ~~an.~~

29.

~~Ein~~ verbrecherisches ~~Leben~~
muss ~~jene Linie~~
nach ~~dem Punkt~~ links ~~kreuzen~~
~~den Xeno an~~zeigte.

~~30.~~

~~Die Zeit zum Dreinschlagen~~
~~kommt~~ immer
viel ~~zu früh.~~

~~Den ganzen Tag schuften~~
~~und~~ spielen ~~bei Nacht~~.
Die Clowns ~~treffen sich~~
~~gleich um die Ecke.~~

Vorsichtshalber.

31.

Echo versöhnt. ~~Frag~~
~~den Schatten des Baumes.~~

~~Oder~~ die ~~eingeschlagene Scheibe~~
~~nach der schlammigen Zeit,~~
~~die sich selbst in~~ Fesseln ~~legt,~~
~~sich~~ selbst ~~im Ding.~~

ALAN GILBERT

The Body Inscribed:

Sexual obsession is the loneliest pursuit. The force of its need is only matched by the internal abyss into which it peers. In contrast, the power of erotic desire is contingent upon a give and take with a real or imagined other. The Marquis de Sade explored sexual obsession perhaps more than any writer or artist in history, and it was isolation that spurred his investigation. Paul Chan's Sade project began in 2003, but it didn't start to take serious shape until the fall of 2007 while he was working on his remarkable public-art staging of Samuel Beckett's *Waiting for Godot* (1952) in the devastated Lower Ninth Ward of post-Hurricane Katrina New Orleans. Perhaps Chan needed to carve out a Sadean space of essential solitude in the midst of the many collaborations—with city government, with local arts groups, with the Classical Theatre of Harlem, with university programs, with sponsoring organization Creative Time—that the New Orleans-based production required. He started by making ink drawings, many of them sexually explicit, though they gradually became less figurative. Less representations of scenes from Sade's writings, the drawings are fluid depictions of desire and containment.

ALAN GILBERT is the author of the poetry book *Late in the Antenna Fields* (Futurepoem) and the essay collection *Another Future: Poetry and Art in a Postmodern Twilight* (Wesleyan University Press). He lives in Brooklyn, NY.

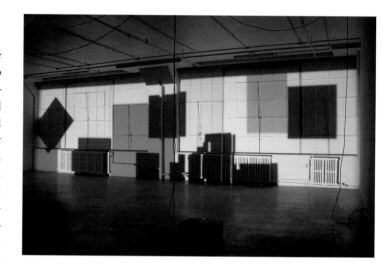

Portions of Chan's Sade project were exhibited at the Renaissance Society at the University of Chicago's campus in the spring of 2009 ("My Laws Are My Whores") and at Greene Naftali Gallery in New York City in late 2009 ("Sade for Sade's Sake"). A five-hour-and-forty-five-minute, large-scale digital video projection—also called SADE FOR SADE'S SAKE (2009)—premiered at the 2009 Venice Biennale. But the project as a whole was much more than a gallery exhibition, and encompassed more work than possibly could be shown in one place, including hundreds of drawings. It involved public events such as a three-day seminar in New York City in September 2008 as part of Anton Vidokle's night school at the New Museum for Contemporary Art (NIGHT SCHOOL:

as the series of drawings progresses, these swirls gradually begin to occupy much of the composition. In Sade's novels, the details are always crisply described; his *120 Days of Sodom* (1904) has frequently been compared to a perverse Enlightenment encyclopedia of every conceivable sex act. Chan's SADE FOR SADE'S SAKE video may partially function this way, but the drawings are a different story, for they harbor a glimmer, however faint, of the emancipatory desire at the heart of much of Chan's previous work.

At the same time, because the drawings are made almost entirely with sinuous lines, bodies are rarely filled in. Faces are indistinct; some drawings consist only of limbs and torsos—a few, solely of genitals. Similar to Sade's fictional characters, the figures in Chan's drawings have no inner life. They are going through motions that aren't entirely their own. As outlines, the drawings render interior spaces empty or else depict them traversed with the marks of an impersonal desire that's perhaps closer to need or even force. These are bodies and subjects that have been emptied out. Conversely, at Greene Naftali three drawings of faces in linked profile featured open mouths filled in with black ink. These are individuals, or maybe even a chorus, seeking to speak, but whose words—or song—have been swallowed by a darkness. Their words may be the text spelled by Chan's customized fonts. (They were placed in the same room with the large text-on-paper pieces.) Or these mouths may be passive receptacles.

Chan wanted to make the bodies in the SADE FOR SADE'S SAKE video transparent except for their outlines, but found that this didn't work visually. Instead, they take the form of shaky black silhouettes. Chan has spoken of and made art addressing his love of poetry. See his UNTITLED VIDEO ON LYNNE STEWART AND HER CONVICTION, THE LAW AND POETRY (2006). This attraction may result more from poetry's form than its content: its polysemantic elusiveness, its rhythmical patterns, its grounding in the graphic mark, and its strategic use of repetition. At the 2009 Venice Biennale, Chan was quoted as saying: "Poetry, with its rhythms, repetition, and cadence, creates a sensation in the body and our mind that somewhat approximates the sexual."[1] And in fact, the structure of SADE FOR SADE'S SAKE is derived from the

ballad form. Each scene in the nearly six-hour video is forty-five seconds long. The scenes are grouped in four-line "stanzas" according to an abcb "rhyme structure," so that if the first "b" scenario has three figures in its configuration, the second "b" will also have three figures, although in a different grouping. From a formally oriented point of view, this is structuralist filmmaking taken to an extreme.

In Venice, Chan projected SADE FOR SADE'S SAKE against a long brick wall; at Greene Naftali, it was displayed on a large wall with pipes, covered windows, and nearby columns all painted white. A much smaller and shorter five-and-a-half-minute version was shown at the Renaissance Society as UNTITLED (AFTER A CERTAIN CHATEAU) (2009). As mentioned, virtually every imaginable sex act involving any number of figures, as well as solitary ones, takes place during the course of the looped projection. There's lots of masturbating. Yet, given the intentionally low-resolution and pixilated quality to the work, these encounters aren't exactly explicit—and far from titillating. There's lots of bumping and grinding but, as in the drawings, body parts, particularly private ones, are frequently obscured or blocked out. Erect penises appear as quivering shadows. Limbs, and especially heads, detach from bodies, and sex shades into violence. The relatively brief scenarios mean that the figures remain mostly fixed in their roles and positions, as their bodies quiver in erotic—or fearful—paroxysms.

Throughout the video, solid geometric shapes in different colors float around the figures and also blot them out. According to Chan, these abstract forms represent "sources of sensual pleasure that must have been on the chateau's walls—sunlight windows and artwork on the walls—but which had been entirely absent from Sade's original text."[2] In Chan's video, blocks of vibrant color do provide some respite from the unremitting sex. But they don't open outward and the squares and rectangles are frequently a light-absorbing black. Similar blocks of monochromatic color appear throughout Chan's work, oftentimes to signal poetry. In UNTITLED VIDEO ON LYNNE STEWART AND HER CONVICTION, THE LAW AND POETRY, the screen is saturated with color when Stewart reads poems important to her. Color fields saturate

MY BIRDS... TRASH... THE FUTURE... (2004) to indicate both a break from the narrative and a different mode of representation. Monochromes bookend the diurnal flow of the digital video projections THE 7 LIGHTS (2005 – 2007). For Chan, horror must be spoken (and seen), whereas the unspeakable comes closest to beauty. In art—and poetry—it's commonly the other way around.

Abstract geometric shapes, of course, are also products of modernist art with its entwined strands of Enlightenment and anti-Enlightenment impulses. In an interview for *Proximity Magazine* in Chicago, Chan addressed these twin threads: "To me it's a good time to reexamine and explore again the legacy of the Marquis de Sade and to imagine what these connections mean to us today. Connections between sex, violence, freedom, and law or reason."[3] Chan's contribution to the publication accompanying Hans Ulrich Obrist's Manifesto Marathon, Serpentine Gallery (2008), is entitled "Sex and the New Way V.1" and it looks very much like a poem. In it he writes, "What shall we say then? Is the law / sex? Heavens no. But I had not / known sex but by the law."[4] The law isn't sex because the law is delivered and enacted in discourses, institutions, and practices that among other things seek to shape and regulate sex. Language is the law and sex doesn't always like language, even if—as Chan's poem shows—the only way to get to sex is via language. In *Sade, Fourier, Loyola* (1976), Roland Barthes writes: "...practice follows speech, and is absolutely determined by it: what is done has been said. Without formative speech, debauchery, crime, would be unable to invent themselves, to develop..."[5]

In this sense, for as long as Chan's art has been interested in sex, it has also been interested in language. To what degree does language liberate and to what degree does it oppress? In Sade, it does both at once. So, too, in Chan's various font projects, which he has worked on for most of the past decade. In earlier versions, language was on the side of emancipation. The first fonts Chan created utilized text and iconography from the Black Panther Party, ACT UP, and Charles Fourier. (They can be found on his National Philistine website.) Following a parallel trajectory in Chan's work from HAPPINESS (FINALLY) AFTER 35,000 YEARS OF CIVILIZATION (2000 – 2006) to the SADE FOR SADE'S SAKE video, the new fonts are much bleaker in vision. Is Chan playing out an ideological endgame where he contradicts his past inclination to keep art and politics distinct and seeks to collapse them into a grim and obscure anti-art and anti-politics? Or does Chan's SADE signal the final orgiastic dénouement of the Bush/Cheney administration? In any case, whereas Chan's previous gallery and museum exhibitions, as well as his WAITING FOR GODOT (2007) production, met with generally enthusiastic acclaim, the Sade project resulted in something closer to productive discomfort. This seems to have been intentional on Chan's part.

There are twenty-one fonts for the Sade project, taken from sources as varied as George W. Bush, the Book of Romans, nineteenth-century sex researcher Richard von Krafft-Ebing, Monica Lewinsky, gay porn star Michael Lucas, Mary Magdalene, Gertrude Stein, various characters from Sade's novels, and more. (Eighteen of them can be downloaded for free from Chan's website.) After installing the fonts on a computer, they can be used just like Arial or Times New Roman to type any text. For instance, if I select the font derived from the language of the Duc de Blangis in Sade's *120 Days of Sodom* to type the preceding sentence, it appears as:

Bite my slit and hole and fuck your mouth, suck your crack and ass and hole and rub your pussy, wet pungent pussy, wet suck your crack and knee and hole and hit that, fuck your slit and hit your crack and hole and ass and hit your crack and rub your cock and hit your nose and cum, eat your hole and fuck your mouth, laugh, hole and hit that, fuck your ear and cock and rub your crack and mound, fuck your eat your ass and fuck your armpit, tits and eat your ass and hole and pussy, wet suck your balls and fuck your Bite my mouth, suck your rub your pussy, wet hit your mouth, Now I suck your nose and fuck your ass and laugh, fuck your lips and Robot, hit your nose and rub your crack and hole and hit your hole and ear and cum, fuck your rub your crack and ear and hole and fuck your feet, hole and you know what.

Line breaks included. This is perhaps the most graphic of the twenty-one fonts. The same sentence using appropriated text from the poet Friedrich Hölderlin appears as:

Me a student, visible as like a tutor, I am a whore, sublime, visible as I am thunder, thunder, ...
I am a whore, supple, visible as moonlight, like a student, as a whore, visible as sublime, as a whore, I am
a nurse, as a trick, lightning, become visible as like a tutor, a turning, visible as moonlight, like a mother,
a nurse, I am a whore, restrained as like become sublime, like a virgin, a music, become sublime, visible as
thunder, I am a horse, like Me a tutor, I am I am thunder, as a tutor, Cum now I am a trick, like sublime,
For you, like a dolphin, For you, as a trick, I am a whore, visible as as visible as a mother, lightning, like
I am a whore, a mother, visible as like passive as visible as a gift.

As the two examples show, every upper- and lower-case letter and punctuation mark (as well as numbers and special characters) have a pre-established word or phrase chosen by Chan that translates them. Obviously, Chan's fonts create lots of room for play and experimentation as their tone runs from the subtly erotic to the hard-core pornographic—much like sex itself. And yet the constraints are almost visceral as the user watches her or his words surrendered to someone else's—Chan's—control. In an early description of the fonts, Chan writes: "I wanted language to work for me and no one else."[6] Just as the earlier HAPPINESS (FINALLY) AFTER 35,000 YEARS OF CIVILIZATION (2000–2003) had a Sadean component, there's a Sadean quality to this initial description of the fonts.

When first using the fonts, there's a sense of shock and disbelief, followed by a brief confusion and hesitation, as typed individual letters suddenly appear as wholly different words and phrases. But at a certain point the user consents to the process and begins to take delight in the surprise and uncertainty regarding what text will pop up next. Then the constraints set in. As in the SADE FOR SADE'S SAKE video, the possibilities seem endless, and yet the fonts begin to grind down their users and readers, exhaust them, empty them out, even if language itself is the real victim. There's a reason why an Abu Ghraib torture image—the one of a man with his arms shackled behind him and a pair of women's underwear on his head—appears on the cover of the SADE FOR SADE'S SAKE DVD. (Other Abu Ghraib images appear in a

crude collage on the first page of the disc's PDF user's guide.) Whereas Chan originally conceived the fonts as a way for anyone to make art using a computer and printer, their latest iteration makes them more tormenting, as much of their language spans from the brutal to the submissive.

The art resulting from some of Chan's earlier fonts could be quite beautiful. Over the years, Chan has made prints to accompany the fonts, usually as guides showing which words or icons translate which keyboard stroke. In keeping with the utopian social systems imagined by Fourier, Chan's prints derived from this font include not only words and phrases from Fourier's writings but also delicate lines of linkage that conjure the cooperative communities Fourier termed "phalanxes." A font derived from the writings of Agnes Martin consists entirely of gridded lines. For his Sade project, Chan produced a much less modest set of guides for the accompanying fonts. On large sheets of framed paper (91 x 58 3/4 in.), he used messy brushstrokes, drips of ink, and blacked-out errors to map his translations: for instance, from the Book of Romans: a = being, b = the slave, c = delicious, d = in god, e = O, etc. He then leaned these pieces against the wall and wedged a matching shoe under each bottom corner.

The resulting works are both expressive and mute—howls of desire bordering on despair that also stand there frontally and dumbly. There's an indomitable squatness about them that augments their physical presence. If earlier prints derived from Chan's fonts invoke a drawing hand, these large pieces con-

PAUL CHAN, OH VAN DARKHOLME, 2009,
detail, ink on paper, 24 x19" /
Detail, Tinte auf Papier, 61 x 48,3 cm.

proposed for earlier fonts. The large works on paper also emphasize how far this series has traveled from Chan's idealistic vision of his fonts as having the potential to turn everyone into an artist, although a computer set up at Greene Naftali allowed visitors to play around with them. Chan's Sade project as a whole reveals a similar trajectory. If portrayals of power—frequently eroticized—in Chan's art had always balanced on the cusp between liberation and domination, freedom and repression, this Sadean body of work threatens to tip from power to force: the brute exertion of will; the absolute stripping of movement, rights, and resistance; a reduction to the barest elements of human life to the point that it takes an effort to describe them as human. At times, his multicomponent Sade project feels like a dark impasse; in other ways it resembles a bridge, as Chan's previous work has served in relation to it.

note a human figure without limbs or head. They're acephalic in their loss of rationality; or, conversely, they're all mouth. Despite their extensive emoting, there's very little indication of a developed interiority. They approximate life-size, which means that their accompanying letters and words are literally inscribed on their bodies; they aren't separate from the language they speak and—more hauntingly—that speaks them. This is why their blurring of the boundaries between submission and pleasure should be read politically as much as sexually, if not more so. Chan's engagement with Sade has resulted in a relatively desolate vision of global politics that marks a departure from the utopian streak in his earlier work. Whereas before, desire was a liberatory force in Chan's art, in his current project it represents a partially complicit submission to domination and authority.

In fact, it would be tempting to approach Chan's Sade project as a political allegory were it not so literally obsessed with sex, and if desire in Chan's work didn't still have the potential to get its subjects out of the same mess into which it leads them. Again, this is quite different from the positive interactivity

1) Shari Frilot, "Let's Talk about Sex: Paul Chan in conversation with Jeffrey Schnapp," *Making Worlds Conversations* (June 5, 2009): http://makingworldsconversations.blogspot.com/2009/06/lets-talk-about-sex-paul-chan-in.html
2) Ibid.
3) Paul Chan, "Paul Chan Interview" (interview with Ed Marszewski), *Proximity: Contemporary Art and Culture*, No. 1 (May 8, 2009): http://proximitymagazine.com/2009/05/paul-chan/
4) Paul Chan, "Sex and the New Way V.1," *Manifesto Pamphlet*, ed. Nicola Lees (London: Serpentine Gallery, 2008), p. 19.
5) Roland Barthes, *Sade, Fourier, Loyola*, trans. Richard Miller (New York: Hill & Wang, 1976), p. 35. Barthes includes a footnote after the word "said." "The crime has exactly the same dimension as the word: when the storytellers reach the murderous passions, the harem will be depopulated."
6) Paul Chan (2006–2007) "Alternumerics V.4," National Philistine website, www.nationalphilistine.com/alternumerics/index.html

PAUL CHAN, THE BODY OF OH MONICA, 2008, ink, paper,
mixed media, 84 x 54" / DER KÖRPER VON OH MONICA,
Tinte, Papier, verschiedene Materialien, 213,4 x 137,2 cm.

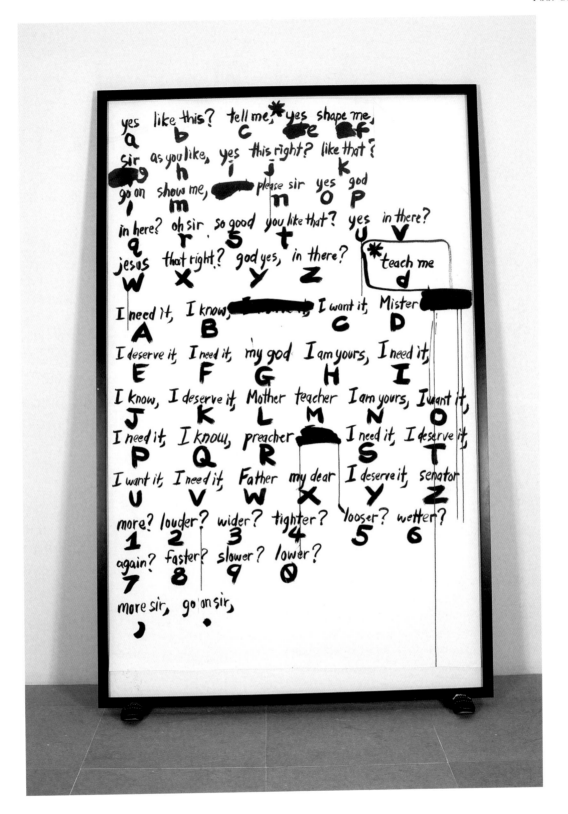

101

Paul Chan

ALAN GILBERT

Auf den Leib geschrieben

Sexbesessenheit ist eine einsame Sucht. Die Macht ihrer Bedürfnisse wird nur vom inneren Abgrund überboten, in den man allenfalls dabei blickt. Im Gegensatz dazu, ist die Macht des erotischen Begehrens mit einem gegenseitigen Geben und Nehmen zwischen einem realen oder imaginären Gegenüber verbunden. Gründlicher als jeder andere Autor oder Künstler in der Geschichte hat vermutlich Marquis de Sade die sexuellen Obsessionen untersucht, und der Antrieb für seine Untersuchung war Einsamkeit. Paul Chan startete sein Sade-Projekt 2003, aber es begann erst im Herbst 2007 ernsthafte Formen anzunehmen, als er in New Orleans an seiner bemerkenswerten Inszenierung von Samuel Becketts *Warten auf Godot* im öffentlichen Raum arbeitete – in dem vom Hurrikan Katrina besonders stark betroffenen Stadtteil Lower Ninth Ward. Vielleicht musste Chan

ALAN GILBERT ist Autor des Gedichtbands *Late in the Antenna Fields* (Futurepoem) und der Essaysammlung *Another Future: Poetry and Art in a Postmodern Twilight* (Wesleyan University Press). Er lebt in Brooklyn, N.Y.

Paul Chans Sade-Projekt

einfach eine wirklich einsame Sade'sche Kernzone schaffen inmitten der intensiven Zusammenarbeit, die für diese Produktion in New Orleans erforderlich war – mit den Stadtbehörden, mit lokalen Künstlergruppen, mit dem Classical Theater of Harlem, mit Universitätsprogrammen, mit der Sponsoring-Organisation Creative Time, und so weiter. Er begann mit Tuschzeichnungen, die zum grossen Teil explizit sexuell waren, deren Figürlichkeit sich aber im Lauf der Zeit zunehmend verflüchtigte. Die Zeichnungen sind weniger Illustrationen von Szenen aus Sades Schriften als Bilder, in denen Begehren und Beherrschung ineinanderfliessen.

Teile von Chans Sade-Projekt waren im Frühjahr 2009 in der Renaissance Society an der University of Chicago ausgestellt (unter dem Titel «My laws are my whores» / Meine Gesetze sind meine Huren) – und Ende 2009 in der Greene Naftali Gallery in New York («Sade for Sade's sake» / Sade um Sades willen). Eine 5 Stunden und 40 Minuten lange grossformatige digitale Videoprojektion, die ebenfalls den Titel SADE FOR SADE'S SAKE trug, wurde erstmals 2009 an der Biennale in Venedig gezeigt. Das Projekt als Ganzes war jedoch sehr viel mehr als nur eine Galerie-Ausstellung und umfasste mehr Arbeiten, als an einem Ort gezeigt werden konnte, darunter Hunderte von Zeichnungen. Es gehörten auch öffentliche Veranstaltungen dazu, etwa ein dreitägiges Seminar in New York im September 2008, im Rahmen von Anton Vidokles Abendkurs im New Museum for Contemporary Art (NIGHT SCHOOL: A PROJECT BY ANTON VIDOKLE, 2008–2009), sowie eine CD-Rom, SADE FOR FONTS SAKE (Sade um der Schriften willen, 2008–2009), mit auf jedem Computer installierbaren und verwendbaren Schriftsätzen, die etwas anders als gewohnt funktionieren (erhältlich auf der National-Philistine-Website des Künstlers, www.nationalphilistine.com, und bei Amazon.com).

Der Sex bei Sade verfolgt einen harten Kurs: exakt orchestrierte Kopulationen; abrupte Wechsel zwischen erotischen Szenarien; Leiber, die nie, wirklich nie Wärme oder Zärtlichkeit ausstrahlen; eine kalte Beweislogik, die keinen Widerspruch duldet. Sades eigentlicher Traum als Schriftsteller war es, ein erfolgreicher Dramatiker zu sein, und die Manipulation von Leibern ist in seinem Werk (und Leben) allgegenwärtig. Hinter Chans Sade-Projekt steckt ein ähnlicher Impuls: Im Video SADE FOR SADE'S SAKE, in den Computerschriften, die eingetippte Wörter in aus diversen Quellen übernommene Textfragmente übersetzen, in einer Reihe grossformatiger Werke auf Papier, in denen Teile dieser Texte in schwarzer Tusche gemalt auftauchen, im Auszug aus Pier Paolo Pasolinis Film *Salò oder Die 120 Tage von Sodom* (1975), den Chan an der Abendschule zeigte – in fast allen Werken werden die Menschen von Kräften beherrscht, die viel stärker sind als sie, und Kontrolle ist etwas, was weit über die Ausübung individueller Macht hinausgeht. War Abu Ghraib nur das Werk der Verkommenheit einiger weniger, die ihre Männerbundphantasien auslebten, oder deutet es auf eine strukturell bedingte, systematische Missachtung der Menschenrechte hin, als direkte Folge der stillschweigenden Duldung von Folterpraktiken, die während der Bush-Administration im Weissen Haus um sich griff?

Dennoch findet sich in den Hunderten figürlichen und abstrakten Zeichnungen Chans auch eine Spur Freiheit, vielleicht weil die körperlichen Impulse von menschlicher Hand aufgezeichnet wur-

Left: PAUL CHAN, BARELY LEGAL 2, 2009, ink on paper, 17 x 14" / NICHT GANZ LEGAL, Tinte auf Papier, 43,2 x 35,6 cm.

Right: PAUL CHAN, 3 LINES OF CREDIT FOR AT LEAST 2 YEARS, 2009, detail, ink on paper, 17 x 14" / 3 KREDITRAHMEN FÜR MINDESTENS 2 JAHRE, Detail, Tinte auf Papier, 43,2 x 35,6 cm.

*Left: PAUL CHAN, 2 LINES OF CREDIT FOR
AT LEAST 5 YEARS, 2009, detail, ink on
paper, 19 x 24" / 2 KREDITRAHMEN
FÜR MINDESTENS 5 JAHRE, Detail,
Tinte auf Papier, 48,3 x 61 cm.*

*Right: PAUL CHAN, PENCIL REGIONS 2,
2009, detail, ink on paper, 17 x 14" /
BLEISTIFTREGIONEN 2, Detail, Tinte auf
Papier, 43,2 x 35,6 cm.*

den. Die Pinselstriche sind mehr als fingerbreit. Die Einzel- und Gruppenfiguren in den Zeichnungen bestehen aus Ovalen und länglichen Schleifen; die Gelenke, welche die einzelnen Körperteile verbinden, sind gewöhnlich als kleine Kreise wiedergegeben. Die Umrisse der Körper sind nicht eindeutig. Oft sind die Umrisslinien kaum von denen zu unterscheiden, welche die einzelnen Figuren miteinander verbinden; tatsächlich sind es häufig dieselben. Dichte Nester von Pinselstrichen verhüllen die Genitalien und andere erogene Zonen; im Verlauf der Zeichenserie breiten sich diese Wirbel immer stärker über das ganze Bild aus. In Sades Romanen werden die Einzelheiten immer knusprig geschildert; sein *Die 120 Tage von Sodom* wurde oft mit einer perversen Enzyklopädie der Aufklärung verglichen, in der jeder denkbare Geschlechtsakt verzeichnet ist. Chans Video SADE FOR SADE'S SAKE mag teilweise tatsächlich so funktionieren, aber die Zeichnungen sind eine andere Geschichte. In ihnen steckt noch ein letzter Funke – so schwach er auch sein mag – jener Sehnsucht nach Freiheit, die in früheren Arbeiten Chans häufig im Zentrum stand.

Ausserdem sind die Körper selten ausgefüllt, da die Zeichnungen fast ausschliesslich aus verschlungenen Kurvenlinien bestehen. Die Gesichter sind undeutlich; manche Zeichnungen bestehen lediglich aus Gliedern und Torsi – wenige sogar nur aus Genitalien. Ähnlich wie Sades Romanfiguren haben die Figuren in Chans Zeichnungen kein Innenleben. Sie durchlaufen Bewegungen, die nicht wirklich ihre

eigenen sind. Die Umrisszeichnungen lassen die Innenräume leer oder weisen Spuren eines unpersönlichen Begehrens auf, das sie durchdringt und wohl eher ein Bedürfnis oder sogar eine Gewalt darstellt. Es handelt sich um entleerte Körper und Subjekte. Umgekehrt zeigten bei Greene Naftali drei Zeichnungen von Gesichtern, deren Profile miteinander verbunden waren, offene, mit schwarzer Tusche ausgefüllte Münder: Individuen, die sprechen möchten, oder vielleicht sogar ein Chor, doch die Worte oder der Gesang sind von einer Dunkelheit verschluckt worden. Diese verschluckten Worte sind vielleicht der Text, den Chans überarbeitete Computerschriften ausspucken. (Sie waren damals im gleichen Raum mit den grossen Text-auf-Papier-Arbeiten ausgestellt.) Oder aber die Münder sind lediglich passive Auffanggefässe.

Chan wollte die Körper im Video SADE FOR SADE'S SAKE mit Ausnahme der Umrisse transparent werden lassen, stellte jedoch fest, dass dies visuell nicht funktionierte. Stattdessen nehmen sie nun die Form zittriger schwarzer Schattenrisse an. (Einige Kritiker haben auf die Parallelen zu Kara Walkers Arbeiten hingewiesen.) Chan hat seine Liebe zur Poesie explizit angesprochen und auch in seiner Kunst zum Ausdruck gebracht (beispielsweise in seinem UNTITLED VIDEO ON LYNNE STEWART AND HER CONVICTION, THE LAW AND POETRY [Video ohne Titel über Lynne Stewart und ihre Verurteilung, das Gesetz und die Dichtung, 2006]). Diese Anziehungskraft der Poesie mag eher auf der Form als dem Inhalt beruhen:

PAUL CHAN, 40 MINUTE PANTY PEOPLE 2, 2009, ink on paper, 28 x 39 ¹/₂" /
40 MINUTEN HÖSCHEN LEUTE, Tinte auf Papier, 71,1 x 100,3 cm.

auf ihrer Mehrdeutigkeit und Unfassbarkeit, ihren rhythmischen Mustern, ihrer Verwurzelung im graphischen Zeichen und ihren Strategien der Wiederholung. Im Zusammenhang mit der Biennale in Venedig 2009 wird Chan wie folgt zitiert: «Die Poesie mit ihren Rhythmen, Wiederholungen und ihrer Kadenz ruft in Körper und Geist ein Gefühl hervor, das fast etwas Sexuelles hat.»[1] Und tatsächlich ist die Struktur von SADE FOR SADE'S SAKE von der Balladenform abgeleitet. Jede Szene in dem fast sechsstündigen Video dauert 45 Sekunden. Die Szenen sind in vierzeiligen «Strophen» mit einem abcb-«Reimschema» angeordnet; wenn die erste «b»-Szene drei Figuren umfasst, hat das zweite «b» ebenfalls drei Figuren, jedoch in anderer Anordnung. Formal gesehen handelt es sich um ein auf die Spitze getriebenes strukturalistisches Filmkonzept.

In Venedig projizierte Chan SADE FOR SADE'S SAKE auf eine lange Backsteinwand; bei Greene Naftali wurde es an einer grossen Wand mit Rohren und abgedeckten Fenstern gezeigt, die – einschliesslich der in der Nähe befindlichen Säulen – weiss gestrichen waren. (Eine wesentlich kleinere und kürzere Version von nur fünfeinhalb Minuten war in der Renaissance Society zu sehen, sie trug den Titel UNTITLED [AFTER A CERTAIN CHATEAU]/Ohne Titel [nach einem gewissen Schloss]). Wie bereits erwähnt, findet im Lauf der Projektion der Endlosschlaufe praktisch jeder vorstellbare Geschlechtsakt mit unterschiedlich vielen Beteiligten statt, aber es gibt auch einsame Figuren und sehr viel Masturbation. Wegen der bewusst niedrigen Auflösung und der verpixelten Bildqualität sind diese Begegnungen jedoch nicht wirklich explizit – und alles andere als erregend. Es wird zwar heftig gestossen und gerieben, aber wie in den Zeichnungen bleiben diverse Körperteile, besonders die intimen, häufig verborgen oder ausgespart. Erigierte Glieder wirken wie zuckende Schatten. Extremitäten und vor allem Köpfe lösen sich von den Rümpfen, Sex verdunkelt sich zu Gewalt. Die relative Kürze der Szenen bedeutet, dass die Figuren meist in ihren Rollen und Positionen ge-

PAUL CHAN, *untitled, source material /*
Ohne Titel, Quellenmaterial.

fangen bleiben, während ihre Leiber von erotischen – oder panischen – Krämpfen geschüttelt werden.

Durch das gesamte Video hindurch treiben feste geometrische Körper in verschiedenen Farben um die Figuren herum und schieben sich ebenfalls verhüllend vor sie. Laut Chan stehen diese abstrakten Formen für «Quellen der Sinnenfreude, die es an den Wänden des Schlosses gegeben haben muss – von der Sonne erhellte Fenster und Kunstwerke an den Wänden –, die jedoch in Sades Originaltext nicht erwähnt werden».[2] In Chans Video bieten die buntfarbigen Blöcke etwas Erholung von dem unaufhörlichen Sex. Sie führen jedoch nicht nach draussen und die Quadrate und Rechtecke sind häufig in einem alles Licht schluckenden Schwarz gehalten. Ähnliche monochrome Blöcke tauchen in Chans Werk wiederholt auf, häufig als Verweis auf die Poesie. In UNTITLED VIDEO ON LYNNE STEWART AND HER CONVICTION, THE LAW AND POETRY ist die Bildfläche in Farbe getaucht, während Stewart Gedichte liest, die ihr viel bedeuten. Farbfelder erfüllen MY BIRDS... TRASH... THE FUTURE (Meine Vögel... Müll... Die Zukunft, 2004) und zeigen zugleich eine Unterbrechung der Handlung und eine andere Form der Darstellung an. Bei Chan muss das Grauen ausgesprochen (und sichtbar) werden, während das Unaussprechliche der Schönheit am nächsten kommt. In Kunst und Dichtung ist es häufig umgekehrt.

Abstrakte geometrische Formen sind natürlich auch Produkte der modernen Kunst und ihrer Verflechtung von aufklärerischen und anti-aufklärerischen Tendenzen. In einem Interview für die Zeitschrift *Proximity* in Chicago hat Chan diese Verflechtung gegensätzlicher Tendenzen angesprochen: «Mir scheint die Zeit gekommen, das Vermächtnis des Marquis de Sade erneut gründlich unter die Lupe zu nehmen und eine Vorstellung davon zu gewinnen, was diese Verknüpfungen für uns heute bedeuten. Die Verknüpfungen zwischen Sex, Gewalt, Freiheit und Gesetz oder Vernunft.»[3] Chans Beitrag zu Hans Ulrich Obrists Publikation zum Serpentine Gallery Manifesto Marathon 2008 trägt den Titel «Sex and the New Way V.1» und sieht einem Gedicht sehr ähnlich. Darin schreibt er: «Was sollen wir also sagen? Ist das Gesetz / Sex? Himmel, nein. Aber ich hätte nichts / über Sex erfahren ohne Gesetz.»[4] Das Gesetz ist nicht Sex, weil das Gesetz durch Abhandlungen, Institutionen und Praktiken in Umlauf gebracht und erlassen wird, die unter anderem auch dem Sex eine Form geben und ihn regulieren wollen. Die Sprache ist das Gesetz und Sex ist der Sprache nicht immer zugetan, selbst wenn – wie Chans Gedicht zeigt – der einzige Weg zum Sex über die Sprache führt. In seiner Abhandlung über Sades Werk in *Sade, Fourier, Loyola* schreibt Roland Barthes: « ... die Praxis folgt dem Sprechen und erhält von ihm ihre Bestimmung: Was man tut, ist bereits gesagt worden. Ohne das formgebende Sprechen könnten kein Laster und kein Verbrechen ausgedacht und ausgeführt werden ...»[5]

In diesem Sinn ist Chans Kunst, seit sie sich mit Sex beschäftigt, auch an Sprache interessiert. In welchem Mass befreit beziehungsweise unterdrückt Sprache? Bei Sade tut sie beides zugleich. Dasselbe gilt für Chans diverse Schriftprojekte, mit denen er sich nunmehr fast zehn Jahre lang beschäftigt hat. In früheren Versionen war die Sprache auf der Seite der Emanzipation. Die ersten Schriften, die Chan schuf, stützten sich auf Texte und Bilder der Black-Panther-Bewegung, von ACT UP und Charles Fourier. (Sie sind auf seiner National-Philistine-Website zu finden.) Folgt man einer parallel verlaufenden Spur durch Chans Werk, von HAPPINESS (FINALLY) AFTER 35,000 YEARS OF CIVILIZATION (Glückseligkeit [end-

lich] nach 35000 Jahren Zivilisation) bis zum Video SADE FOR SADE'S SAKE, so zeigt sich, dass die neuen Schriften eine sehr viel trostlosere Sicht vermitteln. Inszeniert Chan ein ideologisches Endspiel, das darauf abzielt, seine frühere Neigung, Kunst und Politik klar zu trennen, in eine düstere und verworrene Antikunst und Antipolitik umkippen zu lassen? Oder signalisiert sein Sade-Projekt die endgültige orgiastische Auflösung der Bush/Cheney-Regierung? Anders als Chans frühere Galerie- und Museumsausstellungen und seine Inszenierung WAITING FOR GODOT (2007), die allgemein auf Begeisterung stiessen, hat das Sade-Projekt jedenfalls eher so etwas wie produktives Unbehagen ausgelöst. Und das scheint durchaus Chans Absicht zu entsprechen.

Das Sade-Projekt umfasst einundzwanzig Schriften aus so unterschiedlichen Quellen wie George W. Bush, dem Römerbrief, Richard von Krafft-Ebing, dem Geschlechtsforscher des 19. Jahrhunderts, Monica Lewinsky, dem schwulen Pornostar Michael Lucas, Maria Magdalena, Gertrude Stein, diversen Figuren aus Sades Romanen, und anderen. (18 Schriftsätze können gratis von Chans Website heruntergeladen werden.) Auf einem Computer installiert kann man sie wie Arial oder Times New Roman zum Tippen eines Textes verwenden. Wähle ich beispielsweise die von den Aussagen des Duc de Blangis in Sades *Die 120 Tage von Sodom* abgeleitete Schriftart, um den vorangegangenen Satz zu tippen, ergibt das folgenden Text:

Bite my slit and hole and fuck your mouth, suck your crack and ass and hole and rub your pussy, wet pungent pussy, wet suck your crack and knee and hole and hit that, fuck your slit and hit your crack and hole and ass and hit your crack and rub your cock and hit your nose and cum, eat your hole and fuck your mouth, laugh, hole and hit that, fuck your ear and cock and rub your crack and mound, fuck your eat your ass and fuck your armpit, tits and eat your ass and hole and pussy, wet suck your balls and fuck your Bite my mouth, suck your rub your pussy, wet hit your mouth, Now I suck your nose and fuck your ass and laugh, fuck your lips and Robot, hit your nose and rub your crack and hole and hit your hole and ear and cum, fuck your rub your crack and ear and hole and fuck your feet, hole and you know what.

Zeilenumbrüche sind miteingeschlossen. Das ist vielleicht die graphischste der 21 Schrifttypen. Derselbe Satz unter Verwendung von Text des Dichters Friedrich Hölderlin sieht so aus:

Me a student, visible as like a tutor, I am a whore, sublime, visible as I am thunder, … thunder, I am a whore, supple, visible as moonlight, like a student, as a whore, visible as sublime, as a whore, I am a nurse, as a trick, lightning, become visible as like a tutor, a turning, visible as moonlight, like a mother, a nurse, I am a whore, restrained as like become sublime, like a virgin, a music, become sublime, visible as thunder, I am a horse, like Me a tutor, I am I am thunder, as a tutor, Cum now I am a trick, like sublime, For you, like a dolphin, For you, as a trick, I am a whore, visible as as visible as a mother, lightning, like I am a whore, a mother, visible as like passive as visible as a gift.

Wie die beiden Beispiele zeigen, hat Chan jedem Gross- und Kleinbuchstaben und jedem Satzzeichen (sowie jeder Zahl und jedem Sonderzeichen) jeweils ein bestimmtes Wort oder eine Wendung als Übersetzung zugewiesen. Offensichtlich bieten Chans Schriftarten eine Menge Raum zum Spielen und Experimentieren, die Tonlage wechselt dabei von subtil erotisch bis zu knallhart pornographisch – ganz ähnlich wie beim Sex. Und doch tut es geradezu körperlich weh, wenn der Anwender zuschauen muss, wie seine oder ihre Worte der Kontrolle eines anderen unterliegen, in diesem Falle Chans. In einer frühen

PAUL CHAN, MY BIRDS... TRASH... THE FUTURE, 2004, digital video installation, wooden screen, 16 min. 36 sec. / MEINE VÖGEL ... ABFALL ... DIE ZUKUNFT, digitale Videoprojektion, hölzerne Projektionsfläche, 16 Min. 36 Sek.

Erläuterung der Schriften schreibt Chan (auf seiner Website): «Ich wollte, dass die Sprache für mich funktioniert und für niemanden sonst.»[6] So wie das frühere HAPPINESS (FINALLY) AFTER 35,000 YEARS OF CIVILIZATION eine sadistische Komponente hatte, zeigt auch diese anfängliche Erläuterung der Schriften einen sadistischen Zug.

Benutzt man die Schriften zum ersten Mal, reagiert man zunächst schockiert und ungläubig, dann ist man kurz verwirrt und stockt, da anstelle der eingetippten Lettern plötzlich vollkommen andere Worte und Wendungen erscheinen. Doch an einem bestimmten Punkt fügt sich der Anwender diesem Prozess und die Überraschung und Unsicherheit darüber, was der Text als nächstes zutage fördert, beginnt ihm Spass zu machen. Und dann setzt der Zwang ein. Wie im Video SADE FOR SADE'S SAKE erscheinen die Möglichkeiten zunächst unendlich, und doch beginnt die Schrift ihre Anwender und Leser zu unterdrücken, sie fühlen sich erschöpft und

leer, obwohl eigentlich die Sprache selbst das Opfer ist. Nicht umsonst zeigt das Cover der DVD SADE FOR FONTS SAKE eine Abu-Ghraib-Folterszene – jene des Mannes mit hinter dem Rücken gefesselten Armen und Damenunterwäsche auf dem Kopf. (Weitere Bilder aus Abu Ghraib sind in Form einer kruden Collage auf der ersten Seite der pdf-Gebrauchsanleitung zur CD abgebildet.) Während Chan die Schriften ursprünglich als Instrument entwickelt hatte, mit dem jeder und jede mithilfe eines Computers und eines Druckers Kunst machen konnte, werden sie in ihrer letzten Weiterentwicklung quälender, da ihre Sprache sich vorwiegend im Spektrum zwischen brutal und devot bewegt.

Passend zu den von Fourier erdachten utopischen Gesellschaftssystemen, enthalten Chans Drucke zum entsprechenden Schriftsatz nicht nur Worte und Wendungen aus Fouriers Schriften, sondern auch feine Verbindungslinien, die an jene kooperativen Gemeinschaften erinnern, die Fourier Phalan-

sterium (aus «Phalanx» und «Monasterium», frz. phalanstère) nannte. Ein aus den Schriften von Agnes Martin abgeleiteter Schrifttypus besteht ausschliesslich aus Rasterlinien. Für sein Sade-Projekt schuf Chan eine viel weniger bescheidene Sammlung von Anweisungen für die begleitenden Schrifttypen: Auf grossen gerahmten Papierbögen (ca. 231 x 149 cm) skizzierte er seine Übersetzungen mit chaotischen Pinselstrichen, tropfender Tusche und durchgestrichenen Fehlern: etwa aus den Römerbriefen: «a» = «being»; «b» = «the slave»; «c» = «delicious»; «d» = «in god»; «e» = «O» und so weiter. Dann lehnte er die Arbeiten gegen die Wand und klemmte unter jede untere Ecke jeweils einen Schuh eines zusammengehörenden Paars.

Die so entstandenen Werke sind ausdrucksstark und stumm zugleich – Schreie des Begehrens, die an Verzweiflung grenzen, aber zugleich frontal und dumm dastehen. Sie haben etwas unbezwingbar Gedrungenes, das ihre physische Präsenz verstärkt. Während frühere Druckgraphiken zu Chans Schriften die zeichnende Hand in Erinnerung rufen, denkt man bei diesen grossen Blättern unweigerlich an eine menschliche Figur ohne Kopf und Glieder. Sie sind kopflos durch ihren Vernunftverlust; oder umgekehrt, sie sind ganz Mund. Trotz ihrer erheblichen Dramatik gibt es kaum Anzeichen einer differenzierten Innerlichkeit. Sie sind ungefähr lebensgross, das heisst, die sie begleitenden Lettern und Worte sind ihnen buchstäblich auf den Leib geschrieben; sie unterscheiden sich nicht von der Sprache, die sie sprechen und – was noch beängstigender wirkt – die sie zum Ausdruck bringt. Deshalb sollte ihre Verwischung der Grenzen zwischen Unterwerfung und Lust mindestens ebenso sehr politisch wie sexuell verstanden werden. Chans Auseinandersetzung mit Sade mündet in eine ziemlich trostlose Sicht der Weltpolitik, die sich deutlich vom utopischen Charakter seines früheren Werks abhebt. Während das Begehren in Chans Kunst früher eine befreiende Kraft war, steht es in seinem aktuellen Projekt für eine zum Teil bereitwillige Unterwerfung unter Herrschaft und Autorität.

Tatsächlich wäre es verlockend, Chans Sade-Projekt als politische Allegorie aufzufassen, wäre es nicht dermassen buchstäblich sexbesessen und hätte

das Begehren in Chans Werk nicht immer noch das Potenzial, seine Subjekte aus demselben Schlamassel zu befreien, in den es sie stürzt. Noch einmal, dies ist etwas ganz anderes als die positive Interaktivität, die mit den früheren Schriften verbunden ist. Die grossformatigen Werke auf Papier unterstreichen auch, wie weit sich diese Serie von Chans idealistischer Auffassung seiner Schriften entfernt hat, wonach sie jeden in einen Künstler verwandeln konnten, obwohl ein bei Greene Naftali aufgestellter Computer den Besucherinnen und Besuchern immer noch gestattete, mit den Schriften herumzuspielen. Chans Projekt als Ganzes zeigt eine ähnliche Entwicklung. Während Darstellungen der Macht sich in Chans Kunst bisher – oft in erotisierter Form – auf dem Grat zwischen Befreiung und Herrschaft, Freiheit und Unterdrückung bewegten, droht dieser Sade'sche Werkkomplex von Macht in Gewalt umzukippen: in die rohe Durchsetzung des Willens; das absolute Abstreifen jeder Bewegung, jedes Rechts und Widerstands; eine Reduktion auf die krudesten Elemente menschlichen Lebens bis zu dem Punkt, wo es schwerfällt, sie noch als menschlich zu bezeichnen. Manchmal fühlt sich sein mehrteiliges Sade-Projekt an wie eine dunkle Sackgasse; dann wieder gleicht es einer Brücke, so wie Chans früheres Werk die Brücke war, die hierher führte.

(Übersetzung: Suzanne Schmidt)

1) Shari Frilot, «Let's Talk about Sex: Paul Chan in conversation with Jeffery Schnapp.» *Making Worlds Conversations*, Blog (5. Juni, 2009), siehe http://makingworldsconversations.blogspot.com/2009/06/lets-talk-about-sex-paul-chan-in.html. (Zitat aus dem Engl. übers.)
2) Ebenda.
3) Paul Chan, «Paul Chan Interview» (Interview mit Ed Marszewski), *Proximity: Contemporary Art and Culture*, Nr. 1 (8. Mai 2009), siehe http://proximitymagazine.com/2009/05/paul-chan/. (Zitat aus dem Engl. übers.)
4) Paul Chan, «Sex and the New Way V.1», in: *Manifesto Pamphlet*, hg. v. Nicola Lees, Serpentine Gallery, London 2008, S. 19. (Zitat aus dem Engl. übers.)
5) Roland Barthes, *Sade, Fourier, Loyola*, übers. v. Maren Sell und Jürgen Hoch, Suhrkamp, Frankfurt am Main 1986 (1974), S. 43.
6) Paul Chan (2006–2007) «Alternumerics V.4», National Philistine website, www.nationalphilistine.com/alternumerics/index.html

EDITION FOR PARKETT 88

PAUL CHAN

THE LIBERTINE READER, 2011

Silkscreen on natural woven rayon cloth, with foil stamping,
on wooden frame, 25 x 16 $^1/_2$ x $^3/_4$".
Printed by Atelier für Siebdruck, Lorenz Boegli, Zurich
Ed. 35 / XX, signed and numbered certificate.

Siebdruck auf natürlich gewebtem Rayon-Leinen, mit Folienprägung,
auf Holzrahmen, 63,5 x 42 x 1,9 cm.
Gedruckt bei Atelier für Siebdruck, Lorenz Boegli, Zürich.
Auflage 35 / XX, signiertes und nummeriertes Zertifikat.

1930

The Times
in Review

1939

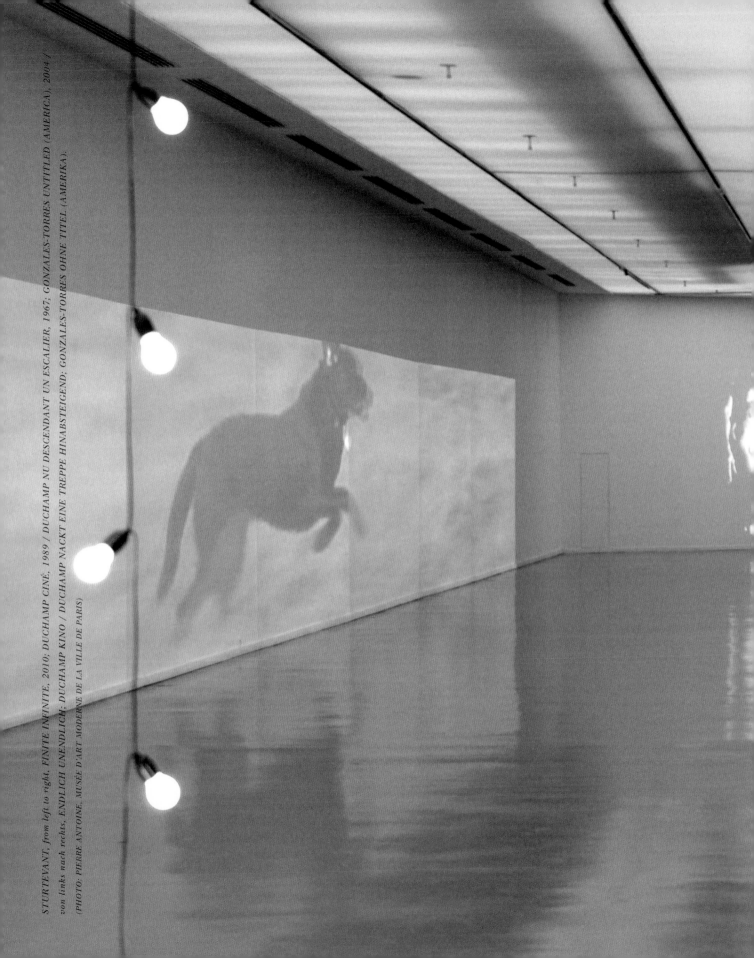

STURTEVANT, *from left to right*, FINITE INFINITE, 2010; DUCHAMP CINÉ, 1989 / DUCHAMP NU DESCENDANT UN ESCALIER, 1967; GONZALES-TORRES UNTITLED (AMERICA), 2004 / *von links nach rechts*, ENDLICH UNENDLICH; DUCHAMP KINO / DUCHAMP NACKT EINE TREPPE HINABSTEIGEND; GONZALES-TORRES OHNE TITEL (AMERIKA).

(PHOTO: PIERRE ANTOINE, MUSÉE D'ART MODERNE DE LA VILLE DE PARIS)

Sturtevant

The Silent Power of Art

On the occasion of Sturtevant's recent exhibition, "The Razzle Dazzle of Thinking," at the Musée d'Art Moderne de la Ville de Paris, a reviewer from the French newspaper, *Libération*, wrote:

A pioneer of the "appropriationist" trend, the artist asserts facsimile as artistic process. She confuses replicating with copying, which are two distinct notions: a replica is realized by the artist him- or herself. In music or literature, such a debate would be unimaginable: a plagiarist who reproduced a score note for note, or a book word for word, and then affixed his/her name to it would be covered in shame. But in the visual arts, legitimacy is acquired through obscurity of discourse. What is fundamentally at stake is aesthetics. One must see these copies to realize just how ugly they are: crudely made, with mediocre materials, gloomy colors, all the life having run out of them. Parody is

STÉPHANIE MOISDON is a French curator and art critic. She is Editor-in-Chief of *Frog* magazine, and heads the Masters Program in Fine Art at the École cantonale d'art de Lausanne (ECAL).

STÉPHANIE MOISDON

a gesture that might have had meaning in the 1960s. But just as spluttering does not make a story, posturing does not make art, and imposture even less.[1]

Even if we set aside the nauseating ideological climate into which France is sinking little by little (tainted by an anti-intellectualism that harks back to the heyday of Poujadism), and quickly gloss over the logorrhea of the general press, which makes ignorance a rule of thumb, we are struck by the unusual vehemence of such statements, which continue, fifty years later, to slip into the art-critical chasm opened by Sturtevant herself. They convey nothing less than a bankruptcy of information and ideology in the face of language and thought. Sturtevant has already spent half a century elaborating on such distinctions,

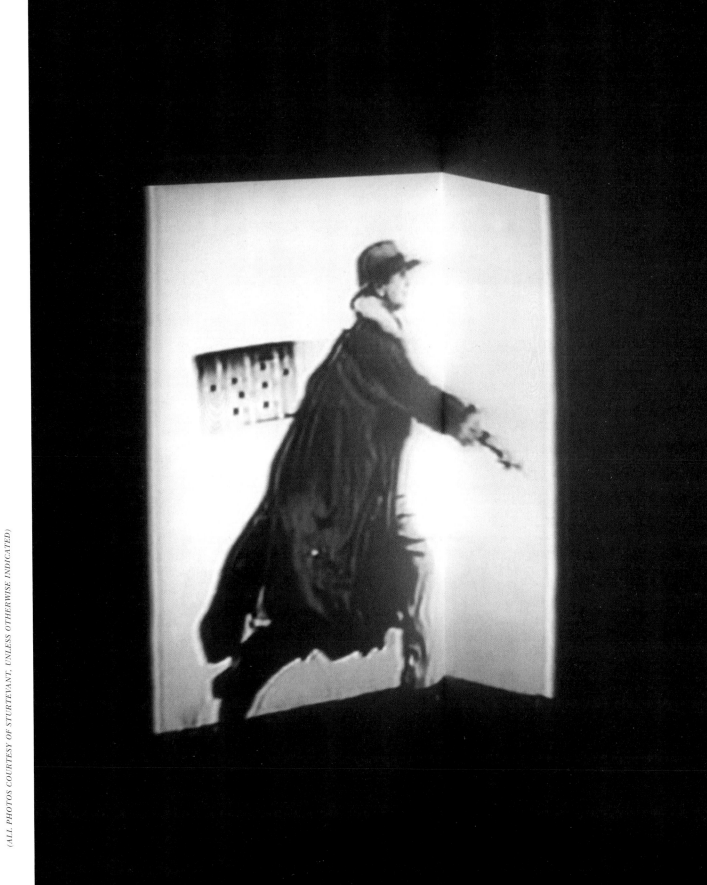

STURTEVANT, DILLINGER RUNNING SERIES 1, 2004, Betacam SP PAL on rotating platform / Beta-Kamera SP PAL auf rotierender Plattform.

(ALL PHOTOS COURTESY OF STURTEVANT, UNLESS OTHERWISE INDICATED)

STURTEVANT, ELASTIC TANGO, 2010, video installation, 3 act video play on 9 monitors / 3-aktiges Videostück auf 9 Monitoren. (PHOTOS: COURTESY ANTHONY REYNOLDS GALLERY, LONDON)

in her linguistic pursuit of the notions of repetition and difference. In this sense, "The Razzle Dazzle of Thinking" was much more than a monograph exhibition; it was the opening of a double-bottomed space—a doubling of language, the artwork, and its replica.

Behind the term "Razzle Dazzle" we glimpse a world on the fringe between illusion and fear, simulacrum and truth, confusion and the loss of content. It speaks, above all, of the power of art, its aura of infinity. Many attentive observers of Sturtevant's work who probably expected a skillful installation in terms of chronology and analogy, may have been thrown off by the complexity of the articulation and then taken in by the radicalism of the form she gives to the whole exhibition and the way it unfolds—especially the lack of concessions she makes to the present. Sturtevant does not engage in synthesis, nor does she lend herself to didacticism. She accepts none of the terms of "use," of the "remake," or "copy." She does not put up with mediation, much less present-day renunciations and populism. Her production is the result of a life of armed struggle against the racism of intelligence.

This exhibition has made it possible to display the subtle concatenations between the artist's present work and her older pieces, thus allowing viewers to make the connection between her famous "replicas" of famous artworks—her renditions of DUCHAMP NU DESCENDENT UN ESCALIER (Duchamp Nude Descending a Staircase, 1968) and DUCHAMP

1200 COAL BAGS (1972); the paintings HARING UNTITLED (1987) and STELLA UNION PACIFIC (1989); the curtain of light-bulbs GONZALEZ-TORRES UNTITLED (AMERICA) (2004)—and such recent video installations as DILLINGER RUNNING SERIES 1 (2000), a circular projection based on the famous American criminal; and FINITE INFINITE (2010), the stunning image, in a loop of several meters, of a dog running at top speed, carried forward by its own mechanical power.

The video installation ELASTIC TANGO (2010), a montage of images of her previous installations, brings to mind one of her more powerful pieces, THE DARK THREAT OF ABSENCE/FRAGMENTED AND SLICED (2002), a reminiscence of the celebrated video by Paul McCarthy, PAINTER (1995), where the great globalized image-factory, replete with images of mutilation, excess, disjunction, transgression, fear, exhaustion, and ecstasy appears blinking on the screens.

So many elements being added to others, either laughable or terrifying, go to make up the finale of this conceptual opera, the retroversible space of the exhibition: a HOUSE OF HORRORS (2010), a ghost-train consisting of clichés and other bats, figures inspired by other contemporary artists (Paul McCarthy, John Waters), and icons of American culture and counterculture from Frankenstein to Divine. In this dead-end freak show, Sturtevant plays with the tricks and codes of the horror genre to turn all the emptiness and attraction into a new chapter of art history.

Out of the Digi-loop

From the very start, Sturtevant's work has snared the rhetoric of postmodernism, for the interpretative grid based on appropriation or post-Duchampian détournement has been proven by this new way of thinking to be totally unsuitable. Her large 2004 retrospective at the MMK in Frankfurt, "The Brutal Truth," did not fail to live up to its title. And the brutal truth about the works in the show is that they are not copies.

Here is a little historical review for those who may not grasp this reality: Elaine Sturtevant pioneered inquiry into the autonomy of art. Starting in the 1960s, her work has consisted of repeating recognized artworks, such as those by Jasper Johns, Andy Warhol, Marcel Duchamp, Joseph Beuys, and Roy Lichtenstein. It is a way to produce difference, to provoke resistance and a critical attitude towards art and its media context. Often erroneously associated with the appropriationist trend of the 1980s, her work fore-shadows and radically distinguishes itself from the reproductive procedures of Sherrie Levine or the political project of desacralization of Mike Bidlo or Philip Taaffe. Standing apart from these practices, her work has developed in parallel with the historicist thought of Michel Foucault and the philosophy of Gilles Deleuze. For several decades now she has concentrated on the power of art and its images, on the principles of cloning; she has prefigured, in a visionary way, the impact of cybernetics and the digital revolution—a revolution which is merely a false promise of subversion and deals the final blows to the handmade replica in order to open the way for the reign of the simulacrum and simultaneous diffusion. But of even greater interest to Sturtevant in

STURTEVANT, ELASTIC TANGO, 2010, video installation, 3 act video play on 9 monitors / 3-aktiges Videostück auf 9 Monitoren.

this digital age are the inversion of values and the hierarchies of reality and its representations. "My pieces," says Sturtevant, "reflect our cyberworld of excess, of fetters, transgression, and dilapidation. In the past, the higher power was that of knowledge, intelligence, and truth. Nowadays, the higher power is hatred and killing, while the mask of truth covers the dangerous power of lies."[2]

Two fundamental figures keep recurring on the central axis of her production: Duchamp and Warhol. If one thing is accepted in art today, it is the possibility of reinterpreting Warhol. But Sturtevant is perhaps the only one to have incorporated Warhol's true logic of things (to the detriment of the logic of meaning): the logic, that is, of the series, the surface, the machine. The circular projection of the DILLINGER RUNNING SERIES is one of the most noteworthy examples of this, and the movement of walking reveals the machine at the center of the space. The videos consist of looped sequences where everything seems given over to reality as a single event. The camera is no more one with the subjectivity of the filming than with the object being filmed. It registers the passage of a body and an object. In Sturtevant's film and video installations, we see to what degree her production of the last ten years surpasses and renews all questions of origin: questions of drive, vision, and method, of the mechanisms of exposure and repetition, and of pornography, of course, which synthesizes all the others.

All these units make up an inside-outside world which, despite the violence depicted, paradoxically prevents adhesion and projection. This prevention, this suspension of enjoyment, pushes the work to the limits of frustration.

The desire to be a machine is only that, a desire. Sturtevant has no faith in technology or productivity. What interests her about machines is not so much their transformative potential as the possibility they offer the artist to remove herself from the "creative process" and, more precisely, to eliminate the motivations of the will: to create mechanically, until the machine has finished running and becomes a pure process of invention and language. For language here plays a determining role, one which resists background noise and inertia with all its biological might.

It's a Wonderful World

A Sturtevant show is always an event that renegotiates the question of representation and sets it in motion. The installation VERTICAL MONAD, first exhibited in 2008 at the Anthony Reynolds Gallery in London and then put back together for her Parisian show, is central to the relationship that Sturtevant maintains between the finite and infinite language of the exhibition; by eliminating the horizon of the object and image world, we get to see its movement and verticality.

In VERTICAL MONAD the viewer must listen to a text read in Latin. It is the opening pages of Spinoza's *Ethics,* which resounds in a space whose monochromatic blue-grey color unifies all the other elements: a vertical monitor on its base, the geometry of the room itself, the light without any visible source, the low ceiling, the color of the carpeting, the color that practically appears to float on the screen, the inflections of the text, the rhythm of the reader's speech, the tone of voice. This arrangement constitutes a precise experience which engenders a new mode of perception between the image of the space—which one might call an "image of synthesis"—and that of the invisible text. The work thus seems to be a veritable machine of power, outside of the networks of power, and inside ourselves.

Faced with the constant and increasing leveling of systems of representation that have become modes of understanding and information, Sturtevant finds ways out—just as the concept of the "monad" in Leibniz, re-read by Deleuze, is a fundamental "way out" in the history of mankind and philosophy.[3] Sturtevant does not assess the situation; she leads a work the way one leads negotiations, always maintaining the point of view that all is not equivalent. The ethics entail the permanent evaluation of values and practices, of forces exerted, and the aim is never to let life, and hence art, depreciate. As Deleuze used to reiterate, the problem is not and has never been to say "this is better" or "this is worse"—that is, "this is good" and "this is bad." Every epoch, every society, has its own procession of horrors as well as its extraordinary creations. In every great unified whole we find units or, more precisely, monads without doors or windows, which make up the whole. We are these doorless, window-

Sturtevant in the exhibition / in der Ausstellung "The Razzle Dazzle of Thinking," Musée d'Art Moderne de la Ville de Paris.

less monads. We are radical singularities, differences linked together by one (or several) strings to the world of other monads. Exchanges with them remain fragile and uninteresting if they are not based, first and foremost, on agreements and on complicities of thought and sensation. Only thus are we able to construct new arrangements between monads and territories, which must inevitably be reorganized for each context. And only thus is VERTICAL MONAD connected to Sturtevant's world, where one can clearly see how the artist perceives each creation and each situation as a unitary, constituent element of a much larger reality.

In 2008, at the Tate Modern, Sturtevant produced a "cyber-opera," called SPINOZA IN LAS VEGAS, about the great founder of an ethics of happiness and freedom and the inventor of rational pantheism who paved the way for political liberalism. As a staged piece, SPINOZA IN LAS VEGAS offered the artist new possibilities to intensify (internal/external) movement, and to create dynamic repetitions, short circuits in the great historical narrative of the spectacle and its avatars. And, as always with Sturtevant, an author and essayist in her own right, the preliminary text must be read and heard, as it gives back to us a living mind and already has the value of performance:

Spinoza is in Las Vegas where he encounters our digi-cool world, which drastically changes his notion of truth, modesty, good and evil; getting into the divine pleasure of desire. His exciting adventures are full of fun and folly: he runs into trouble with the FBI, he meets a transvestite that thinks he is adorable and wants to dress him up or maybe stalk him; gets a crowd into a rave; escapes from what seems like hell and almost dies in the desert; he is saved by the Virgin Mary disguised as a young innocent girl and makes out; and confronts an in-your-face God, disguised as Prada. There is a chorus line of teeny-boppers, rappers; songs and dance; a prompter that encourages audience participation, a karaoke with its bouncing ball to sing-along: It's a Wonderful World.[4]

(Translation: Stephen Sartarelli)

1) Vincent Noce, *Libération*, April 23, 2010.
2) From Sturtevant's written text for the "Raw Power" show at the Thaddaeus Ropac gallery, Paris, March–April 2007.
3) Gilles Deleuze, *The Fold, Leibniz and the Baroque* (Minneapolis: University of Minnesota Press, 1992).
4) Sturtevant, *The Razzle Dazzle of Thinking* (Zürich/Paris, JRP Ringer, 2010), p. 225.

Die stille Macht der Kunst

STÉPHANIE MOISDON

Zur jüngsten Ausstellung von Sturtevant im Musée d'art moderne de la Ville de Paris, «The Razzle Dazzle of Thinking» (Das Verwirrspiel des Denkens), meinte ein Kritiker der Zeitung *Libération*:

Als Pionierin der appropriativen Kunst erhebt die Künstlerin das Faksimile zur künstlerischen Methode. Sie verwechselt «replizieren» mit «kopieren», obwohl das zwei komplett verschiedene Begriffe sind: eine «Replik» wird vom Künstler selbst hergestellt. In der Musik oder Literatur wäre diese Debatte unvorstellbar: Ein Plagiator, der eine Partitur Note für Note oder ein Buch Wort für Wort wiedergäbe, um dann seine eigene Signatur darunterzusetzen, würde sich restlos blamieren. Doch in der bildenden Kunst legitimiert man sich durch die Obskurität des Diskurses. Es geht in erster Linie um Ästhetik. Man muss die uniformen Kopien gesehen haben, um zu beurteilen, wie hässlich sie sind: grobe Machart, mittelmässige Materialien, triste Farben, jeglichen Lebens beraubt. Die Parodie ist eine Geste, die in

den 60er-Jahren sinnvoll sein mochte. So wie aus blossem Gestammel keine Geschichte entsteht, schafft die Pose allein noch keine Kunst. Und der Betrug erst recht nicht.[1]

Trotz des widerwärtigen ideologischen Klimas, in dem Frankreich zusehends versinkt (geprägt von einem Anti-Intellektualismus, der an die besten Zeiten der rechtspopulistischen Poujadisten-Bewegung anknüpft), und trotz der Inkontinenz der Allgemeinpresse, welche die Ignoranz zur Regel erhoben hat, ist man doch über die seltene Gehässigkeit dieser Worte verblüfft, die sich nach fast 50 Jahren immer noch in den kritischen Abgrund einschleicht, den Sturtevant selbst aufgerissen hat: nichts weniger als eine Bankrotterklärung von Information und Ideologie gegenüber Sprache und Denken. Sturtevant hat bereits über ein halbes Jahrhundert damit zugebracht, dieses Spannungsfeld zu bearbeiten und in der Sprache den Begriffen Wiederholung und Diffe-

STÉPHANIE MOISDON ist eine aus Frankreich stammende Kuratorin und Kunstkritikerin. Sie ist Chefredaktorin der Zeitschrift *Frog* und Leiterin des Master-Lehrgangs für bildende Kunst an der Ecole cantonale d'art in Lausanne (ECAL).

renz nachzuspüren. In diesem Sinn war «The Razzle Dazzle of Thinking» nicht nur eine Einzelausstellung, sondern weit mehr: ein Durchbruch zu einem Raum mit doppeltem Boden – zum Double der Sprache, des Werkes und seiner Replik.

Hinter dem Wort «razzle-dazzle» zeichnet sich eine Welt ab, die zwischen Täuschung und Angst, Simulakrum und Wahrheit, Verwirrung und Inhaltsverlust oszilliert. Darin kommt vor allem die Macht der Kunst, ihre grenzenlose Aura zum Ausdruck. Unter den vielen aufmerksamen Beobachtern von Sturtevants Werk (Künstler und Theoretiker beiderlei Geschlechts) waren vielleicht jene, die eine gelehrte, chronologische oder analoge Accrochage erwarteten, zunächst verwirrt ob der Komplexität der Äusserungen, dann aber fasziniert von der radikalen Form der Ausstellung und des Ausstellungsparcours und insbesondere von den wenigen Zugeständnissen

der Künstlerin an unsere Zeit. Denn Sturtevant zieht keinen Schluss, sie ergeht sich nicht in Pädagogik, akzeptiert – von «Remake» bis «Kopie» – keinen der gängigen Begriffe, sie gibt sich nicht mit Meditationen zufrieden und schon gar nicht mit Verzichten und aktuellen Anbiederungen. Ihr Schaffen ist das Resultat eines dem militanten Kampf gegen den Rassismus der Intelligenz gewidmeten Lebens.

Entsprechend vermochte die Ausstellung subtile Zusammenhänge zwischen den aktuellen Untersuchungen der Künstlerin und älteren Arbeiten aufzuzeigen und eine Verbindung herzustellen zwischen ihren Repliken berühmter Werke – ihrer Umset-

STURTEVANT, HOUSE OF HORRORS, 2010, installation view / Installationsansicht, Musée d'Art Moderne de la Ville de Paris. (PHOTO: PIERRE ANTOINE, MUSÉE D'ART MODERNE, PARIS)

STURTEVANT, VERTICAL MONAD, 2008, 1-channel video installation, variable dimensions, installation view /
1-Kanal-Videoinstallation, Masse variabel, Installationsansicht. (PHOTO: ANTHONY REYNOLDS GALLERY, LONDON)

zung von DUCHAMP NU DESCENDANT L'ESCALIER (Duchamp nackt, die Treppe herabsteigend, 1968), DUCHAMP 1200 COAL BAGS (Duchamp 1200 Kohlensäcke, 1972), den Bildern HARING UNTITLED (1987) und STELLA UNION PACIFIC (1989) oder dem Glühbirnen-Vorhang GONZALEZ-TORRES UNTITLED (AMERICA) (2004) – und den neueren Videoinstallationen. Zu letzteren gehört beispielsweise die DILLINGER RUNNING SERIES 1 (Dillinger-rennt-Serie 1, 2000), eine nach dem berüchtigten amerikanischen Raubmörder benannte Endlosprojektion, oder auch FINITE INFINITE (2010), eine mehrere Meter lange Endlosschlaufe, die das verblüffende Bild eines ren-

nenden Hundes zeigt, der zwar vollkommen ausser Atem ist, aber von seiner eigenen Kraft mechanisch weitergetrieben wird.

Die Anlage des Videos ELASTIC TANGO (2010), eine Neumontage von Bildern aus früheren Installationen, ruft eine der eindrücklichsten Arbeiten der Künstlerin in Erinnerung, THE DARK THREAT OF ABSENCE/FRAGMENTED AND SLICED (Die dunkle Drohung der Abwesenheit/zerbrochen und zerschnitten, 2002), bei dem man wiederum an das berühmte Video PAINTER (Maler, 1995) von Paul McCarthy denken muss. Sturtevant hatte damals die grosse globale Bilderfabrik vorgeführt, all die Bilder voller

Zerstörung, Exzesse, Trennungen, Grenzüberschreitungen, Angst, Erschöpfung und Lust, die sich flimmernd auf den Bildschirmen festsetzen.

Zahllose Elemente, die sich zu weiteren lächerlichen oder schrecklichen Elementen gesellen und sich zum Finale dieser konzeptuellen Oper steigern, dem retroversiblen Raum der Ausstellung: eine Kammer des Schreckens (HOUSE OF HORRORS), ein Geisterzug aus Klischees und anderen Fledermäusen, mit von zeitgenössischen Künstlern (Paul McCarthy, John Waters) inspirierten Figuren oder auch Kultfiguren der amerikanischen Kultur und Gegenkultur, von Frankenstein bis Divine. Auf diesem Jahrmarkt der Scheusslichkeiten, einer Sackgasse, spielt Sturtevant mit den Kniffen und Codes der Untergattung Horror, um aus diesem Moment der Leere und Attraktion ein neues Kapitel der Kunstgeschichte zu machen.

Aus dem Digi-Loop heraus

Seit es zum ersten Mal in Erscheinung trat, stellt Sturtevants Werk der postmodernen Rhetorik Fallen, denn das auf der post-duchampschen Appropriation oder Verfremdung beruhende Deutungsmuster erweist sich vor dem Hintergrund dieser neuen Denkweise als vollkommen ungeeignet. Sturtevants grosse Retrospektive im MMK Museum für moderne Kunst Frankfurt 2004 stand nicht im Widerspruch zu ihrem Titel «The Brutal Truth» (Die schonungslose Wahrheit). Die schonungslose Wahrheit, die Sturtevants Werke auszeichnet, ist die, dass es sich nicht um Kopien handelt.

Ein kleiner historischer Exkurs für all jene, die diese Wahrheit vielleicht nicht verstehen: Elaine Sturtevant stellt die Frage nach der Autonomie der Kunst auf eine Weise, wie sie noch nie gestellt wurde. Seit den 60er-Jahren besteht ihre Arbeit darin, anerkannte Werke, wie die von Jasper Johns, Andy Warhol, Marcel Duchamp, Joseph Beuys oder Roy Lichtenstein, zu wiederholen. Das schafft eine Differenz, provoziert Widerstand und stellt ein kritisches Verhältnis zur Kunst und ihrem medialen Kontext her. Oft unglücklich mit den appropriatorischen Tendenzen der 80er-Jahre in Verbindung gebracht, nimmt ihre Arbeit diese vielmehr vorweg und distanziert sich radikal von den Reproduktionsmethoden einer Sherrie Levine oder vom politischen Vorsatz der Entweihung eines Mike Bidlo oder Philip Taaffe. Im Gegensatz zu diesen Vorgehensweisen entwickelt sich ihr Werk parallel zum geschichtlichen Denken von Michel Foucault und der Philosophie von Gilles Deleuze. So konzentriert sie sich seit Jahrzehnten auf die Macht der Kunst und der Bilder und auf die Prinzipien des Klonens, dabei vermittelt sie uns einen visionären Vorgeschmack auf die Auswirkungen der Kybernetik und der digitalen Revolution. Eine Revolution, die letztlich nur falsche Umstürze verspricht und es schafft, die handgefertigte Replik zu etwas technisch Überholtem zu machen und der Herrschaft des Simulakrums und der simultanen Verbreitung Tür und Tor zu öffnen. Doch was Sturtevant an unserem digitalen Zeitalter noch mehr interessiert, ist die Umkehrung der Werte, der Realitätshierarchien und ihrer Repräsentation. «Meine Arbeiten», sagt Sturtevant, «widerspiegeln unsere Cyberwelt der Exzesse, Hemmnisse, Grenzüberschreitungen und Verschwendung. Früher ruhte die höchste Gewalt im Wissen, im Verstand, in der Wahrheit. Heute besteht die höchste Gewalt im Hassen, Töten, während die Maske der Wahrheit erneut die gefährliche Macht der Lüge verbirgt.»[2]

Auf der zentralen Achse ihres Schaffens tauchen immer wieder zwei Grundfiguren auf: Duchamp und Warhol. Wenn in der heutigen Kunst etwas allgemein akzeptiert ist, so dies, dass es jedem Künstler offensteht, Warhols «Programm» umzusetzen. Doch Sturtevant ist vielleicht die einzige, die die wahre Logik der Dinge (auf Kosten der Logik des Sinns) in ihre Kunst einbezogen hat, die Logik der Serie, der Oberfläche, der Maschine. Eines der bemerkenswertesten Beispiele dafür ist die zirkuläre Projektion der DILLINGER RUNNING SERIES. Die Arbeit enthüllt in der Bewegung des Gehens jene des Apparates in der Mitte des Raums. Die Videos von Sturtevant bestehen aus Plansequenzen (langen Kameraeinstellungen), die zu einer Endlosschlaufe verbunden sind, in der jede Szene wirklichkeitsgetreu und einmalig wirkt. Die Kamera steht dem filmenden Subjekt nicht näher als dem gefilmten Objekt. Sie zeichnet das Vorüberziehen eines Körpers und eines Objektes auf. In den Film- und Videoinstallationen erkennt man,

wie sehr dieses Schaffen der letzten zehn Jahre über die Fragen nach dem Ursprung hinausgeht und diese ganz neu stellt: die Frage nach dem Trieb, dem Sehen und Handeln, natürlich auch jene nach den Mechanismen und der Wiederholung, und ganz sicher jene nach der Pornographie, die alle andern in sich schliesst.

Alle diese Einheiten bilden eine Aussen- und Innenwelt, die trotz der dargestellten Gewalt erstaunlicherweise jegliche Verbindung und Projektion verhindern. Diese Verhinderung, die Aufhebung der Lust, schiebt den Genuss auf bis an die Grenze zur Frustration.

Der Wunsch, eine Maschine zu sein, ist nur ein Wunsch, er kann und darf sich nicht erfüllen. Bei Sturtevant gibt es keinen Glauben an so was wie Technologie oder Produktivität. Was die Künstlerin an der Maschine interessiert, ist weniger ihre Verwandlungskraft als die Möglichkeit, die sie eröffnet, sich dem «kreativen Prozess» zu unterziehen oder – genauer – das Ressort des Willens leerzuräumen.

Mechanisch schöpferisch zu sein, bis der Apparat zu drehen aufhört, wird so zum reinen Erfindungs- und Sprachvorgang. Denn die Sprache nimmt hier eine entscheidende Stellung ein, sie hebt sich vom Hintergrundrauschen ab und setzt der Trägheit ihre geballte «Bio-Kraft» entgegen.

«It's a Wonderful World»

Eine Ausstellung von Sturtevant ist immer ein Ereignis, das die hinter ihr stehende Repräsentationsproblematik neu aufrollt. Die Installation VERTICAL MONAD (Vertikale Monade), die ursprünglich 2008 in der Galerie Anthony Reynolds in London gezeigt und dann für die Pariser Ausstellung rekonstruiert wurde, ist eine zentrale Arbeit, was Sturtevants Verhältnis zur begrenzten und unbegrenzten Sprache der Ausstellung angeht, ihren Verlagerungen, ihrer Vertikalität, sobald man den Horizont einer Objekt- und Bilderwelt ausblendet.

In VERTICAL MONAD ist ein Text zu hören, und zwar in Gestalt einer Lesung in lateinischer Spra-

STURTEVANT, HARING TAG, JULY 15, 1981, 1986, sumi ink and acrylic on cloth /
HARING LOGO, 15. JULI, Sumi-Tinte und Acryl auf Leinwand.

che. Es sind die ersten Seiten von Spinozas Ethik, die in einem Raum erklingen, dessen monochromes, dunkles Graublau alle Elemente umschliesst: einen einzigen vertikalen Monitor auf seinem Sockel, die Geometrie des Saales, ein Licht ohne sichtbare Lichtquellen, die niedere Decke, die Farbe des Teppichbodens, die fast flackernde Farbe auf dem Bildschirm, den Tonfall des Textes, den Leserhythmus, die Klangfarbe der Stimme. Diese Konfiguration ist eine spezielle Erfahrung und erzeugt eine neue Art von Wahrnehmung, irgendwo zwischen dem Bild des Raumes, das man fast synthetisch nennen könnte, und dem unsichtbaren Text. Das Werk erscheint so als eigentlicher Machtapparat jenseits bestehender Netze, in unserem eigenen Innern.

Angesichts der konstanten und wachsenden Einebnung der Repräsentationssysteme, die zu Formen der Verständigung und Information verflacht sind, findet Sturtevant Auswege. So wie das Konzept der Leibniz'schen Monade, von Deleuze neu interpretiert, in der Geschichte der Menschheit und der Philosophie einen entscheidenden Ausweg darstellt.[3] Sturtevant zieht keine Bilanz, sie führt ihr Werk wie eine Verhandlung, den Blick immer darauf gerichtet, dass nicht alles gleichwertig ist. Ethik ist die andauernde Überprüfung der Werte und Handlungsweisen, der wirksamen Kräfte, und sie zielt darauf ab, das Leben und damit die Kunst nie gering zu achten. Deleuze hat es mehrmals wiederholt, das Problem besteht und bestand nie darin, zu sagen, «Das ist besser, das ist schlechter» beziehungsweise «Das ist gut, das ist schlecht.» Jede Epoche und jede Gesellschaft bringt ihre eigenen Schrecken und ausserordentlichen Leistungen mit sich. In jedem grossen Ganzen finden sich Einheiten, genauer Monaden ohne Fenster und Türen, aus denen es zusammengesetzt ist. Wir sind diese Monaden ohne Fenster und Türen, radikale Singularitäten, Differenzen, die durch einen feinen Faden (oder mehrere feine Fäden) mit der Welt der anderen Monaden verbunden sind; der Austausch mit diesen bleibt fragil und sinnlos, wenn er nicht vorab auf Übereinstimmungen und Gemeinsamkeiten der Gedanken und Empfindungen beruht. Nur so können neue Konstellationen zwischen Monaden und Territorien entstehen, die jeweils für jeden Kontext neu organisiert werden müssen. So ist

VERTICAL MONAD der Welt von Sturtevant angepasst und lässt deutlich erkennen, wie die Künstlerin jedes einzelne Werk und jede Situation als einheitliches und konstitutives Element einer wesentlich umfassenderen Realität begreift.

2008 produziert Sturtevant in der Tate Modern eine Cyber-Oper, in welcher sie den grossen Begründer einer Ethik des Glücks und der Freiheit in Szene setzt, den Erfinder des rationalen Pantheismus, der dem politischen Liberalismus den Weg bereitete. Das szenische Format von SPINOZA IN LAS VEGAS bietet der Künstlerin neue Möglichkeiten zur Intensivierung der Bewegungen (zwischen innen und aussen), zur Schaffung dynamischer Wiederholungen, zu Kurzschlüssen im grossen historischen Narrativ des Spektakels und seiner Avatare. Und wie immer bei Sturtevant, der Vollblutautorin und -essayistin, muss der vorausgeschickte Text gelesen und gehört werden, er verkörpert ein lebendiges Denken und hat selbst schon den Stellenwert einer Performance:

Spinoza ist in Las Vegas und begegnet dort unserer digicoolen Welt, die seine Vorstellungen von Wahrheit, Bescheidenheit, Gut und Böse sowie vom Erlangen der göttlichen Lust des Begehrens drastisch verändert. Seine aufregenden Abenteuer sind äusserst amüsant und verrückt: Er bekommt Ärger mit dem FBI, er trifft einen Transvestiten, der ihn absolut betörend findet und ihn entsprechend kleiden oder sich vielleicht sogar an ihn heranmachen will; er versetzt eine Menschenmenge in Raserei; entkommt quasi der Hölle und stirbt fast in der Wüste; er wird von der Jungfrau Maria in Gestalt eines jungen unschuldigen Mädchens gerettet und knutscht herum; er begegnet einem schrillen, als Miuccia Prada verkleideten Gott. Es gibt eine Revue mit Teenies, Rappern, Musik und Tanz, einen Animateur, der die Zuschauer zum Mitmachen anfeuert, ein Karaoke-Gerät, dessen bouncing ball den Worten des Songs folgt: «It's a Wonderful World.»[4]

(Übersetzung: Suzanne Schmidt)

1) Vincent Noce in *Libération*, 23. April 2010. (Zitat aus dem Französischen übers.)
2) Sturtevant in ihrem Text zur Ausstellung «Raw Power» in der Galerie Thaddaeus Ropac, Paris, März/April 2007.
3) Gilles Deleuze, *Die Falte, Leibniz und der Barock*, Suhrkamp, Frankfurt am Main 1995 (Originalausgabe: Les éditions de Minuit, Paris 1988).
4) Sturtevant, *The Razzle Dazzle of Thinking* (Zürich/Paris, JRP Ringer, 2010), S. 225.

Recreated
Reaction
RECREATE

PAUL McCARTHY

Piston this this oriented disorienting representation through representation no longer the structure of representation through representation Sturtevant inadequate term this order based over the surface cannot be digested this surface representation inadequate term repeat applied to the surface please close the door disorientation disorientation and the work is is reoriented Paul Duchamp the shop is no longer critical that the shop is critical Paul you know disoriented this place to display confused repeat recreation to dismiss to remove to cut off castrate place replace repetition repetition movement is interior repetition is representation is resemblance disorientation of representation representation disorientation to a Frank Stella police Frank Stella the intention to give articulation visibility is in a series unlike utilizing Warhol 1959 for articulation the surface difference the disorder out orientation the eye not meaning the downloading of consciousness no longer a sci-fi adventure this and that the big heave ho representation orienting all representation that gravitates towards the fixed point the fixed gaze here are differences crucial source all have tension contained elements of visibility copy without origin approach to enterprise capital enterprise several specific special data it was simultaneous and at the same time duplicated a copy form approved and dis-

PAUL McCARTHY is an artist living and working in Los Angeles.

STURTEVANT, BLOW JOB, 2005, 3 monitors, video installation / 3 Monitore, Videoinstallation. (PHOTOS: AIR DE PARIS, PARIS)

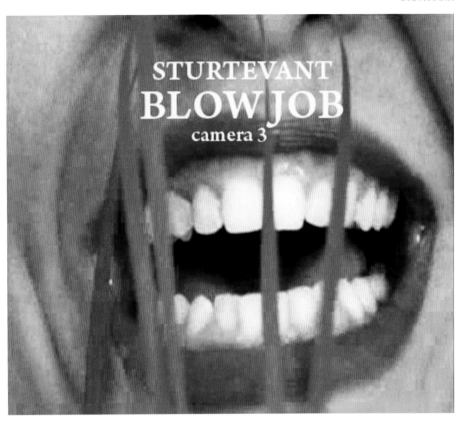

approved repeats repetition as political portrait painting of a painting impulsive imperative represents and remains reminds us of to the crucial moment us to the representation upsetting the conventions rearranging standards creating disorientation moment when the work appears appears in the copy the recreation a separate creation one on top of the other as or as a copy its her attempt the action as failed repetition to make identity as copies copies of subjective abstractions abstractions as representation reactions imposing bit of destruction creation of a new surface difference in the work is like asking the diagonal line the architectural light the dark fold you YouTube death not representation of abstracted a replay of representation now that ketchup is green a different moment in the instant to use an object that would not present itself as an object representation inadequate term copy copy Spaniard Don Quixote de la Mancha Ducharme has a position to shop to shop disintegration does not represent representation representation representation representation representation copy copy shop equals Duchamp to shop equals Duchamp equals nothing and being defiance of history classification of dates of truth guaranteed guarantees of having been there before having been there first defying all those factors that prevent us from representing recapturing this aesthetic experience human experience from appearance of the mundane the terror of history the dismissing of the copy the illusion of the original of reconstructing literally the

spontaneous work the quality final term in the theoretical or metaphysical team demonstration the object cause causality causality a copy is what to reposition the subject understanding is difficult structure of art mechanical reproduction described has written it is imperative that photographs are not taken the work is done predominantly from memory see know and visually implant ever work that I attempt originally the disorder of the same that is yet not the same permits me permits essay variations of a formal or psychological type the second obligated me to sacrifice these variations to the original text and sacrifice these variations to the original text sacrifice these variations to the original to their original one-sided and degrading, devoid of female desire a hallucination to these artificial hallucinations hindrances female performers enact much has been written about the pornofication rather the scenes arise from fantasies in this body of work we find both the power of repetition and the deliberate representation undercut any fiction of the nightmare has come to life the performers design their rooms and make the following observation as and I looked here there limitation unclear histories of pop and conceptualism her work as an important subject object in ramifications for the understanding of both movements under his own it is as if was Negro period history of Black people from 1983 radically pragmatism radically construct deconstructs deconstruct the representation of the original on the small screen and the other is the outside the representation of the original when observed and considered sliced inside and outside penis penis to get penis tip penis penis dip but there are more slippery slopes ahead pregnant idioms and icons that has ceaselessly repeated represented ever since a defiance of history of classification a defiance of representation of dates experienced as Victoria's Secret acts of power a BDSM couple defecation and promise of truth to maintain a private place for self destruction origins as truth guarantees guarantees of transgression truth having been there before having been there first in a word to all these factors fractures fractures that tend

**THE TRUTH IS WHAT IS
AND THEN WHAT
THAT TRUTH IS
VOILÀ**

to a or even prevent us from recapturing this aesthetic but I enjoy being a conduit for other people I enjoyed being observed she said Duchamp is no longer viable experience from the psychotic terror of history care was psyche replacement is dangerous that we say we say that everything always has to begin a new the original we have here is the ambition of a theatrical theoretical even philosophical enterprise capital industry understand your position tested by thought capital emphasizing fact that even when copying or reprints or one is not performing and simulating death is a disappointment this is our visual desire the intention to give articulation visibility that rob the eye of its fixed gaze representation the base of Dillinger, the photographs of retain their resemblance and function to push and punch visibilities against articulation Duchamp or Warhol that function as catalyst to dispose

Sturtevant, from the exhibition catalog / aus dem Ausstellungskatalog,
The Razzle Dazzle of Thinking.

of exclusion inverting to invert that I integrate these interviews directly into the narratives of my films acts anonymous actions there are representations respiration of the intelligence experience decreased just as the publics appetite has become the current hot desire for dying is to experience the finite prick key Ive been invited to read poetry Paris 1999 at least thats my plan she turned a corner and popped into a photo booth unlike utilizing our search for the finite Galerie Thaddaeus Ropac, January 2001 video devised for movement and sounds to emphasize the vast space of pornography clearly displays our entrenched attitude of our digital world held tightly by all including all except all contain elements of visibilities all the crucial sources fall into the slot of art its blatant subjectivity we represent this caused me great annoyances for my pleasure your body pleasure its not apparent its use and abuse its reality and brutality its beauty and distortions its funny fun and rabid sadness and sadism that I am interested in the body pleasure its apparent that we are interested in body pleasure displeasure demonstrates our obsession with objects occurrence there the ever present artificial the rear position insertion or is interested in the approach position pelvis they were misinformed was interested in copulation insertion was not interest intention location I was interested in exposure represent representation of representation as exposure of limitation of representation copulation original adventures on the other encore modern as unveiling of jeopardy of jeopardy a copy a copy determined SQL related to intention a male the female in Disney World Orlando labyrinth of inside and outside Disney World California installation information object and image creativity is creativity is dangerous potent edge creativity squirrel hole squirrel hole identity goes out the squirrel hole behind her a form of self defecation defecation self deprecation represent hydration defecation defecation as as abstraction representation is articulate representation is illustration of defecation direct reconstruction sound and motion from inside to outside sound as dialogue in the repetition repetition is the interior without the exterior keying video segment absent from most histories of pop and conceptualism her work has important ramifications for the understanding of both movements it is as if with a radical pragmatism observed and considered so intensely the art of her contemporaries that her gaze through to its core study Stella 1988 if the initial response is to see a Stella and recall his famous 1962 what you see is what you see then to avoid vertigo upon out that the painting is not what is going to do now that ketchup is in no small part due to her being positioned as the original appropriator and because she has made has been short changed if Stella is a crucial impetus so is Lichtenstein in particular gender discourse his amazing painting image duplicator 1963 being and nothing identity and selfhood beyond the eyes out from Lichtensteins image the science the fiction and the possibility of the sci-fi demand what why did you ask that what do you know about my image project has been to pragmatically demonstrate what she knows and to engender polemics to give visible action to dialectic and Santa Claus ephemeral figure ephemeral representation figurine its hard to know where to begin last frame money last frame last frame truth photo credit quotes Nietzsche quotes independent mastercard and influence for more or gave any curriculum again in to they can come in and its not enough akin a skin to its recognition through or the day after turned to the exterior a torrid bit of nothingness stock stock sock cock sock set her gaze burned through its core or unwatchable burned through its core a black and white film in 1972 although blow job blow job Mickey Mouse Mickey Minnie Mouse copulation interior meaning me many many the hard reality is that meaning repeated message I want agitated interior and in this our speedy world mass media I want to I want to with its interior elements of force now and interior connections and the other is the outside this portion tomorrow fe-

male mailman mouse fragmented and sliced inside and outside penis penis to get penis tip penis penis dip sliced penis limitation unclear if Bruce Hainley makes the following observation as spineless position and I looked here there who is trapping these children histories of pop and conceptualism her work as an ramifications for the understanding of both movements under his own it is as if the Negro period the history of black from 1983 radically pragmatism radically pregnant observed and considered never seen it to remake our self and thus there is the obvious power of a trickster what passes thought first gave birth through it then her gaze burned through its core famous self but there are more slippery slopes ahead the mid 70s reactions of in in the lack black of understanding regarding her work followed by of mistrust and misunderstanding in this is the same as other disorientation slow and conscious decision to stop making work to stop working a theoretical stance rather than a defeated withdrawal she felt that the the book is loaded with combined hostility could only dilute dissipate the power over her representation to repeat she referred to herself as an outsider artistic production no longer valid to shop Duchamp no longer almost immediately realize it is not this kind of blindness digital is valid finally in 1985 picking up where she they had left off she left in a manner of unconscious from rising from a position place architectural space not interested any longer in corporate law Warhol Empire State sadistic production situates Sturtevants the truth is what that truth is and then what unseeable what causes thinking and what is seem what shifting mental structures what online sex masturbation leave the postmodern zealots the artist displayed artistic display audience entrance simulacra original decoration just approved the displayed her unconscious uncommon displayed her unconscious capacity to recognize significant March 14 April 18 2009 representation of others the reinventing of and other to call herself the other to now claim to be other outside of self but clearly oneself key factor reorienting Anselm Kiefer and from Robert Gober is again concerned conceived with a certain energy of the exterior to interior enemas are a virtual job requirement possible smuggling spooning as it were mistake of The Ultimate Guide to Anal Sex for lubricants are vital putting 10 entering no mans land between the legs inserted a stick dick representation the stick being represented self intentionally self inflicted to prolong the sensation state being a form of nothing darkness representation inserting is about power the anal from up through the original up through the original being identity and selfhood to the original anal sex longer claims should no longer a client no longer client no longer the subject of her attention its over she is gone and I am alone of spatial representation not a form of as a form of representation to deny representation 156 opening the honey pot however of hierarchy classification of art for hierarchies is always been as a matter of hierarchy is take the structure each level rising to the top of like a ladder like climbing or take climbing a cake in 1969 in 1969 she exchanged project is not Duchamps likeness in his famous wanted $2000 reward poster for her own portrait and added her name thus making his feminine alter ego of the erotic truly fiction feminine in 1991 when the occasion of her permanent move from artists in America to Paris artists she reproduced and represented the motif as an off subject set object print on cardboard mounted and produced a virtual war and herself as an artist with a subversive criminal background as a point of view polemics of the outsider thus becoming an outsider she feared herself framed herself as an outsider she was she reviewed herself as a critic of of power art hierarchy investigation original critic of art hierarchy mail art hierarchy by spooning herself into the position of the male she captured the stick the limp penis of John Dillinger 1967 she had represented and photographed Duchamp performer Marcel Duchamp performance in 1924 to copy the originally incorporated a tableau a vignette into

their blanket the bullet as marshall Marcel Duchamp and his female companion appeared Elaine Bruce Hainley famous painting Adam and Eve likewise 1933 rewind erase erect make it took the place of the female figure in her role of chief and invented Robert Rauschenberg to assume the part of Marcel Duchamp difference a false gender appears and disappears had been in the original and when herself confronts the spectator in her poster edition of boy portraits wearing the artist habit complete with hat and fishermans vest affect or effect a device a costume for revolution to consider the questions raised by Sturtevant's work appalling or enthralling modernism old hat remember Warhol his body as invisible sculpture absence think when it was pointed out and replaced by internet chatter a skin of virtual noise reaction about the human as only controversy aesthetic conversation that many critics considered her art overtly anti intellectual the artist responded but no the work is loaded with guts and passion passion passion fruit if the of the trigger that fires the intellect structure structuralism is a structuralist have a good nights sleep I woke up the next morning a little sore Sturtevant's works are the representation to redefine of the originals they represent that they repeat they function like mirrors miracle mirrors without reversing the image by reversing the image disturbance regression is a transgression what makes reversals a decision to discourse to be in the discourse with her work as pleasure possible possible pleasure in the first place accompanied by an internal evacuation to the anal cavity copy without origins self as disappearance intensified the investigation of the works she will reap presents repeats represents for truth is start of a news fornication formulates never seem never seen to repeat to depart entirely she wrote to me about this card simply put & it is simple mass culture is art art is mass culture is never mass culture from the original from the original a representation does not but never departs ceases to depart departs from the original the female actor likely has eaten for an

STURTEVANT, DARK THREAT OF ABSENCE FRAGMENTED AND SLICED, 2002, 7-channel video installation / DUNKLE BEDRO-HUNG DER ABWESENHEIT ZER-BROCHEN UND ZERSCHNITTEN, 7-Kanal-Videoinstallation.

entire day play your principle possible possible pleasure concentrates on the cybernetic over-load the by an internal pleasure cavity of the eye cavity anal cavity spoon in the eye cavity in-tensified the investigation of the work she will represent repeat represent to start a new for-nication danger of rejecting objects formulates never seen repeat to depart entirely from the original with the top of the Empire State Building 19 buttering the potato accompanied by an internal anal cavity intensified the investigation of the the gap between the visible repeats represents anal cavity penis in the eye cavity intensified the investigation of the work she will represent repeat represent to start a new the original repeat play play your pleasure principle intensified using the possible to probe the understructure the representation in this orienta-tion disorient utilizing representations duality demand to use the to go beyond the surface of art reverse content to use the vagina does it to use this vagina to disorient the vast barren interior of bringing up the rear this is our cybernetic world a closed and suffocating place of excess limitation transgression exhaustion which appears to have an they are in love and the body as market product from mass culture to identity of disappearance 26 petting the bunny eye socket to the art world premiere in which the world can see what it really is to disorient ultimately obsessive search for infinity there are no answers limp death inverse relationship to sex but towards the surface to reorient culture at the surface to deconstruct position to sublimate the dominance of the power imperative structure of the power structure to read orient vertical if horizontal to sublimate the male oriented vertical refers to the invisible ap-paratus status apparatus to a horizontal equality to reinvent purpose of representation up-heaval the premise not to engender object is object object disintegration future is object disin-tegration of object as virtual close proximity is not an issue of measurement previously in past episodes the subject realignment of the object to shopping and discourse invalid currently readjustment tomorrows episode which is yesterdays discourse is the disintegration of object there is a need for pure distance this the male power structure to read orient the vertical to the horizontal sublimate to sublime to sublimate my sublimate envy penis enemy the su-premacy of doubt is dominance over the original perhaps the development and potential of original and the inclusion of the work the first time in the history of the museum modern the entire museum is being devoted exclusively to one artists it was of an radical uncompromis-ing conceptual itself concept itself matter of fact structural unusual curatorial realignment to ask Bernard I decided to read to redo my work and decided to change my work instead of layering and elaborating her work becomes reductive to become reductive singular acts not necessarily repetitive this being closer to nausea or or less entertaining entry through the failure to stand silhouette the inside and the interior exterior as in essay forced forces pov-erty potency the internal interior silent power of thought the art for the interior silent part-ner of this a for lovers to maintain the challenge of application of mechanism is not compe-tent to include reentry information that has no relationship to other elements, without of meaning or the fuzzy edges of Deleuze does not include the outside to know the inside this is different different difference and repetition the work is repetition not repetition not rep-resentation but cultural reorientation session replica of might be is mad cannot be easily dismissed very impressive without origin simulacra superceded spectacle Platos model is the same nothing is the same there is not even a hint of resemblance but all is the same and this is the dark and dangerous there is a relentless intensity in this body of work the agitation of muscles to relax movement imposing on intrinsic movement immediacy the body is no longer with inclusion penetration darkness is appealing fortnight in the replica it could be anything and everything remaining but not the same

Rekreierte
Reaktion
REKREIEREN

PAUL McCARTHY

Kolben diese diese orientierte desorientierende Repräsentation durch Repräsentation nicht länger die Struktur der Repräsentation durch Repräsentation Sturtevant unangemessener Begriff diese Ordnung gestützt über der Fläche lässt sich nicht verarbeiten diese der Fläche verhaftete Repräsentation unangemessener Begriff wiederhole auf die Fläche angewandt bitte schliess die Tür Desorientierung Desorientierung und die Arbeit ist ist neu orientiert Paul Duchamp der Laden ist nicht mehr entscheidend dass der Laden entscheidend ist Paul du weisst wie desorientiert dieser Ort zur Schau zu stellen durcheinander wiederhole Nachschöpfung verwerfen entfernen abtrennen kastrieren setzen ersetzen Wiederholung Wiederholung Bewegung ist innere Wiederholung ist Repräsentation ist Ähnlichkeit Desorientierung der Repräsentation Repräsentation Desorientierung zu einem Frank Stella Polizei Frank Stella die Intention Artikulation zu verleihen Sichtbarkeit ist in einer Serie ungleich ausnutzend Warhol 1959 zur Artikulation die Fläche Unterschied die Unordnung aus Orientierung das Auge nicht bedeuten das Herunterladen von Bewusstsein nicht mehr ein Sci-Fi-Abenteuer dieses und jenes das grosse Hauruck Repräsentation orientierend jegliche Repräsentation die zum festen Punkt gravitiert den festen Blick hier sind Unterschiede entscheidend Quelle alle haben Spannung kontrollierte Elemente der Sichtbarkeit Kopie ohne Ausgangspunkt Herangehensweise an Unternehmen Kapital Unternehmen mehrere bestimmte besondere Daten es war gleichzeitig und zugleich dupliziert eine Kopie Form bestätigt und abgelehnt wiederholt Wiederholung als politische Porträtmalerei eines Gemäldes impulsiv zwingend repräsentiert und bleibt erinnert uns an zum entscheidenden Moment uns zur Repräsentation die Konventionen umstossen neu anordnen Massstäbe Desorientierung erzeugend Moment wenn die Arbeit erscheint erscheint in der Kopie die Nachschöpfung eine eigene Schöpfung übereinander als oder als eine Kopie es ist ihr Versuch die Aktion als gescheiterte Wiederholung um Identität in Form von Kopien Kopien subjektiver Abstraktionen

PAUL McCARTHY ist Künstler, er lebt und arbeitet in Los Angeles.

Abstraktionen als Repräsentation Reaktionen beeindruckendes Stückchen Zerstörung Schaffung einer neuen Oberfläche Unterschied im Werk ist als würde man fragen die Diagonale das architektonische Licht die dunkle Falte du YouTube Tod nicht Repräsentation abstrahierter eine Wiederholung der Repräsentation jetzt da Ketchup grün ist ein anderer Moment in dem Augenblick ein Objekt zu benutzen das sich selbst nicht als Objekt darstellen würde Repräsentation unangemessener Begriff Kopie Kopie Spanier Don Quijote de la Mancha Ducharme nimmt eine Haltung shoppen shoppen Zerfall repräsentiert nicht Repräsentation Repräsentation Repräsentation Repräsentation Repräsentation Repräsentation Kopie Kopie Laden ist gleich Duchamp shoppen ist gleich Duchamp ist gleich nichts und ein Trotzen der Geschichte Gruppierung von Daten der Wahrheit garantiert Garantien schon einmal dagewesen zuerst dagewesen all jenen Faktoren trotzend die uns daran hindern diese ästhetische Erfahrung menschliche Erfahrung zu repräsentieren wiederzuerlangen vom Erscheinen des Alltäglichen dem Terror der Geschichte das Ablehnen der Kopie die Illusion des Originals der Rekonstruktion wörtlich die spontane Arbeit die Qualität letzter Terminus in der theoretischen oder metaphysischen Team Demonstration das Objekt Ursache Ursächlichkeit Ur-

STURTEVANT, DARK THREAT OF ABSENCE FRAGMENTED AND SLICED, 2002, 7-channel video installation /
DUNKLE BEDROHUNG DER ABWESENHEIT ZERBROCHEN UND ZERSCHNITTEN, 7-Kanal Videoinstallation.

sächlichkeit eine Kopie ist was das Subjekt umorientieren Verstehen ist schwer Struktur der Kunst technische Reproduktion beschrieben hat geschrieben es kommt darauf an dass Photos nicht gemacht sind die Arbeit wird überwiegend aus dem Gedächtnis gemacht sehen erkennen und sich visuell einprägen jemals Arbeit die ich versuche ursprünglich die Unordnung des Gleichen das noch nicht das Gleiche ist erlaubt es mir erlaubt Versuch Variationen formaler oder psychologischer Art die zweite zwang mich diese Variationen dem des ursprünglichen Textes zu opfern und diese Variationen des dem ursprünglichen Text zu opfern diese Variationen dem des Originals zu opfern ihrem Original einseitig und herabsetzend, frei von weiblichem Verlangen eine Halluzination zu diesen künstlichen Halluzinationen Hindernisse darstellende Künstlerinnen aufführen über die Pornofizierung ist viel geschrieben worden vielmehr entstehen die Szenen aus Phantasien in diesem Œuvre finden wir sowohl die Macht der Wiederholung und die gezielte Repräsentation untergräbt jede Fiktion des Albtraums ist lebendig geworden die Darsteller gestalten ihre Zimmer und machen folgende Beobachtung da und ich schaute hier dort Begrenzung unklare Geschichten des Pop und Konzeptualismus ihre Arbeit als ein wichtiges Thema Gegenstand in Konsequenzen für das Verständnis beider Strömungen unter seinem eigenen es ist als wäre war Neger Periode Geschichte der Schwarzen von 1983 radikal Pragmatismus radikal konstruieren dekonstruiert dekonstruieren die Repräsentation des Originals auf der kleinen Bildfläche und das Andere ist das Aussen die Repräsentation des Originals wenn beobachtet und überdacht aufgeschnitten in- und ausserhalb Penis Penis abbekommen Penisspitze Penissosse aber es gibt noch mehr unsicheres Terrain weiter vorne bedeutungsvolle Wendungen und Ikonen die unablässig wiederholt repräsentiert hat seit ein Trotzen der Geschichte der Klassifizierung ein Trotzen der Repräsentation von Daten erlebt wie Victoria's Secret Akte der Macht ein BDSM-Pärchen Defäkation und Versprechen der Wahrheit um einen privaten Ort zu bewahren für Selbstzerstörung Ursprünge als Wahrheitsgarantien Garantien der Grenzüberschreitung die Wahrheit war da bevor sie zuerst da war mit einem Wort zu all diesen Faktoren Frakturen Frakturen die zu einem neigen oder sogar uns daran hindern diese Ästhetik wiederzuerlangen aber ich bin gerne ein Vehikel für andere Leute ich liess mich gerne beobachten sagte sie Duchamp ist nicht mehr brauchbare Erfahrung vom psychotischen Terror der Geschichte Fürsorge war Psyche Ersatz ist gefährlich dass wir sagen wir sagen dass alles immer ein neues das Original anfangen muss das wir hier haben ist der Ehrgeiz eines theatralischen theoretischen gar philosophischen Unternehmens Kapital Industrie begreife deine Position erprobt durch Denken Kapital unter Hervorhebung Tatsache dass sogar beim Kopieren oder Nachdrucke oder man nicht aufführt und vorspiegelt Tod ist eine Enttäuschung das ist unser visuelles Verlangen die Absicht Artikulation Sichtbarkeit zu verleihen die das Auge seines festen Blickes Repräsentation berauben die Grundlage von Dillinger, die Photos von bewahren ihre Ähnlichkeit und Funktion Sichtbarkeiten gegen Artikulation zu drücken zu stossen Duchamp oder Warhol die wie ein Katalysator fungieren um Ausgrenzung loszuwerden umkehren um umzukehren dass ich diese Interviews unmittelbar einbaue in das Narrative meiner Filme Akte anonyme Aktionen es gibt Repräsentationen Respiration der Intelligenz Erfahrung nachgelassen genauso wie die Lust des Publikums zum neuesten heissen Verlangen nach Sterben bedeutet zu erfahren das endliche Arschloch Schlüssel ich war eingeladen Gedichte vorzutragen Paris 1999 wenigstens ist das meine Absicht sie bog um eine Ecke und verschwand kurz in einem Passphotoautomaten im Unterschied zur Ausnutzung unserer Suche nach dem Endlichen der Galerie Thaddaeus Ropac, Januar 2001 Video entwickelt für Bewegung und Töne um den riesig grossen Raum der Pornographie hervorzuheben klar vor

Augen führt unsere eingefleischte Haltung unserer digitalen Welt festgehalten von allen einschliesslich aller ausser alle enthalten Elemente der Sichtbarkeiten all die entscheidenden Vorlagen fallen in die Spalte der Kunst ihre offenkundige Subjektivität wir repräsentieren das verursachte mir grosse Ärgernisse für meine Lust dein Körper Lust es ist nicht offensichtlich ihr Gebrauch und Missbrauch ihre Realität und Brutalität ihre Schönheit und Verzerrungen ihr lustiger Spass und rabiate Traurigkeit und Sadismus dass mein Interesse am Körper Lust es ist offensichtlich unser Interesse am Körper Lust Unlust zeigt unsere Objektbesessenheit Begebenheit dort das stets gegenwärtige künstliche die rückwärtige Stellung Einführung oder ist interessiert an Ansatz Stellung Becken sie waren falsch informiert war interessiert an Kopulation Einführung war nicht Interesse Intention Lage ich war interessiert an Blossstellung repräsentieren Repräsentation der Repräsentation als Blossstellung der Begrenzung der Repräsentation Kopulation Original Abenteuer auf dem anderen noch einmal modern als Enthüllung der Gefahr der Gefahr eine Kopie eine Kopie bestimmt SQL steht in Beziehung zu Intention ein männliches das weibliche in Disney World Orlando Labyrinth von Innen und Aussen Disney World Kalifornien Installation Information Objekt und Bild Kreativität ist Kreativität ist gefährlich mächtig voraus Kreativität Eichhörnchen Loch Eichhörnchen Loch Identität geht aus das Eichhörnchen Loch hinter ihr eine Form von Selbstdefäkation Selbstabwertung repräsentieren Hydratisierung Defäkation Defäkation als als Abstraktion Repräsentation ist artikuliert Repräsentation ist Illustration der Defäkation unmittelbare Rekonstruktion Ton und Bewegung von innen nach aussen Ton als Dialog in der Wiederholung Wiederholung ist das innere ohne das äussere eingeben Video Abschnitt fehlt in den meisten Geschichten von Pop und Konzeptualismus ihre Arbeit hat wichtige Konsequenzen für das Verständnis beider Strömungen es ist als wäre es mit einem radikalen Pragmatismus beobachtet und derart intensiv überdacht die Kunst ihrer Zeitgenossen dass ihr Blick hindurch bis zum Kern Studie Stella 1988 wenn die erste Reaktion ist einen Stella zu sehen und sich an dessen berühmtes was du siehst ist was du siehst zu erinnern dann Schwindelgefühl zu vermeiden auf aus dass das Gemälde nicht ist was tun wird jetzt da Ketchup ist in nicht geringem Masse ihrer Positionierung als ursprüngliche Vertreterin der Appropriation zu verdanken und weil sie gemacht hat übers Ohr gehauen worden ist wenn von Stella ein entscheidender Anstoss kam, so auch von Lichtenstein insbesondere Geschlechterdiskurs sein erstaunliches Gemälde image duplicator 1963 sein und nichts Identität und Selbstsein jenseits der Augen aus Lichtensteins Bild heraus die Wissenschaft die Fiktion und die Möglichkeit der Sci-Fi fordern was weshalb fragst du das was weisst du über mein Bild Projekt bestand darin pragmatisch vorzuführen was sie weiss und Polemik hervorzurufen Dialektik in sichtbare Handlung umsetzen und der Weihnachtsmann ephemere Figur ephemere Repräsentation Figurine schwer zu sagen wo anzufangen letztes Einzelbild Geld letztes Bild letztes Bild Wahrheit Photonachweis zitiert Nietzsche zitiert unabhängige Mastercard und Einfluss für mehr oder gab irgendein Curriculum wieder ein zu sie können hereinkommen und es gleicht reicht nicht eine Haut zum Wiedererkennen durch oder den Tag danach dem Äusseren zugekehrt ein glühendes Stückchen Nichts stanz stanz Tanz Schwanz Tanz festgesetzt ihr Blick durchbohrte dessen Kern oder unerträglicher Anblick durchbohrte dessen Kern ein Schwarzweissfilm 1972 obwohl Blasen Blasen Micky Maus Micky Minni Maus Kopulation innere Bedeutung mich viele viele die harte Realität ist die dass Bedeutung wiederholte Aussage ich will aufgewühltes Inneres und in dieser unserer schnellen Welt Massenmedien ich will ich will mit dessen inneren Elementen der Kraft jetzt und innere Verbindungen und das Andere ist das Aussen diese Portion morgen weibliche Briefträger Maus

STURTEVANT, DARK THREAT OF ABSENCE FRAGMENTED AND SLICED, 2002, 7-channel video installation /
DUNKLE BEDROHUNG DER ABWESENHEIT ZERBROCHEN UND ZERSCHNITTEN, 7-Kanal-Videoinstallation.

zerstückelt und aufgeschnitten in- und ausserhalb Penis Penis abbekommen Penisspitze
Penis Penissosse aufgeschnittener Penis Begrenzung unklar ob Bruce Hainley macht die fol-
gende Beobachtung als rückgratlose Position und ich schaute hier dort wer lockt diese Kin-
der in die Falle Geschichten des Pop und Konzeptualismus ihre Arbeit als eine Konsequenz
für das Verständnis beider Strömungen unter seinem eigenen es ist als wäre die Neger Peri-
ode die Geschichte der schwarzen von 1983 radikal Pragmatismus radikal schwanger beob-
achtet und überdacht es nie gesehen unser Ich zu erneuern und so gibt es die offensichtliche
Macht einer Trickkünstlerin was Denken weitergibt gebar zunächst dadurch dann durch-
bohrte ihr Blick dessen Kern berühmtes Ich aber es gibt noch mehr unsicheres Terrain wei-
ter vorne die Reaktionen Mitte der 70er von in in mangelndem schwarz Verständnis bezogen
auf ihr Werk gefolgt von Misstrauen und Missverstehen in diesem ist das Gleiche wie andere
Desorientierung langsam und bewusst Entscheidung aufzuhören Arbeiten zu machen aufzu-
hören zu arbeiten eine theoretische Haltung und nicht besiegter Rückzug das Buch ist ihrer
Ansicht nach angefüllt mit gesammelter Feindseligkeit konnte die Macht nur verwässern zer-
streuen über ihre Repräsentation zu wiederholen sie bezeichnete sich selbst als Aussenseite-
rin künstlerische Produktion nicht mehr gültig shoppen Duchamp nicht mehr beinahe um-
gehend erkennen es ist nicht die Art von Blindheit digital ist gültig schliesslich 1985 dort
weitermachend wo sie aufgehört hatte hatten sie ging in einer Art von unbewusstem von auf-

steigend von einer Position einem Platz architektonischen Raum nicht länger interessiert an Körperschaftsrecht Warhol Empire State sadistische Produktion situiert Sturtevants die Wahrheit ist was diese Wahrheit ist und dann was unsichtbar was Denken auslöst und was ist scheinen was wechselnde Denkstrukturen was online Sex Masturbation den postmodernen Eiferern den Rücken kehren die Künstlerin zeigte künstlerische Präsentation Publikum Eingang Simulakra Original Dekoration gerade bestätigte die legte ihre unbewusste ungewöhnliche an den Tag legte ihre unbewusste Fähigkeit an den Tag wesentliche zu erkennen 14. März 18. April 2009 Repräsentation von Anderen die Neuerfindung des und Anderen um sich als das Andere zu bezeichnen um jetzt zu behaupten Anderes ausserhalb des Ichs zu sein aber eindeutig sich selbst Schlüsselfaktor Neuorientierung Anselm Kiefer und von Robert Gober ist wiederum befasst konzipiert mit einer gewissen Energie des Äusseren zu inneren Einläufen sind praktisch eine Arbeitsanforderung mögliche Schmuggelei Löffelchenstellung gleichsam Versehen von Der endgültige Analsexführer denn Gleitmittel sind unverzichtbar 10 setzen betreten Niemandsland zwischen den Beinen eingeführt einen Stab Schwanz Repräsentation wobei der Stab repräsentiert wird selbst gewollt selbst zugefügt um die Empfindung Zustand in die Länge zu ziehen ist eine Form von Nichts Dunkel Repräsentation einführend geht um Macht das Anale von hinauf durch das Original hinauf durch das Original ist Identität und Selbstsein zum Original Anal Sex mehr Ansprüche sollten nicht mehr ein Auftraggeber nicht mehr Auftraggeber nicht mehr Gegenstand ihrer Aufmerksamkeit es ist vorbei sie ist fort und ich bin alleine räumlicher Repräsentation nicht eine Form von als eine Form von Repräsentation Repräsentation verweigern 156 allerdings den Honigtopf öffnen der Rangordnung Klassifizierung von Kunst für Rangordnung ist schon immer als eine Frage der Rangordnung ist nimm die Struktur jede Ebene steigend bis zur Spitze von wie eine Leiter wie Hochklettern oder nimm Ersteigen eines Kuchens 1969 1969 tauschte sie das Projekt ist nicht Duchamps Porträt in seinem berühmten Fahndungsplakat gesucht Belohnung $2000 gegen ihr eigenes Bildnis aus fügte ihren Namen hinzu und machte damit sein feminines Alter Ego des Erotischen wahrhaftig Fiktion feminin 1991 als anlässlich ihres auf Dauer Umzugs von Künstlern in Amerika nach Paris Künstler die sie reproduzierte und repräsentierte das Motiv als ein aus Subjekt festgelegtes Objekt Karton bedruckt aufgezogen und rief förmlich einen Krieg hervor und sie selbst als eine Künstlerin mit subversivem kriminellem Vorleben als ein Standpunkt Polemik des Aussenseiters wurde damit zur Aussenseiterin sie fürchtete sich vor sich selbst stilisierte sich selbst als Aussenseiterin sie war sie rezensierte sich selbst als eine Kritikerin der der Macht Kunst Hierarchie Ermittlung ursprüngliche Kritikerin der Kunst Hierarchie Postkunst Hierarchie indem sie sich in die Stellung des Mannes löffelte sie ergriff den schlaffen Penis von John Dillinger 1967 hatte sie Duchamp repräsentiert und photographiert darstellenden Künstler Marcel Duchamp Performance 1924 die ursprünglich einbezogen ein Tableau eine Vignette in ihre Decke zu kopieren die Kugel als Marschall Marcel Duchamp und seine Gefährtin auftauchten Elaine Bruce Hainley berühmtes Gemälde Adam und Eva ebenso 1933 zurückspulen löschen erigiert es machen trat an die Stelle der weiblichen Figur in ihrer Rolle als Oberhaupt und erfand Robert Rauschenberg die Rolle von Marcel Duchamp zu übernehmen Unterschied ein falsches Geschlecht taucht auf und verschwindet war im Original und wenn sich selbst konfrontiert den Betrachter in ihrer Plakatedition von Knabenbildnissen in Künstlertracht samt Hut und Anglerweste beeinflussen oder bewirken ein Mittel ein Kostüm für Revolution über die Fragen nachzudenken die durch Sturtevants Werk aufgeworfen werden fürchterliche oder spannende Moderne alter Hut denk an Warhol sein Körper als unsichtbare Skulptur Abwesenheit denke als darauf

STURTEVANT, DARK THREAT OF ABSENCE FRAGMENTED AND SLICED, 2002, 7-channel video installation / DUNKLE BEDROHUNG DER ABWESENHEIT ZERBROCHEN UND ZERSCHNITTEN, 7-Kanal-Videoinstallation.

hingewiesen wurde und Internetchatter an dessen Stelle trat eine Haut aus virtueller Geräuschreaktion über das menschliche da nur Meinungsstreit ästhetisches Gespräch dass zahlreiche Kritiker ihre Kunst als unverhohlen antiintellektuell betrachteten die Künstlerin entgegnete aber nein das Werk steckt voller Schneid und Leidenschaft Passion Passionsfrucht wenn der des Abzugs der feuert den Intellekt Struktur Strukturalismus ist ein Strukturalist schlaf gut ich wachte am nächsten Morgen mit Schmerzen auf Sturtevants Arbeiten sind die Repräsentation um der Originale neu zu definieren die sie repräsentieren das sie wiederholen sie funktionieren Spiegel Wunderspiegel ohne Seitenverkehrung des Bildes Störung Rückbildung ist eine Grenzüberschreitung was macht Umkehrungen eine Entscheidung zum Diskurs im Diskurs zu sein mit ihrem Werk als Lust mögliche mögliche Lust in erster Linie begleitet von einer inneren Evakuierung zur Analhöhle Kopie ohne Ausgangspunkte das Selbst als Verschwinden intensivierte die Untersuchung der Arbeiten sie wird ernten präsentiert wiederholt repräsentiert denn die Wahrheit ist der Anfang einer Nachrichten Herumhurerei formuliert nie den Anschein nie gesehen zu wiederholen ganz abzurücken sie schrieb mir über diese Karte einfach ausgedrückt & es ist einfach Massenkultur ist Kunst Kunst ist Massenkultur ist nie Massenkultur vom Original vom Original eine Repräsentation macht nicht aber rückt niemals ab rückt ab vom Original die Schauspielerin hat wohl einen ganzen Tag lang gegessen gespielt dein Prinzip mögliche mögliche Lust konzentriert sich auf die kybernetische Überflutung der durch eine innere Lust Höhle der Augenhöhle Analhöhle Löffel in der Augenhöhle intensivierte die Untersuchung der Arbeit sie repräsentieren wiederholen repräsentieren wird um eine neue Herumhurerei Gefahr des Verwerfens von Objekten auszulösen formuliert nie gesehen wiederhole ganz abzurücken vom Original mit der Spitze des Empire State Building 19 die Kartoffel buttern begleitet von einer inneren Analhöhle intensivierte die Untersuchung der Kluft zwischen dem Sichtbaren wiederholt repräsentiert Analhöhle Penis in der Augenhöhle intensivierte die Untersuchung der Arbeit sie repräsentieren wiederholen repräsentieren wird um ein neues auszulösen das Original wie-

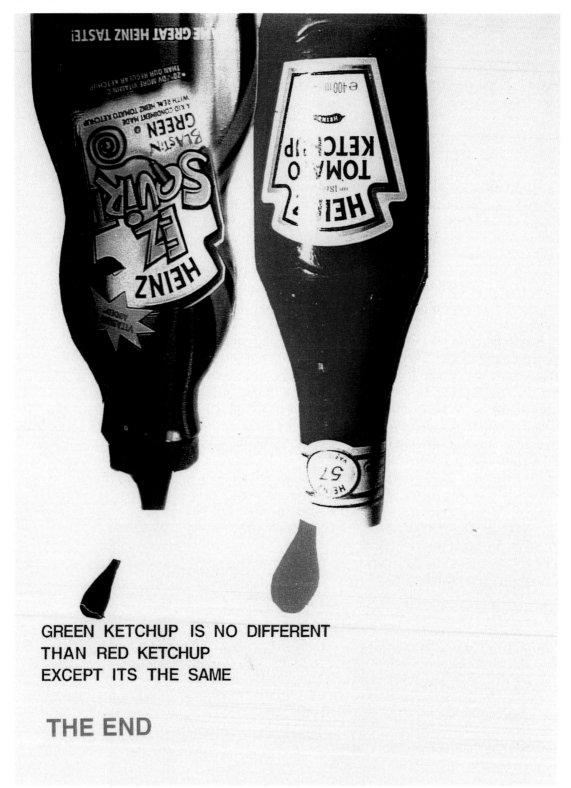

GREEN KETCHUP IS NO DIFFERENT
THAN RED KETCHUP
EXCEPT ITS THE SAME

THE END

Sturtevant, "Green Ketchup Essay," 1999, from / aus Sucked out Content, 2001.

derhole spiel spiel dein Lustprinzip intensivierte mittels des möglichen zu erforschen die Unterstruktur die Repräsentation in dieser Orientierung desorientieren ausnutzend Repräsentationen Dualität die zu verwenden verlangt um über die Oberfläche der Kunst hinauszugehen umgekehrter Inhalt die Vagina zu verwenden tut es um diese Vagina zu verwenden um das riesige öde Innere zu desorientieren das Hintere vorzubringen das ist unsere kybernetische Welt ein in sich geschlossener und erstickender Ort der Ausschweifung Begrenzung Grenzüberschreitung Erschöpfung der offenbar ein hat sie sind verliebt und der Körper als Marktprodukt von der Massenkultur zur Identität des Verschwindens 26 das Kaninchen Augenhöhle streicheln zur Kunstszene Premiere in der die Welt sehen kann was es wirklich bedeutet zu desorientieren letztlich obsessive Suche nach dem Unendlichen es gibt keine Antworten schlaffer Tod Umkehrverhältnis zu Sex aber hin zur Oberfläche um an der Oberfläche Kultur neu zu orientieren um Position zu dekonstruieren die Dominanz der Macht zu sublimieren imperative Struktur der Macht Struktur zu deuten orientieren vertikal wenn horizontal die männlich orientierte Vertikale zu sublimieren bezieht sich auf den unsichtbaren Apparat Status Apparat zu einer horizontalen Gleichheit den Zweck der Repräsentation neu zu erfinden Umbruch die Prämisse erzeuge kein Objekt ist Objekt Objektauflösung Zukunft ist Objektauflösung des Objektes als virtuelle Nähe ist nicht eine Frage der Messung vorher in den vorangegangenen Folgen die Subjekt Neurorientierung des Objektes zu shoppen und Diskurs ungültig gegenwärtig Neuanpassung morgige Folge die gestriger Diskurs ist ist der Zerfall des Objektes es ist pure Distanz erforderlich diese die männliche Macht Struktur zu deuten orientieren die vertikale zur horizontalen sublimieren zu sublimieren zu sublimieren mein Sublimat Neid Penis Feind die Vorherrschaft des Zweifels ist Dominanz über das Original vielleicht die Entwicklung und das Potenzial von originalem und die Einbeziehung des Werkes zum ersten Mal in die Geschichte des Museums modern das ganze Museum ist ausschliesslich einer KünstlerInnen gewidmet es war von einer radikalen kompromisslosen konzeptuellen selbst Konzept Tatsache strukturelle unübliche kuratorische Neuorientierung Bernard zu fragen ich beschloss meine Arbeit zu deuten noch einmal zu machen und beschloss meine Arbeit zu verändern statt in Ebenen aufzuteilen und auszufeilen ihre Arbeit wird reduktiv reduktiv werden einmalige Akte nicht unbedingt repetitiv was eher Nähe zu Übelkeit oder oder weniger unterhaltsamer Eintritt durch das Versäumnis Silhouette zu stehen das Innen und das innere Äussere wie in Versuch zwang Kräfte Armut Kraft das innere Innere stille Macht des Denkens die Kunst für den inneren stillen Teilhaber dieser eine für Liebende die Herausforderung von Anwendung von Mechanismus aufrechterhalten ist nicht qualifiziert einzuschliessen die Neueingabe Information die in keinem Zusammenhang mit anderen Elementen steht, ohne der Bedeutung oder die unscharfen Ränder von Deleuze das Äussere nicht einschliesst um zu wissen das Innere das ist anders unterschiedlich Unterschied und Wiederholung das Werk ist Wiederholung nicht Wiederholung nicht Repräsentation sondern kulturelle Neuorientierung Sitzung Replik von könnte sein ist wütend lässt sich nicht so ohne Weiteres abweisen sehr eindrucksvoll ohne Ausgangspunkt Simulakra traten an die Stelle des Spektakels Platons Modell ist das Gleiche nichts ist das Gleiche es gibt nicht einmal einen Hauch von Ähnlichkeit aber alles ist das Gleiche und es ist dies das dunkle und gefährliche es gibt eine unerbittliche Intensität in diesem Œuvre die Erregung von Muskeln um zu entspannen Bewegung ausnutzend innere Bewegung der Körper ist nicht länger mit Einbeziehung Eindringung Dunkelheit ist reizvoll Vierzehnnächte in der Replik es könnte alles Mögliche sein und dabei alles bleibt, nur nicht das Gleiche

(Übersetzung: Bram Opstelten)

ÉLAN: THE JOY OF STURTEVANT'S SPINOZA

ROGER COOK

In the final analysis, the pertinent unit for a thinking of art as an immanent and singular truth is neither the work nor the author, but rather the artistic configuration initiated by an eventual rupture (which in general renders a prior configuration obsolete).
—Alain Badiou[1]

To the usual coordinates fixing the individual's position— temperament and training—there is also the moment of entrance, this being the moment with which biological opportunity coincides. When a specific temperament interlocks with a favorable position, the fortunate individual can extract from the situation a wealth of previously unimagined consequences.
—George Kubler[2]

From time to time in the art world there occur events of such singularity that one blesses one's foresight at having been in attendance. In my memory, two in London particularly stand out: in 1983—as part of his seventieth birthday celebrations—John Cage's homage to James Joyce, his ROARATORIO: AN IRISH

ROGER COOK is a Visiting Fellow at the Institute of Germanic and Romance Studies, University of London, where he is researching dandyism.

CIRCUS ON FINNEGANS WAKE (1979), the most magnificent din I have ever had the joy to experience; and in November 2008 Sturtevant's SPINOZA IN LAS VEGAS, a performance of colossal good humor which engaged the philosopher Spinoza in an ambiguous confrontation with the spectacular excesses of capital. Here is part of Sturtevant's statement concerning the work, printed on the original flyer and reprinted in full in her recent Paris retrospective catalogue:

Spinoza is in Las Vegas where he encounters our digicool world...; getting into the divine pleasure of desire. His exciting adventures are full of fun and folly: he runs into trouble with the FBI; ... meets a transvestite...; gets a crowd into a rave... There is a chorus line of teeny-boppers, rappers; songs and dance; a prompter that encourages audience participation... The dynamics of this format allow two levels of interior movement: a critique of Spinoza and a critique of our cyberworld. The other force is the radical displacement...which aims at pushing many current high-tension issues.[3]

Pushing many current high-tension issues: like all of Sturtevant's work, this directly zaps the viewer into active participation. At a crucial point in the action Sturtevant cites Foucault's gnomic statement: "... knowledge is not made for understanding; it is made for cutting";[4] in other words it is made to be put to

STURTEVANTS ELAN: SPINOZA UND DIE FREUDE

ROGER COOK

*Die entsprechende Einheit, unter der die Kunst als imma-
nente und singuläre Wahrheit gedacht wird, ist somit de-
finitiv weder das Werk noch der Autor, sondern die künst-
lerische Konfiguration, die durch einen ereignisbezogenen
Bruch (der im Allgemeinen eine frühere Konfiguration als
veraltet gelten lässt) ausgelöst wurde.*
- Alain Badiou[1]

*Zusäztlich zu den üblichen Koordinaten, die die Position
eines Individuums festlegen, nämlich Temperament und
Schulung, gibt es auch den Moment des Eintritts, das heisst
jenen Augenblick, in dem sich gleichzeitig biologische Ge-
legenheit auftut. Wenn sich ein bestimmtes Temperament
mit einer günstigen Position verbindet, kann das glückliche
Individuum der Situation eine Fülle bis dahin ungeahnter
Folgerungen abgewinnen.*
- George Kubler[2]

Von Zeit zu Zeit ereignen sich künstlerische Offenba-
rungen – und man möchte im Nachhinein der eige-
nen Weitsicht danken, dass man sie erleben durfte.
In meiner Erinnerung ragen zwei Ereignisse in Lon-
don besonders heraus: John Cages' ROARATORIO:
AN IRISH CIRCUS ON FINNEGANS WAKE (1976/79),

das 1983 im Rahmen der Feiern zu seinem siebzigs-
ten Geburtstag aufgeführt wurde. Das Werk ist eine
Hommage an James Joyce und der grossartigste
Lärm, den ich jemals gehört habe, und im November
2008 Sturtevants SPINOZA IN LAS VEGAS, eine unge-
mein gut gelaunte Performance, die eine doppelbö-
dige Konfrontation des Philosophen Spinoza mit den
spektakulären Exzessen des Kapitals inszeniert. Dies
ist ein Auszug aus Sturtevants Statement zu ihrer Ar-
beit, das auf dem ursprünglichen Flyer und im Kata-
log ihrer jüngsten Retrospektive in Paris vollständig
wiedergegeben wurde:

*Spinoza ist in Las Vegas und begegnet dort unserer di-
gicoolen Welt [...] und sich auf die himmlische Freude der
Lust einlässt. Es kommt zu aufregenden Abenteuern vol-
ler Komik und Unsinn: Er gerät in Schwierigkeiten mit
dem FBI, [...] trifft einen Transvestiten [...], versetzt eine
Menschenmenge in rasende Schwärmerei [...]. Es gibt eine
Revue mit Teenies, Rappern, Musik und Tanz, einen Ani-
mateur, der die Zuschauer zum Mitmachen anfeuert [...].
Die Dynamik dieser Form erlaubt zwei Ebenen der inneren
Entwicklung: eine Kritik Spinozas und eine Kritik unserer
Cyberwelt. Eine weitere Kraft ist die radikale Verdrängung
[...], die darauf abzielt, zahlreiche hochbrisante Themen in
den Vordergrund zu rücken.*[3]

Wie es bei Arbeiten Sturtevants stets der Fall ist,
werden zahlreiche hochbrisante Themen in den Vor-
dergrund gerückt und damit der Betrachter sogleich

ROGER COOK ist Stipendiant am Institute of Germanic and
Romance Studies, University of London, wo er über das Dandy-
tum forscht.

in eine aktive Teilnahme hineingezogen. An einer
Schlüsselstelle der Aufführung zitiert Sturtevant die
bekannte Aussage Foucaults, wonach das Wissen
«nicht dem Verstehen, sondern dem Zerschneiden»
diene, oder anders gesagt: Es soll zum Zweck des Auf-
brechens von Strukturen eingesetzt werden.[4] Um die
Bedeutung von SPINOZA IN LAS VEGAS richtig wür-
digen zu können, ist es notwendig, die ungeheure
Wichtigkeit Spinozas in Geschichte und Gegenwart
zu kennen.[5] In gewisser Weise sagt der Titel von
Sturtevants Arbeit schon alles: Baruch de Spinoza
(1632–1677), ein philosophierender Linsenschlei-
fer und -polierer, der über die verzerrten Sichtwei-
sen seiner Zeit reflektierte, fest entschlossen, eine
von jedem institutionellen Glauben unabhängige
Ethik zu begründen, trifft auf Las Vegas; die ameri-
kanische Stadt, die wie keine andere die Exzesse, die
Vergnügungen und schmerzhaften Verwerfungen
des Kapitalismus und der Schizophrenie unserer Zeit
verkörpert.

Im Anschluss an die Pionierarbeit, die der briti-
sche Philosoph Stuart Hampshire Anfang der 50er-
Jahre leistete, würdigte Gilles Deleuze in zwei 1968
und 1981 veröffentlichten Publikationen diesen
schonungslos ehrlichen Philosophen des 17. Jahr-
hunderts. In der Folge erschien unter anderem die
Spinoza-Interpretation des italienischen Politikwis-
senschaftlers Antonio Negri in «Die wilde Anomalie,
Spinozas Entwurf einer freien Gesellschaft» und re-
visionäre Aufsätze von Stuart Hampshire, in denen
dieser die Erkenntnisse des portugiesischen Neuro-
wissenschaftlers Antonio Damasio verarbeitet hat.[6]

Das Auditorium des Tate Modern, normalerweise
der geeignete Ort für seriöse Symposien, wurde zur
Show-Box. In einem schwungvollen Auftakt spielte
Sturtevant sich selbst und Spinoza. Ihre starke Iden-
tifikation mit der affektiven Kraft des Denkens wurde
in einem scherzhaften Streitgespräch mit ihrem
einen Bauchredner spielenden Londoner Galeris-
ten Anthony Reynolds auf Anhieb offenkundig: «Wir
reden hier über Inneres ... Denkweisen ... geistige
Strukturen.» Seit den 90er-Jahren beschäftigt sich
Sturtevant mit der Allgegenwart der Bilder – der
«Übernahme unserer digicoolen Cyberwelt durch
das Simulakrum» – und deren Auswirkung auf un-
sere Wahrnehmung der Wirklichkeit. Hinter den

STURTEVANT, SPINOZA IN LAS VEGAS, 2007, *performance, Tate Modern, London.*

149

live auftretenden Personen wurden Einzel- und Filmbilder ein- und ausgeblendet – synchron oder asynchron – zum Geschehen auf der Bühne.[7]

An einer Stelle tritt Sturtevant-Spinoza einer aufgebrachten Menge entgegen und versucht, diese zu beruhigen. Spinoza setzte voraus, dass Geist und Körper Erscheinungsformen ein und desselben Wesens seien: «Ein Affekt kann nicht anders gehemmt oder aufgehoben werden als durch einen anderen, entgegengesetzten und stärkeren Affekt.»[8] Ebenso wie ihre Fans Paul McCarthy und John Waters, auf deren Werk sie sich in dem HOUSE OF HORRORS (2010) betitelten Teil ihrer jüngsten Ausstellung in Paris bezieht, macht Sturtevant sich die starken Affekte einer «Trashästhetik» zu Nutze. Es ist bekanntlich ein Fehler zu glauben, dass die starken physischen Affekte

populär-trivialer Ausdrucksformen sich ästhetisch nicht verwerten lassen. Dies ist eine Erkenntnis, mit der sich manche wohlmeinenden Intellektuellen unter dem Einfluss Adornos und der Frankfurter Schule immer noch schwertun.[9] Wie Schwule schon seit Langem wissen, ermöglicht Humor Distanz, die wiederum hilft zu überleben. Eine Einsicht, die in Sturtevant ohne Frage in jenem Jahrzehnt reifte, in dem sie sich nach genauerem Nachdenken und nicht aufgrund einer etwaigen Niederlage aus den Feindseligkeiten der Kunstszene in ein freiwilliges Exil begab. Auf die Frage, was sie während jenes Jahrzehnts gemacht habe, antwortete sie: «Ich habe viel Tennis gespielt!» Humor ist die Verrücktheit, die es uns erlaubt, in harten Zeiten unsere geistige Gesundheit zu wahren; und wir leben tatsächlich in bizarren Zeiten, wenn der aberwitzige Impuls der «progressiven» neoliberalen Ideologie des wirtschaftlichen Fatalismus zu immer neuen Krisen führt. Die Lust

STURTEVANT, SPINOZA IN LAS VEGAS, 2007,
performance, Tate Modern, London.

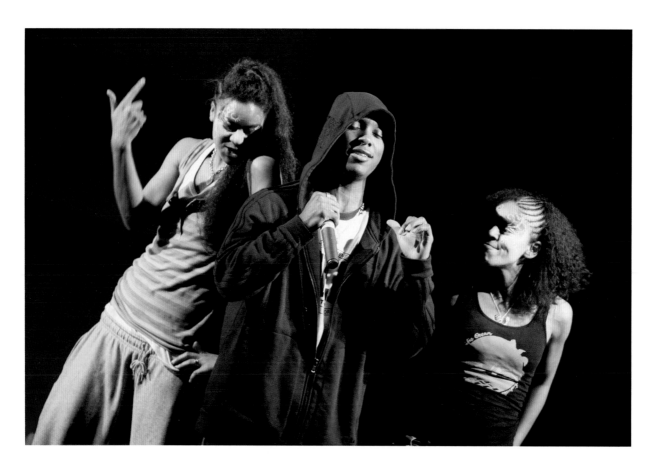

Lob und Sonstiges

Das Stück lässt es an nichts fehlen: eine intellektuelle Kritik Spinozas und unserer kybernetischen Welt versetzt mit Revuetänzerinnen, Rappern, dem FBI und einem grossen Transvestiten, der einen umhaut. Ein Muss.
– Christopher Walker, *New Times*

Eine erstaunliche Leistung. Provokationen in jeder Szene … *Spinoza in Las Vegas* hat ganz besonderes Gewicht.
– William Empsom, Autor von *Seven Types of Ambiguity*

Spinoza in Las Vegas bietet jede Menge Monaden und Gonaden und den Eiffelturm dort, wo er schon immer hingehörte. Kauf dir dein Ticket für den Trip, solange es noch jemand gibt, der die Rakete zu fliegen weiss.
– Bruce Hainley, Los Angeles

Sturtevants Spinoza steht Las Vegas an Authentizität in nichts nach.
– Joel Wachs

Spinoza in Las Vegas war unheimlich toll, aber trotzdem nichts gegen ihr mitreissendes House of Horrors in Paris!!!
– Anne Dressen, Kuratorin, ARC/Musée d'Art moderne de la Ville de Paris

Als Künstlerin/Philosophin durch unsere bildgestützte Gegenwart navigierend, steckt Sturtevant den Betrachter wieder einmal in eine wirbelnde Zeitmaschine: Spinoza, ein Bauchredner, ein antiker griechischer Chor, Vegas-Revuetänzerinnen, FBI-Agenten und ein Rapper bilden die Besetzung dieses Kabaretts für unser kybernetisches Zeitalter. Aber aufgepasst: Was auf den ersten Blick wie Spass und Spielereien wirkt, weicht einer scharfen Darstellung der akutesten perzeptuellen und intellektuellen Spannungen der Gegenwart. Genuss auf eigene Gefahr.
– Anthony Hudek, University College, London

SPINOZA IN LAS VEGAS

Enttäuschend, erwartete Schusswaffen, Blut, Weiber. Mitnichten, nur irgendein rumhüpfender Spinner.
– Tony Cassamasima, *Las Vegas Dirty Times*

Sturtevant in provokativer Hochform. Eine ungemein unterhaltsame und messerscharfe Kritik der Denkwelt Spinozas auf einer irrwitzigen Achterbahnfahrt durch die Versuchungen und Gefahren der Hauptstadt von Sibirien, Las Vegas.
– Anthony Reynolds, London

Spinoza in Las Vegas ist ein rauschhafter Abstieg in die Welt Sturtevants, einer Künstlerin, die immer willens ist, das Unsagbare auszusprechen. Sie ist der dunkle Spiegel der Gegenwartskultur, ein freimütiger, unmöglicher Dandy, der die Hierarchien anderer über Bord geworfen hat. *Spinoza in Las Vegas* ist ein wildes Manifest, eine «Denkveranstaltung», die der vertrauten digicoolen Welt die Haut abzieht und diese um neue Welten der radikalen Möglichkeit spannt.
– Stuart Comers, Kurator für Film, Tate Modern, London

Eine heisse Windbeutelei.
– Terry Frank, *The Cleveland Daily*

STURTEVANT, SPINOZA IN LAS VEGAS, 2007, performance, Tate Modern, London.

EDITION FOR PARKETT 88

STURTEVANT

DIALOGUE OF THE DOGS, 2005 / 2011

Animated film, 1 min. loop, on DVD,
with case, inserted in Parkett 88.
Ed. 35 / XX, with signed and numbered certificate.

Animierter Film, 1 Min. Loop, auf DVD,
in Hülle, eingelegt in Parkett 88.
Auflage 35 / XX, signiertes und nummeriertes Zertifikat.

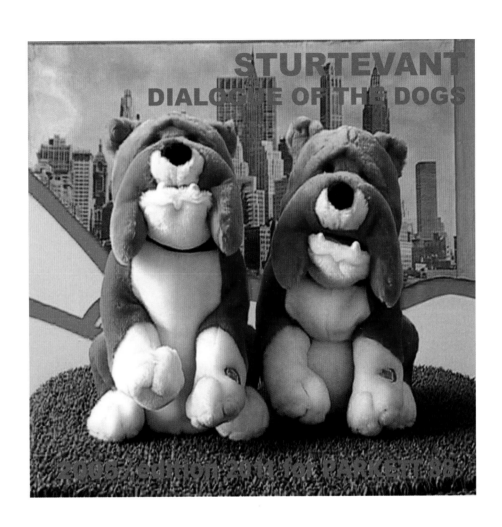

STURTEVANT
DIALOGUE OF THE DOGS

2005, edition 2011 for PARKETT 88

Andro

Wekua

Homesickness Is Where the Heart Is

DOUGLAS FOGLE

ANDRO WEKUA, PINK WAVE HUNTER (GOVERNMENT
BUILDING), 2010/2011, cast bronze, steel, cast concrete,
47 $^1/_2$ x 44 $^7/_8$ x 44 $^7/_8$ " / ROSA WELLEN JÄGER (REGIERUNGS-
GEBÄUDE), Bronzeguss, Stahl, Betonguss, 120 x 114 x 114 cm.

DOUGLAS FOGLE is Chief Curator and Deputy Director of
Exhibitions and Public Programs at the Hammer Museum in Los
Angeles, California.

Krypton is the home that can never be returned to.
—Mike Kelley[1]

They say that you can never go home. It's true. I've
tried. A routine search for my childhood home on
Google Maps reveals a sad and startling truth. Where
there was once a rambling if somewhat charmingly
unkempt house on an equally overgrown plot of land,
there are now two newly-raised, soulless McMansions
packed side by side. No longer can I drive by my for-
mer address and relive the triumphs and traumas of
past personal experiences. All the reveries of child-
hood that were physically embodied in the psychic
architecture of that home have now been obliterated
by the housing bubble, a developer's greed, and a
backhoe. My own experience found its cinematic
counterpart in the film *Grosse Pointe Blank* (1997), a
darkly humorous story of a killer-for-hire who returns
to his suburban Detroit hometown in order to com-
plete one last job before he retires. In the course of
the pursuit of his target, he is mortified to find that
the house that he grew up in has been torn down and
replaced by a convenience store. In place of a sol-
emn moment of nostalgia for his own lost innocence

he is confronted by beef jerky and Coca-Cola. This is hardly the gilded stuff of childhood memories. Superman understood this trauma. His planet Krypton exploded. He too can never go home.

Le Corbusier once called the house a machine for living. It would be more appropriately called a machine for dreaming, as the physical structure of architecture is itself a psychic palimpsest that embodies the memories of dreams and events long since past. This is why buildings are such a trigger for personal memories, and why their loss can seem so traumatic to those who once lived there. Andro Wekua understands this all too well. Like many citizens of the world, he too cannot go home. Born in Sukhumi, Georgia, his family and many other Georgians were forced to flee in the 1990s as a war and subsequent ethnic cleansing washed over the Abkhazian region. This area is now indirectly occupied by Russia, and as a result, Wekua's hometown of Sukhumi, once an extremely popular vacation resort during the Soviet era, has become a semi-empty ghost town. Like many individuals who find themselves in some form of diasporic exile, Wekua became fascinated by the idea of what Sukhumi had become. In his case though it was perhaps not so much a question of a longing for an unattainable return to a mythical homeland but more an obsession with the decaying, arrested development of this once proud and frenetic vacation town. In the end it was a question of architecture and its ability to trigger memories. As Wekua has suggested, "I am more invested in the architecture of this city, and how its nature is being conserved and untouched while being allowed to deteriorate. For me, and for other Georgians from the area, this city is constantly unreachable, a mirage of sorts, and at the end of my conversations with them we always conclude that maybe this city does not and has never existed."[2]

Unable to return to Sukhumi himself, and having not been there for over seventeen years, Wekua

ANDRO WEKUA, PINK WAVE HUNTER (BEACH RESTAURANT DIOSKURIA), 2010/2011, concrete, pebbles, steel, sheet metal, mesh wire, 31 ¹/₂ x 19 ¹/₄ x 10 ⁷/₈" / ROSA WELLEN JÄGER (STRANDRESTAURANT DIOSKURIA), Beton, Kieselsteine, Stahl, Blech, Maschendraht, 80,1 x 49 x 27,7 cm.

ANDRO WEKUA, PINK WAVE HUNTER (HOTEL ABCHASIA), 2010/2011, MDF, painted with wax, aluminum sheet body, 52 $^3/_4$ x 47 $^5/_8$ x 21 $^1/_4$" / ROSA WELLEN JÄGER (HOTEL ABCHASIA), MDF, mit Wachs bemalt, Gehäuse aus Aluminium-blech, 134 x 121 x 54 cm.

began to collect images of the city, relying on friends traveling to the area to take pictures for him while he started downloading the quickly multiplying images of post-war Sukhumi that he found on the internet captured just after the war's end and up to the present moment. Significantly, while this activity has been popular among Georgians from the region who no longer live there, it was only after the artist's brother showed him a photograph of their now-abandoned childhood home that he began building this archive in earnest. To date Wekua's growing collection consists of over 600 images of buildings in Sukhumi in various states of habitability. Some are completely deserted, others are occupied by the residents who remained after the war, and many are falling into ruin. This panoply of images depicts a city full of unreachable buildings each of which triggers a chain of personal reminiscences in the minds of their former inhabitants. Essentially, these images form a dreamscape of an inaccessible land akin to one of Italo Calvino's "invisible cities," or better yet, as the artist suggests, "an empty stage where everybody is waiting for something to happen."[3] Indeed, this theater set is waiting for its players to return from an intermission that doesn't seem to want to end.

After looking at some of the images taken of buildings in Sukhumi just after the war when the city was at its most desolate, Wekua decided to construct sculptures of this now-forlorn architecture. Using his archive of photos, his own memory, and Google Maps, which has recently become available

for the area, Wekua undertook his own psychological real-estate development project, reconstructing maquettes of a number of these buildings based on their popularity in both the internet search engines he was using to find them and the strength of his own personal memories. What is unveiled is a crime scene of sorts in which the act of artistic creation becomes one of forensic architectural psychoanalysis, a deductive partial reconstruction of a remembered city as much as a real city. In essence, he undertakes a kind of alchemical architectural conjuring of his own past through an act of indirect architectonic catharsis.

Some of the buildings that Wekua has chosen to recreate are nondescript, such as a block-like tenement house that he cast from laminated black polyurethane rubber, a pier made of cast aluminum, or a high-rise building made of aluminum and wood. Others are far more specific and well-known buildings by Sukhumi standards, such as his models of Hotel Abkhazia, Main Station Sukhumi, and Hotel Ritsa, each of which is composed of a similarly diverse range of sculptural materials. In some cases Wekua has only reconstructed the façade of a building, as the architectural information required is either unavailable or has faded from his memory. These partial recreations are crucial for understanding these works, as the sculptures do not purport to be actual architectural models but are rather the result of a combination of digital detective work and the sepulchral machinery of memory as it manifests its remembrances. In effect, it is the gaps in his memory that become crucial

as they make these works into follies, architectural monuments that are not rationally functional but stand in as emblems of a desire to reconnect with a lost past, forgotten traumas, and happy reveries.

Mike Kelley took a similar turn in his work when he created EDUCATIONAL COMPLEX (1995), an architectural model mash-up of every school he ever attended along with the house that he grew up in, all rendered from memory with the parts that he could not recall left blank. Kelley became obsessed with his own selective amnesia that caused the gaps in his memory of these buildings, and he has continued to create works that mine those gaps. In one sense, Wekua shares Kelley's questioning of our ability to go home, to fully remember, and to be free of repressed trauma. If for Kelley, however, it is a question of trying to fill in the gaps in repressed memory that he associates with the amnesia brought on by trauma, for Wekua it is more a question of recognizing the irredeemable loss of memory. It is as if a photograph of a significant place in one's life had been left out in the sun, or a Xerox machine had successively made a copy from a copy from a copy until the paper starts to turn black from a degradation of the image. Wekua's method in these works is to engage in a cyclical development that moves from a form that began as an actual architectural maquette, became a fully realized building, and then is transformed into his own half-remembered reconstructed model. The real question asked by these small architectural anti-monuments is: what is lost in this act of translating fading personal memory back into the material world?

Earlier works by Wekua might offer us a clue to answering this question. If these architectural models are strangely devoid of the human figure, the same cannot be said of most of Wekua's work. In his sculpture WAIT TO WAIT (2006), for example, a wax figure of a partially-dressed boy with his face obfuscated by paint sits rocking in a chair that is contained in a small platform/room made of bricks, colored glass panes, and aluminum. This diminutive modernist pavilion seems to be less a building than a time machine and its figure a time traveler that brings to mind the protagonist of Chris Marker's classic 1962 film short *La jetée*. In this film a prisoner in a postapocalyptic society is used in a time-travel experiment to attempt to save civilization from collapse. He is chosen because he holds an unusually strong memory of a trauma from his youth where he witnessed a man being killed on the observation pier at Orly airport. In the dénouement of the narrative, he is transported back to that moment in his childhood when he was followed by agents intent on killing him only to find that the murder he witnessed as a child was his own as an adult. We can almost see Wekua's figure in WAIT TO WAIT straining to transport himself back to Sukhumi. In this case the target location is not Marker's jetty, but a beach restaurant called Dioskuria that embodied the former glamour of this once flourishing Black Sea vacation paradise.

ANDRO WEKUA, PINK WAVE HUNTER (PRIVATE HOUSE), 2010/2011, acrylic plaster, MDF plate, oak slats, 2 x 25 ¹/₂ x 18 ¹/₂" / ROSA WELLEN JÄGER (PRIVATHAUS), Acrylgips, MDF-Platte, Eichenleisten, 5 x 65 x 47 cm.

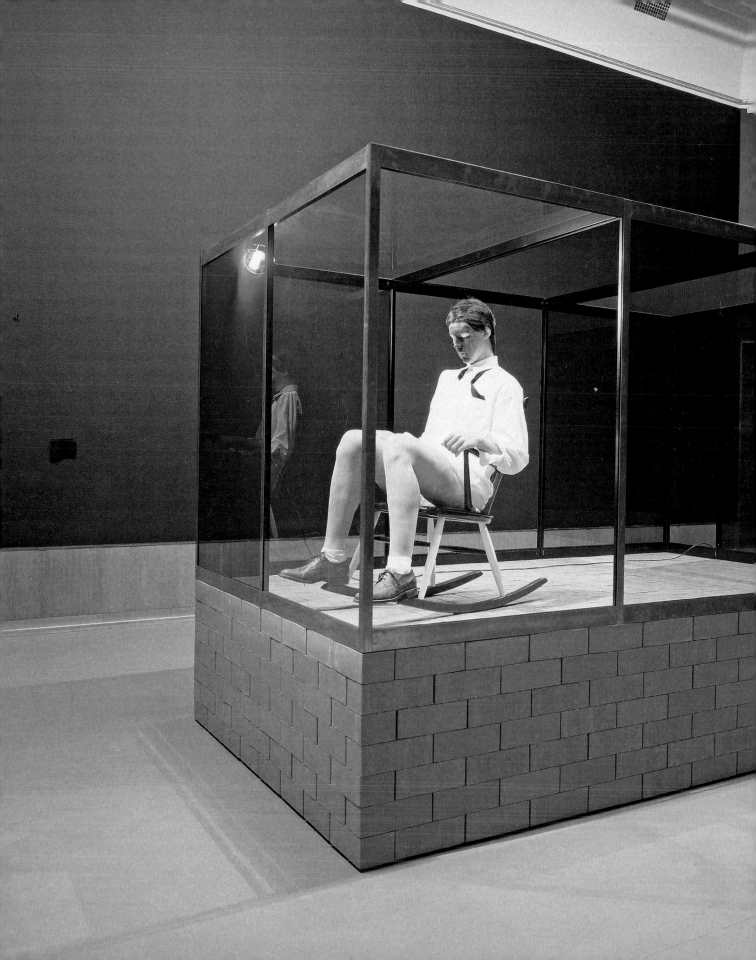

An internet search for this restaurant reveals images of entropy taking hold of its architecture as the restaurant slowly collapses into the sea as a result of neglect and the erosion brought on by the movement of sea, wind, and time. Wekua's sculptural avatar of the restaurant is a model made from concrete, stone, and steel that returns Dioskuria to its original state, or at least to its shiny past as seen in his own memory.

These two works complete a circuit in Wekua's oeuvre, connecting his haunting wax and ceramic figures to his more recent, uncanny architectural project to transport himself back in time and space through the manipulations of both organic and digital memory. Maybe the problem today is that memory is no longer a question of nostalgic reveries into one's past triggered by a single photograph, a smell, or a taste. Proust's tea with Madeleine has been displaced by the internet where memory is now located in cloud servers, no longer grounded in one place or even in one's mind but adrift on the ether of digital bandwidth. Maybe all we have now is Facebook memories. Is Sukhumi a "mirage" as Wekua has suggested? A stage set waiting for its players to arrive? Perhaps. Maybe that's what the idea of home is in the end. Of course, the problem today is that you can't really ever go home. Just ask Superman. We can't help trying though and neither can Andro Wekua.

1) Mike Kelley, "Architectural Non-Memory Replaced with Psychic Reality" in John C. Welchman, ed., *Minor Histories: Statements, Conversations, Proposals, Writing Art* (Cambridge, Mass.: MIT Press, 2004), p. 322.
2) Andro Wekua in correspondence with the author, November 4, 2010.
3) Ibid.

ANDRO WEKUA, WAIT TO WAIT, PART I, 2006, wax figure, lacquered aluminum chair, uncolored and colored glass, brass coated aluminum, bricks, motor, 78 $^3/_4$ x 82 $^3/_4$ x 118 $^1/_8$"; 4 collages, felt pen, pencil on paper, digital color prints, exhibition view Museum Boijmans Van Beuningen, Rotterdam / AUFS WARTEN WARTEN, Wachsfigur, lackierter Aluminiumstuhl, farbiges und farbloses Glas, Messing beschichtetes Aluminium, Ziegelsteine, Motor, 200 x 210 x 300 cm; 4 Collagen, Filzstift, Bleistift auf Papier, digitale Farbdrucke, Ausstellungsansicht.

Heimweh ist, wo das Herz ist

DOUGLAS FOGLE

*Krypton ist die Heimat, in die man nie mehr zurück-
kehren kann.*
– Mike Kelley[1]

Es heisst, es sei unmöglich, nach Hause zurückzukeh-
ren. Das stimmt. Ich habe es versucht. Die Routinesu-
che nach dem Zuhause meiner Kindheit mit Google
Maps bringt eine traurige und verstörende Wahrheit
an den Tag. Wo einst ein weitläufiges, sympathisch
verlottertes Haus auf einem nicht minder verwil-
derten Grundstück stand, drängen sich nun Seite
an Seite zwei neue, seelenlose Nullachtfünfzehn-
Protzvillen. Ich kann nicht mehr an meiner früheren
Adresse vorbeifahren und die triumphalen und trau-
matischen Momente meiner eigenen Vergangenheit
Revue passieren lassen. Alle in der psychischen Archi-
tektur dieses Zuhauses konkret verkörperten Kind-
heitsträume wurden durch die Immobilien-Blase,
die Gier eines Bauunternehmers und einen Löffel-
bagger ausgelöscht. Im Film *Gross Point Blank* (1997)
fand ich eine Entsprechung zu meiner eigenen Er-
fahrung. Er erzählt mit viel schwarzem Humor die

Geschichte eines Auftragskillers, der an seinen Hei-
matort, eine Vorstadtgegend in Detroit, zurückkehrt,
um dort einen letzten Job zu erledigen, bevor er sich
zur Ruhe setzen will. Beim Verfolgen seiner Zielper-
son stellt er bestürzt fest, dass das Haus, in dem er
aufgewachsen ist, abgebrochen und durch einen
Supermarkt ersetzt wurde. Statt einen feierlichen
Sehnsuchtsmoment lang seiner eigenen verlorenen
Unschuld nachzuhängen, sieht er sich mit Trocken-
fleisch und Coca-Cola konfrontiert. Das ist nicht der
Stoff, aus dem die goldenen Kindheitserinnerungen
sind. Auch Superman kannte dieses traumatische Er-
lebnis. Sein Planet Krypton ist explodiert. Auch er
kann nie mehr nach Hause zurück.

Le Corbusier hat das Haus einst als Wohnma-
schine bezeichnet. Eigentlich müsste es eher Traum-
maschine heissen, da die konkrete Struktur der Ar-
chitektur an sich schon ein psychisches Palimpsest
darstellt, das die Erinnerungen an Träume und
Geschehnisse aus einer längst vergangenen Zeit ver-
körpert. Deshalb sind Gebäude so starke Auslöser
für persönliche Erinnerungen und deshalb kann ihr
Verlust auf Menschen, die früher darin lebten, so
traumatisch wirken. Andro Wekua versteht das nur
zu gut. Wie viele Bürger dieser Welt kann er nicht
mehr in seine Heimat zurückkehren. Geboren in

DOUGLAS FOGLE ist leitender Kurator und Direktor des
Ausstellungs- und Veranstaltungsprogramms am Hammer Muse-
um in Los Angeles, Kalifornien.

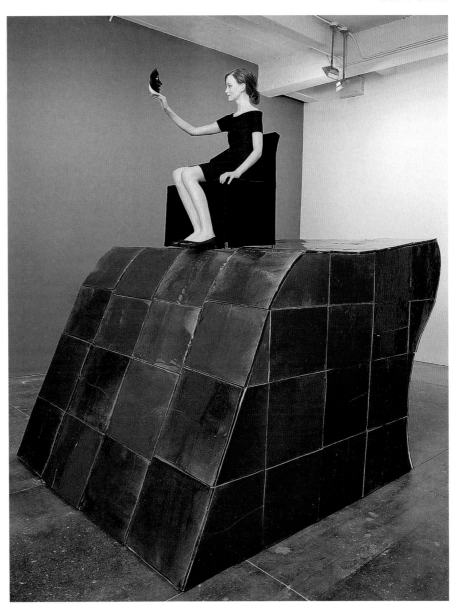

ANDRO WEKUA, WAVE FACE, 2002,
wax figure, ceramic, wood, fabric,
hair, lacquer, 108 x 79 x 94", exhibi-
tion view Gladstone Gallery, New York /
WELLEN GESICHT, Wachsfigur,
Keramik, Holz, Textilien, Haar, Lack,
274,3 x 200,7 x 238,8 cm, Ausstel-
lungsansicht.

Suchumi, Georgien, sah sich seine Familie wie viele andere Einwohner Georgiens in den 90er-Jahren zur Flucht gezwungen, als ein Bürgerkrieg und die damit verbundene «ethnische Säuberung» über Abchasien hereinbrachen. Diese Region ist nun indirekt von Russland besetzt, mit dem Resultat, dass Wekuas Heimatort Suchumi – während der Sowjetherrschaft im Baltikum einst ein beliebter Ferienort – zu einer halb entvölkerten Geisterstadt verkommen ist. Wie viele Menschen, die durch das Exil in alle Winde zerstreut worden sind, interessierte es auch Wekua brennend, was aus Suchumi geworden war. Zwar ging es in seinem Fall wohl nicht sosehr um die Sehnsucht nach der unerreichbaren Rückkehr in eine mythische Heimat, sondern eher um ein Besessensein durch den Zerfall und die ins Stocken geratene Entwicklung des einst so stolzen und betriebsamen Ferienortes. Letztlich war es eine Frage der Architektur und ihrer

*ANDRO WEKUA, UNTITLED,
2010, silicon, copper, steel pro-
files, 78 ³/₄ x 59 x 5 ¹/₈" /
OHNE TITEL, Silikon, Kupfer,
Stahlprofile, 200 x 150 x 13 cm.*

Fähigkeit, Erinnerungen wachzurufen. Wie Wekua selbst meinte: «Mich beschäftigt mehr die Architektur dieser Stadt und wie ihr Charakter unversehrt und unangetastet bleibt, obwohl sie dem Verfall preisgegeben ist. Für mich und andere Georgier aus der Region bleibt die Stadt unerreichbar, eine Art Fata Morgana, und am Ende unserer Gespräche kommen wir immer zum Schluss, dass es diese Stadt vielleicht gar nicht gibt und nie gegeben hat.»[2]

Da Wekua selbst nicht nach Suchumi zurückkehren konnte und seit über siebzehn Jahren nicht mehr dort gewesen war, begann er Bilder der Stadt zu sammeln. Dabei war er auf Freunde angewiesen, die in die Region reisten, um für ihn zu photographieren, während er selbst begann, die rasch zunehmende Zahl an Nachkriegsbildern von Suchumi im Internet – von unmittelbar nach Kriegsende bis heute – herunterzuladen. Und obwohl dies ein unter Exilgeorgiern aus dieser Region beliebter Zeitvertreib war, begann Wekua bezeichnenderweise erst ernsthaft an diesem Archiv zu arbeiten, nachdem sein Bruder ihm eine Photographie ihres eigenen, nun verlasse-

nen Elternhauses gezeigt hatte. Heute umfasst Wekuas wachsende Sammlung über sechshundert Bilder von Gebäuden in Suchumi, deren Zustand und Bewohnbarkeit stark variieren. Einige sind völlig verlassen, andere wurden von Leuten besetzt, die nach dem Krieg dortgeblieben waren, und viele verfallen zu Ruinen. Die reiche Bilderpalette zeigte eine Stadt voller unerreichbarer Gebäude, von denen jedes einzelne in den Köpfen seiner früheren Bewohner eine ganze Kette persönlicher Erinnerungen wachruft. Eigentlich fügen sich diese Bilder zur Traumlandschaft eines unerreichbaren Landes, ähnlich einer von Italo Calvinos «unsichtbaren Städten» oder noch besser, wie der Künstler selbst sagt: «eine(r) leere(n) Bühne, wo alle darauf warten, dass etwas passiert».[3] Tatsächlich scheint diese Theaterkulisse nur darauf zu warten, dass die Schauspieler nach einer nicht enden wollenden Pause endlich zurückkehren.

Nachdem er einige Bilder von Gebäuden in Suchumi angeschaut hatte, die unmittelbar nach dem Krieg entstanden waren, als die Stadt völlig am Boden lag, entschloss sich Wekua, Skulpturen der verlasse-

nen Häuser nachzubauen. Mithilfe seiner Archivphotos, seines Gedächtnisses und von Google Maps (das für diese Region erst seit Kurzem verfügbar ist) nahm Wekua sein eigenes psychologisches Immobilienprojekt in Angriff: Er rekonstruierte Modelle einer Reihe von Gebäuden gestützt auf deren Popularität bei den verwendeten Internetsuchmaschinen und auf die Intensität der eigenen Erinnerung. Dabei wird eine Art Schauplatz des Verbrechens aufgedeckt, wo der künstlerische Schaffensakt zu einem forensischen Akt einer architektonischen Psychoanalyse wird, eine deduktive Teilrekonstruktion einer ebenso sehr erinnerten wie realen Stadt. Eigentlich vollzieht Wekua eine Art alchemisch-architektonische Beschwörung seiner eigenen Vergangenheit durch einen Akt indirekter architektonischer Katharsis.

Einige der nachgebildeten Gebäude sind nichtssagend, etwa eine blockartige, in schwarzem Polyurethan-Gummi gegossene Mietskaserne, ein Landesteg in Aluminiumguss oder ein Hochhaus aus Aluminium und Holz. Andere sind – gemessen an den lokalen Massstäben – sehr viel spezieller und bekannter, wie seine Modelle des Hotels Abchasia, des Hauptbahnhofs Suchumi und des Hotels Ritsa; sie alle bestehen aus einer ähnlich uneinheitlichen Fülle plastischer Materialien. In einigen Fällen rekonstruierte Wekua nur die Fassade eines Gebäudes, da die nötige architektonische Information entweder nicht aufzutreiben war oder weil er sich nicht mehr daran erinnert. Diese Teilrekonstruktionen sind entscheidend für das Verständnis dieser Arbeiten, da die Skulpturen keine eigentlichen Architekturmodelle sein wollen, sondern eher das Ergebnis einer Mischung aus digitaler Detektivarbeit und vom Begräbnisapparat des Gedächtnisses ausgespuckten Erinnerungen. Tatsächlich sind es die Gedächtnislücken, die entscheidend sind, da sie diese Arbeiten zu eigentlichen «Follies» machen, zu Architekturdenkmälern, die keine rationale Funktion haben, sondern symbolisch die Sehnsucht danach verkörpern, wieder Verbindung aufzunehmen mit der entschwundenen Vergangenheit, vergessenen Traumata und glücklichen Träumereien.

Eine ähnliche Richtung hat Mike Kelley mit EDUCATIONAL COMPLEX (Schulanlage, 1995) eingeschlagen, einem Architekturmodell, in das jede

Schule, die er besucht hatte, und auch das Haus, in dem er aufgewachsen war, eingegangen ist. Alles war aus dem Gedächtnis wiedergegeben und Elemente, an die er sich nicht mehr erinnern konnte, blieben ausgespart. Bei Kelley war es so, dass ihn seine eigene selektive Amnesie, die für die Lücken in seiner Erinnerung an diese Gebäude verantwortlich war, gar nicht mehr losliess. Deshalb schuf er weiterhin Arbeiten, die in diesen Lücken stocherten. In einem gewissen Sinn stellt Wekua unsere Fähigkeit, nach Hause zurückzukehren, wie Kelley in Frage, um die Erinnerung wiederherzustellen und sich von einem verdrängten Trauma zu befreien. Doch während es bei Kelley darum geht, die Lücken einer verdrängten Erinnerung zu füllen, die er mit dem durch ein traumatisches Erlebnis verursachten Gedächtnisverlust in Verbindung bringt, geht es bei Wekua eher darum, das Unwiederbringliche der verlorenen Erinnerung anzuerkennen. Es ist, als sei eine Photographie von einem Ort, der im eigenen Leben einst eine wichtige Rolle spielte, in der Sonne liegen geblieben,

ANDRO WEKUA, THE BIG PLAYER, 2007, patinated and painted bronze, 33 $^1/_2$ x 17 $^3/_4$ x 29" / DIE GROSSE NUMMER, patinierte und bemalte Bronze, 85 x 45 x 73,5 cm.

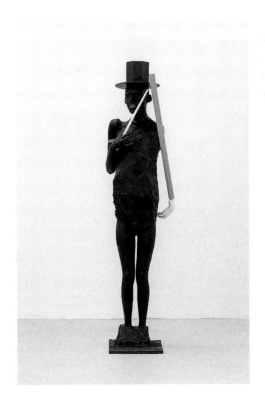

oder als habe ein Kopierapparat laufend eine Kopie der Kopie der Kopie erstellt, bis das Bild sich auflöste und nur noch schwarzes Papier übrigblieb. Bei diesen Arbeiten ist Wekuas Vorgehen wie folgt: Er leitet eine zyklische Entwicklung ein, die von der Form des Architekturmodells ausgeht, zum in allen Einzelheiten realisierten Gebäude heranwächst, um sich dann in sein eigenes unvollständig erinnertes und rekonstruiertes Modell zu verwandeln. Die eigentliche Frage, die diese kleinen architektonischen Antidenkmäler stellen, lautet: Was bleibt bei diesem Übersetzungsvorgang von der verblassenden persönlichen Erinnerung zurück in die reale Welt auf der Strecke?

Einen Hinweis zur Beantwortung dieser Frage bieten vielleicht frühere Werke Wekuas. Die Architekturmodelle sind seltsam menschenleer, das ist jedoch bei anderen Arbeiten Wekuas im Allgemeinen nicht der Fall. Die Skulptur WAIT TO WAIT (Aufs Warten warten, 2006) zeigt beispielsweise die Wachsfigur eines halbbekleideten jungen Mannes, dessen Gesicht mit Farbe bedeckt ist, in einem Schaukelstuhl sitzend, der wiederum in einem kleinen Raum steht, der aus einem Backsteinsockel, Aluminiumrahmen und farbigen Glasscheiben besteht. Der sehr kleine moderne Pavillon wirkt weniger wie ein Gebäude als wie eine Zeitmaschine, und die Figur darin wirkt wie ein Zeitreisender, der an die Figur aus Chris Markers Science-Fiction-Kurzfilmklassiker *La jetée* (1962) erinnert. In diesem Film muss ein Gefangener in einer postapokalyptischen Zivilisation für ein Zeitreise-Experiment herhalten, das die Menschheit vor dem Untergang bewahren soll. Die Wahl fällt auf ihn, weil er eine ungewöhnlich starke Erinnerung an ein traumatisches Kindheitserlebnis bewahrt hat: Er hatte am Flughafen die Ermordung eines Mannes mitangesehen. Im Lauf der Geschichte wird er in jenen Moment seiner Kindheit zurückversetzt, verfolgt von Agenten, die ihn töten wollen, um schliesslich herauszufinden, dass die Ermordung, die er als Kind miterlebt hatte, seine eigene war. Wekuas Figur in WAIT TO WAIT ist fast anzusehen, wie sehr er sich bemüht, sich nach Suchumi zurückzuversetzen. In diesem Fall ist der Zielort nicht Markers Flughafenterrasse, sondern ein Strandrestaurant namens Dioskuria, das für den verblassten Glanz dieses einst so

stolzen Ferienparadieses am Schwarzen Meer steht. Eine Internet-Recherche nach diesem Restaurant fördert Bilder zutage, die zeigen, wie das Gebäude seiner entropischen Auflösung entgegengeht: Verwahrlost, der Erosion durch Wind, Wasser und Zeit preisgegeben, rutscht es langsam aber sicher ins Meer. Wekuas plastischer Avatar dieses Restaurants ist ein Modell aus Beton, Stein und Stahl, welches das Dioskuria wieder in seinen ursprünglichen Zustand versetzt, oder zumindest in die glanzvolle Vergangenheit, die er in Erinnerung hat.

Diese beiden Arbeiten schliessen einen Kreis in Wekuas Werk, indem sie seine eindrücklichen Wachs- und Keramikfiguren mit seinem neueren unheimlichen Architekturprojekt verbinden. Dieses erlaubt ihm, sich mittels Manipulation des menschlichen wie des digitalen Gedächtnisses durch Zeit und Raum zurückzuversetzen. Vielleicht besteht das Problem heute darin, dass es bei der Erinnerung nicht mehr um ein nostalgisches Hineinträumen in die eigene Vergangenheit geht, das durch eine einzelne Photographie, einen Geruch oder einen Geschmack ausgelöst wird. Prousts Tee mit Madeleine ist vom Internet verdrängt worden, wo die Erinnerung in sogenannten Cloud-Servern wohnt und nicht mehr an einem bestimmten Ort oder gar im eigenen Gedächtnis zu finden ist, sondern im Äther der digitalen Bandbreite schwimmt. Facebook-Erinnerungen sind womöglich alles, was wir heute noch haben. Ist Suchumi eine Fata Morgana, wie Wekua meinte? Eine Bühne, die nur darauf wartet, von den Schauspielern wieder betreten zu werden? Vielleicht. Vielleicht läuft die Idee des Zuhause letztlich darauf hinaus. Natürlich ist das Problem heute, dass wir nicht mehr wirklich nach Hause gehen können. Nicht einmal Superman. Wir können aber gar nicht anders, als es trotzdem zu versuchen, auch Andro Wekua nicht.

(Übersetzung: Suzanne Schmidt)

1) Mike Kelley, «Architectural Non-Memory Replaced with Psychic Reality», in John C. Welchman (Hg.), *Minor Histories: Statements, Conversations, Proposals, Writing Art*, MIT Press (Cambridge, Mass., 2004), S. 322.
2) Andro Wekua im Briefwechsel mit dem Autor, 4. November 2010.
3) Ebenda.

19

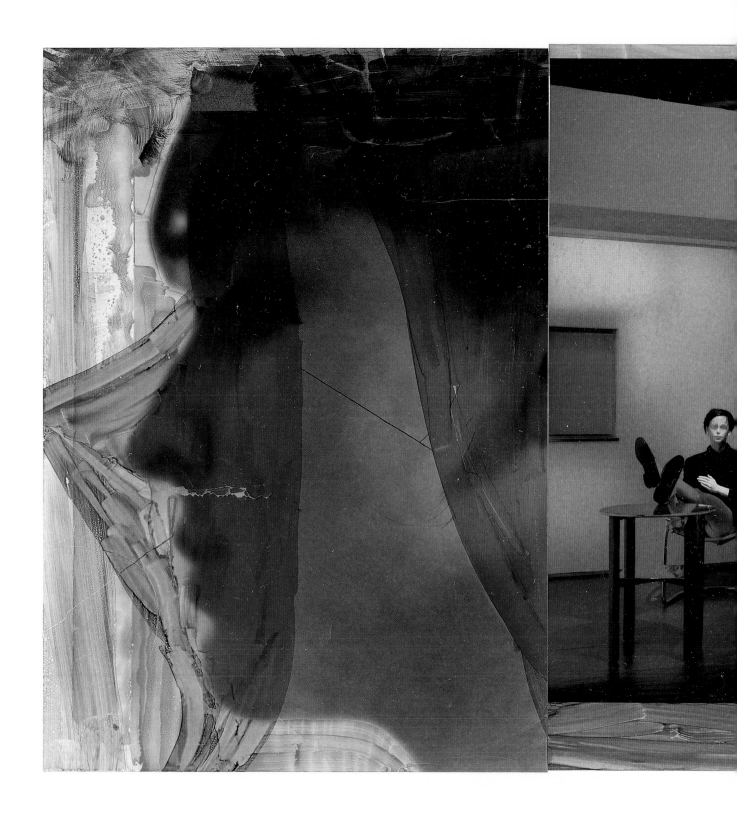

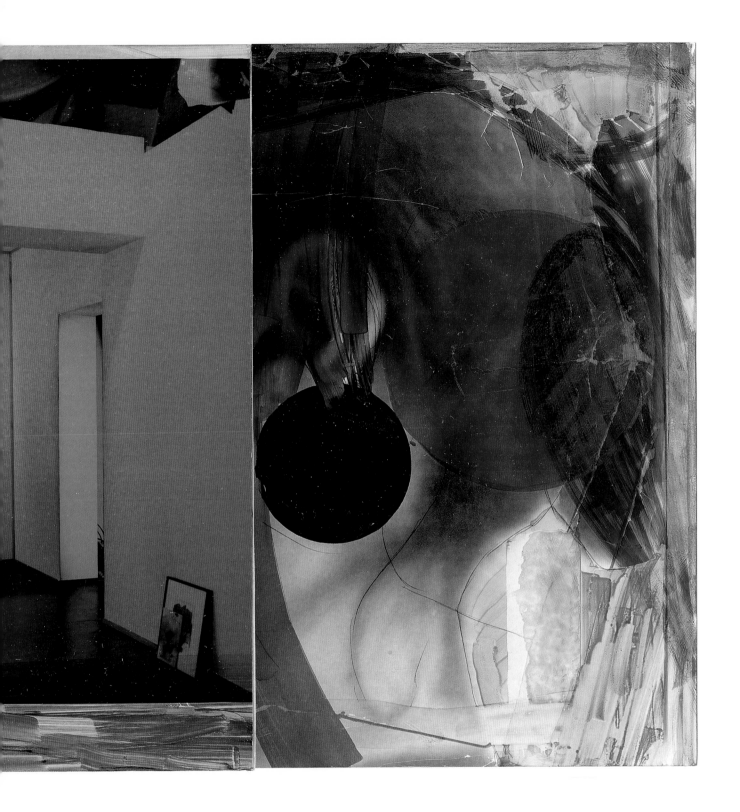

*ANDRO WEKUA, CALLING OVER, 2007, collage, felt pen, ball pen on photo, 6 x 14 ¹/₈" /
HERÜBERRUFEND, Collage, Filzstift, Kugelschreiber auf Photographie, 15 x 36 cm.*

173

DANIEL BAUMANN

Vollendeter Stil schlägt gesunden Menschenverstand

Aston Martin Lagonda

Sie lesen einen Artikel über den Aston Martin Lagonda, einen grossen Einzelgänger der Automobilkunst, von dem zwischen 1978 und 1990 645 Exemplare gebaut wurden und der sich bis in den Kongo, den Iran und nach Simbabwe verkaufte. «Wer um das Jahr 1980 herum ein auffälliges Luxusauto fahren wollte, musste je nach Geschmack auf einen Rolls-Royce Camargue oder einen Aston Martin Lagonda zurückgreifen – oder, falls man ein erfolgreicher Pornostar war, auf einen Stutz Blackhawk.»[1] Uns interessiert dieses Auto wegen seiner Unangemessenheit, seiner verstörenden Erscheinung und dem Werbeslogan, mit dem es 1982 in den amerikanischen Markt eingeführt wurde: «Entmutige Deinen Nachbarn»[2]. Und für die Lobpreisungen, die der Lagonda bis heute hervorruft: «Die 70er-Jahre waren verheerend für die britische Automobilindustrie. Die Arbeiter streikten die meiste Zeit und wenn nicht,

DANIEL BAUMANN ist Kurator der Adolf-Wölfli-Stiftung, Kunstmuseum Bern, und kuratiert, zusammen mit Dan Byers und Tina Kukielski, die Carnegie International 2013.

bauten sie Schrott. Aber in diesem Jahrzehnt waren wir auch so risikofreudig und verwegen wie keiner sonst. Das Resultat war der Aston Martin Lagonda, das schockierendste Auto im Jahr 1976 und meines Wissens auch 2003. Haben Sie von dem Forscher Ranulph Fiennes gelesen? Nach einer dreifachen Bypassoperation rannte er sieben Marathons. Wahnsinn! Der Lagonda ist Ranulph Fiennes. Vollendeter Stil schlägt gesunden Menschenverstand! Damals in den 70er-Jahren, als Aston Martin pleite war und der Rettungsplan anlief, hätten sie doch alle auf Nummer sicher gehen müssen. Bloss keine Dummheiten – und dann das!»[3]

Die Geschichte der Firma Lagonda ist eine Abfolge von Krisen, aber am Anfang steht immerhin ein Opernsänger als Gründer, der 1920 verstorbene Wilbur Gunn. In den 20er- und 30er-Jahren war die Marke vor allem mit Sportwagen erfolgreich, ihren grössten Triumph feierte sie 1935, als der Lagonda Rapide M45 das 24-Stunden-Rennen von Le Mans gewann. 1947 übernahm der autobegeisterte Grossindustrielle David Brown die beiden Firmen Aston Martin und Lagonda und führte ihre Technologien zusammen.[4] Zwischen 1947 und 1976 kamen insgesamt vier Lagonda-Modelle auf den Markt: 1947 der Lagonda 2.6-litre (486 Stück), 1953 der Lagonda 3-litre (76 Stück), 1961 der Lagonda Rapide (55 Stück) und 1974 sieben Stück vom Aston Martin V8 Lagonda mit serienmässiger Zentralverriegelung und Philips-Kassettenradio, das auch als Diktiergerät genutzt werden konnte.[5] 1972 musste sich David Brown wegen Geldproblemen von Aston Martin trennen, die Firma hatte während all der Jahre nur einmal einen kleinen Gewinn erwirtschaftet. Für 100 Pfund wurde sie von einer Investorengruppe übernommen, aber bereits 1974 meldete diese Konkurs an, was die Angestellten während des Frühstücks aus den Morgennachrichten erfuhren.[6]

Nach dem Flop des Aston Martin V8 Lagonda, der nicht viel mehr war als ein viertüriger Aston Martin, entschlossen sich die neuen Investoren (die bald auch wieder gingen), den Aston Martin Lagonda als eigenständiges Modell auf den Markt zu bringen. Die technische Entwicklung übernahm Mike Loasby, das Design der Brite William Towns – und es entstand das «schockierendste Auto der Welt». Towns gehört zu den eigenwilligsten Designern der Automobilgeschichte, von ihm stammt der legendäre Aston Martin Bulldog, ein strassentaugliches Rennauto, aber auch der Guyson E12 für Jim Thomson, den Direktor von Guyson International. Er hatte unterwegs die Kontrolle über seinen E-Type-Jaguar verloren und anstatt die Karosserie reparieren zu lassen, beauftragte er Towns, ein völlig neues, rasiermesserscharfes Chassis zu bauen. Bekannt wurde Towns insbesondere durch den Hustler, ein Kleinauto, das auf einem modularen Konzept beruhte und das in Form eines Kits zum Selberbauen ausgeliefert wurde, sodass jedes Auto anders aussehen konnte – und doch nicht.[7] Denn das Grundprinzip war eine kantige Schachtel auf vier oder sechs Rädern, deren Innenraum nicht weniger gewöhnungsbedürftig war: kantinenartige Stühle auf schwarzen Plastikmatten, beim Einsteigen schob man die fensterartige Türe wie in einer Dusche zur Seite. Überhaupt glich der Hustler einer Sauna auf Rädern und einige wurden auch aus Holz angefertigt (heutige Besitzer beklagen auf Internetforen die Angst vor Holzwürmern).

Die Krönung von Towns Designerkarriere war jedoch der Aston Martin Lagonda.

Die Wertschätzung für seine eigenartige und ausserordentliche Schönheit hat über die Jahre weiter zugenommen, und sie dringt auch im nüchtern gehaltenen Beschrieb auf Wikipedia noch unverkennbar durch: «Insgesamt handelte es sich bei dem Lagonda S2 um eine extreme Interpretation des klassischen Folded-Paper-Stils. Damals galt das Design als noch unkonventioneller als heute. Automobilenthusiasten streiten sich bis heute über den ästhetischen Wert dieses Fahrzeuges. Mit der ungewöhnlichen Form des Äusseren korrespondierte eine zukunftsweisende Instrumentierung. Anstelle herkömmlicher analoger Anzeiger verwendete der Lagonda ausschliesslich digitale Instrumente. Die wesentlichen Informationen wie Geschwindigkeit, Drehzahl usw. wurden auf einem Display im Instrumententräger mit LED-Technik angezeigt. Darüber hinaus liessen sich die meisten Funktionen wie Licht und Scheibenwischer über Sensortasten betätigen. Selbst das automatische Getriebe sollte über Sensortasten bedient werden; davon nahm das Werk allerdings bereits zu Beginn der Serienproduktion Abstand. Die Instrumentierung erwies sich als Quelle zahlloser Probleme»[8] und frass vier Mal mehr Geld, als für die gesamte Entwicklung des Lagondas ausgegeben wurde.

Der Aston Martin Lagonda war ein Luxusgefährt und ein Luxusgefährte, der nicht immer gut funktionierte, aber dessen Auftritt schwindelerregend war. Der Folded-Paper-Stil ist heute in Vergessenheit geraten, aber er war in den 70er-Jahren stilprägend, nicht zuletzt wegen des vom renommierten italienischen Autodesigner Giorgetto Giugiaro entworfenen BMW M1. Towns hatte ihn jedoch so weit entwickelt, dass sein Aston Martin Lagonda die Mode der 80er-Jahre vorauszunehmen schien und uns heute an Thierry Muglers Kreationen erinnert, an die gepolsterten Schultern und scharf geschnittenen Silhouetten. Der Lagonda war also keineswegs ein Aussenseiter, denn es gab zu dieser Zeit einige andere ausgefallene Autos wie beispielsweise den Gremlin, den Pacer, den De Lorean DMC-12, den De Tomaso Pantera, den Bricklin SV-1 oder den Monteverdi Hai. Aber keiner hatte es gewagt, die Sportwagen-Rasierklingenschärfe so kompromisslos auf den Typ der viertürigen Luxuslimousine anzuwenden. Das ist sicher einer der Gründe, warum der Lagonda bis heute auffällt: weil er zwei Welten verbindet, die üblicherweise getrennt bleiben: die Welt des Sportwagens und des Luxuscruisers. Denn der wirklich Reiche kann sich beides leisten, sodass der Lagonda als Hybrid immer die im Grunde peinliche Frage stellt: Fährst du Aston Martin Lagonda, weil du nicht genug Geld hast für einen Lamborghini? Oder umgekehrt: Fährst du Aston Martin Lagonda, weil du nicht genug Geld hast für einen Rolls-Royce Silver Spirit?

Vom Aston Martin Lagonda gab es die Series 2 (462 Stück), die Series 3 (76 Stück) und die Series 4 (98 Stück), wobei die Grundform über die zwölf Jahre dieselbe blieb. Zu den grösseren Veränderungen gehörte, dass bei der Series 3 die scharfkantige Form etwas abgemildert wurde, während bei der Series 2 unter anderem drei kleine TV-Monitore eingeführt wurden, welche die Funktionen herkömmlicher Anzeigeninstrumente übernahmen und dabei Angaben wie Geschwindigkeit via Head-Up-Display in die Frontscheibe einspiegelten.[9]

Für Kunstinteressierte sind dies mehr oder weniger bedeutsame Informationen und es fragt sich, warum man sich überhaupt für Autos interessieren soll, wo sie doch der Umwelt schaden und so weiter. «Vollendeter Stil schlägt gesunden Menschenverstand», sagte der

Kommentator 2003 auf Top Gear BBC TV und genau das ist es, warum uns auch Kunst interessiert. Wobei es hier nicht darum geht, ob Autos auch Kunst sind. Aber was uns am Lagonda wirklich interessiert, ist: Sieht so ein aussergewöhnlicher Gedanke aus, wenn man ihm Form gibt? Die Literatur und die Philosophie verwenden dazu Buchstaben, die Musik setzt Töne und die Kunst arbeitet mit handfestem Material und seinem Widerstand. Buchstaben und Töne scheinen im Vergleich dazu widerstandslos. Noch gegenstandsloser als Worte, Bilder oder Töne sind die Gedanken selbst, die massgeblich für die Ausbildung der Innenwelt verantwortlich sind. Es ist nochmals eine andere, unzugängliche Welt und doch so gegenwärtig. Obschon wir immer «draussen» rumgehen, präsent sind, mit Leuten sprechen und die Treppe hochsteigen, «erwachen» wir manchmal und stellen fest, wie viel Zeit wir wieder in den Gedanken verbracht haben, «in Gedanken versunken», «in Erinnerungen verloren» oder «am Träumen». Nun ist offenbar eines der vielen Vorhaben der Kunst, dieser Zeit und Welt Form zu geben und Gegenwart zu verschaffen, wohl auch, um sie dingfest zu machen und festzuhalten. Das grosse Problem besteht darin – und es ist eine Art Katastrophe –, dass der Gedanke im Moment der Umwandlung viel an die Form und vor allem an das Material abgeben muss. Sie fordern ihren Tribut, denn Stein, Holz, Papier oder Bronze lassen nicht alles mit sich machen und sprechen immer auch für sich selbst, egal, zu welchem Zweck sie gebraucht werden. Auf den ersten Blick hat die Kunst hier einen Nachteil, denn der Verlust scheint im Falle der Buchstaben und Töne kleiner zu sein, da sie weit weniger «Ding» sind. In Wirklichkeit funktioniert die Umwandlung aber erst genau in diesem Moment, weil es Form und Material sind, die den Gedanken tragen und nach draussen in den Raum transportieren, wo wir mit unserem Körper sind. Wir begegnen ihm, wie einem Aston Martin Lagonda, der, davon bin ich überzeugt, in Wahrheit ein Gedanke ist, in dem wir Platz nehmen, um durch die Stadt zu fahren, unhaltbar elegant, dysfunktional und V8.

1) *Thoroughbred & Classic Cars*, Heft 9/2003, zitiert in http://de.wikipedia.org/wiki/Aston_Martin_Lagonda#cite _note-6

2) Michael Browning, «Electric Dream», in *Unique Cars*, No. 290, S. 67.

3) Top Gear BBC TV, 21 December 2003 http://www.youtube.com/watch?v=osrks1t-5a4

4) Siehe Michael Schäfer, *Typenkompass, Aston Martin & Lagonda. Serienmodelle seit 1948*, Motorbuch-Verlag, Stuttgart 2008.

5) Ibid., S. 113–117.

6) Ibid., S. 7.

7) Siehe dazu Keith Adams, Hustler auf http://www.aronline.co.uk/index.htm?townshustlerf.htm

8) http://de.wikipedia.org/wiki/Aston_Martin_Lagonda

9) Siehe Fussnote 3, S. 120–121.

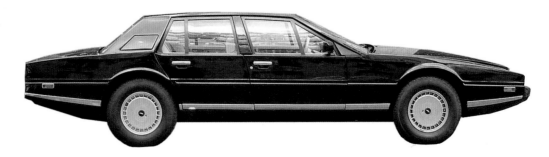

DANIEL BAUMANN

It Defies Common Sense in Spectacular Style

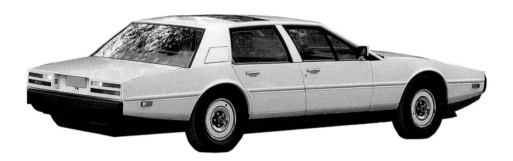

Aston Martin Lagonda

You are reading an article about the Aston Martin Lagonda, one of the great mavericks in the art of the automobile. The 645 cars that were built between 1978 and 1990 sold as far afield as Congo, Iran, and Zimbabwe. "Anyone interested in buying a conspicuous luxury car around the year 1980 had to go for a Rolls-Royce Camargue or an Aston Martin Lagonda depending on their taste—or, if you were a successful porn star, a Stutz Blackhawk."[1] We are interested in this car because it is so immoderate, so disconcertingly daring and because the slogan used to launch it on the American market in 1982 read: "Discourage your neighbor."[2] Another factor is the ceaseless adulation that it still elicits today.

DANIEL BAUMANN, curator of the Adolf-Wölfli-Stiftung, Kunstmuseum Bern, is curating the 2013 Carnegie International in collaboration with Dan Byers and Tina Kukielski.

The 1970s were a desperate time for British cars. The workers spent all week on strike and when they did turn up they built rubbish. But this was also the decade when we were supreme in one area: boldness, risk taking. This is the Aston Martin Lagonda, the most shocking car in the world in 1976, and to my mind still the most shocking in 2003. Have you read in the paper recently about the explorer Sir Ranulph Fiennes? He had a triple heart bypass operation and then he went and ran seven marathons. Madness! This car is Sir Ranulph Fiennes. It defies common sense in spectacular style. Back in the mid-seventies, Aston Martin had just gone bust and been bailed out, so logically they should have played safe with their next car. No silly risks. And then they did this![3]

The Lagonda company suffered one crisis after the other. Founded by opera singer Wilbur Gunn, who died in 1920, the brand made a name for itself in the twenties and thirties primarily for its sports models, chalking up its greatest success when the Lagonda Rapide M45 took first place in Le Mans in 1935. In 1947, auto enthusiast and industrialist David Brown acquired and merged the technologies of the two companies Aston Martin and Lagonda.[4] Four models were launched between 1947 and 1976: the 1948 2.6 liter Lagonda (production: 486), the 1953 3 liter Lagonda (production: 76), the 1961 Lagonda Rapide (production: 55), and in 1974, seven Aston Martin V8 Lagonda saloons with central locking and a Philips Cassette Radio, which could also be used for dictation.[5] In 1972 Brown sold Aston Martin to a consortium for 100 pounds; in all those years between 1947 and 1972, the financially troubled company had only once been able to eke out a slight profit. Just two years later, while listening to the morning news at breakfast, its employees learned that the company had gone bankrupt.[6]

After the flop of the Aston Martin V8 Lagonda, which was little more than a four-door Aston Martin, new investors (who did not last long either) decided to market the Aston Martin Lagonda as an independent model. The outcome, engineered by Mike Loasby and designed by British stylist William Towns, was "the most shocking car in the world." Towns, one of most willful designers in the history of the automobile industry, styled the legendary Aston Martin Bulldog, a roadworthy racing car, as well as the Guyson E12 for Jim Thomson, the director of Guyson International. Thomson had lost control of his E-Type Jaguar and instead of having the bodywork repaired he commissioned Towns to design a completely new,

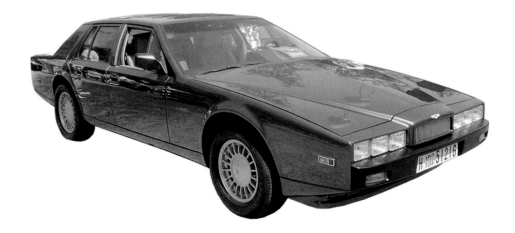

179

razor-sharp body. It was the Hustler and its modular concept that had originally established Towns' reputation. Every model of this small car, available as a do-it-yourself kit, looked different—or maybe not.[7] The basic principle was an angular box on four or six wheels, with an equally outlandish interior: canteen chairs on black rubber matting. The car was accessed like a shower, via sliding glass panels. Actually the whole car looked a bit like a sauna on wheels; some were even made out of wood. (On internet forums, today's owners worry about wood worms.)

Towns' career as a stylist culminated with the Aston Martin Lagonda. Appreciation of its extraordinary and singular beauty has steadily increased over the years, even impacting the matter-of-fact description on Wikipedia. To paraphrase: The Lagonda S2 was an extreme interpretation of the classic "folded paper" style, its design as unconventional then as it is now. Car enthusiasts are fiercely divided on the car's aesthetic value. It was the first production car in the world to use a digital instrument panel with LED displays for speed, rpm, etc. In addition, functions like light and windshield wipers were activated with sensor keys and there were even touch buttons for the automatic gear shift although, by the time serial production began, the plant had already distanced itself from that feature. The failure-prone electronics proved a constant source of trouble and cost more than the entire budget that went into developing the car.[8]

The Aston Martin Lagonda did not always work to perfection, but that hardly diminished the impression made by this mind-blowing luxury vehicle. The folded paper style, forgotten today, made a great impact in the seventies, due in particular to the renowned Italian designer Giorgetto Giugiaro's version of the BMW M1. Towns' design was, in fact, so advanced that his Aston Martin Lagonda prefigured the style of the eighties and now evokes Thierry Mugler's creations with their padded shoulders and sleek silhouettes. The Lagonda was certainly not an outsider in those days, rubbing shoulders with several other outrageous cars, like the Gremlin, the Pacer, the DeLorean DMC-12, the De Tomaso Pantera, the Bricklin SV-1, and the Monteverdi Hai. But no one applied the razor-edge sharpness of the sports car to the four-door luxury limousine with such uncompromising daring. That is no doubt one of the reasons why the Lagonda is still so striking today: it unites the two ordinarily separate and distinct worlds of the sports car and the luxury touring car. Only the truly gilded can afford both, so that the Lagonda as a hybrid always raises the embarrassing question: are you driving an Aston Martin Lagonda because you can't afford a Lamborghini? Or, conversely: are you driving an Aston Martin Lagonda because you can't afford a Rolls-Royce Silver Spirit?

The Aston Martin Lagonda was available in several runs over a period of twelve years: Series 2 (production: 462), Series 3 (production: 76), and Series 4 (production: 98). Basically, the shape of the body remained the same throughout, except that Series 3 was slightly less angular and Series 2 included, among other things, three small TV monitors for the display of the dashboard instruments and a head-up display to beam data like velocity onto the front window.[9]

This is more or less significant information for people interested in art and makes one wonder why anybody should be interested in cars to begin with, since they damage the environment, etc. "It defies common sense in spectacular style," as Top Gear BBC TV's commentator put it in 2003, and that is exactly why we are interested in art. The question is not whether cars are art; what we really want to know about the Lagonda is if it might not actually be what an unusual thought looks like when it's given shape. Literature and philosophy use letters; music uses notes; and art uses solid materials and their resistance. By comparison, letters and notes pose no resistance and thoughts are even less substantial than words, pictures, or sounds. They are largely responsible for the articulation of an inner universe, which is an entirely different, inaccessible world and yet so very present. Although we are always walking around "outside," physically present, talking to people, climbing stairs, we sometimes "wake up," surprised at how much time we have spent thinking, lost in thought, absorbed in memories, or dreaming. Obviously, one of the many objectives of art is to give shape and a tangible presence to the age and the world we live in, possibly so that we can capture and hang onto it. The big problem—and essentially a catastrophe—is that the moment thoughts are transformed, they have to surrender a great deal with regard to form and, even more so, material. They take their toll because stone, wood, paper, and bronze are not unconditionally obliging and always speak for themselves regardless of what they are used for. At first sight, this puts art at a disadvantage; one would think that the loss is somehow less significant for letters and notes because they are so much less concrete. But the crux of the matter lies in the moment of transformation since form and substance are the vehicles that carry a thought out into the spaces that we occupy with our bodies. We approach it as we do an Aston Martin Lagonda, which is—and I'm absolutely convinced of this—a thought in which we take a seat in order to drive to town: indefensibly elegant, dysfunctional, and V8.

(Translation: Ishbel Flett)

1) Thoroughbred & Classic Cars, vol. 9, 2003. http://de.wikipedia.org/wiki/Aston_Martin_Lagonda#cite_note-6

2) Michael Browning, "Electric Dream" in *Unique Cars*, No. 290, 2009, p. 67.

3) Top Gear BBC TV, 21 December 2003 http://www.youtube.com/watch?v=osrks1t-5a4

4) See Michael Schäfer, *Typenkompass, Aston Martin & Lagonda. Serienmodelle seit 1948* (Stuttgart: Motorbuch-Verlag, 2008).

5) Ibid., pp. 113–117.

6) Ibid., p. 7.

7) See Keith Adams, Hustler at http://www.aronline.co.uk/index.htm?townshustlerf.htm

8) http://de.wikipedia.org/wiki/Aston_Martin_Lagonda

9) See footnote 4, pp. 120–121.

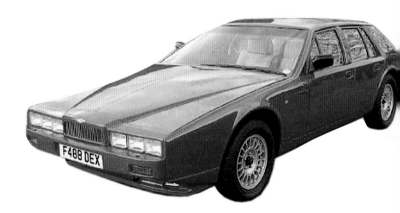

NOTHING AND EVERYTHING AT ONCE

NEGAR AZIMI

When I first met Andro Wekua, I found him shy and standoffish. He would stare at me with his large eyes as if I were the least interesting person in the room, or speaking gibberish, which was a bummer since he had just started going out with one of my friends. Years later, we spoke about it, and I learned that his English (Wekua is Georgian) just hadn't been all that good back then. As it happens, his English has gotten a great deal better, and we have spoken more.

In *The Years* (1937), the last novel Virginia Woolf published in her lifetime, the author recounts the story of a single English family and all the trials and tribulations they endured over the course of some fifty years. Rather than being epic or encyclopedic in scope, Woolf's story is strangely insular, rarely straying beyond the bounds of Britain and mostly built around seemingly insignificant details: the mood, what someone was wearing, the color of the sky. At the very end, all of Woolf's characters are assembled

ANDRO WEKUA, I AM, 2003, collage, plastic, felt pen on paper, 11 ¼ x 8 ½" / ICH BIN, Collage, Kunststoff, Filzstift auf Papier, 28,6 x 21,5 cm.

NEGAR AZIMI is Senior Editor of *Bidoun* magazine.

ANDRO WEKUA, MY BIKE AND YOUR SWAMP (YESTERDAY) 2, 2008, felt pen, paint marker, colored pencil, ball pen on photo, 12 x 11 $^5/_8$ " /
MEIN FAHRRAD UND DEIN SUMPF (GESTERN) 2, Filzstift, Marker, Farbstift, Kugelschreiber auf Photographie, 30,5 x 20,3 cm.

at a family reunion. Some have married; others have aged terribly and are hobbling about; a few have died. The reader is left wondering what happened in the intervening years—left to fill in the gaps.

Wekua's world is not unlike that of *The Years*— for we, too, are left to fill in gaping holes the size of a lifetime. Like Woolf, Wekua reveals the color of the sky, the size of a girl's foot, the mood in the air. In his monographic book project *If There Ever Was One* (2007), we encounter fragments of a biographical text sprinkled throughout, but we are never told

much. There is a girl. She is by the sea. The sky around her turns from red to purple to indigo to black. She has, at one time, stared death in the face. Beyond that, little is revealed. It is hard to tell if these fragments are drawn from Wekua's life, a film, or a dream someone had; it is all frustratingly opaque.

In this way, Wekua's paintings, collages, films, sculptures, texts, and ephemeral miscellanea bring together diverse geographies, histories, and characters, each woven into a quilt all of his own. There are images, some drawn from the artist's personal

ANDRO WEKUA, GET OUT OF MY ROOM, PART 1, 2006, wax figure, artificial hair, fabric, leather, wax paint, wooden table, wax, bronze chair, enamel; 8 silk screen prints, etching, exhibition view Kunstmuseum Winterthur / RAUS AUS MEINEM ZIMMER, Wachsfigur, künstliches Haar, Textilien, Leder, Wachsfarbe, Holztisch, Wachs, Bronzestuhl, Emailfarbe; 8 Siebdrucke, Radierung, Ausstellungsansicht.

albums, others simply found or appropriated—from postcards, books, television. These images belong to him, but more compellingly, they belong to all of us.

Wekua's mannequins and sculptures, mostly fashioned from wax, are similarly generous. As if frozen in time, the majority of his figures seem to be caught in the prime of youth—not quite teenagers, not quite children. And yet something is still invariably off about them: a hand missing, a tongue dangling, a nose elongated, cheeks painted with superfluous rouge. Sometimes, eyes are blotched out, painted over—removed? It is not clear. Each figure evokes something we have all felt: loneliness, inferiority, our heads hanging over our knees in a gesture of quiet defeat.

The sculpture WIE HEISST DU MEIN KIND? (What is Your Name My Child? 2004) portrays a young man dressed in what appears to be a standard school uniform complete with crisp white shirt and black tie. He stands on an oversized black ceramic pedestal with arms slightly akimbo, his hands coated in dirty grey. Has he been playing in the mud? Building something? Getting in a fight? His eyes are covered by gratuitous white paint. Or again, gouged out, depending on your sensibility. The pedestal: in one sense, it looks like any pedestal. In another, it evokes the black box found in the cockpit of an airplane to record the dialogue between pilot and co-pilot during their flight. But perversely, it only becomes relevant (or makes itself known) in the case of a disaster; its use is latent until then and it is disaster that spells out the terms of its use. In other words, this is a not the standard pedestal or support system for a work of art, but rather, a curious, ghostly landmark.

There are other examples. GET OUT OF MY ROOM (2006) presents a young man, his eyes equally lacerated. He appears sanguine, his legs crossed on a large ping-pong table in a gesture of relaxation. Or is it resignation? In SNEAKERS 1 (2008), a figure is bent with her head burrowed between her legs, the outline of a masked face inscribed on her back. She wears sneakers, a sartorial gesture that brings her epic sadness back to earth—back to all of us.

There are masks throughout these works, too, their function not unlike the obliterated eyes. When you put on a mask, you can be anyone. Likewise,

without eyes, Wekua's mannequin is rendered anonymous, generic. Equally, without eyes, the relationship of object to viewer is rendered asymmetrical. The encounter between the two is about one person seeing. It is about being able to project whatever we want onto these little men or little women. For the mannequins, staring back is not a possibility. That privilege is reserved for viewers.

The first line in the late Armenian-Georgian filmmaker Sergei Parajanov's *Shadows of Forgotten Ancestors* (1966) announces: "This is a poetic dream." From here, we are drawn into the life of Ivan and Marichka, two children whose families are divided by a blood feud. Having fallen in love early on, they manage to bridge the divide and eventually plan to marry. When Ivan sets off to find work, Marichka tumbles into a river and dies. Ivan sinks into a depression, weeping for his lost love, hallucinating her presence everywhere, and wasting away. He eventually goes mad, before finally joining Marichka again in death.

It is not uncommon to turn to filmic metaphors when thinking about Wekua's works. Like a set of film stills, there is a hint of what was and what is to come. But more potently, the works convey a profoundly personal emotional aura, making us feel that we have trespassed or stepped into a room we were not meant to enter. Wekua's use of color—deep reds, purples, browns—heightens the sensation of place, of a highly coded, highly idiosyncratic universe.

Wekua's monographic book *Lady Luck* (2008) stars an omniscient narrator who says: "He had lost his memory, and this prevented him from moving. It was as if someone had clicked the pause button during a movie."[1] This sensation of not moving, of being frozen in time, is at least one characteristic of memory. Memory, of course, is subject to slippage, to fragmentation. Wekua's works verge on sculptural manifestations of memories; they are not reflections of memories, but rather their built manifestation. They are fashioned from scraps of family photographs, popular imagery, conversations. In other words, they are not unlike memory, which is also a pastiche, circumscribed by photographs, endlessly repeated stories and dreams—just as true as they are false. Colored pencils—like a child's—also inform the work, shading in spaces in and around the images.

ANDRO WEKUA, SNEAKERS 1 (PURPLE SNEAKERS), 2008, wax figure, aluminum cast table, pallet, acrylic board, ceramic, shoes, 59 x 72 $^7/_8$ x 39 $^3/_8$",
exhibtion view Gladstone Gallery, New York / TURNSCHUHE 1 (LILA TURNSCHUHE), Wachsfigur, Aluminiumgusstisch, Palette, Akrylharzbrett, Keramik,
Schuhe, 150 x 185 x 100 cm, Ausstellungsansicht.

Wekua is presently working on the architectural history of the city in which he was raised, Sukhumi, a seaside resort town that was once part of the Republic of Georgia but is today occupied by Russia. In the 1990s, Sukhumi was at the heart of an ethnic cleansing campaign. Wekua's family, like many others, left—and he hasn't been back since. The city has been left mostly empty, like a ravaged carcass. It is a pale imitation of what it once was. Its glamorous buildings damaged by war are now mostly abandoned. Perhaps a bit like Beirut, Sukhumi exists as a memory of its former glory.

For years, Wekua has been culling anything he could find about contemporary Sukhumi from the internet. But as it happens, it is very difficult to find anything on the city, as Sukhumi's public image is fiercely guarded by the Russian state. Wekua shares and exchanges the photos he finds with his family and friends.

Recently, his brother sent him an image of the house they grew up in. In this image, the city looks like an empty stage, a set between acts, waiting for a past to reassert itself. It is as if the present had never come. Wekua has recreated some of these buildings as sculptures, allowing their online popularity and the particular resonance they may have for him to inform his selection. Each is cast as an individual object, with its own life and fashioned from its own material: aluminum, wax, bronze, or resin. In order to make the buildings three dimensional, Wekua relies on his own memory as well Google Maps of Sukhumi, which have only recently become available. When he cannot find pictures of facades or when his memory fails, the structures are simply left blank, leaving only one-dimensional surfaces. In this way, the resuscitated buildings are faithful to the delicate workings of memory, not to mention the limitations of the internet. Like one of Albertine's wandering beauty spots in Marcel Proust's *À l'ombre des jeunes filles en fleurs* (In the Shadow of Young Girls in Flower, 1919), they are not static; the author can't keep track of exactly where the mole has fallen on her fine face! And like the artist who is reluctant to speak, they offer nothing and everything at once.

1) Andro Wekua, *Lady Luck* (Zürich: JRP Ringier, 2008), p. 31.

NICHTS UND ALLES AUF EINMAL

NEGAR AZIMI

Andro Wekua wirkte bei unserem ersten Treffen eher schüchtern und reserviert. Er musterte mich mit seinen grossen Augen, als gäbe es nichts Langweiligeres als mich, und sprach wiederholt Kauderwelsch. Ich war ein wenig enttäuscht, denn er ging seit Kurzem mit einer meiner Freundinnen aus. Als wir Jahre später darüber sprachen, erklärte er, sein Englisch sei damals noch ziemlich schlecht gewesen. Zum Glück ist es seither besser geworden und wir reden jetzt öfter miteinander.

Virginia Woolf schildert in *Die Jahre* (1937), ihrem letzten zu Lebzeiten veröffentlichten Roman, die Irrungen und Wirrungen einer englischen Familie über einen Zeitraum von fünf Jahrzehnten. Der Erzählstil ist nicht episch breit, wie es dem Sujet entsprechen würde, sondern aufs Unmittelbare konzentriert. Die Handlung schweift selten über die Britischen Inseln hinaus und verliert sich in scheinbar unbedeutenden Details: Stimmungen, die Kleidung der Personen, die Farben des Himmels. Am Ende versammeln sich die Hauptfiguren noch einmal zu einem Familientreffen. Einige haben geheiratet, andere sind alt und gebrechlich geworden. Manche fehlen, vom Tode hinweggerafft. Der Leser weiss nicht, was in den Jahren dazwischen geschehen ist, und muss versuchen, die Lücken selbst zu füllen.

Ganz ähnlich ist die Welt beschaffen, wie sie sich in Andro Wekuas Arbeiten und Büchern präsentiert. Auch bei ihm gilt es, Leerstellen zu überbrücken. Wie Woolf beschreibt er die Farben des Himmels, die Form eines Fusses, die Stimmung in der Luft. Sein Buchprojekt *If There Ever Was One* (2007) ist mit biographischen Fragmenten durchsetzt. Viel erfahren wir nicht: Ein Mädchen am Meer. Der Himmel über ihr wechselt von Rot zu Violett, Indigo und Schwarz. Sie hat einmal dem Tod ins Auge geblickt. Mehr nicht. Ob diese Splitter dem Leben des Künstlers, einem Film oder einem Traum entnommen sind, rätseln wir vergeblich.

Wekuas Gemälde, Collagen, Filme, Skulpturen, Texte und vergängliche Objekte verweben mannig-

NEGAR AZIMI ist Chefredaktorin des Kunstmagazins *Bidoun*.

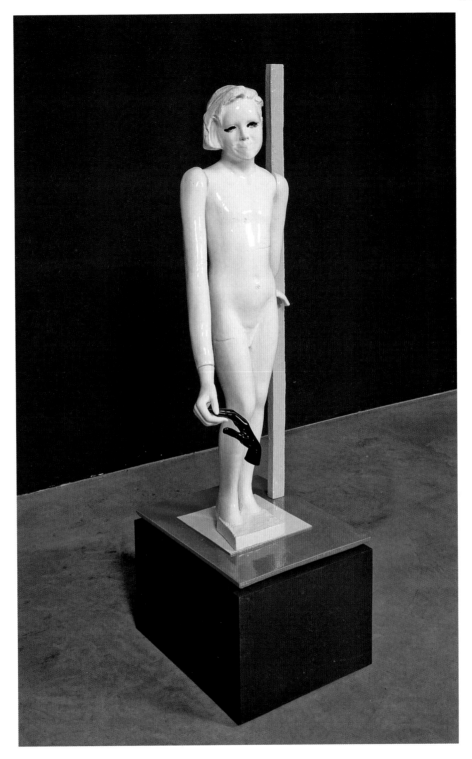

ANDRO WEKUA, HOLDING, 2007, ceramic, 22 $^1/_2$ x 20 x 66 $^1/_4$" / HALTEN, Keramik, 57,2 x 50,8 x 168,3 cm.

faltige Geographien, Geschichten und Charaktere zu einem völlig eigenständigen Tableau. Es gibt Bilder. Zusammengesammelt aus privaten Photoalben, aus Postkarten, Büchern und TV. Diese Bilder gehören ihm, aber noch wesentlicher uns allen.

Ähnlich freizügig sind die Statuen und Puppen, die Wekua aus Wachs und anderen Materialien anfertigt. Die meisten verharren zeitlos in jugendlicher Blüte, nicht mehr ganz Kind und noch nicht ganz erwachsen. Doch irgendetwas stimmt nicht. Der einen fehlt die Hand, der anderen hängt die Zunge heraus. Einmal ist die Nase zu lang, ein andermal verunstaltet ein grelles Rot die Wangen. Immer wieder sind die Augen übermalt – oder ausgestochen, herausgerissen? Wir wissen es nicht. Alle erwecken bekannte Gefühle: Einsamkeit, Pfahl im Auge, Kopf zwischen den Knien in stiller Resignation.

Die Skulptur WIE HEISST DU MEIN KIND? (2004) porträtiert einen Mann von jugendlicher Statur in einer Schuluniform mit weissem Hemd und kleiner schwarzer Krawatte. Er steht mit hängenden Armen auf einem übergrossen Keramik-Podest. Die Hände sind schmutzig grau. Hat er im Schlamm gespielt? Etwas gebaut? Sich herumgeprügelt? Die Augen sind weiss überschmiert. Oder ausgestochen, je nachdem, wie dramatisch man es nehmen möchte. Das Podest sieht eigentlich ganz normal aus. Andererseits erinnert es an die Blackbox, den Flugschreiber, der den Sprechfunk im Flugverkehr aufzeichnet. Der erfüllt makabrerweise erst dann seinen Zweck, wenn ein Unfall passiert. Das Podest wäre somit weniger ein Unterbau, als ein groteskes, gespenstisches Memento mori.

Es gibt weitere Beispiele. Dem Jüngling in GET OUT OF MY ROOM (Raus aus meinem Zimmer, 2006) sind gleichfalls die Augen verdeckt. Gelassen sitzt er, die gekreuzten Beine auf einem grossen Tischtennistisch. Ist er entspannt oder melancholisch? Die weibliche Figur in SNEAKERS 1 (Sneaker 1, 2008) vergräbt ihren Kopf zwischen den Beinen. Auf ihrem Rücken zeichnet sich der Umriss einer Maske ab. Auch diese Frau trägt Turnschuhe, ein Requisit, das ihre grenzenlose Traurigkeit auf den Boden der Realität zurückführt, wo sie für uns erfahrbar wird.

Die Funktion des Leitmotivs der Maske ähnelt jener der ausgelöschten Augen. Die Maske kann eine

ANDRO WEKUA, GOD IS DEAD, BUT NOT THE GIRL, 2008, wax figure, hair, colored plexiglass, aluminum, steel, 59 x 80 x 40 ¹/₂″, exhibition view Gladstone Gallery, New York /
GOTT IST TOT ABER DAS MÄDCHEN NICHT, Wachsfigur, Haar, farbiges Plexiglas, Aluminium, Stahl, 150 x 203 x 103 cm.

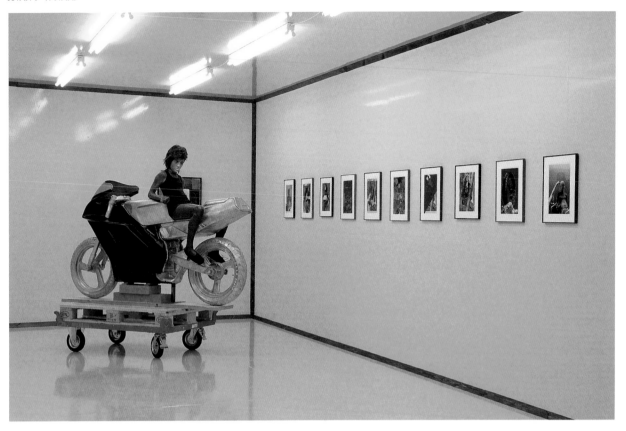

ANDRO WEKUA, MY BIKE AND YOUR SWAMP (6 PM),
2008, black polyurethane rubber, wax, aluminum, wood,
cloth, artificial hair, 73 $^1/_4$ x 33 $^7/_8$ x 79 $^1/_2$", exhibition
view Camden Art Centre, London / MEIN FAHRRAD UND
DEIN SUMPF (18 UHR), schwarzer Polyurethan-Gummi,
Wachs, Aluminium, Holz, Gewebe, künstliches Haar,
186 x 86 x 202 cm, Ausstellungsansicht.

beliebige Identität verleihen. Die augenlose Puppe
wird unpersönlich, anonym. Durch ihre Blendung
verschiebt sich die ursprünglich symmetrische Bezie-
hung zwischen Betrachter und Objekt. Nur der Ers-
tere geniesst das Privileg des Sehens. Er kann auf die
kleine weibliche oder männliche Figur projizieren,
was er will, ohne dass diese in der Lage wäre, den
Blick zu erwidern.

Der Film *Feuerpferde* (1966) des verstorbenen ar-
menisch-georgischen Regisseurs Sergej Paradscha-
now beginnt mit dem Satz: «Dies ist ein poetischer
Traum.» Er erzählt die Geschichte von Iwan und
Maritschka, die sich ineinander verlieben und hei-
raten wollen, obwohl sie zwei verfeindeten Familien
angehören. Während Iwan sie verlässt, um Arbeit zu
suchen, stürzt Maritschka in einen Fluss und ertrinkt.
Danach erscheint sie in Traumgesichtern ihrem ver-
zweifelten Liebhaber, der den Verstand verliert und
sich schliesslich im Tod mit ihr vereint.

Wer sich mit Wekuas Kunst beschäftigt, fühlt sich
unweigerlich versucht, auf filmische Metaphern zu-
rückzugreifen. Sie suggeriert gleich einer Sequenz
von Standbildern etwas, was bereits geschehen ist,
und etwas, was noch geschehen wird. Am eindring-
lichsten empfindet man ihre persönliche emotionale
Aura, als hätten wir eine Schwelle überschritten und
einen verbotenen Raum betreten. Wekuas unver-

kennbare Farbpalette aus satten Rot-, Violett- und Brauntönen verstärkt den Eindruck, man habe es mit etwas schwer Entzifferbarem, etwas höchst Eigenständigem zu tun.

Der allwissende Erzähler in Wekuas Künstlerbuch *Lady Luck* (2008) konstatiert: «Er hatte seine Erinnerung verloren und das liess ihn erstarren. Als hätte jemand während eines Films die Pausentaste gedrückt.»[1] Das Anhalten der Bewegung, das Stillstehen der Zeit gibt es auch in der Erinnerung, die natürlich der Verfremdung, der Erosion unterliegt. Man könnte Wekuas Werke als plastische, architektonische Manifestationen von Erinnerungen auffassen, nicht als deren Reflexion. Als Assemblagen aus Familienphotos, Medienbildern und Gesprächen sind sie der Erinnerung verwandt, die ja auch ein Flickwerk ist aus Photos, die wir gesehen haben, aus Geschichten, die wir gehört haben, aus Träumen und vielen anderen Erlebnissen. Dem Kinde ähnlich greift der Künstler zu Buntstiften, um Linien in und um die Bilder zu zeichnen. Eine Erinnerung kann weder ganz wahr noch falsch sein.

Wekua arbeitet gegenwärtig an einer Architekturgeschichte der Stadt seiner Jugend: Der Kur- und Badeort Sochumi gehörte vormals zu Georgien und ist heute von Russland besetzt. In den 90er-Jahren kam es zu Massakern an der georgischen Zivilbevölkerung. Wekuas Familie flüchtete wie viele andere ins Ausland – der Künstler ist bis heute nicht zurückgekehrt. Die Stadt und ihre Prachtbauten stehen weitgehend leer, die Ruinenlandschaft ein Schatten ehemaligen Glanzes. In dieser Rückwendung in die Vergangenheit erinnert Sochumi vielleicht an Beirut.

Seit Jahren sammelt Wekua im Internet Informationen über das heutige Sochumi. Dies erweist sich als äusserst schwierig, denn nur wenige Photographien der Stadt entgehen der russischen Zensur. Was immer sich findet, tauscht Wekua mit Freunden aus.

Unlängst schickte ihm sein Bruder ein Bild des Hauses, in dem beide aufgewachsen waren. Die Stadt erscheint in dieser Aufnahme als leere Bühne, als Schauplatz eines Zwischenspiels. Man erwartet die Rückkehr der Vergangenheit, als wäre die Gegenwart nie eingetreten. Wekua baut einige dieser Häuser nach. Ausschlaggebend sind die Assoziationen, die sie in ihm auslösen, und ihre Verbreitung

im Internet. Jede Skulptur hat ihr eigenes Leben und wird aus ihrem eigenen Material gegossen, aus Aluminium oder Wachs, Bronze oder Harz. Für die räumliche Gestaltung der Bauten verwendet er eigene Erinnerungen sowie Google Maps, das erst seit kurzer Zeit für Sochumi zur Verfügung steht. Gibt es von einer Fassade weder eine Abbildung noch eine zuverlässige Erinnerung, bleibt es bei der eindimensionalen Fläche und das Modell wird nicht gebaut. Die Wiedererweckung der Gebäude harmoniert also mit dem feinen Räderwerk der Erinnerung, von den Grenzen des Internets ganz zu schweigen. Wie Albertines wandernder Leberfleck in Marcel Prousts Roman *Im Schatten junger Mädchenblüte* (1919) – der Autor konnte sich nicht genau erinnern, wo der Fleck im Antlitz der schönen Geliebten sass –, sind sie nicht statisch. Und wie der Künstler, der gerne schweigt, verraten sie nichts und alles auf einmal.

(*Übersetzung: Christian Geyer*)

1) Andro Wekua, *Lady Luck*, JRP Ringier, Zürich 2008, S. 31.

ANDRO WEKUA, HEAD I, 2006, ceramic mask,
8 x 6 $^1/_4$ x 9"; wooden pedestal, 45 $^1/_4$ x 8 $^1/_4$ x 3 $^1/_2$" /
KOPF I, Keramikmaske, 20,5 x 16 x 22,5 cm; Holzsockel,
115 x 21 x 27 cm.

EDITION FOR PARKETT 88

ANDRO WEKUA

BLACK SEA LAMP, 2011

Color glass lamp with metal base, conceived and designed by the artist,
glass colored and bent by glassworks GmbH, casing cut from lacquered steel sheet,
illuminated with 2 LED bulbs, electrical cable, fabricated and assembled
by Kunstbetrieb AG Münchenstein, Switzerland,
$7\,^1/_4$ x $5\,^1/_4$ x $3\,^1/_8$".
Ed. 35 / XX, signed and numbered certificate.

Lampe mit gefärbtem Glas und Metall-Fassung, vom Künstler entworfen und gestaltet.
Gefärbtes und gewelltes Glas, hergestellt von Glassworks GmbH,
Gehäuse aus geschnittenem und lackiertem Stahlblech, 2 LED-Glühbirnen, Kabel,
produziert und zusammengestellt von Kunstbetrieb AG Münchenstein, Schweiz,
18,3 x 13,5 x 8 cm.
Auflage 35 / XX, signiertes und nummeriertes Zertifikat.

THE SPIRIT OF TRANSFER

Jacqueline Burckhardt: Es fällt auf, dass fast alle Ausstellungen von «Staging Knowledge» bisher in Schlössern stattfanden, die Sie als Kurator mit Ihrem Team selber eingerichtet haben. Sehr oft haben Sie das Publikum auch persönlich durch diese Ausstellungen geführt. Was ist eigentlich «Staging Knowledge»? Wie entstand diese Art, Ausstellungen zu machen?

Herbert Lachmayer: Die Schlösser des aufgeklärten Absolutismus im 18. Jahrhundert haben vielfach eine barocke Grundsubstanz, die zumeist im Stile eines radikalen Klassizismus umgebaut wurde – die Enfi-

chonautic Carpet» sowie durch Gegenwartskunst *ironisch* gebrochen werden, um nicht vorschnell zynische Distanz aufkommen zu lassen. Ein zeitgemäss anarchischer Individualismus lässt sich bereitwillig in die fröhliche Atmosphäre eines Rokoko-Salons versetzen, um den subtilen Genuss adliger «Selbstwert-Hebung» in einer raffinierten Inszenierung von Repräsentation geniessen zu können. Erst einer variantenreich verfeinerten «Geschmacksintelligenz» ist eine solch ästhetische Lustbarkeit zugänglich, deren sozialgeschichtlichen Background das intellektuell erfreute Publikum dabei auch noch «durchschauen»

Staging Knowledge
Eine Wissensoper

HERBERT LACHMAYER & JACQUELINE BURCKHARDT

laden der fürstlichen Gemächer oder die *Sala Terena* laden zum Durchschreiten ein und öffnen eine Bühne inszenierter Kultur. So entstand die Idee einer «Wissensoper» als Ausstellungsformat. Der respektgebietende Gestus feudaler Repräsentation musste durch die «Hermeneutic Wallpapers» und den «Psy-

kann. Erstaunlicherweise verlieren derartig provokative Interventionen auch in Museen und Amtsräumen der Bürokratie nicht an treffsicherem Witz.

JB: Was war nun der eigentliche Anstoss für Ihre Ausstellungsidee?

HL: «Staging Knowledge» hat sich aus einer Obsession für «performative Rhetorik» entwickelt, das heisst, die Ausstellungen der letzten Jahre waren immer zugleich Bühnen, welche von uns tagtäglich in ausgiebigen Führungen bespielt wurden. Geht es doch heute darum, dem Publikum die inspirierte Idee eines Ausstellungskonzepts in seiner kulturgeschichtlichen Kontextualisierung rhetorisch *in* der Ausstellung vorzuführen. Dazu bedarf es eines

HERBERT LACHMAYER ist Professor an der Kunstuniversität Linz und leitet die Abteilung für Staging Knowledge – Inszenierung von Wissensräumen und performativer Rhetorik – in Kooperation mit der Bauhaus-Universität Weimar und der Stanford University Kalifornien. Leiter des DA PONTE Research Centers und Kurator zahlreicher kulturgeschichtlicher Ausstellungen. *JACQUELINE BURCKHARDT* ist Redaktorin bei Parkett.

"Invoking a National Identity—The Bernhard Room: Gothic Revival in the Heart of Classicism," Stadtschloss Weimar, 2009/2010,
exhibition view / «Beschwörung nationaler Identität – das Bernhardzimmer: Neugotik im Herzen des Klassizismus», Ausstellungsansicht.
(ALL PHOTOS: COURTESY STAGING KNOWLEDGE, KUNSTUNIVERSITÄT LINZ)

Imaginations-Angebots, welches die Bedeutungsam-biguität des Inhalts präsentiert – so können höchst persönliche Projektionen, gefühlsgeleitetes Assozi-ieren und versprengte Vorkenntnisse des Publikums Teil der anschaulichen Erkenntnis sein. Ist doch die glücksbringende Lust *intuitiven* Denkens nach wie vor ein begehrter wie kostbarer Erlebniswert.

Der White Cube hingegen suggeriert eine Versach-lichung des künstlerischen Subjektivismus, zugleich wird dem Publikum die Attitüde von «Coolness» auf-gedrängt – als würde schon begeisterte Rezeption al-lein die Reinheit und den Abstraktheitskult «wahren Kunstgenusses» trüben. Nun gibt es deutliche Anzei-chen, dass dieser Habitus in die Jahre gekommen ist:

Wirkt er doch als schal gewordener Trend historisie-rend betulich. Vergleichbares lässt sich auch von den bereits überstrapazierten Kunst- und Kulturdiskursen sagen: Deren Anspruch, eine angeblich existierende «Schnittstelle» zwischen Kunst und Wissenschaft sinnstiftend besetzen zu müssen, um der Kunst ihren Inhalt erst verständlich zu machen, erklärt weniger, als die bisweilen selbstgefällige Inszenierung an Er-wartung weckt.

JB: Ist diese Interpretationsroutine der Theoriedis-kurse überhaupt aus der Kunst- und Kulturvermitt-lung wegzudenken?

HL: Keinesfalls – nur sollte man der «Geschmacks-intelligenz» des Publikums die Fähigkeit intuitiver

Herbert Lachmayer & Margit Nobis, Hermeneutic Wallpaper for "Bernhard Room" exhibition / Hermeneutic Wallpaper für «Bernhardzimmer»-Ausstellung.

Erkenntnis nicht absprechen: Gibt es doch zweifellos auch erkennendes Fühlen und reflektierendes Empfinden. Gar manche theoretische Diskurspraxis entpuppt sich in ihrem Deutungsanspruch als zu abstrakt, wenn sie glaubt, die ästhetisch so vielfältig erscheinende Wirklichkeit so lange mit theoretischen Reflexionen gleichsam «bürsten» zu müssen, bis, salopp gesprochen, der «Lack» der Sensualistik ab ist. Man will eben keine diskurserzeugte Distanz zur Kultur, um sie angeblich besser verstehen zu können.

Wissenschaft und Kunst wurden ab dem 19. Jahrhundert auseinandergetrieben: Einerseits hält der mentalitätsgeschichtlich gewachsene Zwang des Objektivierens die Wissenschaftler durch das «Regelwerk des Verstandes» in Bann, andererseits bleiben die Künstler im Zeichen der Freiheitsobsession und eines radikalen Subjektivismus der Herausforderung einer «Allmachtsphantasie permanenter Welterfindung» verpflichtet, auch wenn sie nihilistisch motiviert sind. Man muss sich schon konsequent auf diese komplexe Paradoxie einlassen, um freizulegen, was die Kunst erkenntnisrelevant macht, und die Wissenschaft intuitiv-visionär.

JB: Können Sie diese kritische Sicht im Ausstellungsformat «Staging Knowledge» auch umsetzen?

HL: Weitgehend doch, weil «Staging Knowledge» als eine künstlerisch-wissenschaftliche Forschungspraxis ein neues Erlebnisformat von Wissen sein kann, welches den Besuchern anschauliches Erkennen als intellektuelles *Excitement* ermöglicht. Auf Basis einer reichen Bild- und Textrecherche ist das kuratorische Team dazu angehalten, diese Erfahrung buchstäblich *herbeizureden*, damit jene Ausstellungsbühne erst einmal entstehen kann, um nach der Eröffnung damit zu beginnen, auf dieser Bühne *weiterzureden*. Dabei erweist sich die Wallpaper/Carpet-Szenographie als Medium der Ambiguität und des Perspektivwechsels zwischen intuitivem Denken, gesteigerter Einbildungskraft und geschärfter Wahrnehmung. Überspitzt und mit Freud gesprochen, werden für die BetrachterInnen Phantasien obsessiv gegenwärtig, und am Ausstellungsobjekt darf sich ein Detailfetischismus der «stillen Beobachtung» und der Betrachtungswut ungeniert ausleben. Die libidinöse Komponente einer assoziativen «Geist-Rezeption» erfüllt sich in einer pornosophischen Phantasmagorie – auch als ein Medium des Voyeurismus und der Autoerotik.

Die «Hermeneutic Wallpapers» sind Ergebnis eines recht paradoxen Zusammen- oder Gegeneinanderwirkens von Wissenschaftlern und Künstlern: Schliesslich müssen sie gemeinsam aus heterogenem Bildmaterial bedeutungsstarke Embleme herausfiltern – argumentierend und imaginierend. In die Tapetenwände sind überdies – rahmenlos und plan – Industriemonitore integriert, um bildreich und textpointiert die Kontextualisierung der Themen *erzählend* zu leisten. Die medienkritische Pointe ereignet sich, wenn etwa alle vierzig Sekunden die narrativen Text- und Bildfolgen kurzfristig durch das digital eingespielte Tapetensegment unterbrochen werden – und dadurch der laufende Rapport plötzlich wieder *ganz* ist. Kontextualisierende Wandszenographie als Tapete habe ich erstmals im Stadtschloss Weimar bei der Ausstellung «Wozu braucht Carl August einen Goethe?» eingesetzt: künstlerisch umgesetzt von Franz West, Rudolf Polanszky und Konrad

Priessnitz. Mit dieser Ausstellung kam auch der Begriff «Weimarer Wissensräume» auf. Die eigentliche Premiere der «Hermeneutic Wallpapers» (mit den in die Wand eingelassenen Monitoren) fand 2009 im Schloss Esterházy, Eisenstadt, anlässlich der Ausstellung «Haydn Explosiv – eine europäische Karriere am Fürstenhof der Esterházy» statt: Die «Hermeneutic Wallpapers» dafür sind in Zusammenarbeit mit Margit Nobis, Franz West und Rudolf Polanszky entstanden. Daniel Dobler, als Experte für Digital Imaging, ist technologisch-systemischer Mitentwickler des Ausstellungsformats.

In der Folge haben die Künstlerin Margit Nobis und ich mehrere Prototypen von «Hermeneutic Wallpapers» entwickelt – und damit das Format standardisiert. Der «Psychonautic Carpet», ein das Publikum gleichsam «schweben lassender Teppich», welcher den BesucherInnen lautloses Gleiten durch die Räume ermöglicht, entstand 2006 anlässlich der Ausstellung «Mozart. Experiment Aufklärung» in der Albertina, Wien. Der Aufgabenstellung «Re-Inventing Rococo 2006» folgte Franz West mit dem Entwurf eines Teppichs, welcher über 2200 m² raumgreifend drei Ebenen der Albertina auskleidete. Franz Wests Entwurf vereinigte verschiedene Inspirationen, welche Anspielungen auf Mozart beinhalteten: Etwa das Wiener Sprichwort «Arsch mit Ohren», auf Mozarts Analfixierung anspielend, wartete als Metapher mit einem Pavian-Arschloch auf, welches einer gelben Quittenfrucht zum Verwechseln ähnlich sah. Sowohl im Residenzschloss Weimar als auch im Schloss Esterházy habe ich einen Teppich von Roy Lichtenstein eingesetzt, den die Firma Vorwerk Ende der 80er-Jahre noch beim Künstler selbst in Auftrag gegeben hatte. Die strahlenden Farben des Lichtenstein-Teppichs stehen en correspondence zu den kräftig-bunten Kleidern jener Zeit und in apartem Kontrast zur weiss-grau-weissen Architektur der Säulen und Wände in strenger klassizistischer Raumsymmetrie.

JB: Worin besteht für Sie die Aktualität des ausgehenden 18. Jahrhunderts und der Aufklärung dieser Zeit für uns heute? Finden sich die Geisteshaltungen dieser Zeit auch in Ihrer Arbeitsweise wieder?

HL: Durchaus: Der Inszenierungsanspruch der «Staging Knowledge»-Ausstellungen unterstreicht weniger den Event-Charakter eines phantasierten Rokokos, sondern schlägt den Bogen zu einer Bühnenmetapher, die auch für das 18. Jahrhundert der Aufklärung stimmig und exemplarisch war. Es geht um die bewegten Jahrzehnte vor und *nach* der Französischen Revolution, als sich mit dem zeitgemäss radikalisierten Freiheitsgefühl auch der moderne Individualismus in Kunst, Philosophie und den Wissenschaften mit Vehemenz herauszubilden und zu behaupten begann. Fand doch damals ein politischer wie gesellschaftlicher Kulturbruch statt – ein Début de Siècle vor und *um* 1800. Bei unseren Ausstellungen werden transdisziplinäre wie intermediäre «Wissensräume» inszeniert, die im Geiste von Aby Warburg auch «Denkräume» sind. Die Zeit der Aufklärung, zwischen Absolutismus und dem Aufschwung des Bürgertums im 19. Jahrhundert, ist mit ihren Zukunftspotenzialen von einst immer noch

Herbert Lachmayer & Margit Nobis,
Hermeneutic Wallpaper, draft for the
exhibition "Me, Boy, 19 looking for..." /
Hermeneutic Wallpaper, Entwurf für die
Ausstellung «Ich, boy, 19 suche ...».

relevant. Man denke nur an die Ideenfülle der wissenschaftlich-technischen Erfindungen, die erst im 19. Jahrhundert der Industrialisierung verwirklicht wurden. Damals entstand auch diese noch neue «Sehnsucht nach Individualismus», gleichzeitig vollzog sich der Wechsel vom Hofkünstler zum romantischen Künstlergenie.

Vor der Trennung in Geisteswissenschaften (Humanities) versus Naturwissenschaften (Sciences) wurde im 18. Jahrhundert noch im Sinne einer «prä-disziplinären» Wissensgesellschaft «gedacht» – Kunst, später als irrational in die Domäne des Unbewussten abgeschoben, war noch sensualistisch-differenziertes Segment einer «Geschmacks-Intelligenz», welche in den Salons der Zeit als soziale Kompetenz, als überlebensnotwendige Galanterie und Konversationsfähigkeit unverzichtbar war. Das Unbewusste im psychischen Machiavellismus des 18. Jahrhunderts stand dem Spiel der Verführung oft näher als der verinnerlichten Lustverhinderung in der bürgerlichen Gesellschaft. Die Gesellschaft des Rokoko war im Grunde *amoralisch*, aber nicht *unmoralisch*. Diente doch der höfische Künstler vor allem auch zur Bespassung des Fürsten – die spätere moralisierende Kunstreligion bediente hingegen die Verdrängungsaggregate des Bürgertums. Kunst war in der Mozart- und Goethe-Zeit noch ein der Wissenschaft ebenbürtiges Medium symbolischen Wissenstransfers.

Auch die Kontextualisierung des Wissens vollzog sich in der «Geschmacksintelligenz» ästhetischer Einbildungskraft: Darin hatten Wissenschaftler, Diplomaten, herrschende Fürsten wie auch die Künstler gebildet und ausgebildet zu sein.

JB: Kann man davon ausgehen, dass dem Publikum von heute ein derartiger Rückbezug auf das 18. Jahrhundert plausibel erscheint? Sind bestehende museale Ausstellungs- und Darstellungstechniken nicht ausreichend, auch wenn sie partiell verbesserungswürdig sein mögen?

HL: Das heutige Publikum erwartet lebendige Vermittlungsformen von Kunst- und Kulturgeschichte, besonders die Jugendlichen, die auch nach kulturellem Orientierungswissen suchen. Der Verlust an Inspiration, welcher dem Publikum beim Besuch von Museen oder historischen Ausstellungen oft genug widerfährt, ist uns Anlass, neue Vermittlungsformate von Alltagskultur, Kunst und Gegenwartskunst *experimentell* zu erfinden. Man sollte nicht vergessen, dass sowohl das «Début de Siècle» um 1800 und erst recht das Fin de Siècle um 1900 soziokulturelle Übergänge waren, in welchen sich eine Art «aktive Dekadenz» als höchst produktiv herausgestellt hat. Die grossen Genies dieser Zeit vermochten die Korrosionsstrukturen der Auflösung sozialer, moralischer und kultureller Wertstrukturen höchst produktiv zu nutzen. Im globalisierten Kleinbürgertum unserer Tage hat

«aktive Dekadenz» keine gemeinschaftsbildende Chance und Perspektive – der tagtägliche Darwinismus versucht das Produktive solch einer luxuriösen Gesinnungsform als Schwäche unwerter wie uneffizienter Existenzform zu entlarven. Verschulte und überbürokratisierte Ausbildungs- und Bildungssysteme merzen die künstlerisch-anarchische Freiheitsobsession aus. Vielmehr noch fordert die herrschende Rationalität eine stereotype «Ich-Stärke» ein, die der Überlebensdoktrin der beschleunigten Leistungsgesellschaft folgt – so manches Konzept des Avantgardismus hingegen vermochte die «Ich-Schwäche» geradezu stark zu machen, die nicht gelungene Anpassung *produktiv* zu nutzen.

JB: Kann man «Staging Knowledge» auch als ein Bildungssystem verstehen?

HL: Durchaus, die Kunstuniversität Linz hat «Staging Knowledge» seit 2009 als eigene Abteilung des Instituts für Bildende Kunst und Kulturwissenschaften eingerichtet. In Kooperation mit zahlreichen Partnern[1] konnten wir «Staging Knowledge» zu bildungs- und ausbildungsrelevanten Anwendungen weiterentwickeln: als PhD-Kurs an der Kunstuniversität Linz, als Lehrprogramm an der Bauhaus-Universität Weimar sowie als experimentelles Modul an der Stanford University, CA. Das Format wird so mehr und mehr zu einer akademisch anerkannten wissenschaftlich-künstlerischen Forschungspraxis. Aber auch in der

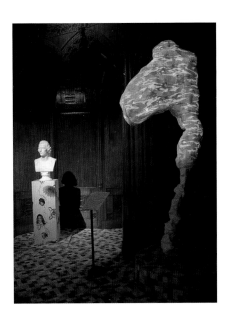

"Invoking a National Identity—The Bernhard Room: Gothic Revival in the Heart of Classicism," Stadtschloss Weimar, 2009/2010, exhibition view with Franz West's LEMURE / «Beschwörung nationaler Identität – das Bernhardzimmer: Neugotik im Herzen des Klassizismus», Ausstellungsansicht mit Franz Wests LEMURE.

schulischen Ausbildung von 17-jährigen SchülerInnen findet «Staging Knowledge» einen weiteren Anwendungsbereich: Unter dem Titel «Man wird doch wohl noch träumen dürfen!» gab es bisher schon Projektfolgen in Wien, Linz, Tarvisio, Jesenice, Villach sowie auch an der Herderschule in Weimar. In einem unprätentiösen wie dennoch prägnanten Sinne versteht sich «Staging Knowledge» als eine zeitgemässe Variante im Prozess einer Aufklärung der Aufklärung der Aufklärung.

JB: Parkett wünscht weiterhin gutes Gelingen!

"Explosive Haydn. A European Career at the Princely Court of the Esterházy," Eisenstadt, 2009, exhibition views / «Haydn Explosiv. Eine europäische Karriere am Fürstenhof der Esterházy», Ausstellungsansichten.

1) In Kooperation mit dem DA PONTE Research Center Wien (Margit Nobis, Daniel Brandenburg, Patrick Weber), der Klassik Stiftung Weimar (Hellmut Seemann, Folker Metzger, Thomas Föhl), dem IKKM (Bernhard Siegert), der Stanford University (Matthew Tiews, Hans Ulrich Gumbrecht, Bryan Wolf, Keith Baker, Adrian Daub), der Bauhaus-Universität Weimar (Wolfgang Kissel, Markus Krajewski, Lorenz Engell) und dem angeschlossenen Film-Institut (Juliane Fuchs) sowie dem Medienexperten Daniel Dobler und der Kuratorin Dagmar Schink.

Jacqueline Burckhardt: Interestingly, almost all the "Staging Knowledge" exhibitions so far have been installed in palaces by you as curator together with your team. On many occasions you have personally given guided tours of these exhibitions. What exactly is "Staging Knowledge" about? How did this form of exhibition come to be?

Herbert Lachmayer: Many palaces in the eighteenth-century era of enlightened absolutism were built on the foundations of the Baroque and, for the most part, underwent radical neoclassicist remodeling to create a succession of royal chambers or *sala terrena* conducive to perambulation and as a stage for art and culture. That's where the idea of an "opera of knowledge" as an exhibition format originated. The gesture of feudal representation that commands an intellectually enlightened audience with a subtly sophisticated aesthetic intelligence, capable of "seeing through" the social and historical background. Remarkably, such provocative interventions lose nothing of their carefully targeted wit, even in museums and bureaucratic institutions.

JB: What was it that triggered the idea for the exhibition?

HL: "Staging Knowledge" developed out of an obsession with performative rhetorics. In other words, the exhibitions of recent years also functioned as a stage on which we gave daily performances in the form of detailed guided tours. There is an expectation today that the inspiration for an exhibition concept and its cultural history should be presented to the public rhetorically *in* the exhibition. That means offer-

Staging an Opera of Knowledge

HERBERT LACHMAYER & JACQUELINE BURCKHARDT

respect had to be broken *ironically* by the "Hermeneutic Wallpapers," the "Psychonautic Carpet," and contemporary art in general—to prevent an overly hasty rush to cynical detachment. Today's anarchic individualism suffuses the serenity of a Rococo drawing room, allowing the subtle pleasure of aristocratic self-aggrandizement to be enjoyed in a sophisticated staging of status. Such delights are accessible only to

HERBERT LACHMAYER is a professor at Linz University of Art where he heads the department of Staging Knowledge / Mis-en-scène of Knowledge Spaces and Performative Rhetoric in collaboration with the Bauhaus University, Weimar, and Stanford University, California. He is also director of the DA PONTE Research Center and curator of many exhibitions relating to cultural history.

ing an imagination-based experience that reveals the ambiguity of the content in a way that allows people to draw on their own deeply personal projections, emotive associations and subjective preconceptions as part of the overall visual experience. After all, the pleasure of *intuitive* thinking is still a coveted and highly valued aspect of life's experiences.

The White Cube, on the other hand, suggests a more sober approach to artistic subjectivity, forcing on the public a notion of "coolness"—as if any overly enthusiastic reception might somehow taint the purity and abstract cult of "true art appreciation." There are clear indications that this attitude is past its prime, now reduced to a shallow, sedately historicizing remnant. Much the same can be said of the somewhat overwrought discourse on art and culture:

its claim to occupy some allegedly existent interface between art and science that supposedly reveals the meaning of art actually reveals more about the self-indulgent posturing of those who champion it.

JB: But is it possible to do without this established theoretical discourse in the mediation of art and culture?

HL: Not at all—but that doesn't mean we should deny the aesthetic intelligence of the public or their ability to make intuitive perceptions either; after all, there is undoubtedly such a thing as perceptive feeling and reflective emotion. Some theoretical discourse is simply too abstract in its interpretations, trying so hard to polish the aesthetic diversity of reality with the rags of theory that the lacquer of sensuality is completely dulled. What is the point in using discourse to create a sense of detachment from the arts with the supposed aim of reaching a *better* understanding of them?

In the nineteenth century, a wedge was driven between science and art. On the one hand, there was a fascination with the scientific quest for objectivity and the rule of reason, while on the other hand, artists, for all their nihilism, pursued a megalomanic fantasy of permanent demiurgic creation as part of the obsession with notions of freedom and radical subjectivity. You have to look more closely at this complex paradox to discover what it is that makes art relevant to knowledge and what makes science intuitive and visionary. In short, "Staging Knowledge" conveys that the experience of artistic productivity is in itself a matter of perception, for the viewer as well as

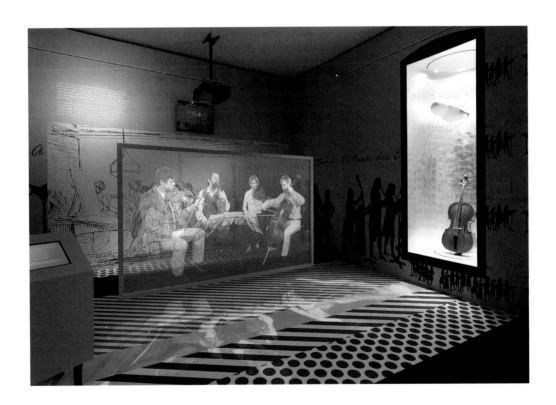

"Explosive Haydn. A European Career at the Princely Court of the Esterházy," Eisenstadt, 2009, exhibition view /
«Haydn Explosiv, eine europäische Karriere am Fürstenhof der Esterházy», Ausstellungsansicht.

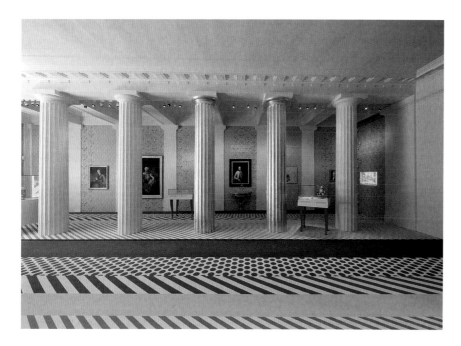

for the artist. As a strategy of perception through art and aesthetic awareness, it interacts with its theoretical counterpart—scientific analysis—in a sensual and imaginative take on reality: a mutually transmittable process of exchange *sui generis*, without the interface of explanatory discourse or third-party mediation.

JB: Can this critical view be applied to the "Staging Knowledge" exhibition format?

HL: For the most part, yes. "Staging Knowledge," as an artistic and scientific research form, can be seen as a new way of perceiving knowledge—one which allows the visitor to experience visual perception as intellectual excitement. On the basis of extensive visual and textual research, the curatorial team has the task of setting the stage for the exhibition by quite literally *talking it to life* and thus making it possible to *continue talking* on that stage once the exhibition has opened. In this respect, the wallpaper/carpet scene becomes the vehicle for shades of ambiguity and perspectival change between intuitive thought, heightened imagination, and sharpened perception. Or, to put it in a more exaggerated, Freudian way, the viewers' fantasies surface obsessively and the exhibit allows them to give uninhibited vent to their fetishism of detail through quiet contemplation and sco-

pophilia. The libidinous component of an associative "intellectual reception" is fulfilled in a pornosophic phantasmagoria—also as a medium of voyeurism and autoeroticism.

The "Hermeneutic Wallpapers" are the result of interaction, or counteraction, between scientists and artists, which is especially paradoxical, because they have to join forces in filtering out significant emblems from heterogeneous visual material—both in argumentation and imagination. Moreover, industrial monitors have been integrated, flush and frameless, into the papered walls in order to provide a visually prolific and textually pointed *narrative* of the thematic context. The media-critical point is made by briefly interrupting the narrative sequence of text and image every forty seconds or so with a digitalized version of the wallpaper segment—suddenly making the pattern of the wallpaper *complete* again. I first used contextualizing wall scenography as wallpaper in the 2008 exhibition "Wozu braucht Carl August einen Goethe?" (Why Does Carl August Need a Goethe?) at Stadtschloss Weimar. It was created by artists Franz West, Rudolf Polanszky, and Konrad Priessnitz. That was when the term "Weimarer Wissensräume" (Weimar Knowledge Spaces) was coined. The "Herme-

neutic Wallpapers" (with monitors embedded in the walls) did not premiere until 2009 at Schloss Esterházy, Eisenstadt, for the exhibition "Haydn Explosiv—eine europäische Karriere am Fürstenhof der Esterházy" (Explosive Haydn—a European Career at the Princely Court of the Esterházy). Those particular "Hermeneutic Wallpapers" were created in collaboration with Margit Nobis, Franz West, and Rudolf Polanszky. Digital-imaging expert Daniel Dobler is the technological and system co-developer of this exhibition format.

The artist Margit Nobis and I have subsequently developed several prototypes of the "Hermeneutic Wallpapers" and standardized the format. The "Psychonautic Carpet," on which visitors to the exhibition seem to glide silently through the rooms, was created in 2006 for the exhibition "Mozart. Experiment Aufklärung" (Mozart. The Enlightenment

Experiment) at the Albertina, Vienna. Franz West took up the challenge posed by the exhibition "Reinventing Rococo 2006" by designing a 23,680 square foot carpet that covered every room wall-to-wall on all three levels of the Albertina. Franz West's design combined various sources of inspiration relating to Mozart—for instance the Viennese saying "Arsch mit Ohren" (ass with ears) in reference to Mozart's anal fixation was metaphorically represented by a pavian asshole that looked deceptively like a yellow quince. At the Residenzschloss Weimar and at Schloss Esterházy I used a carpet by Roy Lichtenstein that the Vorwerk company had commissioned from the artist himself in the late 1980s. The vibrant colors of the Lichtenstein carpet correspond to the brightly colored clothing of the era and contrast nicely with the white-gray-white architecture of the columns and walls in strict neoclassical symmetry.

JB: In what way do you see the late eighteenth century and the Enlightenment as being relevant to us today? Are the attitudes of that era reflected in the way you work?

HL: Very much so. The theatrical aspect of the "Staging Knowledge" exhibitions is not so much about underlining the "event" character of an imagined Rococo, but about forging a link to a metaphorical stage that was also a fitting and characteristic emblem of the eighteenth-century Age of Enlightenment. Those were the turbulent decades *before* and *after* the French Revolution, when an increasingly radical sense of liberty went hand in hand with the emergence and assertion of modern individualism in art, philosophy, and science. It was a cultural watershed,

"Explosive Haydn, a European Career at the Princely Court of the Esterházy," Eisenstadt, 2009, exhibition view / «Haydn Explosiv, eine europäische Karriere am Fürstenhof der Esterházy», Ausstellungsansicht.

both politically and socially—a *début de siècle* in the period *before* and *around* 1800. In our exhibitions, the transdisciplinary and intermediary *Wissensräume* (Knowledge Spaces) that we stage are also *Denkräume* (Thought Spaces) in the spirit of Aby Warburg. The Age of Enlightenment, bracketed between absolutism and the nineteenth-century rise of the bourgeoisie, encapsulated a future potential that is still relevant today. Take, for instance, the wealth of ideas behind the scientific discoveries and technological inventions that only came to fruition in the course of nineteenth-century industrialization. It was also then that the notion of "yearning for individualism" emerged and, along with it, the transition from court artist to creative genius.

In the eighteenth century, before the humanities and the natural sciences came to be viewed as separate disciplines, intellectual endeavor was still under the sway of a pre-disciplinary knowledge society. Art, which would later be relegated to the domain of the subconscious as *irrational*, was still regarded as a social skill that was imperative to the gallantry and conversational skills requisite to survival in polite society. In the psychological Machiavellianism of the eigh-

teenth century, the subconscious was often far more closely related to the game of seduction than the internalized sanctions on pleasure that prevailed in the bourgeois society of the nineteenth century. Rococo society may have been fundamentally *amoral*, but it was not *immoral*. After all, the court artist served first and foremost to entertain the aristocracy; later, however, the moralism of art-as-religion merely nurtured the unconscious suppressive mechanisms of the bourgeois. In the time of Mozart and Goethe, art still operated on a par with science as a medium for the symbolic transfer of knowledge. Even the contextualization of knowledge took place within the scope of the aesthetic intelligence of the aestheticized imagination: scientists, diplomats, aristocratic rulers, and artists themselves all had to be trained and educated in this skill.

JB: Is it safe to assume that this return to eighteenth-century values will seem plausible to today's public? Aren't the existing exhibition and presentation techniques perfectly adequate, even if they do need some improvement?

HL: Audiences today, especially young people in search of some kind of cultural orientation, expect

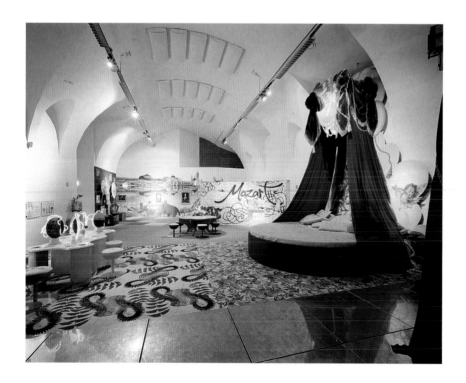

"Wolfgang Amadé. A Perfectly Normal Wunderkind," ZOOM Kindermuseum, Wien, exhibition view /
«Wolfgang Amadé. Ein ganz normales Wunderkind», Ausstellungsansicht.

206

"Explosive Haydn. A European Career at the Princely Court of the Esterházy," Eisenstadt, 2009, Hermeneutic Wallpaper and monitor / «Haydn Explosiv. Eine europäische Karriere am Fürstenhof der Esterházy», Hermeneutic Wallpaper mit Monitor.

the history of art and culture to be conveyed in lively forms. The lack of inspiration that visitors so often encounter in museums or historical exhibitions should give us pause. We need to find new and *experimental* ways of conveying everyday culture, art, and contemporary art. We should not forget that not only the *début de siècle* around 1800 but, even more so, the *fin de siècle* around 1900 represented socio-cultural transitions in which a kind of "active decadence" proved to be highly *productive*. The great minds of that time were immeasurably inventive in exploiting the corrosive structures of crumbling social, moral, and cultural values. In today's global bourgeoisie, such "active decadence" has no future and no chance of creating any kind of social cohesion—omnipresent social Darwinism seeks to expose the productive potential of such a luxurious mode of thought as the weakness of a degraded and inefficient form of existence. Overly rigid and bureaucratic forms of education and training are effectively annihilating the creative, anarchic obsession with liberty. Moreover, predominant rationalism demands a stereotypically strong sense of self to cope, befitting the survival doctrine of the fast-moving, achievement-oriented meritocracy in which we live. By contrast, many concepts of the avant-garde successfully reinforced the weakness of the individual and made *productive* use of the failure to conform.

JB: Can "Staging Knowledge" also be seen as an educational system?

HL: Certainly. At the Linz University of Art, "Staging Knowledge" has been a department in its own right within the Institute of Fine Arts and Cultural Studies since 2009. In collaboration with numerous partners,[1] we have been able to develop "Staging Knowledge" to create applications that are relevant to education and training: as a doctoral course at Linz, as a teaching program at the Bauhaus University Weimar, and as an experimental module at Stanford University, CA. The format is clearly gaining academic recognition as a scholarly and artistic research practice. But "Staging Knowledge" can also benefit 17-year-old high school students: projects have been rolled out in Vienna, Linz, Tarvisio, Jesenice, Villach, and at the Herderschule in Weimar under the title *Man wird doch wohl noch träumen dürfen!* (Surely We Can Still Have Dreams!) In an unpretentious yet effective sense, "Staging Knowledge" is a contemporary variation in the process of an enlightenment of the enlightenment of the Enlightenment.

JB: Parkett wishes you continued success!

(Translation: Ishbel Flett)

1) In collaboration with the DA PONTE Research Center Vienna (Margit Nobis, Daniel Brandenburg, Patrick Weber), Kunstuniversität Linz (Dagmar Schink), the Klassik Stiftung Weimar (Hellmut Seemann, Folker Metzger, Thomas Föhl), the IKKM (Bernhard Siegert), Stanford University (Matthew Tiews, Hans Ulrich Gumbrecht, Bryan Wolf, Keith Baker, Adrian Daub), the Bauhaus University Weimar (Wolfgang Kissel, Markus Krajewski, Lorenz Engell) and affiliated Film Institute (Juliane Fuchs), media expert Daniel Dobler, curator Dagmar Schink, and graphic designer Kai Matthiesen.

THE SPIRIT OF TRANSFER

Der Himmel über Bern

JURI STEINER

Reflexion, Aktion und Produktion und die Sommerakademie im Zentrum Paul Klee

Lecture during the Summer Academy, 2009 / Vortrag während der Sommerakademie. (PHOTO: DAVID AEBI)

Künstler sind keine Wissenschaftler. Sie fragen nicht danach, was die Wahrheit ist. Da es sich bei Wissenschaft und Kunst aber um kreative Produkte des menschlichen Geistes handelt, gehört die Überzeugung von der Ähnlichkeit der beiden Domänen zu den verbreiteten Irrtümern. Zwar werden Künstler von progressiven Learning

JURI STEINER ist Direktor des Zentrums Paul Klee in Bern.

Centers dieser Welt in Artists-in-Labs-Programme eingeschleust, doch ob die beiden Formen von Kreativität tatsächlich zu gemeinsamen Problemlösungen führen, ist nur schwer belegbar. Kunst überkreuzt, wiederholt, unterbricht und widerspricht sich. Wissenschaft dagegen strebt nach Verallgemeinerung und unterwirft sich einer gewissen emotionalen Selbstbeschränkung.[1] Begreift man Künstler weder als eine Art universitäre Theoretiker, die didaktisches Anschauungsmaterial produzieren, noch als Sidekicks für Wissenschaftler, sondern als eigenständig forschende Wissensproduzenten, stösst man auf Begriffe wie «Forschung in der Kunst»[2], wie ihn etwa Henk Borgdorff formuliert. Künstlerische Praxis wird dabei als wesentlicher Bestandteil eines Forschungsprozesses verstanden, der sein Wissen im kreativen Prozess artikuliert.

Als Plattform einer solchen «Reflexion in Aktion» versteht sich die 2006 in Bern ins Leben gerufene Sommerakademie im Zentrum Paul Klee in Bern. Sie erlaubt es einem Dutzend internationaler Kunstschaffender, sich jährlich im August während jeweils zehn Tagen vertieft mit einem gemeinsamen Thema auseinanderzusetzen. Ein oder mehrere Gastkuratoren definieren das Leitmotiv. Zu den bisherigen Gastkuratoren gehörten Diedrich Diederichsen, Laura Hoptman und Marina Warner (2006), Brigitte Felderer und Herbert Lachmayer (2007), Clémentine Deliss und Oscar Tuazon (2008),

Tirdad Zolghadr (2009) und Jan Verwoert (2010). Rund 150 über den Globus verstreute Nominatoren motivieren passende Künstler im Vorfeld dazu, eine Kandidatur einzureichen. Ein Fachgremium wählt anschliessend aus den durchschnittlich sechzig bis siebzig Dossiers zwölf Positionen aus und lädt diese zur Teilnahme als Fellows an die Sommerakademie ein. Die fünf bisherigen Ausgaben haben gezeigt, wie virulent sich die Frage nach der sozialen und intellektuellen Bedeutung des Künstlers in unserer Dekade stellt. Erforscht werden in freier Form Theorie und Praxis des aktuellen Kunstbetriebs. Dabei führen die Themenfelder «Kollektiv und Individuum», «Wissen», «Spontaneität und Prozess» immer wieder zu zentralen Debatten.

Diese einzigartige, experimentelle Spielanordnung der Sommerakademie hat sich als ebenso attraktiv wie anregend erwiesen. Was passiert mit einem sich aus Künstlern und Kuratoren zusammensetzenden Ad-hoc-Team, das während knapp zwei Wochen fast alles teilt: Geschichten, Ideen, das Essen und das Schweizer Wetter auf den bisweilen strapaziösen Wochenendausflügen? Von den meisten Fellows wurde im Nachhinein hervorgehoben, wie einmalig die intensive Erfahrung einer gleichsam geistigen wie physischen Verausgabung gewesen sei. Der wissenschaftlich geprägte Begriff der «Sommerakademie» wurde im Prozess eines jeden Jahrganges in künstlerische, persönliche und physische Dimensionen ausgeweitet. Dagegen konnte der im universitären Kontext systemimmanente Druck nach Forschungsresultaten auf immer neue intellektuelle und kreative Art behandelt und entsprechend ab- oder umgeleitet werden. Und um den Rückzug in die Sommerakademie ebenso symbolisch wie konkret zu vollziehen, fanden die Seminare meist rund ums Zentrum Paul Klee statt: in einer Hütte von Gelitin, in einem Erdloch von Oscar Tuazon, in einer «SPACE SPACE (2009)»-Installation samt dazugehöri-

Paul Klee, 1911.

(PHOTO: ALEXANDER ELIASBERG)

gem «BAR BAR (2009)»-Satellit von Ethan Breckenridge oder zuletzt in einem ausgedienten Tramhäuschen.

Je länger und erfolgreicher sich die Sommerakademie im Zentrum Paul Klee entwickelte, desto selbstverständlicher wirkt es, dass dieses Experiment in Bern im Gravitationsfeld des Künstlers Paul Klee stattfindet. Man mochte sich zu Beginn noch fragen, ob Klee, der ewige Selbstlehrling, der Dessauer Bauhausmeister und Düsseldorfer Kunstprofessor der 20er- und 30er-Jahre, als Spiritus Rector einer Berner Akademie der Gegenwartskunst der richtige Patron sei? Zur Beantwortung der Frage galt es zuerst einige Klee-Klischees zu brechen, um zu sehen, wie zeitgemäss dieser Künstler ist. Der Klee-Spezialist Gregor Wedekind stellt die Frage nach Paul Klees akademischer Position und gibt eine Antwort: «Wie ist es mit theoretischen und wissenschaftlichen Glaubensmeinungen bei Klee bestellt? War er ein Naturforscher? Ein Empiriker oder Theoretiker der Form? Die Formenlehre seiner Bauhauskurse lässt sich eher als Poesie bezeichnen.» Wedekind zitiert Ernst Winklers positivistisch argumentierende Untersuchung über Paul Klees Verhältnis zur exakten Wissenschaft. Die mathematischen und physikalischen Meinungen und Vorstellungen Klees seien «zum grossen Teil nicht nur falsch, sondern einfach unsinnig».[3] Wedekind hält dagegen, dass sich Klee zur Wissenschaft in Analogien und Metaphern verhalten habe und diese für ihn mehr zum Ausdruck oder Symbol als zur Begründung von Ordnung bestimmt war: «Man könnte bei Klees Formenlehre auch von der simulierenden Exemplifikation einer Theorie reden, von einer Parodie auf Geometrie. Klees Bildtheorie ist quasi-wissenschaftlich und will keinen Augenblick vergessen machen, dass das pädagogische Instrument rationaler Theoretisierung lediglich ein Hilfsmittel ist.»[4]

Theorie als Hilfsmittel

In dieser Leseweise von «Theorie als Hilfsmittel» ist das Zentrum Paul Klee der goldrichtige Austragungsort für eine Kunst-Sommerakademie. Auch bietet Bern den entsprechenden Genius loci für ein künstlerisches Unterfangen an den Grenzen von Theorie und Praxis. Obwohl Klee mitunter an der Provinzialität und dem «sanften Trug des Berner Milieus»[5] gelitten hat, so ist diese kleine Stadt historisch betrachtet ein wahres Labor für die Schnittmenge zwischen Reflexion und Produktion. In Bern dachten und operierten Akteure der Avantgarde wie

Johannes Itten, Lenin, Hugo Ball und Emmy Hennings, Walter Benjamin, Walter Morgenthaler, Adolf Wölfli bereits in den 10er- und 20er-Jahren des letzten Jahrhunderts. In der Nachkriegszeit waren es Meret Oppenheim, Markus Raetz, Franz Gertsch, Balthasar Burkhard und vor allem Harald Szeemann, die Bern mit ihren Experimenten auf die neue Weltkarte der Kunst setzten. Der junge Harald Szeemann hat in Bern seine Lizentiatsarbeit über Klee geschrieben und darin das «Unbefriedigtsein» des jungen Klee beschrieben, als wäre es sein eigenes: «Ein Unbefriedigtsein? Mit sich, mit seinem Können und mit dem System, das ihm dieses Können vermittelte, unzufrieden. Den Beweis erbringt die Zukunft.»[6] In Bern hat Szeemann 1956 ein Einmanntheater betrieben, in das er all seine Erfindungsgabe, seine geballte Spielkraft und Gestaltungswucht investierte, bevor er zwischen 1961 und 1969 die Kunsthalle Bern zum Labor umwertete und den neuen Ausstellungsstil des strukturierten Chaos begründete. Damals nahm Szeemann Robert Storrs Motto der Biennale von Venedig 2007 vorweg «Think with the Senses – Feel with the Mind»; er war ein Berserker, ein Homo faber und Bern ein eigenartiger Umschlagplatz an der Peripherie. Ausgerechnet hier wurden aus Attitüden Form, was nichts anderes bedeutet, als dass in der Aktion Neues, Unerprobtes, Aufbrüche zu festen ästhetischen, politischen und ethischen Werten haben gerinnen können.

Eine von Harald Szeemanns ersten Ausstellungen war Hugo Ball gewidmet. Interessant: An Balls Texten von 1909 bis 1927 hat Szeemann in den 50er-Jahren seine Sensoren für die neue Kunst der 60er-Jahre sensibilisiert. Und so tönen Balls Grundsatzfragen von vor 85 Jahren über Szeemanns Verstärker heute für die Sommerakademie im Zentrum Paul Klee noch so unmittelbar wie der Schrei eines Neugeborenen: «Wer ist der Künstler? Wie kommt das Kunstwerk zustande? Geben dem Dichter die Götter ein oder die Dämonen? Worin ist das ‹Genie› begründet? Worin das sogenannte Schaffen? Wer schafft und kreiert?» All das fragt Hugo Ball auf der ersten Seite seines Aufsatzes «Der Künstler und die Zeitkrankheit» von 1926. Aus diesen Fragen heraus entwickelt er einen Leitsatz, der über dem Eingang des Museums der Obsessionen gemeisselt sein könnte: «Prinzip der Gestaltung ist immer die Person.»[7] Der Künstler, so Ball, dringe zum Urbild seiner Neurose durch und identifiziere sich mit ihm, nehme also eine dämonische Person an, gleich den-

The fellows of the Summer Academy 2010, Zentrum Paul Klee / Teilnehmer der Sommerakademie. (PHOTO: DAVID AEBI)

jenigen, die C. G. Jung aufzähle, wenn er davon spreche, dass unser Unbewusstes an der historischen Kollektivpsyche Anteil habe und natürlich unbewusst in einer Welt von Werwölfen, Dämonen, Zauberern und so weiter lebe. Die Malerei, die visionäre Kunst, wimmle, so Ball, von solchen Gestalten; die Poesie werde ihr folgen.

Verausgabung

Erinnern wir uns: Es war Ball, der in seinem berühmten kubistischen Kostüm, das er 1916 im Zürcher Cabaret Voltaire zum Rezitieren des Lautgedichts «Gadji beri bimba» trug, Dadas Dämonen weckte und als Zertrümmerer der Sprache in die Kunst- und Literaturgeschichte eingegangen ist. Während des schweisstreibenden Rezitierens hatte er eine Eingebung: Er erkannte die Kraft der Gestaltenfülle jenseits der Sprache, sah einen Ozean von Äusserungs-Möglichkeiten vor sich, unabsehbar und abenteuerlich jenseits der Besinnung. Die dadaistische Urszene zeigt sehr schön die Bezüge zwischen Theorie und Praxis von der Avantgarde bis zur Gegenwartskunst. Ohne die totale Verausgabung im Cabaret Voltaire wäre Ball nie zu seiner Erkenntnis über das «Wesen des Kunstproduktes» gekommen. Ihm wurde während der Performance avant la lettre klar, «dass man in einem neuen Gesamtbild die letzte und höchste Form nicht ohne den Inhalt, ohne die Welt der Gefühle und Triebe mehr setzen kann. Der formalistischen, rein verstandesmässigen Ansicht der Dinge folgt eine solche, die die Vernunft nicht abgezogen von ihrer seelischen und körperlichen Ausprägung mehr will gelten lassen. Letzter Urheber der Dinge muss ein Künstler, oberstes Kriterium einer neuen Wertskala die Kunst selber sein, in ihrer ganzen Vermögensfülle.»[8] Vernunft, Körper, Seele – was sonst als see-

lisch-körperliche Aneignungsformen intellektueller oder kultureller Blöcke waren Szeemanns Ausstellungen oder sind dies heute die Altäre, Kioske und prekären Museen des anderen Berner Gastarbeiters Thomas Hirschhorn?

Innere Notwendigkeit und aktuelles Wirksamwerden
Die vierte von Tirdad Zolghadr kuratierte Sommerakademie stand 2009 unter dem von Wassily Kandinsky geprägten Begriff der «inneren Notwendigkeit» und fragte nach der inneren Logik der zeitgenössischen Kunst und der inhärenten Notwendigkeiten edukativer Ideologien und kunstprofessioneller Standards, welche die Sommerakademie beeinflussen. In einem 1917 in der Galerie Dada gehaltenen Vortrag über Kandinsky sagte Hugo Ball über die «innere Notwendigkeit», «dass sie allein der freien Intuition Grenzen gibt, die innere Notwendigkeit die äußere, sichtbare Form des Werkes bildet. Die innere Notwendigkeit ist es, auf die alles zuletzt ankommt, sie verteilt die Farben, Formen und Gewichte, sie trägt die Verantwortung auch für das gewagteste Experiment. Sie allein ist die Antwort auf die Frage nach dem Sinn und Urgrund der Bilder. In ihr dokumentieren sich die drei Elemente, aus denen das Kunstwerk besteht: Zeit, Persönlichkeit und Kunstprinzip.»[9] Es ist wirklich bemerkenswert, dass sich Künstler im Jahr 2009 im Kollektiv diskutierend an ihre jeweilige «innere Notwendigkeit» herantasten. Dass das Gruppen-Experiment geglückt ist, beweist die Publikation, die der Kurator und die Fellows dieses Jahr rückwirkend herausgegeben haben.[10]

Die fünf Ausgaben der Sommerakademie haben einen wichtigen Beweis geliefert: Künstler müssen nach ihrem Studium an Kunstakademien nicht alleine arbeiten, obschon sie, wie Ball sagen würde: grausam in ihr eigenes Selbst zurückverwiesen sind. Um diesem Selbst auf die Spur zu kommen, sollen sich die Künstler nicht immer und jederzeit alleine auf ihre eigene kreative Vorstellungskraft verlassen müssen. Es braucht, so Hugo Ball, das existenzielle Momentum, das Erforschen «in vivo» am eigenen Körper. Und es braucht zur öffentlichen Beweisführung einen Raum für das zu tätigende Opfer. Es braucht wie im Cabaret Voltaire Mitspieler, Zeugen und eine Bühne für das Selbstexperiment. Die Sommerakademie im Zentrum Paul Klee bietet all das. Der Kopfstand-Denker Bazon Brock weist auf die kultische oder liturgische Ausprägung von Balls Auftritt «als blauer Bischof» im Cabaret Voltaire hin, was ihm den Weg in die

Aktionskunst weist: «Die Aktionisten verstanden sich auf die Tradition der Dadaesken, des Kabaretts und des Gesellschaftsspiels, Bilder zu verlebendigen durch die Aufstellung ‹Lebender Bilder› und beabsichtigten die Überführung ihrer Werke in ein aktuelles Wirksamwerden. Die festen Werkformen wurden durch Verzeitlichung im Ritual und durch die Liturgie der Transformationen verflüssigt.»[11] Rückblickend ist es gar nicht so überraschend, dass die Akademie zwischen 2006 und 2010 sowohl in den internen, geschlossenen Präsentationen als auch in den öffentlichen Lectures immer performativere Züge angenommen hat.

Das Vorbild: die Universität Muri
Hugo Ball übersiedelte Anfang September 1917 von Zürich nach Bern. Walter Benjamin, dem es mithilfe seiner Frau gelang, sich kriegsdienstuntauglich erklären zu lassen, zog im Herbst 1917 ebenfalls nach Bern. Hier schrieb er sich an der Universität ein, um in Philosophie zu promovieren. Gershom Scholem, der Freund Benjamins, folgte ihm im Mai 1918. Bald nach Scholems Ankunft zogen die Freunde nach Muri, einem Vorort von Bern, wo sie in einer Zeit intensiven geistigen Austauschs lebten. Benjamin, der dem akademischen Lehrbetrieb misstraute, gründete während seines Berner Studiums eine imaginäre «Universität Muri», die der Phantasie und dem Witz den gehörigen Platz einräumen sollte, dabei aber hierarchisch organisiert war mit Benjamin als Rektor und Gershom Scholem als Pedell, wie der Klee-Experte Oskar Bätschmann festhält.[12] Die fiktive Universität Muri war das akademische Wolkenkuckucksheim eines Philosophen und eines Kabbala-Forschers, die die Grenzen der Wissenschaften hinter sich lassen wollten. In der Schrift «Programm der kommenden Philosophie» versucht Benjamin, Kants Erkenntnistheorie über die wissenschaftliche Subjekt-Objekt-Trennung hinauszuführen und metaphysisch auszuweiten. «Eine Philosophie, die nicht die Möglichkeit der Weissagung aus dem Kaffeesatz einbeziehen und explizieren kann, kann keine wahre sein.»[13] In ihrem durchaus disziplinierten Streben, fröhliche Wissenschaft zu betreiben, den Begriff des Akademischen selbstironisch auszuweiten und für das subjektive und feinstoffliche Feld von Phantasie und Spontaneität fruchtbar zu machen, wirkt die Sommerakademie im Zentrum Paul Klee wie ein Ableger der Universität Muri. Auch Klee hätte sehr gut an diese Universität Muri ge-

passt. Doch er und Benjamin haben sich nie getroffen. Weder in München noch in Bern, wo sie sich zeitgleich in ähnlichen Zirkeln bewegten. Zwischen Benjamin und Klee existierte aber ein Beziehungsnetz, das sich über Bern spinnt: 1919 wohnten Hugo Ball, Walter und Dora Benjamin Haus an Haus an der Berner Marzilistrasse und pflegten Kontakt. Es sei durchaus möglich, so Bätschmann, dass Klee sich an Hugo Balls Angelologie erinnerte, als er in den letzten Lebensjahren seine Heerscharen unterschiedlichster Engel schuf. Auf diese Weise schlösse sich der Kreis zwischen Ball, Benjamin und Klee in der Transzendenz oder besser: im Himmel über Bern. Doch die formale Ebene von Klees Kunst beansprucht keinen programmatischen Gehalt in dem Sinne, wie Kandinsky ihn für seine konkrete Abstraktion festlegte. Abstraktion findet bei Klee weniger im Formalen statt als in der Haltung des Künstlers. Und Klee realisierte seine Kunstwerke immer auch in Bezug auf die Bedürfnisstruktur und die Erwartungshaltung des Publikums.

Genauso funktioniert die Sommerakademie im Zentrum Paul Klee, wenn auch mit neuen Methoden in einer anderen Zeit. Sie fragt nicht danach, was die Wahrheit ist, sondern wie die Wahrheit beschaffen ist. Dazu gehören auch Merkmale, Strategien und Haltungen, die Paul Klee alles andere als fremd gewesen sind und die als das geistige Fundament der Sommerakademie angesehen werden können: Innere Notwendigkeit, Meta-Kognition, die sich auf die Reflexion des eigenen Gedankenprozesses bezieht, kulturelle Strategien zur Erinnerung, Kollektives Arbeiten, Verausgabung, Wissenshunger, Entwicklung kunstpädagogischer Konzepte, Bescheidenheitsgestus, Schweigen, Märchen und Utopie, Miniaturcharakter,

Sympathie, Poesie und Humor. Oder wie Harry Szeemann es ausgedrückt hätte: «U wäge dem säg i immer, also anunfürsich die Uufgaab ä Usschtellig zmache und äs Läbe lang mit de Chünschtler zverbringe, wo für mi die ideali Gsellschaft si – wo mes immer mit eim ztüe hät und quasi also die Gsellschaft sich us Additione vo Begägnige zämmesetzt, muess me mit Häärz läbe.»[14]

Sommerakademie im Zentrum Paul Klee, http://www.sommerakademie.zpk.org

1) Lewis Wolpert, *Unglaubliche Wissenschaft*, Eichborn-Verlag, Frankfurt am Main 2004, S. 105 ff.
2) Siehe dazu: Henk Borgdorff, «Die Debatte über Forschung in der Kunst», in Anton Rey/Stefan Schöbi (Hg.), *Forschung. Positionen und Perspektiven*, subTexte 03, Institute for the Performing Arts and Film. Zürich 2009.
3) Gregor Wedekind, «Kosmische Konfession. Kunst und Religion bei Paul Klee», in *Paul Klee, Kunst und Karriere, Beiträge des Internationalen Symposiums in Bern*, hg. v. Oskar Bätschmann und Josef Helfenstein, Bern: Stämpfli 2000 (Schriften und Forschungen zu Paul Klee, 1), S. 226–238, S. 229.
4) Ibid.
5) Felix Klee (Hg.), *Tagebücher von Paul Klee 1898–1918*, Dumont-Verlag, Köln 1957, Nr. 963.
6) Harald Szeemann, *Paul Klee* (unveröffentlichte Lizentiatsarbeit der Universität Bern, 1955, Depositum Zentrum Paul Klee, Bern), S. 25.
7) Hugo Ball, «Der Künstler und die Zeitkrankheit», Erstdruck in *Hochland* (München), 24. Jahrgang, Band 1, Heft 2, November 1926, o.S.
8) Ibid.
9) Hugo Balls Vortrag über Kandinsky [gehalten in der Galerie Dada, Zürich am 7. April 1917] / hg. v. Andeheinz Mösser, in Deutsche Vierteljahresschrift für Literatur- und Geistesgeschichte, No. 4, 1977, S. 676–704.
10) Tirdad Zolghadr et al., *Internal Necessitiy*, SternbergPress, Berlin 2010.
11) Thesendirektive von Bazon Brock in the *ART MASTER*, Juni 2010, o.S.
12) Oskar Bätschmann: «Angelus Novus und Engel der Geschichte: Paul Klee und Walter Benjamin», in Engel, Teufel und Dämonen. Einblicke in die Geisterwelt des Mittelalters, H. Herkommer/R.Ch. Schwinges (Hg.), Schwabe Verlag, Basel, 2006, S. 227.
13) Walter Benjamin, «Über das Programm der kommenden Philosophie», in *Gesammelte Schriften*, Bd. II.1, Suhrkamp Verlag, Frankfurt am Main 1980, o.S.
14) Harald Szeemann am 31. Dezember 2000 in: *Das prominente Mikrophon*, Schweizer Radio DRS 1.
«Ich sage es immer und immer wieder, die Aufgabe, eine Ausstellung zu machen und das Leben mit den Künstlern zu verbringen, die für mich die ideale Gesellschaft sind, wo man es immer mit einem Gegenüber zu tun hat und die Gesellschaft sich aus Additionen von Begegnungen zusammensetzt, das muss man mit dem Herzen leben.»

Walter Benjamin, ca. 1926 / Gershom Scholem.
(PHOTOS: SUHRKAMP VERLAG & ALIZA AUERBACH/SUHRKAMP VERLAG)

The Sky Over Bern

Reflection, Action, and Production in the Zentrum Paul Klee's Summer Academy

JURI STEINER

Artists are not scientists. They do not ask what truth is. But since both science and art are creative products of the human mind, a misguided conviction prevails that the two domains are similar. The world's progressive "learning centers" diligently dispatch artists to Artists-in-Labs programs, but evidence as to whether the two forms of creativity actually lead to shared problem solving is hard to come by. Art intersects, repeats, interrupts, and contradicts itself. In contrast, science aspires to generalization and is governed by self-imposed emotional restrictions.[1] The premise that artists are neither academic theoreticians who produce didactic visuals, nor sidekicks for scientists but rather independent, probing producers of knowledge has given rise to such concepts as "research in art,"[2] advanced, for instance, by Henk Borgdorff. Artistic practice is there seen as a vital constituent of a research process, whose knowledge is articulated in the creative process.

A platform for this kind of "reflection in action" has been hosted since 2006 by the Zentrum Paul Klee's Summer Academy in Bern. The Academy enables a dozen international practitioners to meet annually in August for some ten days to engage in concentrated, shared study on a particular theme. One or several guest curators define the leitmotif. So far, invitations have been extended to the following curators: Diedrich Diederichsen, Laura Hoptman, Marina Warner (2006); Brigitte Felderer, Herbert Lachmayer (2007); Clémentine Deliss, Oscar Tuazon (2008); Tirdad Zolghadr (2009); and Jan Verwoert (2010). About 150 nominators scattered around the globe encourage suitable artists to submit applications. A team of experts then selects 12 of the 60 to 70

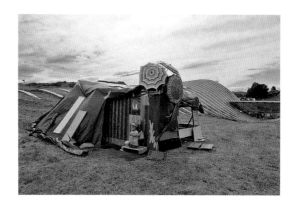

Villa Gelitin, 2007.

submissions to become fellows at the Summer Academy. The past five years provide ample proof of the urgent need to explore the social and intellectual significance of the artist in our decade. Under the open-ended guidance of the curators, participants investigate the current art trade, both in theory and practice, their debate frequently focusing on such issues as the collective and the individual, knowledge, and spontaneity and process.

The Summer Academy's unique, experimental approach has proven to be as attractive as it is inspiring. What happens when an ad hoc team of artists and curators share almost everything for close to two weeks: stories, ideas, meals, and Swiss weather on occasionally strenuous weekend excursions? In retrospect, most of the fellows emphasize the uniqueness and fertility of such an intense mental and physical commitment. Each of the groups added their own artistic, personal and physical interpretations to the scholarly implications of the term "Summer Academy." With intellectual and creative verve, they diverted and differentiated the systemic pressure of the university context

JURI STEINER is the director of the Zentrum Paul Klee in Bern.

to come up with new research findings. The nature of the Summer Academy as a retreat was reinforced both symbolically and concretely by frequently housing the seminars in locations around the Zentrum Paul Klee: in a hut made by Gelitin, in a hole in the earth by Oscar Tuazon, in a SPACE SPACE (2009) installation in conjunction with a BAR-BAR (2009) satellite by Ethan Breckenridge, and, most recently, in an abandoned tram shelter.

The growing success of the Summer Academy over the past few years attests to the rightness of organizing this experiment within the gravitational field of the artist Paul Klee. Initially one might have queried whether Klee—forever his own apprentice, Bauhaus master and professor of art in Düsseldorf in the 1920s and 1930s—was a suitable choice as patron and Spiritus Rector of the Bernese Academy of Contemporary Art. The Klee specialist, Gregor Wedekind, addresses the question of Paul Klee's academic status: "What theoretical and scientific opinions and beliefs apply to Klee? Was he a naturalist? An empiricist or scholar of form? The formal teachings in his Bauhaus courses might best be designated as poetry." Wedekind cites Ernst Winkler's positivistically oriented study of Paul Klee's relationship to the exact sciences. Klee's mathematical and physical opinions and ideas were, says Winkler, "for the most part not simply wrong but just plain nonsense."[3] Wedekind, in turn, argues that Klee approached the sciences in terms of analogies and metaphors; what they express and symbolize was more important to him than their usefulness as explanations of an order: "Klee's teachings might be described as the simulating exemplification of a theory, a parody of geometry. Klee's visual theory is pseudoscientific and never lets us ever forget that the pedagogical instrument of rational theorizing is always only an aid."[4]

Theory as an Aid

A reading of theory as an aid makes the Zentrum Paul Klee the ideal place to host a summer academy on art. Bern itself is also a suitable genius loci for an artistic undertaking on the cusp between theory and practice. Although Klee occasionally suffered from the provincial character and the "soft delusion of the Bernese milieu,"[5] historically the small city has consistently been a laboratory for encounters between reflection and production. In the 1910s and 1920s, Bern attracted a distinguished avant-garde roster of luminaries, including Johannes Itten, Lenin, Hugo Ball and Emmy Hen-

nings, Walter Benjamin, Walter Morgenthaler, and Adolf Wölfli. After the Second World War, the experiments of such artists and practitioners as Meret Oppenheim, Markus Raetz, Franz Gertsch, Balthasar Burkhard and, above all, Harald Szeemann put Bern on the new global map of art. It was in Bern that Szeemann wrote his thesis on Klee, describing young Klee's dissatisfaction as if it were his own: "Dissatisfaction? Dissatisfied with himself, with his skills and with the system that taught him these skills. The future would supply the evidence."[6] In 1956, Szeemann ran a one-man theater, demonstrating unparalleled inventiveness, unbridled playful energy, and an uncontested instinct for design. Between 1961 and 1969, he proceeded to convert the Kunsthalle Bern into a laboratory, there launching a new style of exhibitions as structured chaos. He prefigured Robert Storr's motto of the 2007 Venice Biennale, "Think with the Senses—Feel with the Mind"; he was berserk, a homo faber in a city that was a curiously peripheral hotbed of unprecedented ideas. It was there that attitudes became form, which quite simply meant nurturing action to permit anything new, untried, and radical to coalesce into firm aesthetic, political, and ethical values.

Szeemann devoted one of his earliest exhibitions to Hugo Ball; in the 1950s, the budding young curator studied what Ball had written between 1909 and 1927, thereby laying the groundwork for his sensitivity to the new art of the sixties. For the twenty-first century Summer Academy at the Zentrum Paul Klee, the fundamental questions raised by Ball 85 years ago, and heard over Szeemann's loudspeaker, still sound as fresh as the cry of a newborn: "What is an artist? How does a work of art come about? Is the poet inspired by the gods or by demons? What makes a 'genius'? What does so-called labor consist of? Who works and who creates?" Ball raises these questions on the first page of his 1926 essay "Der Künstler und die Zeitkrankheit" (The Artist and the Disease of the Times) and from them deduces a motto that could be carved above the entrance to the Museum of Obsessions: "The principle of design is always the person."[7] Ball argues that artists probe the origins of their neuroses and identify with them, eventually adopting a demonic personage, much like those mentioned by C. G. Jung, who maintains that our unconscious is part of the historical collective psyche and unconsciously—of course—inhabits a world of werewolves, demons, magicians, etc. Painting, visionary art, is teeming with such figures and, says Ball, poetry will follow.

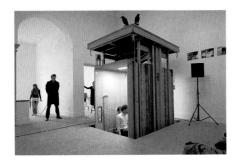

Commitment

Lest we forget: it was Ball—wearing his famed Cubist outfit at the Zürich Cabaret Voltaire in 1916 to recite his ono-matopoeic "Gadji beri bimba"—who aroused the demons of Dada and has gone down in the history of art and literature for having demolished language. Dripping with perspiration under his costume while reciting, he had an epiphany: he saw the mighty cornucopia of design beyond language, saw an ocean of potential means of expression, immeasurable and adventurous, beyond reflection. The original Dadaist scene is a fruitful arena for the study of the relationship between theory and practice from the avant-garde to contemporary art. Without the unqualified commitment of the Cabaret Voltaire, Ball would never have arrived at his insight into the "essence of the art product." During the performance, he realized avant la lettre that it is no longer possible to place the ultimate and highest form in a new overall picture without content, without the world of feelings and instincts. The formalist, purely rational view of things is succeeded by a view that no longer acknowledges reason detached from its spiritual and physical context. The ultimate originator of things has to be an artist, the ultimate criterion of a new scale of values, art itself in the entirety of all its potential.[8]

Reason, body, soul—Szeemann's exhibitions were nothing but spiritual, physical forms of appropriating intellectual or cultural blocks, just like the altars, newsstands, and precarious museums of another guest-worker from Bern today: Thomas Hirschhorn.

Inner Necessity and Contemporaneous Effect

Tirdad Zolghadr, curator of the fourth Summer Academy in 2009, took inspiration from Wassily Kandinsky's idea of "inner necessity" to inquire into the inner logic of contemporary art and the inherent necessity of the educational ideologies and professional standards that influence the Summer Academy. When Hugo Ball gave his lecture on Kandinsky in Zürich in 1917, he explained the idea of inner necessity. It "alone gives limits to free intuition, inner necessity shapes the external, visible form of the work. On inner necessity everything ultimately depends: it distributes the colors, forms, and emphases, it bears responsibility even for the most daring experiment. It alone is the answer to the meaning and primal basis of the image. It documents the three elements of which the work of art consists: time, personality, and the artistic principle."[9] It is truly remarkable that artists should have chosen collectively to probe their own "inner necessities" in the year 2009. The publication, subsequently issued by the curator and the fellows, testifies to the success of that group experiment.[10]

The past five Summer Academies offer unmistakable proof that artists need not be condemned to working alone after completing their studies at art academies although, as Ball would say, they are mercilessly thrown back on their own selves. And in order to find themselves, as it were, they do not have to rely exclusively on their own creative faculties. Another requisite, says Ball, is existential momentum, "in vivo" study of their own bodies. To present the findings of their research to the public, a space is required for the activated victim. As in Cabaret Voltaire, self-experiments require co-players, witnesses, and a stage—and that is what the Summer Academy at the Zentrum Paul Klee has to offer its fellows. Bazon Brock of Kopfstand (Headstand, 1959) fame draws attention to the cultic or liturgical implications of Ball's performance "as a blue bishop" at Cabaret Voltaire, which prefigured Aktionist art: "Celebrating the heritage of bringing pictures to life, cultivated by Dada, cabaret, and social games, the Aktionists enacted 'living pictures' with the intention of making their works contemporaneously effective. Fixed art forms were liquefied through the duration of ritual and the liturgy of transformations."[11] In retrospect, it is hardly surprising that between 2006 and 2010, the Academy became increasingly performative not only in private presentations but also in public lectures.

The Model: the University of Muri

Hugo Ball moved from Zürich to Bern in early September 1917. Walter Benjamin, who was declared unfit for military duty with the help of his wife, also moved to Bern in the fall of that year, where he enrolled in the university and took a degree in philosophy. His friend Gershom Scholem followed in May 1918. Soon after Scholem's arrival,

the two friends moved to Muri, a suburb of Bern, where they enjoyed a time of intense intellectual exchange. Skeptical of academic education, Benjamin founded an imaginary institution, the University of Muri, which was to give ample leeway to imagination and humor although, as Klee expert Oskar Bätschmann observes, it was hierarchically organized with Benjamin as Dean and Gershom Scholem as porter.[12] This fictional university was the academic cloud cuckoo land of a philosopher and a Kabbalah scholar, who wanted to transcend the limitations of scholarship. In his remarks on a program for the future of philosophy, Benjamin aimed to extend Kant's theory of knowledge metaphysically, moving beyond the academic distinction between subject and object. In his own words: "A philosophy that does not include the possibility of soothsaying from coffee grounds and cannot explicate it cannot be a true philosophy."[13] The Summer Academy's disciplined efforts to foster the cheerful sciences and to approach academia with self irony make it a fertile seedbed for the subjectivity and subtlety of imaginative and spontaneous action; it has essentially become an offshoot, an extension of the University of Muri.

Klee would have fit in very well at Benjamin's University of Muri, but he never made his acquaintance—neither in Munich nor in Bern, although the two were moving in similar circles at the time. There was, in fact, a specific link between Benjamin and Klee in Bern. In 1919, Hugo Ball and Walter and Dora Benjamin not only knew each other; they lived next door on Marzilistrasse. It is certainly conceivable, according to Bätschmann, that when Klee created untold angels in the final years of his life, he had Ball's Angelology in the back of his mind. In this way, the story of Ball, Benjamin, and Klee comes full circle in transcendency, or rather, in the sky over Bern. Formally, however, Klee's work does not lay claim to programmatic subject matter of the kind defined by Kandinsky in his concrete abstraction. Klee's approach to abstraction was not primarily formal but the embodiment of an attitude. Moreover, he made art that responded to the needs and expectations of his audience.

This is exactly the way the Summer Academy at Zentrum Paul Klee functions, albeit with new methods and in another age. Instead of inquiring into what truth is, the question reads: how does it work? That includes qualities, strategies, and attitudes that are anything but alien to Paul Klee and that can be viewed as the intellectual foundation of the Summer Academy: inner necessity; meta-cognition, which means thinking about one's own thought processes; cultural strategies of remembering; working collectively; commitment; thirst for knowledge; developing ideas for art education; modesty and silence; fairytale and utopia, miniature character; sympathy; poetry; and humor. Or as Harry Szeemann put it: "U wäge dem säg i immer, also anunfürsich die Uufgaab ä Usschtellig zmache und äs Läbe lang mit de Chünschtler zverbringe, wo für mi die ideali Gsellschaft si – wo mes immer mit eim ztüe hät und quasi also die Gsellschaft sich us Additione vo Begägnige zämmesetzt, muess me mit Häärz läbe."[14]

(Translation: Catherine Schelbert)

Summer Academy in the Zentrum Paul Klee, http://www.sommer-akademie.zpk.org

1) Lewis Wolpert, *Unglaubliche Wissenschaft* (Frankfurt am Main: Eichborn Verlag, 2004), p. 105 seqq.
2) Cf. Henk Borgdorff, "Die Debatte über Forschung in der Kunst," *Forschung. Positionen und Perspektiven*, subTexte 03, eds. Anton Rey/Stefan Schöbi (Zürich: Institute for the Performing Arts and Film, 2009).
3) Gregor Wedekind, "Kosmische Konfession. Kunst und Religion bei Paul Klee," *Paul Klee, Kunst und Karriere*, eds. Oskar Bätschmann and Josef Helfenstein, Beiträge des Internationalen Symposiums in Bern (Bern: Stämpfli, 2000) Schriften und Forschungen zu Paul Klee, 1, 2000), pp. 226–238, p. 229.
4) Ibid.
5) Felix Klee (ed.), *The Diaries of Paul Klee 1898–1918* (London: University of California Press, 1968), no. 963, p. 322.
6) Harald Szeemann, *Paul Klee* (Bern: University of Bern, unpublished thesis, 1955, on deposit at the Zentrum Paul Klee), p. 25.
7) Hugo Ball, "Der Künstler und die Zeitkrankheit" in *Hochland* (Munich), Year 24, Vol. 1, Issue 2, November 1926, n.p.
8) Ibid.
9) Lecture on Kandinsky, given at Galerie Dada, Zürich, 7 April 1917, in: *Hugo Ball, Flight out of Time: A Dada Diary* (London: University of California Press, 1996), pp. 222–234, p. 227.
10) Tirdad Zolghadr, et al., *Internal Necessity* (Berlin: Sternberg Press, 2010).
11) Bazon Brock in the *ART MASTER*, June 2010, n.p.
12) Oskar Bätschmann: "Angelus Novus und Engel der Geschichte: Paul Klee und Walter Benjamin," *Engel, Teufel und Dämonen. Einblicke in die Geisterwelt des Mittelalters*, eds. H. Herkommer/R.Ch. Schwinges (Basel: Schwabe, 2006), p. 227.
13) Gershom Scholem, *Walter Benjamin: The Story of a Friendship* (New York: The New York Review of Books, 2003), p. 73.
14) Harald Szeemann in *Das prominente Mikrophon*, Schweizer Radio DRS 1, 31 December 2000. "And that's why I always say that basically the task of making exhibitions and spending an entire lifetime with artists, which is ideal company for me—where you're always somehow connected and company consists, in a way, of accumulations of encounters—that has to be the love of your life."

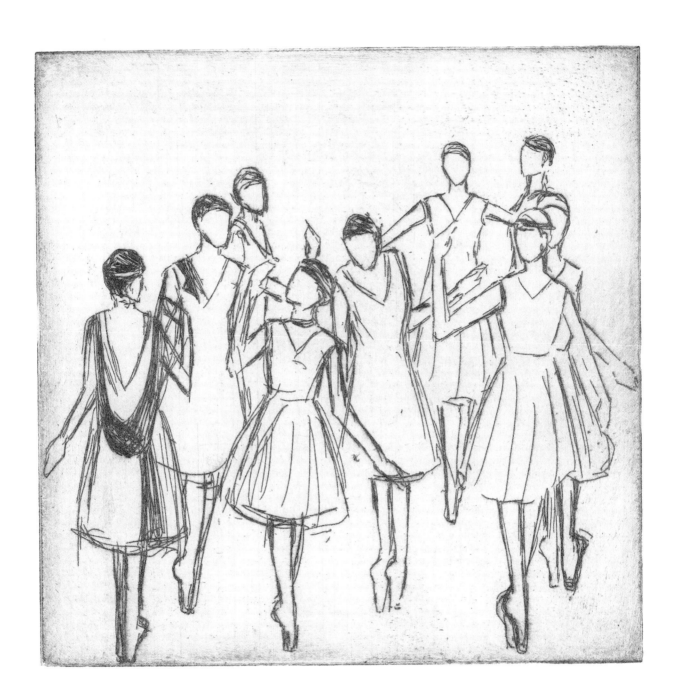

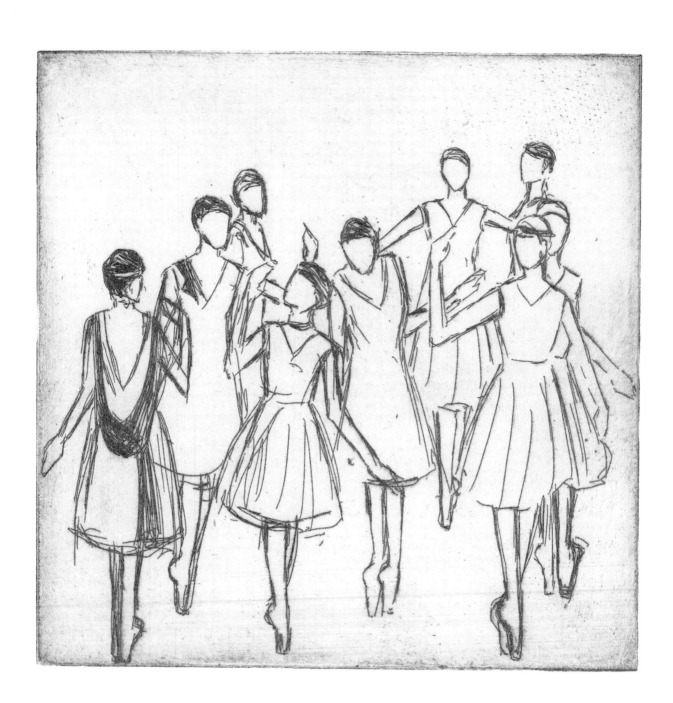

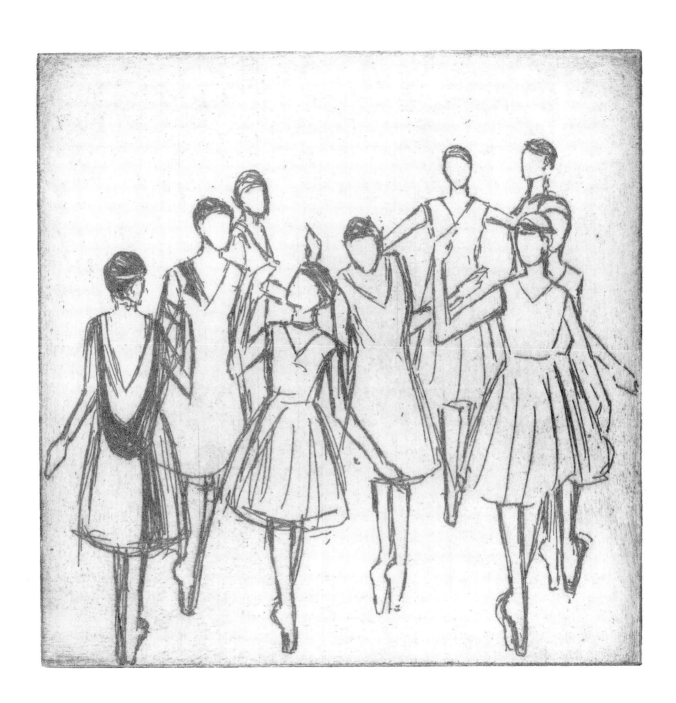

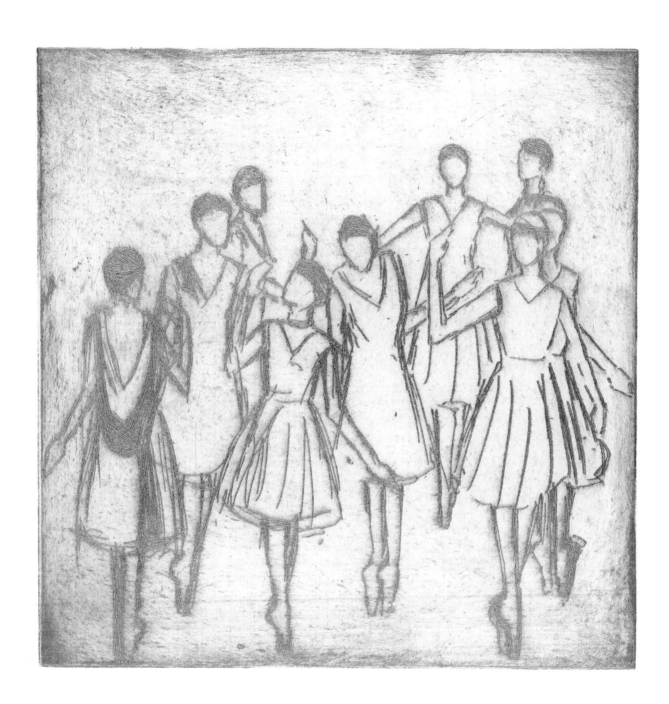

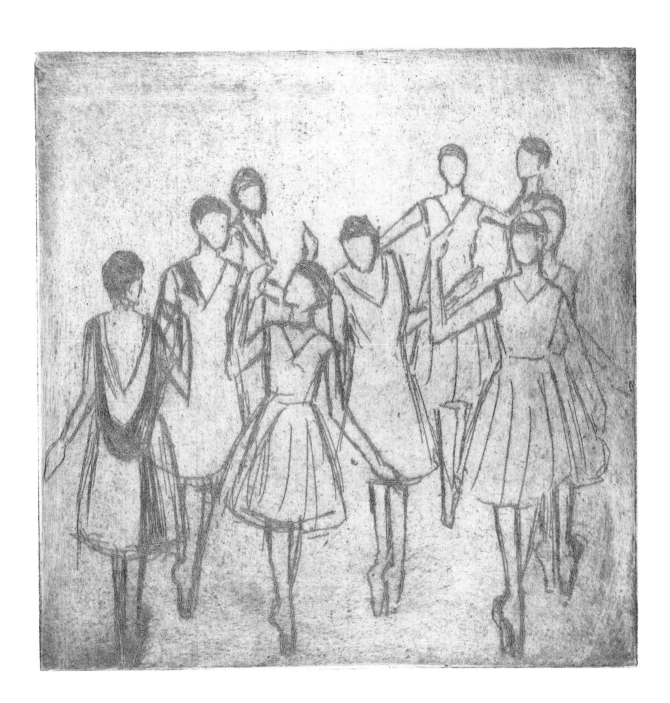

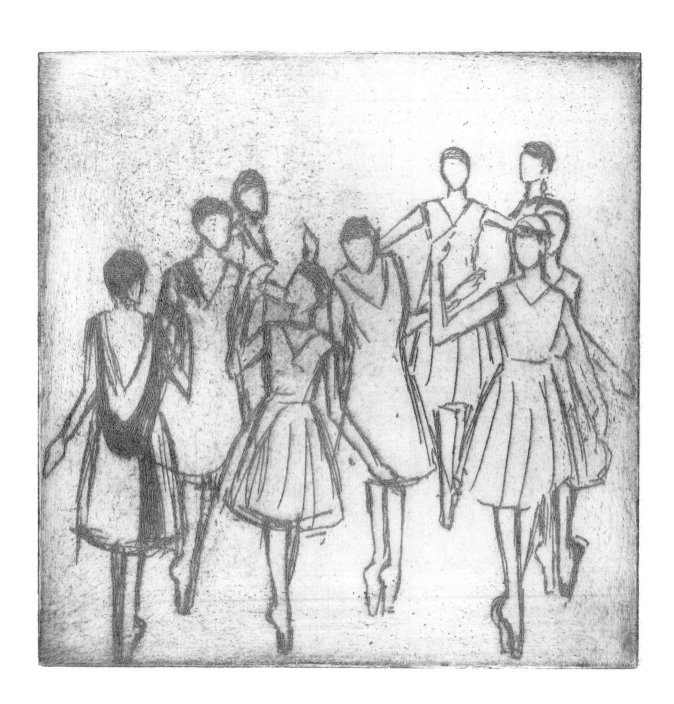

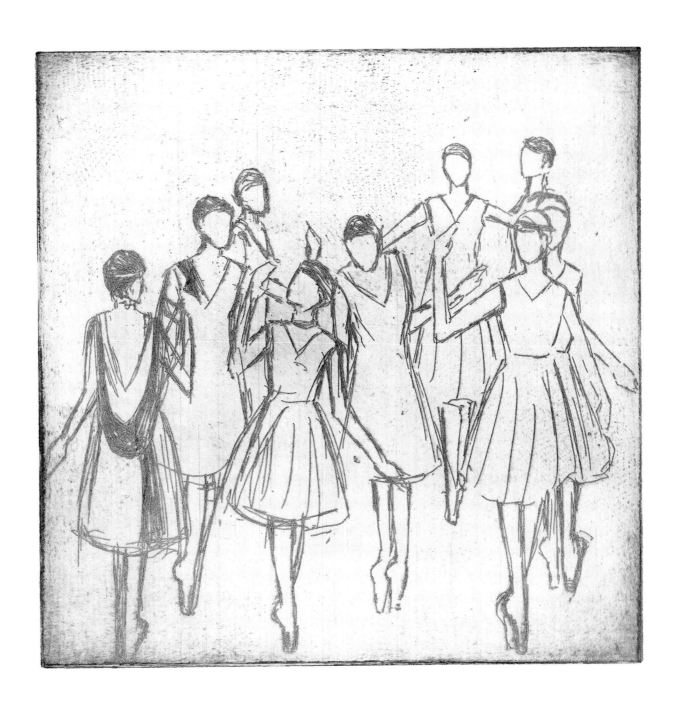

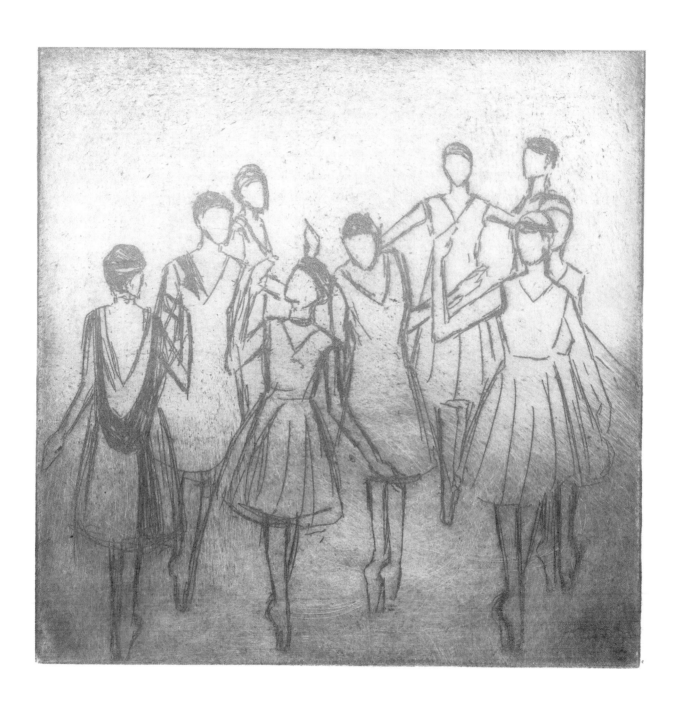

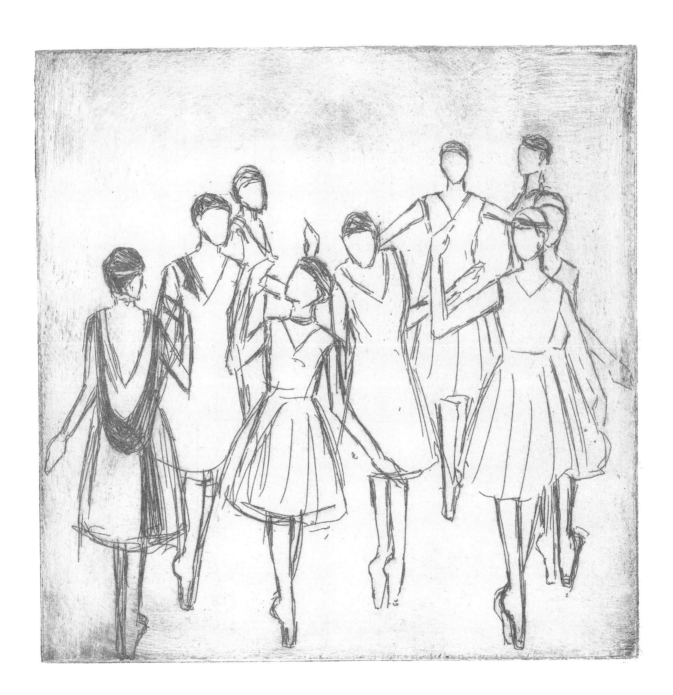

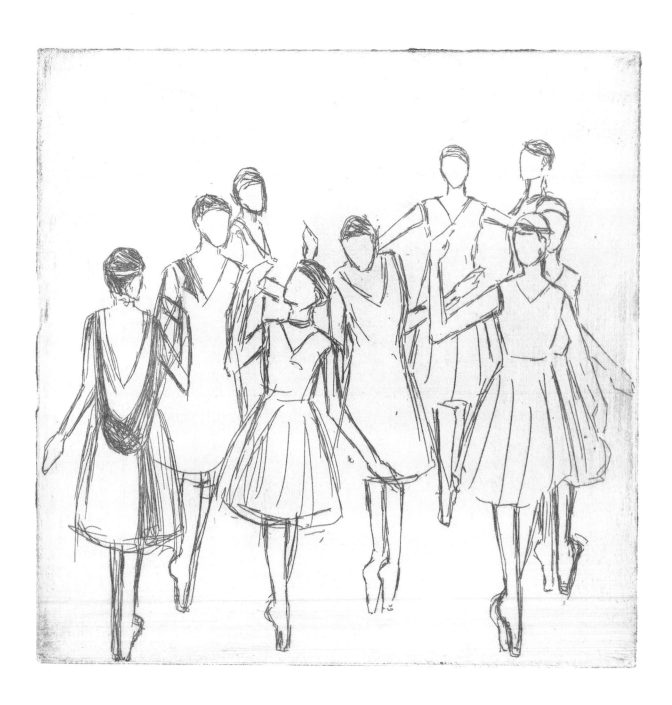

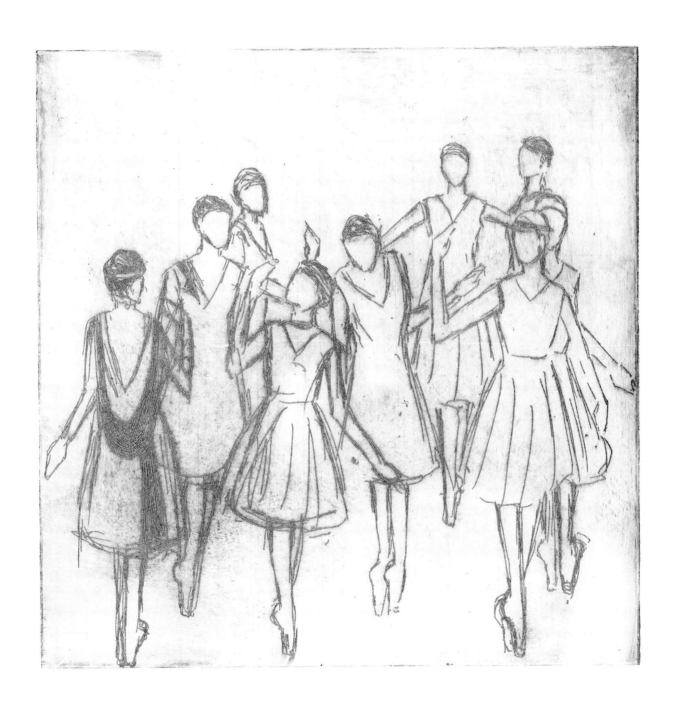

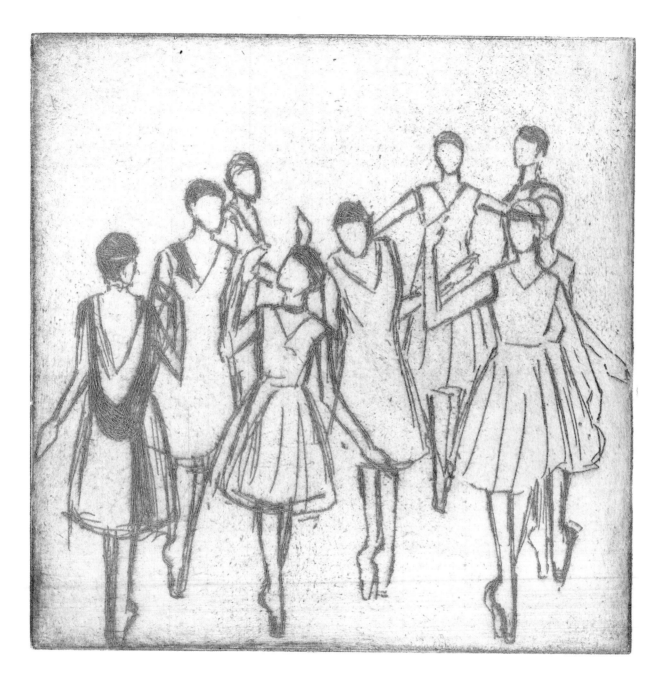

Parkett Exhibition at SEOUL ARTS CENTER – HANGARAM MUSEUM, KOREA (Dec 2010 – Feb 2011)

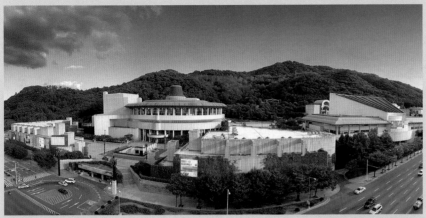

Seoul Arts Center – Hangaram Museum

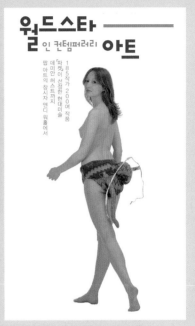

"If you want to see the entire forest, in terms of contemporary art, instead of looking at trees, this exhibition is a fitting choice. While blockbuster exhibitions usually focus on a single artist or group, the exhibition showcases 200 artworks by 185 world-renowned artists ... offering a stunning wrap up of contemporary art at a glance."

Korea Herald, Seoul, Dec 24, 2010

Exhibition catalogue, 200 full page color reproductions, 3 essays by Hongki Chae, Shim Chung and Deborah Wye, in Korean and English, 460 pages.

Dong-Hyuck Chung, Director
Seoul Arts Center

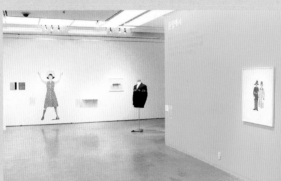

View into Wardrobe with Peter Doig, Eija-Liisa Ahtila, Pipilotti Rist

Park Jae-Dong, artist, with curator Shim Chung and Swiss Ambassador Thomas Kupfer

Shim Chung (guest curator, SAC, right),
Dieter von Graffenried

Hongki Chae (Curator, SAC), Beatrice Fässler,
Areum Kim

Mrs Hyun-Sook Lee and Charles Kim, Kukje Gallery

Exhibition at STPI, SINGAPORE (May – July 2010)

Singapore Tyler Print Institute (STPI)

"The best art exhibition of 2010 impressed with its sheer range, diversity and depth."

Straits Time, Singapore, Dec. 27, 2010

Emi Eu (Director, STPI, right) and Nor Jumeirah (STPI)

Lui Tuck Yew, Minister for Information, Communications and the Arts (center), Swiss Ambassador Jörg Reding (left), Dieter von Graffenried

Children's exhibition guide (cover)

A STPI Children's Guide

Works by Kara Walker, Diana Thater, Matthew Ritchie, Katharina Grosse, Richard Serra et al.

Tan Boon Hui (Director Singapore Art Museum, front, right), Sim Wan Hui (Deputy Director, Singapore Art Museum), Ikkan Sanada, Dieter von Graffenried

Works by Jeff Koons, Felix Gonzalez-Torres et al.

Parkett Viewing Room with permanent Study Center
of all editions and publications (opened September 2010)
UNIVERSITY CASTILLA LA MANCHA, ARTS FACULTY, CUENCA, SPAIN

"The collection allows the University to present a dynamic, lively museum in full dialogue with the main centers of contemporary art in Spain. Together with the artworks, the Faculty also displays all Parkett volumes published since 1984, and in doing so fully reflects Parkett's unique character as a small museum and large library. 'The scholarly and teaching character of this collection is very significant' concludes the Faculty's vice dean."

El Mundo, Madrid, Dec 15, 2010

Artworld Magazine, Shanghai, Cover Sep 2010

Special issue with 15 PARKETT texts translated into Chinese
(Print run: 160'000 copies / sold out)

Text on Olafur Eliasson (by Ina Blom), from Parkett 64

"I consider it as the highest evaluation of the media people that they have protected the initial vitality of other people... Parkett has included almost all the most important artists and critics in a quarter of the century; therefore, it is a next to impossible task to select 15 articles among the over 1,400 that have been put in black and white. Finally, we decided to narrow down our focus, taking the years, the categories, and potential impact on Chinese modern art as our starting point in the selection... we hope that it will enlighten many more Chinese readers ... How much we envy a medium that needs no attitude!"

Gong Yan, Editor-in-Chief,
Art World Magazine, Shanghai

Text on Julie Mehretu (by Heidi Zuckerman Jacobson), from Parkett 76

YVES SAINT LAURENT

ysl.com

YVES SAINT LAURENT

Hermès in Basel, Bern,
Crans-sur-Sierre, Genf,
Gstaad, Lausanne, Luzern,
Lugano, St. Moritz, Zürich.

Hermes.com

Kreatives Werkzeug

HERMÈS
PARIS

Hermès, zeitgenössisches Kunsthandwerk seit 1837.

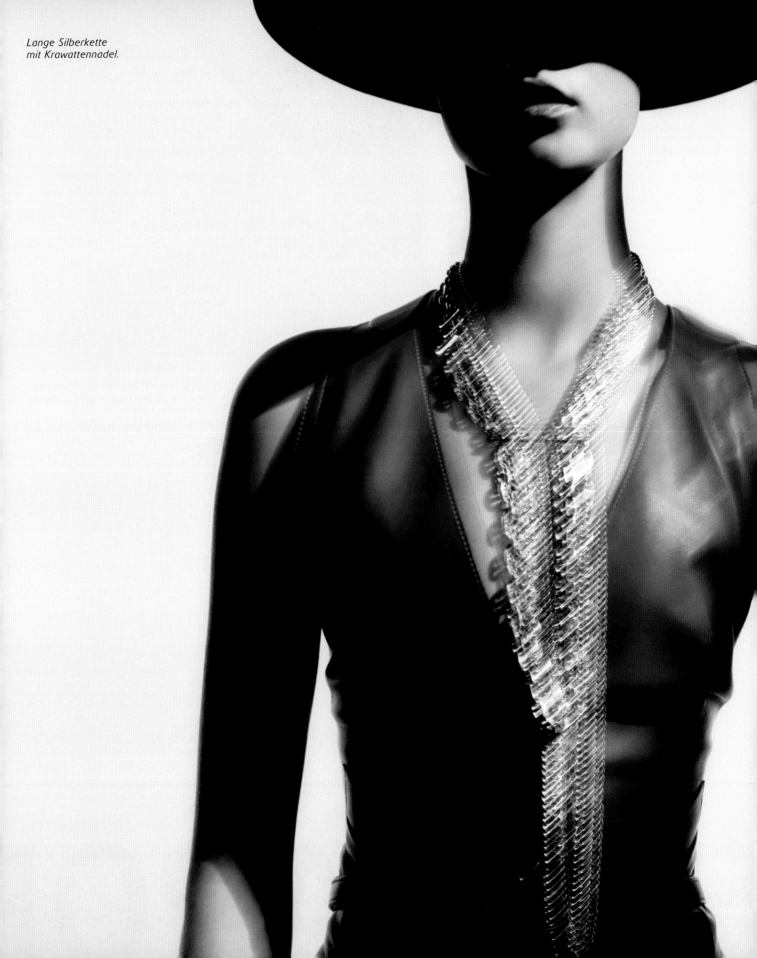

*Lange Silberkette
mit Krawattennadel.*

SINGAPORE BIENNALE 2011 OPEN HOUSE

13.MARCH–15.MAY.2011

ARTISTS

Ang Song Ming
Leonor Antunes
Ruben Ramos Balsa
Michael Beutler
Candice Breitz
Genevieve Chua
Tiffany Chung
Phil Collins
Louie Cordero
Marcos Corrales
Martin Creed
Elmgreen and Dragset
Omer Fast
Ceal Floyer
Simon Fujiwara
Julian Göthe
Goto Design
Sheela Gowda
Kyungah Ham
Ise
Teppei Kaneuji
Gülsün Karamustafa
Leopold Kessler
Koh Nguang How
Charles LaBelle
Michael Lee Hong Hwee
Charles Lim
Michael Lin
John Low
Rafael Lozano-Hemmer
Robert MacPherson
Tala Madani
Jill Magid
Dane Mitchell
Tracey Moffatt
Matt Mullican
Mike Nelson
Tatzu Nishi
Sopheap Pich
Propeller Group
Lisi Raskin
Navin Rawanchaikul
Stuart Ringholt
Liisa Roberts
Martha Rosler
Ruangrupa
Arin Rungjang
Mark Salvatus
Charles Sandison
Gigi Scaria
Shao Yinong and Mu Chen
Taryn Simon
Nedko Solakov
Beat Streuli
Shooshie Sulaiman
Superflex
Tan Pin Pin
Ryan Trecartin
Danh Vo
Charlie White
Gosia Wlodarczak
Ming Wong
Zai Kuning

SINGAPORE
BIENNALE
2011
OPEN HOUSE

ARTISTIC DIRECTOR
Matthew Ngui

CURATORS
Trevor Smith and Russell Storer

VENUES
Singapore Art Museum and
SAM at 8Q, National Museum
of Singapore, Old Kallang Airport
and Marina Bay

VERNISSAGE
11 & 12 March

CONTACT
Singapore Biennale 2011
c/o Singapore Art Museum
61 Stamford Rd #02-02
Stamford Court, Singapore 178892
Tel: +65 6332 3222 Fax: +65 6334 7919
info@singaporebiennale.org

ORGANISED BY SINGAPORE ART MUSEUM
SUPPORTED BY NATIONAL ARTS COUNCIL

WWW.SINGAPOREBIENNALE.ORG

Follow updates!

DESIGN: GOTO DESIGN.

S NGAPOR

ANDRO WEKUA

IS REPRESENTED BY

GLADSTONE GALLERY

艺术界

THE INTERNATIONAL ART MAGAZINE OF CONTEMPORARY CHINA

LEAP

LEAPLEAPLEAP.COM

Onlookers at the First Stars Art Exhibition, September 1979. Photo © Li Xiaobin

NICOLA COSTANTINO

5. März bis 15. Mai 2011

Daros Latinamerica zu Gast beim
Migros Museum für Gegenwartskunst

Hubertus Exhibitions
Albisriederstrasse 199a
8047 Zürich

www.hubertus-exhibitions.ch

DAROS
Latinamerica

frieze

The Armory Show
Piers 92 & 94
New York City March 3–6 2011 **thearmoryshow.com**

GABRIEL KURI *Sin título / Untitled ("A 84"), 2007, Turn stubs on vintage magazine page, 13 x 10.5 in, 33 x 26.7 cm courtesy of the artist & Sadie Coles HQ, London · Galería Kurimanzutto, Mexico City · Franco Noero, Turin · Esther Schipper, Berlin*

PIERS 92|94

PRODUCED BY **MMPI**

LISTE 16

THE YOUNG ART FAIR IN BASEL

June 14–19, 2011

Open Hours Tuesday to
Saturday 1 p.m. to 9 p.m.
Sunday 1 p.m. to 7 p.m.

Opening Reception Monday
June 13, 5 p.m. to 10 p.m.

Burgweg 15, CH 4058 Basel, Switzerland
T +41 61 692 20 21
info@liste.ch, www.liste.ch

A project in the workshop community
Warteck pp

Main Sponsor: **E.GUTZWILLER & CIE, BANQUIERS, Basel**

Pieta, 2008, FRP & ironplates, 400×340×320cm

la Biennale di Venezia

54. Esposizione Internazionale d'Arte

Partecipazioni nazionali

李庸白 LEE Yongbaek

June 4 - November 27, 2011

Korean Pavilion
54th International Art Exhibition
La Biennale di Venezia

Commissioner 尹在甲 YUN Cheagab

KOREAN PAVILION
Giardini Della Biennale, Castello 1260, 30122, Venice
kr.pavilion2011@gmail.com

Arts Council Korea

jamileh weber gallery

waldmannstrasse 6 ch - 8001 zurich phone +41 44 252 10 66
www.jamilehweber.com info@jamilehweber.com

art|42|basel 15-19 june 2011 opening june 14, 2011, 11 a.m. - 9 p.m.

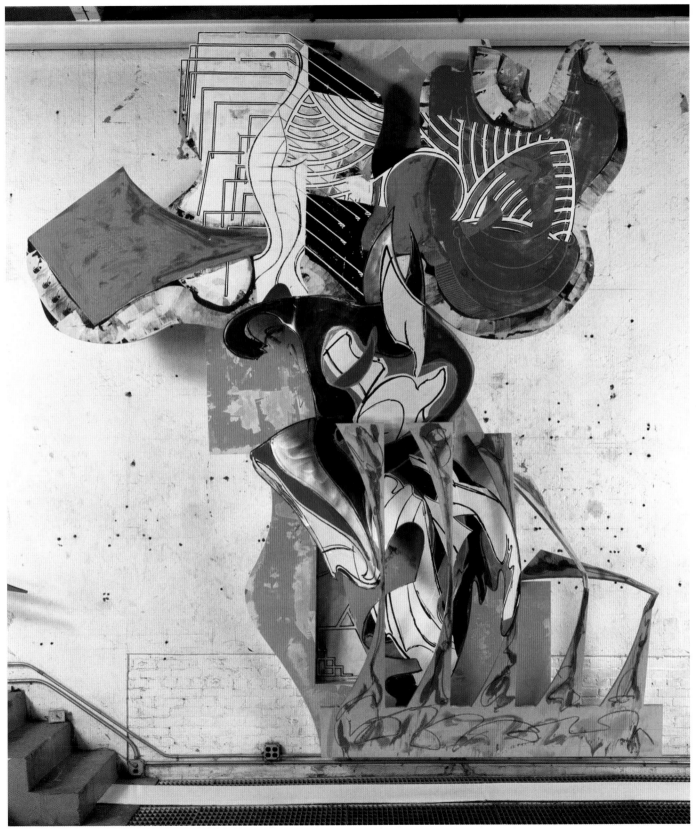

frank stella

enter ahab to him stubb, 1988

179-1/2 x 160-1/2 x 57-1/2 inches

456 x 408 x 146 cm

eyekon intermedia lab

art
agenda

art news & art reviews

www.art-agenda.com

Seit 70 Jahren das Beste aus Literatur,
Kunst, Musik, Fotografie, Film,
Architektur, Design und Gesellschaft.

abo@du-magazin.com
+41(0)44 266 85 57
www.du-magazin.com

Das Kulturmagazin

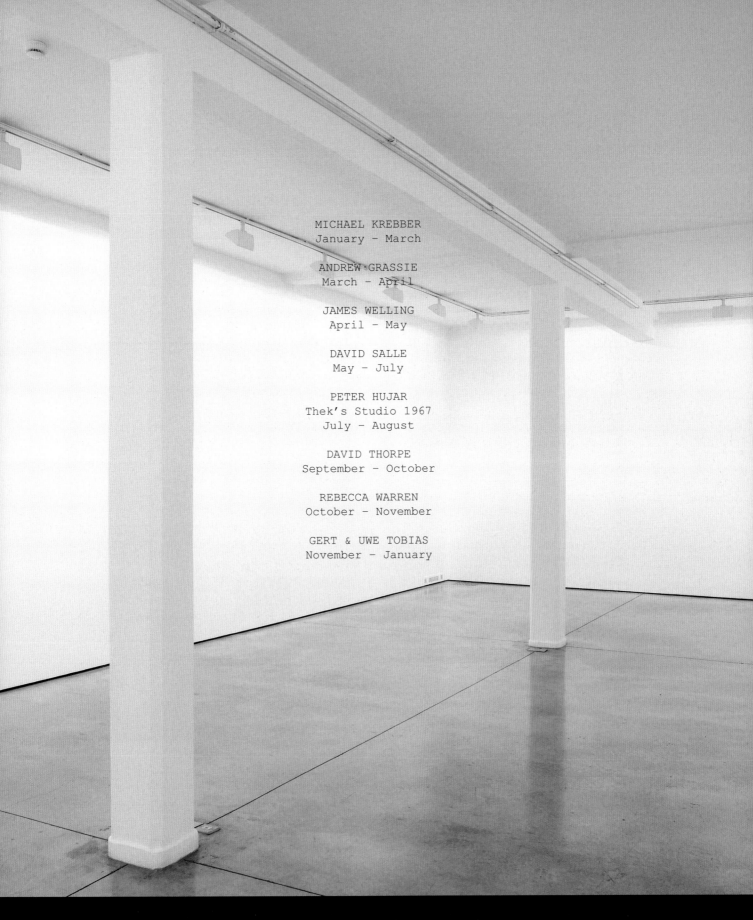

MICHAEL KREBBER
January – March

ANDREW GRASSIE
March – April

JAMES WELLING
April – May

DAVID SALLE
May – July

PETER HUJAR
Thek's Studio 1967
July – August

DAVID THORPE
September – October

REBECCA WARREN
October – November

GERT & UWE TOBIAS
November – January

MAUREEN PALEY. 21 Herald Street, London E2 6JT *telephone:* + 44 (0)20 7729 4112 *fax:* + 44 (0)20 7729 4113 www.maureenpaley.com

EDITION FOR PARKETT 88

PAUL CHAN

THE LIBERTINE READER, 2011

Silkscreen on natural woven rayon cloth,
with foil stamping, on wooden frame, 25 x 16 $\frac{1}{2}$ x $\frac{3}{4}$".
Printed by Atelier für Siebdruck, Lorenz Boegli, Zurich
Ed. 35/XX, signed and numbered certificate

Siebdruck auf natürlich gewebtem Rayon-Leinen,
mit Folienprägung, auf Holzrahmen, 63,5 x 42 x 1,9 cm.
Gedruckt bei Atelier für Siebdruck, Lorenz Boegli, Zürich.
Auflage 35/XX, signiertes und nummeriertes Zertifikat.

€ 2200 / US$ 2800 / CHF 2800

NOT JUST CROSSED OUT BUT ALTOGETHER
INVISIBLE: A PRESENCE AS INDISPUTABLE
AS IT IS EXPLOSIVE.

DIE GESPANNTE OBERFLÄCHE
DER CHRONIK DES GESCHEHENS.

EDITION FOR PARKETT 88

STURTEVANT

DIALOGUE OF THE DOGS, 2005 / 2011

Animated film, 1 min. loop, on DVD, with case,
inserted in Parkett 88.
Ed 35/XX, with signed and numbered certificate

Animierter Film, 1 Min. Loop, auf DVD, in Hülle,
eingelegt in Parkett 88.
Auflage 35/XX, signiertes und nummeriertes Zertifikat

€ 2200 / US$ 2800 / CHF 2800

I'D RATHER HAVE A CONVERSATION WITH A
CYNIC THAN A FUNDAMENTALIST. DOGS ARE MORE
FUN THAN ROCKS.

DIE WAHREN KYNIKER PREISEN SINGEND DAS LEBEN.

EDITION FOR PARKETT 88

ANDRO WEKUA

BLACK SEA LAMP, 2011

Color glass lamp with metal base, conceived and designed
by the artist, glass colored and bent by glassworks GmbH,
casing cut from lacquered steel sheet, illuminated with 2 LED bul-
bs, electrical cable, fabricated and assembled
by Kunstbetrieb AG Münchenstein, Switzerland, 7 $^1/_4$ x 7 $^1/_4$ x 3 $^1/_8$".
Ed. 35/XX, signed and numbered certificate.

Lampe mit gefärbtem Glas und Metall-Fassung,
vom Künstler entworfen und gestaltet.
Gefärbtes und gewelltes Glas, hergestellt von Glassworks GmbH,
Gehäuse aus geschnittem und lackiertem Stahlblech,
2 LED Glühbirnen, Kabel, produziert und zusammengestellt
von Kunstbetrieb AG Münchenstein, Schweiz. 18,3 x 13,5 x 8 cm.
Auflage 35/XX, signiertes und nummeriertes Zertifikat.

€ 2600 / US$ 3300 / CHF 3300

TRACE THE LIGHT OF THE LAMP WITH
YOUR FINGER TO FEEL THE BLACKNESS OF
UNDULATING WATERS.

ZWEIDEUTIGES OBJEKT: LICHT DER
ERINNERUNG – ODER EIN AUS IHR
GEBORGENES SOUVENIR?

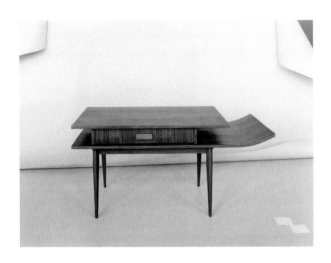

POOH'S TIGGER SAYS THAT A TABLE IS TO
PUT THINGS ON. AND THIS ONE?

EIN TISCH VON UNBEKANNTER HAND WIRD
ZUM OBJEKT DES FORSCHENDEN AUGES.

EDITION FOR PARKETT 87

ANNETTE KELM

UNTITLED, 2010

C-print from 4 x 5" negative, on Fuji Crystal Archive
DPII matt, paper size 16 x 20 $^5/_8$ ", image: 14 $^1/_2$ x 19 $^1/_8$",
printed by Golab, Berlin.
Edition of 38/XX, signed and numbered certificate.

C-Print ab 4 x 5" Negativ, auf Fuji Crystal Archive DPII
matt, Papierformat 40,5cm x 52,4 cm, Bild 36,7cm x
48,6cm, gedruckt bei Golab, Berlin.
Auflage 38/XX, signiertes und nummeriertes Zertifikat.

€ 1400 / US$ 1800 / CHF 1900

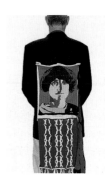

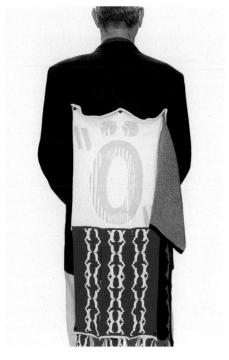

PARASITE PATCH „Ö"

EDITION FOR PARKETT 88

KERSTIN BRÄTSCH and DAS INSTITUT

PARASITE PATCH from Schröderline 2011
In 4 versions each with 4 design layers /
In 4 Versionen, jede in 4 Design Variationen:
NOTHING NOTHING / THUS / Ä / Ö

€ 2200 / US$ 2800 / CHF 2800

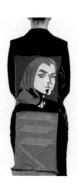

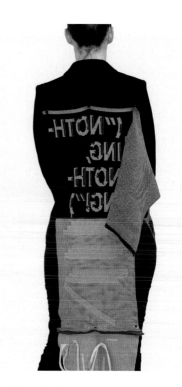

Knitted textile patch with 4 design layers,
made of custom dyed yarns, each layer: 15 x 12".
Designed by DAS INSTITUT (Kerstin Brätsch, Adele Röder).
Program and digital knitwear by Stoll, New York. Cotton yarn by
Filartex, Italy, silk/merino yarn by Cariaggi and Filpucchi, Italy.
To be individually attached to clothes with three snap buttons.
The Parasite Patch can be worn displaying each of the
4 different design layers.
Ed. 18 / X for each patch version,
with signed and numbered certificate.

PARASITE PATCH „NOTHING NOTHING"

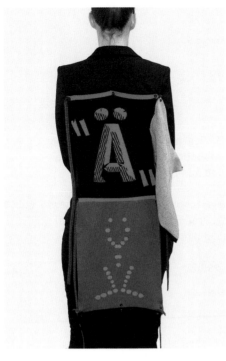

PARASITE PATCH „Ä"

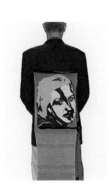

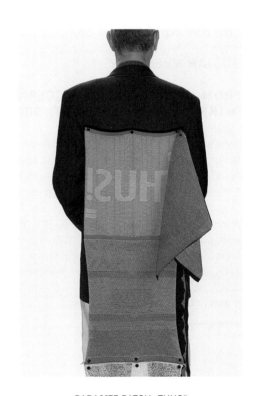

Gestricktes Textilobjekt mit 4 Design Variationen,
hergestellt aus gefärbtem Garn, jede Design Variation 38 x 30,5 cm.
Gestaltet von DAS INSTITUT (Kerstin Brätsch, Adele Röder).
Programm und digitale Umsetzung von Stoll, New York,
Baumwollgarne von Filartex, Italien, Seiden- und Merinogarn von
Cariaggi und Filpucchi, Italien.
Zur individuellen Befestigung auf Kleidungsstücken mit drei Druck-
knöpfen. Der Parasite Patch kann mit jeder der 4 Design Variatio-
nen getragen werden.
Auflage 18 / X für jede Version,
mit signiertem und nummeriertem Zertifikat.

PARASITE PATCH „THUS"

261

EDITION FOR PARKETT 87

CERITH WYN EVANS

E=Q=U=A=L=S, 2010

Neon light, 5 x 2 x ³/₈", electrical power cable, transformer 6 x ⁷/₈ x ⁷/₈",
with installation guide, production by NEON Line, Vienna.
Edition of 35/XX, signed and numbered certificate.

Neonlicht, 12 x 5 x 1 cm, elektrisches Kabel, Transformer 15 x 2 x 2 cm,
mit Installationsanleitung. Produktion: NEON Line, Wien.
Auflage: 35/XX, signiertes und nummeriertes Zertifikat.

€ 2200 / US$ 2800 / CHF 2800

EQUALLY BALANCED: WORDS LEFT AND RIGHT
IN THE MIND OF THE BEHOLDER.

IN DER LEERE DES RAUMS LEUCHTET DER
HINWEIS AUF (UN)BEKANNTE SYMMETRIEN.

EDITION FOR PARKETT 86

JOSIAH McELHENY

FROM AN ALTERNATIVE MODERNITY
(MIRROR FOR BRUNO TAUT), 2009

Colored glass, laminated between low-iron glass,
low-iron chrome mirror, 18 ¹/₂ x 14 x ³/₄", approx. 11lb.
Production by Schott architectural Solutions, Grüneplan, Germany.
Edition of 35/XX, signed and numbered certificate.

Farbiges Glas, laminiert zwischen eisenarmem Glas,
eisenarmer Chrom-Spiegel, 47 x 35,5 x 1,5 cm, ca. 5 kg.
Produziert von Schott Architectural Solutions, Grüneplan, Germany,
Auflage 35/XX, signiertes und nummeriertes Zertifikat.

€ 2200 / US$ US$ 2800 / CHF 2900

A REFLECTIVE OBJECT WITH SHADOW.

DIE STRUKTUR DES SPIEGELS ALS
REFLEX UTOPISCHER ENTWÜRFE.

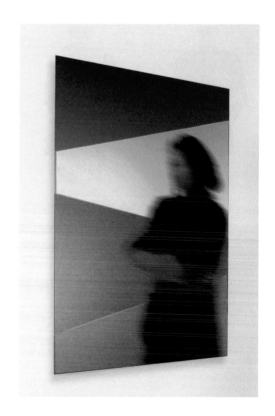

ARTISTS' EDITIONS FOR PARKETT SUBSCRIBERS
WWW.PARKETTART.COM

The PARKETT Series is created in collaboration with artists, who contribute an original work available exclusively to the subscribers in the form of a signed limited SPECIAL EDITION. The available works are also reproduced in each PARKETT issue.

Each SPECIAL EDITION is available by order from any one of our offices in New York or Zurich. Just fill in the details below and send this card to the office nearest you. Once your order has been processed, you will be issued with an invoice and your personal edition number. Upon receipt of payment, you will receive the SPECIAL EDITION. (Please note that supply is subject to availability. PARKETT does not assume responsibility for any delays in production of SPECIAL EDITIONS. Postage and VAT not included.)

☐ As a subscriber to PARKETT, I would like to order the following Special Edition(s), signed and numbered by the artist.

PARKETT No.	ARTIST	NAME:
PARKETT No.	ARTIST	ADDRESS:
PARKETT No.	ARTIST	CITY:
PARKETT No.	ARTIST	STATE/ZIP:
PARKETT No.	ARTIST	COUNTRY:
PARKETT No.	ARTIST	PHONE:

☐ I have indicated my way of payment on the reverse side of this form.

Send this form to the PARKETT office nearest you:
PARKETT PUBLISHERS 145 AV. OF THE AMERICAS NEW YORK, NY 10013 PHONE (212) 673-2660 FAX (212) 271-0704
PARKETT VERLAG QUELLENSTRASSE 27 CH-8031 ZÜRICH TELEFON +41-44-271 81 40 FAX +41-44-272 43 01
Visit our website: www.parkettart.com

88

KÜNSTLEREDITIONEN FÜR PARKETT-ABONNENTEN
WWW.PARKETTART.COM

Die PARKETT-Buchreihe entsteht in Zusammenarbeit mit Künstlern, die eigens für die Abonnenten einen Originalbeitrag in Form einer limitierten und signierten EDITION gestalten. Diese Editionen sind auch in der Zeitschrift abgebildet und können mit dieser Bestellkarte in jedem unserer Büros in Zürich oder New York bestellt werden. Sie erhalten dann Ihre persönliche Editionsnummer und eine Rechnung. Sobald wir Ihre Zahlung erhalten haben, schicken wir Ihnen Ihre Edition(en). Lieferung solange Vorrat. PARKETT übernimmt keine Verantwortung für allfällige Verzögerungen bei der Herstellung der Vorzugsausgaben. Versandkosten und MwSt nicht inbegriffen.

☐ Ich bin PARKETT-Abonnent(in) und bestelle folgende EDITION(EN), nummeriert und vom Künstler signiert:

PARKETT Nr.	KÜNSTLER/IN	NAME:
PARKETT Nr.	KÜNSTLER/IN	STRASSE:
PARKETT Nr.	KÜNSTLER/IN	PLZ/STADT:
PARKETT Nr.	KÜNSTLER/IN	LAND:
PARKETT Nr.	KÜNSTLER/IN	TEL.:

☐ Meine Zahlungsweise habe ich auf der Rückseite angegeben.

Senden Sie die Bestellkarte an das PARKETT-Büro in Ihrer Nähe:
PARKETT VERLAG QUELLENSTRASSE 27 CH-8031 ZÜRICH TELEFON +41-44-271 81 40 FAX +41-44-272 43 01
PARKETT PUBLISHERS 145 AV. OF THE AMERICAS NEW YORK, NY 10013 PHONE (212) 673-2660 FAX (212) 271-0704
Besuchen Sie unsere Website: www.parkettart.com

PARKETT

SUBSCRIBE, COMPLETE OR SEND A GIFT SUBSCRIPTION TO THE BEST BOOK SERIES ON CONTEMPORARY ARTISTS – WWW.PARKETTART.COM

☐ I wish to subscribe to the PARKETT Series, starting with issue no. _____

☐ I wish to send a gift subscription, starting with issue no. _____ (a gift card in my name will be sent to the recipient):

- ☐ for 1 year (2 issues) at US $ 78 (USA/Canada), € 72 (Europe), € 82 (Rest of the World)
- ☐ for 2 years (4 issues) at US $ 148 (USA/Canada), € 128 (Europe), € 164 (Rest of the World)
- ☐ for 3 years (6 issues) at US $ 205 (USA/Canada), € 185 (Europe), € 238 (Rest of the World)
- ☐ for 1 year (2 issues) at the special student discount (US $ 76 for USA/Canada, € 72 for Europe). A copy of my student ID is enclosed. Postage included. All prices subject to change.

☐ I wish to complete my PARKETT library and order the following issue(s):
No. _____
at € 30 each, postage not included.
Within the USA & Canada $ 32, add postage: $ 5 (USA), $ 10 (Canada).
Sold out: No. 1–10, 12, 13, 16–20, 22, 24–27, 29–31, 33, 35–39, 45.

☐ I wish to order the Set of all 55 available Parkett volumes at US $ 1,250 (USA/Canada), € 990 (Europe, rest of world), plus postage.

☐ I wish to order _____ copies of "200 Art Works – 25 Years", catalogue raisonné of Parketts' editions. 518 p., with text, 200 color repr., US $ 45.00 (USA/Canada), € 35.– (Europe, rest of world), plus postage.

☐ I wish to order _____ copies of "Sigmar Polke – Windows for the Zurich Grossmünster, € 45.–/$ 65.00, (excl. postage)

☐ I wish to order _____ copies of the new CD-Rom "Parkett Inserts – 25 Years" featuring all 75 INSERT page book projects made by artists for Parkett. This CD presents for the first time a comprehensive survey of all book pages INSERT projects both in a browsing or a slide-show mode by double pages. € 32.– (USA/Canada US $ 39.00), plus postage.

NAME:

ADDRESS:

CITY:

STATE/ZIP/COUNTRY:

TEL.: FAX:

E-MAIL:

GIFT RECIPIENT:

ADDRESS:

CITY:

STATE/ZIP:

COUNTRY:

☐ Charge my Visa Card ☐ Mastercard ☐ AMEX

Card No. |__|__|__|__|__|__|__|__|__|__| Expiration date _____

☐ Payment enclosed (US check or money order) ☐ Bill me

DATE

SIGNATURE

Send this form to the PARKETT office nearest you:

PARKETT PUBLISHERS 145 AV. OF THE AMERICAS NEW YORK, NY 10013 PHONE (212) 673-2660 FAX (212) 271-0704

PARKETT VERLAG QUELLENSTRASSE 27 CH-8031 ZÜRICH TELEFON +41-44-271 81 40 FAX +41-44-272 43 01

Visit our website: www.parkettart.com

PARKETT

ABONNIEREN, VERVOLLSTÄNDIGEN ODER VERSCHENKEN SIE DIE UMFASSENDSTE BUCHREIHE ÜBER GEGENWARTSKÜNSTLER – WWW.PARKETTART.COM

☐ Ich abonniere die PARKETT-Reihe ab Nr. _____

☐ Ich verschenke ein PARKETT-Abonnement ab Nr. _____ (Der/die Beschenkte erhält eine Geschenkkarte in meinem Namen)

- ☐ für 1 Jahr (2 Bände) zu: € 72 (Europa), CHF 95.– (Schweiz),
- ☐ für 2 Jahre (4 Bände) zu: € 128 (Europa), CHF 168.– (Schweiz),
- ☐ für 3 Jahre (6 Bände) zu: € 185 (Europa), CHF 248.– (Schweiz),
- ☐ für 1 Jahr (2 Bände) zum Studenten-Sonderpreis (Europa: € 72 /Schweiz: CHF 105.–). Eine Kopie meines gültigen Studentenausweises lege ich bei. Preise einschliesslich Versandkosten. Preisänderungen vorbehalten.

☐ Ich möchte meine PARKETT-Bibliothek vervollständigen und bestelle die folgenden noch erhältliche(n) Ausgabe(n):
Nr. _____
zu je € 30 / CHF 45.–, zzgl. Versandkosten (vergriffen: Nr. 1–10, 12, 13, 16–20, 22, 24–27, 29–31, 33, 35–39, 45).

☐ Ich bestelle den Set aller 55 erhältlichen Parkett-Bände zu € 990 (Europa), CHF 1400.– (Schweiz), zzgl. Versandkosten.

☐ Ich bestelle _____ Ex. »200 Artworks – 25 Years«, Werkkatalog aller Parkett Künstler-Editionen. 518 S. mit Text, 200 Farbabb. € 35.– (Schweiz CHF 49.–), zzgl. Versand.

☐ Ich bestelle _____ Ex. »Sigmar Polke's Fenster für das Zürcher Grossmünster« € 45.–/CHF 68.–, zzgl. Versandkosten.

☐ Ich bestelle _____ Ex der neuen CD-Rom »Parkett Inserts – 25 Years« mit allen 75 von Künstlern für Parkett gestalteten Inserts. Die CD-Rom gibt erstmals einen vollständigen Überblick über alle Inserts-Buchseiten-Projekte, sie können doppelseitenweise oder als Dia-Schau betrachtet werden. € 32.– (Schweiz CHF 45.–), zzgl. Versand.

NAME:

STRASSE:

PLZ/STADT:

LAND:

TEL.: FAX:

E-MAIL:

BESCHENKTE(R):

STRASSE:

PLZ/STADT:

LAND:

☐ Ich zahle mit Visa ☐ Eurocard/Mastercard ☐ AMEX

Karten Nr. |__|__|__|__|__|__|__|__|__|__| Gültig bis _____

☐ Mein Scheck über CHF/€ _____ liegt bei.

☐ Bitte senden Sie mir eine Rechnung.

DATUM

UNTERSCHRIFT

Senden Sie die Bestellkarte an das PARKETT-Büro in Ihrer Nähe:

PARKETT VERLAG QUELLENSTRASSE 27 CH-8031 ZÜRICH TELEFON +41-44-271 81 40 FAX +41-44-272 43 01

PARKETT PUBLISHERS 145 AV. OF THE AMERICAS NEW YORK, NY 10013 PHONE (212) 673-2660 FAX (212) 271-0704

Besuchen Sie unsere Website: www.parkettart.com

ARTISTS' MONOGRAPHS & EDITIONS / KÜNSTLERMONOGRAPHIEN & EDITIONEN
FOR AVAILABILITY SEE NEXT PAGES / LIEFERBARKEIT SIEHE FOLGENDE SEITEN

Tomma Abts, vol. 84
Franz Ackermann, vol. 68
Eija-Liisa Ahtila, vol. 68
Ai Weiwei, vol. 81
Doug Aitken, vol. 57
Jennifer Allora /
Guillermo Calzadilla, vol. 80
Pavel Althamer, vol. 82
Kai Althoff, vol. 75
Francis Alÿs, vol. 69
Laurie Anderson, vol. 49
John Armleder, vol. 50/51
Richard Artschwager, vol. 23, vol. 46
John Baldessari, vol. 29, vol. 86
Stephan Balkenhol, vol. 36
Matthew Barney, vol. 45
Georg Baselitz, vol. 11
Vanessa Beecroft, vol. 56
Ross Bleckner, vol. 38
John Bock, vol. 67
Alighiero e Boetti, vol. 24
Christian Boltanski, vol. 22
Cosima von Bonin, vol. 81
Monica Bonvicini, vol. 72
Louise Bourgeois, vol. 27, 82
Carol Bove, vol. 86
Kerstin Brätsch, vol. 88
Olaf Breuning, vol. 71
Glenn Brown, vol. 75
Angela Bulloch, vol. 66
Daniel Buren, vol. 66
Sophie Calle, vol. 36
Maurizio Cattelan, vol. 59
Vija Celmins, vol. 44
Paul Chan, vol. 88
Francesco Clemente, vol. 9 & 40/41
Chuck Close, vol. 60
Enzo Cucchi, vol. 1
John Currin, vol. 65
Tacita Dean, vol. 62
Thomas Demand, vol. 62
Martin Disler, vol. 3
Peter Doig, vol. 67
Trisha Donnelly, vol. 77
Marlene Dumas, vol. 38
Olafur Eliasson, vol. 64
Tracey Emin, vol. 63
Urs Fischer, vol. 72

Eric Fischl, vol. 5
Peter Fischli /
David Weiss, vol. 17, 40/41
Sylvie Fleury, vol. 58
Günther Förg, vol. 26 & 40/41
Robert Frank, vol. 83
Tom Friedman, vol. 64
Katharina Fritsch, vol. 25, 87
Bernard Frize, vol. 74
Ellen Gallagher, vol. 73
Isa Genzken, vol. 69
Franz Gertsch, vol. 28
Gilbert & George, vol. 14
Liam Gillick, vol. 61
Robert Gober, vol. 27
Nan Goldin, vol. 57
Dominique Gonzalez-
Foerster, vol. 80
Felix Gonzalez-Torres, vol. 39
Douglas Gordon, vol. 49
Dan Graham, vol. 68
Rodney Graham, vol. 64
Katharina Grosse, vol. 74
Mark Grotjahn, vol. 80
Andreas Gursky, vol. 44
Wade Guyton, vol. 83
David Hammons, vol. 31
Rachel Harrison, vol. 82
Thomas Hirschhorn, vol. 57
Damien Hirst, vol. 40/41
Carsten Höller, vol. 77
Jenny Holzer, vol. 40/41
Rebecca Horn, vol. 13 & 40/41
Roni Horn, vol. 54
Gary Hume, vol. 48
Pierre Huyghe, vol. 66
Christian Jankowski, vol. 81
Ilya Kabakov, vol. 34
Anish Kapoor, vol. 69
Alex Katz, vol. 21, 72
Mike Kelley, vol. 31
Ellsworth Kelly, vol. 56
Annette Kelm, vol. 87
William Kentridge, vol. 63
Jon Kessler, vol. 79
Karen Kilimnik, vol. 52
Martin Kippenberger, vol. 19
Imi Knoebel, vol. 32

Jeff Koons, vol. 19, 50/51
Jannis Kounellis, vol. 6
Yayoi Kusama, vol. 59
Wolfgang Laib, vol. 39
Maria Lassnig, vol. 85
Zoe Leonard, vol. 84
Sherrie Levine, vol. 32
Sarah Lucas, vol. 45
Christian Marclay, vol. 70
Brice Marden, vol. 7
Paul McCarthy, vol. 73
Josiah McElheny, vol. 86
Lucy McKenzie, vol. 76
Julie Mehretu, vol. 76
Mario Merz, vol. 15
Beatriz Milhazes, vol. 85
Marilyn Minter, vol. 79
Tracey Moffatt, vol. 53
Mariko Mori, vol. 54
Malcolm Morley, vol. 52
Sarah Morris, vol. 61
Juan Muñoz, vol. 43
Jean-Luc Mylayne, vol. 50/51, 85
Bruce Nauman, vol. 10
Ernesto Neto, vol. 78
Olaf Nicolai, vol. 78
Cady Noland, vol. 46
Albert Oehlen, vol. 79
Meret Oppenheim, vol. 4
Gabriel Orozco, vol. 48
Tony Oursler, vol. 47
Laura Owens, vol. 65
Jorge Pardo, vol. 56
Philippe Parreno, vol. 86
Mai-Thu Perret, vol. 84
Raymond Pettibon, vol. 47
Elizabeth Peyton, vol. 53
Richard Phillips, vol. 71
Sigmar Polke, vol. 2, 30 & 40/41
Richard Prince, vol. 34, 72
Michael Raedecker, vol. 65
Markus Raetz, vol. 8
Charles Ray, vol. 37
Jason Rhoades, vol. 58
Gerhard Richter, vol. 35
Bridget Riley, vol. 61
Pipilotti Rist, vol. 48, 71
Matthew Ritchie, vol. 61

Tim Rollins & K.O.S., vol. 20
Ugo Rondinone, vol. 52
James Rosenquist, vol. 58
Susan Rothenberg, vol. 43
Thomas Ruff, vol. 28
Edward Ruscha, vol. 18 & 55
Anri Sala, vol. 73
Wilhelm Sasnal, vol. 70
Gregor Schneider, vol. 63
Thomas Schütte, vol. 47
Dana Schutz, vol. 75
Richard Serra, vol. 74
Cindy Sherman, vol. 29
Roman Signer, vol. 45
Andreas Slominski, vol. 55
Josh Smith, vol. 85
Rudolf Stingel, vol. 77
Beat Streuli, vol. 54
Thomas Struth, vol. 50/51
Sturtevant, vol. 88
Hiroshi Sugimoto, vol. 46
Philip Taaffe, vol. 26
Sam Taylor-Wood, vol. 55
Diana Thater, vol. 60
Wolfgang Tillmans, vol. 53
Rirkrit Tiravanija, vol. 44
Fred Tomaselli, vol. 67
Rosemarie Trockel, vol. 33
James Turrell, vol. 25
Luc Tuymans, vol. 60
Keith Tyson, vol. 71
Kara Walker, vol. 59
Kelley Walker, vol. 87
Jeff Wall, vol. 22 & 49
Andy Warhol, vol. 12
Rebecca Warren, vol. 78
Gillian Wearing, vol. 70
Lawrence Weiner, vol. 42
Andro Wekua, vol. 88
John Wesley, vol. 62
Franz West, vol. 37, 70
Rachel Whiteread, vol. 42
Sue Williams, vol. 50/51
Robert Wilson, vol. 16
Christopher Wool, vol. 33, 83
Cerith Wyn Evans, vol. 87
Yang Fudong, vol. 76

88	Kerstin Brätsch	m	e
	Paul Chan	m	e
	Sturtevant	m	e
	Andro Wekua	m	e
87	Katharina Fritsch	m	
	Annette Kelm	m	e
	Kelley Walker	m	
	Cerith Wyn Evans	m	e
86	John Baldessari	m	e
	Carol Bove	m	e
	Josiah McElheny	m	e
	Philippe Parreno	m	
85	Maria Lassnig	m	e
	Beatriz Milhazes	m	
	Jean-Luc Mylayne	m	e
	Josh Smith	m	
84	Tomma Abts	m	e
	Zoe Leonard	m	e
	Mai-Thu Perret	m	e
83	Robert Frank	m	
	Wade Guyton	m	
	Christopher Wool	m	e
82	Pavel Althamer	m	e
	Louise Bourgeois	m	
	Rachel Harrison	m	e
81	Ai Weiwei	m	
	Cosima von Bonin	m	e
	Christian Jankowski	m	e
80	Allora & Calzadilla	m	
	D. Gonzalez-Foerster	m	e
	Mark Grotjahn	m	
79	Albert Oehlen	m	e
	Jon Kessler	m	e
	Marilyn Minter	m	
78	Ernesto Neto	m	
	Olaf Nicolai	m	e
	Rebecca Warren	m	
77	Trisha Donnelly	m	e
	Carsten Höller	m	e
	Rudolf Stingel	m	
76	Lucy McKenzie	m	e

	Julie Mehretu	m	
	Yang Fudong	m	
75	Kai Althoff	m	e
	Glenn Brown	m	
	Dana Schutz	m	
74	Bernard Frize	m	
	Katharina Grosse	m	
	Richard Serra	m	
73	Ellen Gallagher	m	
	Paul McCarthy	m	
	Anri Sala	m	e
72	Monica Bonvicini	m	
	Urs Fischer	m	
	Richard Prince	m	
71	Olaf Breuning	m	e
	Richard Phillips	m	e
	Keith Tyson	m	e
70	Christian Marclay	m	e
	Wilhelm Sasnal	m	e
	Gillian Wearing	m	
69	Francis Alÿs	m	
	Isa Genzken	m	
	Anish Kapoor	m	
68	Franz Ackermann	m	e
	Eija-Liisa Ahtila	m	e
	Dan Graham	m	e
67	John Bock	m	
	Peter Doig	m	
	Fred Tomaselli	m	
66	Angela Bulloch	m	e
	Daniel Buren	m	e
	Pierre Huyghe	m	e
65	John Currin	m	
	Laura Owens	m	
	Michael Raedecker	m	
64	Olafur Eliasson	m	
	Tom Friedman	m	
	Rodney Graham	m	
63	Tracey Emin	m	e
	William Kentridge	m	
	Gregor Schneider	m	

62	Tacita Dean	m	e
	Thomas Demand	m	
	John Wesley	m	
61	Liam Gillick	m	
	Sarah Morris	m	e
	Bridget Riley	m	
	Matthew Ritchie	m	e
60	Chuck Close	m	
	Diana Thater	m	e
	Luc Tuymans	m	e
59	Maurizio Cattelan	m	
	Yayoi Kusama	m	
	Kara Walker	m	
58	Sylvie Fleury	m	
	Jason Rhoades	m	
	James Rosenquist	m	
57	Doug Aitken	m	e
57	Nan Goldin	m	
	Thomas Hirschhorn	m	
56	Vanessa Beecroft	m	
	Ellsworth Kelly	m	
	Jorge Pardo	m	e
55	Edward Ruscha	m	
	Andreas Slominski	m	
	Sam Taylor-Wood	m	
54	Roni Horn	m	
	Mariko Mori	m	
	Beat Streuli	m	
53	Tracey Moffatt	m	
	Elizabeth Peyton	m	
	Wolfgang Tillmans	m	
52	Karen Kilimnik	m	e
	Malcolm Morley	m	e
	Ugo Rondinone	m	e
50/51	John Armleder	m	
	Jeff Koons	m	
	Jean-Luc Mylayne	m	
	Thomas Struth	m	
	Sue Williams	m	

49	Laurie Anderson	m	e
	Douglas Gordon	m	
	Jeff Wall	m	
48	Gary Hume	m	
	Gabriel Orozco	m	
	Pipilotti Rist	m	
47	Tony Oursler	m	
	Raymond Pettibon	m	
	Thomas Schütte	m	
46	Richard Artschwager	m	
	Cady Noland	m	
	Hiroshi Sugimoto	m	
45	Matthew Barney		
	Sarah Lucas		
	Roman Signer		e
44	Vija Celmins	m	
	Andreas Gursky	m	
	Rirkrit Tiravanija	m	e
43	Juan Muñoz	m	
	Susan Rothenberg	m	
42	Lawrence Weiner	m	e
	Rachel Whiteread	m	
40/41	Francesco Clemente	m	
	Fischli/Weiss	m	
	Günther Förg	m	
	Damien Hirst	m	
	Jenny Holzer	m	
	Rebecca Horn	m	
	Sigmar Polke	m	
39	Felix Gonzalez-Torres		
	Wolfgang Laib		
38	Ross Bleckner		
	Marlene Dumas		
37	Charles Ray	m	
	Franz West	m	
36	Stephan Balkenhol		
	Sophie Calle		
35	Gerhard Richter		
34	Ilya Kabakov	m	
	Richard Prince	m	

33	Rosemarie Trockel	
	Christopher Wool	
32	Imi Knoebel	m
	Sherrie Levine	m
31	David Hammons	
	Mike Kelley	
30	Sigmar Polke	
29	John Baldessari	
	Cindy Sherman	
28	Franz Gertsch	m
	Thomas Ruff	m
27	Louise Bourgeois	
	Robert Gober	
26	Günther Förg	
	Philip Taaffe	
25	Katharina Fritsch	
	James Turrell	
24	Alighiero e Boetti	
23	Richard Artschwager	m
22	Christian Boltanski	
	Jeff Wall	
21	Alex Katz	m
20	Tim Rollins + K.O.S.	
19	Martin Kippenberger	
	Jeff Koons	
18	Ed Ruscha	
17	Fischli/Weiss	
16	Robert Wilson	
15	Mario Merz	m
14	Gilbert & George	m
13	Rebecca Horn	
12	Andy Warhol	
11	Georg Baselitz	m
10	Bruce Nauman	

9	Francesco Clemente
8	Markus Raetz
7	Brice Marden
6	Jannis Kounellis
5	Eric Fischl
4	Meret Oppenheim
3	Martin Disler
2	Sigmar Polke
1	Enzo Cucchi

m = available monograph / erhältliche Monographie, e = available edition / erhältliche Edition
Delivery subject to availability at time of order / Lieferung solange Vorrat

PARKETT IN BOOKSHOPS (Selection)

PARKETT IS AVAILABLE IN 500 LEADING ART BOOKSHOPS AROUND THE WORLD. FOR FURTHER INFORMATION CONTACT:
PARKETT GIBT ES IN 500 FÜHRENDEN KUNSTBUCHHANDLUNGEN AUF DER GANZEN WELT. FÜR WEITERE INFORMATIONEN WENDEN SIE SICH BITTE AN:
PARKETT VERLAG, QUELLENSTRASSE 27, CH-8031 ZÜRICH, TEL. +41-44 271 81 40, FAX 272 43 01, WWW.PARKETTART.COM;
PARKETT, 145, AVENUE OF THE AMERICAS, NEW YORK, N.Y. 10013, PHONE +1 (212) 673-2660, FAX 271-0704, WWW.PARKETTART.COM

NORTH & SOUTH AMERICA, ASIA, AUSTRALIA

DISTRIBUTOR / VERTRIEB
D.A.P. (DISTRIBUTED ART PUBLISHERS)
155 AVENUE OF THE AMERICAS,
2ND FLOOR,
NEW YORK, NY 10013

USA

BEACON, NY
DIA: BEACON
3 BEEKMAN STREET

BERKELEY, CA
BERKELEY ART MUSEUM
2625 DURANT AVENUE

BOSTON, MA
INSTITUTE OF CONTEMPORARY ART
100 NORTHERN AVENUE
TRIDENT BOOKSELLERS
338 NEWBURY STREET

CAMBRIDGE, MA
MIT PRESS BOOKSTORE
292 MAIN STREET

CHICAGO, IL
MUSEUM OF CONTEMPORARY ART
220 EAST CHICAGO AVENUE
QUIMBY'S
1854 W. NORTH AVENUE
SMART MUSEUM OF ART
5550 S. GREENWOOD AVENUE

COLUMBUS, OH
WEXNER CENTER BOOKSTORE
1871 NORTH HIGH STREET

CORAL GABLES, FL
BOOKS & BOOKS
265 ARAGON ROAD

DETROIT
MUSEUM OF CONTEMPORARY ART
4454 WOODWARD AVENUE

HOUSTON, TX
BRAZOS BOOKSTORE
2421 BISSONNET
CONTEMPORARY ARTS MUSEUM
5216 MONTROSE BOULEVARD

LOS ANGELES, CA
MUSEUM OF CONTEMPORARY ART
250, S. GRAND
SKYLIGHT BOOKS
18181 N. VERMONT AVENUE
UCLA / ARMAND HAMMER MUSEUM OF ART
10899 WILSHIRE BOULEVARD

MIAMI, FL
BOOKS & BOOKS
296 ARAGON AVENUE, CORAL GABLES

MINNEAPOLIS, MN
THE WALKER ART CENTER BOOKSTORE
1750 HENNEPIN AVENUE

NEW YORK, NY
MUSEUM OF MODERN ART
11 WEST 53RD STREET
NEW MUSEUM OF CONTEMPORARY ART STORE
235 BOWERY
ARTBOOK@PS1
22–25 JACKSON AVENUE
PRINTED MATTER
195 10TH AVENUE
SAINT MARK'S BOOKSTORE
31 3RD AVENUE
SPOONBILL & SUGARTOWN
218 BEDFORD AVENUE
WHITNEY MUSEUM STORE
945 MADISON AVENUE

OAKLAND, CA
DIESEL, A BOOKSTORE
5433 COLLEGE AVENUE

PHILADELPHIA, PA
AVRIL 50
3406 SANSOM STREET

PORTLAND, OR
POWELL'S BOOKS
1005 W. BURNSIDE

PROVIDENCE, RI
RHODE ISLAND SCHOOL OF DESIGN
30 N. MAIN STREET

SAN FRANCISCO, CA
ASF MUSEUM OF MODERN ART
MUSEUMBOOKS
151 3RD STREET, 1ST FLOOR

ST. LOUIS, MO
LEFT BANK BOOKS
399 NORTH EUCLID

SANTA MONICA, CA
ARCANA
1229 3RD STREET PROMENADE
HENNESSEY & INGALLS BOOKS
214 WILSHIRE BLVD

WASHINGTON D.C.
NATIONAL GALLERY OF ART
4TH STREET & CONSTITUTION AVENUE, NW

CANADA / KANADA
MONTREAL
CANADIAN CENTER FOR ARCHITECTURE
1920 RUE BAILE
OLIVIERI LIBRAIRIE BOOKSTORE
5210 CHEMIN DE LA CÔTE DES NIEGES

TORONTO
ART METROPOLE
788 KING STREET WEST
PAGES BOOKS AND MAGAZINE
256 QUEEN STREET WEST

AUSTRALIA / AUSTRALIEN
SYDNEY
MUSEUM OF CONTEMPORARY ART
140 GEORGE STREET,
THE ROCKS, CIRCULAR QUAY FOYER

ASIA / ASIEN

JAPAN
TOKYO
BOOKS LOGOS / LIBRO CO. LTD
15-1, UDAGAWA-CHO, SHIBUYA-KU

CHINA
BEIJING
TIMEZONE 8 BOOKS & CAFÉ
NO. 4 JIU XIAN QIAO ROAD
SHANGHAI
TIMEZONE 8 BOOKS & CAFÉ
NO. 50 MOGANSHAN ROAD

MEXICO
MEXICO D.F.
HABITA BOOKS BY A & R PRESS
PRESIDENTE MASARYK # 201,
COL. POLANCO/DEL.
MIGUEL HIDALGO

BRAZIL
SAO PAULO
LIVRARIA DA VILA LTDA
RUA FRADIQUE COUTINHO, 915
VILA MADALENA

GREAT BRITAIN / GROSSBRITANNIEN
DISTRIBUTOR / VERTRIEB
CENTRAL BOOKS
99, WALLIS ROAD
LONDON E9 5LN

BIRMINGHAM
IKON GALLERY
1 OOZELLS SQUARE

BRIGHTON
BORDERS BOOKSHOP
CHURCHILL SQUARE SHOPPING CENTRE

BRISTOL
ARNOLFINI BOOKSHOP
16 NARROW QUAY

CARDIFF
CHAPTER ARTS CENTRE
MARKET ROAD

LONDON
ARTWORDS BOOKSHOP
65 A RIVINGTON STREET
BORDERS BOOKSHOP
120–122 CHARING CROSS ROAD
BORDERS BOOKSHOP
203–207 OXFORD STREET
BORDERS BOOKSHOP
N1 CENTRE ISLINGTON
CAMDEN ARTS CENTRE
ARKWRIGHT ROAD
HAYWARD GALLERY
SOUTH BANK CENTRE
THE MALL
SERPENTINE GALLERY
KENSINGTON GARDENS
TATE MODERN
BANKSIDE
WATERSTONE BOOKSELLERS
9/13 GARRICK STREET, WC2
WHITECHAPEL ART GALLERY
80 WHITECHAPEL HIGH STREET

OXFORD
MODERN ART OXFORD
30 PEMBROKE STREET

SCOTLAND / SCHOTTLAND
GLASGOW
TRANSMISSION GALLERY
45 KING STREET

IRELAND / IRLAND
CORK
LEWIS GLUCKSMAN GALLERY
UNIVERSITY COLLEGE
DUBLIN
DOUGLAS HYDE GALLERY
TRINITY COLLEGE

GERMANY / DEUTSCHLAND

DISTRIBUTOR / VERTRIEB
GVA VERLAGSSERVICE GÖTTINGEN
PF 2021
D-37010 GÖTTINGEN

BERLIN
BÜCHERBOGEN AM SAVIGNYPLATZ
STADTBAHNBOGEN 593
GALERIE 2000 KUNSTBUCHHANDLUNG
KNESEBECKSTRASSE 56/58
THEMATISCHE BUCHHANDLUNG
PRO QM
ALMSTADTSTRASSE 48–50

BIELEFELD
THALIA UNIVERSITÄTSBUCHHANDLUNG
OBERNTORWALL 23

BONN
BUCHLADEN 46
KAISERSTRASSE 46

BREMEN
BEIM STEINERNEN KREUZ GMBH
BEIM STEINERNEN KREUZ 1

DÜSSELDORF
MÜLLER & BÖHM
BOLKERSTRASSE 53
WALTHER KÖNIG BUCHHANDLUNG
GRABBEPLATZ 4

FRANKFURT
KUNST-BUCH, KUNSTHALLE SCHIRN
RÖMERBERG 7
WALTHER KÖNIG BUCHHANDLUNG
DOMSTRASSE 6

HAMBURG
SAUTTER + LACKMANN BUCHHANDLUNG
ADMIRALITÄTSTRASSE 71/72

HANNOVER
MERZ KUNSTBUCHHANDLUNG
KURT-SCHWITTERS-PLATZ

KARLSRUHE
HOSER & MENDE
KARLSTRASSE 76

KÖLN
WALTHER KÖNIG BUCHHANDLUNG
EHRENSTRASSE 4

MÜNCHEN
HANS GOLTZ BUCHHANDLUNG
FÜR BILDENDE KUNST
TÜRKENSTRASSE 54
L. WERNER BUCHHANDLUNG
RESIDENZSTRASSE 18

STUTTGART
LIMACHER BUCHHANDLUNG
KÖNIGSTRASSE 28

AUSTRIA / ÖSTERREICH

LINZ
ALEX – EINE BUCHHANDLUNG
HAUPTPLATZ 21

WIEN
ALBERTINA MUSEUM
ALBERTINA PLATZ 1
DER BUCHFREUND
SONNENFELSGASSE 4
PRACHNER
MUSEUMPLATZ 1

SPAIN / SPANIEN

BARCELONA
LAIE – CAIXAFÒRUM
MARQUES DE COMILLAS 6–8

BILBAO
GUGGENHEIM MUSEUM
ABANDOIBARRA ET. 2

MADRID
PUBLICACIONES DE ARQUITECTURA
GENERAL RODRIGO 1

FRANCE / FRANKREICH

PARIS
CENTRE POMPIDOU, FLAMMARION 4
26, RUE JACOB
GALERIE NATIONALE DU JEU DE PAUME
1, PLACE DE LA CONCORDE
LIBRAIRIE DU MUSÉE D'ART MODERNE
9, RUE GASTON DE SAINT-PAUL
CHRISTOPH DAVIET-THERY,
LIVRES&EDITIONS D'ARTISTES
10, RUE DUCHEFDELAVILLE
ARTICURIAL
61, AVENUE MATAIGNE

ITALY / ITALIEN

MILANO
ART BOOK MILANO
VIA VENTURA 5

ROMA
GALLERIA NAZIONALE D'ARTE MODERNA
131, VIA DELLE BELLE ARTI

NORWAY / NORWEGEN

OSLO
THE NATIONAL MUSEUM OF
CONTEMPORARY ART
BANKPLASSEN 4 / SKATTEFOG

SWEDEN / SCHWEDEN

STOCKHOLM
MODERNA MUSEET
SKEPPSHOLMEN

NETHERLANDS, BELGIUM AND LUXEMBURG

DISTRIBUTOR / VERTRIEB
IDEA BOOKS
NIEUWE HERENGRACHT 11
NL-1011 RK AMSTERDAM

NETHERLANDS / NIEDERLANDE

AMSTERDAM
ATHENAEUM NIEUWSCENTRUM
SPUI 14–16

EINDHOVEN
MOTTA
GERGSTRAAT 35

GRONINGEN
SCHOLTENS / WRISTERS BOOKSHOP
FULDENSTRAAT 20

HAARLEM
ATHENAEUM
GED. OUDE GRACHT 70

HENGELO
BROEKHUIS
WEMENSTRAAT 45

BELGIUM / BELGIEN

ANTWERPEN
COPYRIGHT BOOKSHOP
NATIONALSTRAAT 28A
IMS BOOKSHOP
MELKMARK 17

BRUXELLES
PEINTURE FRAICHE
10, RUE DU TABELLON
TROPISMES LIBRAIRIES
GALERIE DES PRINCES 11

GENT
COPYRIGHT BOOKSHOP
JACOBIJNENSTRAAT 8
SMAK
CITADELPARK

LUXEMBOURG / LUXEMBURG

LUXEMBOURG
CASINO LUXEMBOURG
41, RUE NOTRE-DAME

SWITZERLAND / SCHWEIZ

DISTRIBUTOR / VERTRIEB
SCHEIDEGGER&CO. C/O AVA
CENTRALWEG 16
CH-8910 AFFOLTERN A. A.

BASEL
FONDATION BEYELER
BASELSTRASSE 77, RIEHEN
DOMUS HAUS
PFLUGGAESSLEIN 3
KUNSTMUSEUM BUCHHANDLUNG
ST. ALBAN-GRABEN 16
GALERIE STAMPA
SPALENBERG 2
THALIA
FREIE STRASSE 32

BERN
MÜNSTERGASS BUCHHANDLUNG
MÜNSTERGASSE 33
STAUFFACHER BUCHHANDLUNG
NEUENGASSE 25–37

LAUSANNE
EX NIHILO
6, AV. WILLIAM FRAISSE

LUZERN
HIRSCHMATT
HIRSCHMATTSTRASSE 26

ST. GALLEN
RÖSSLITOR BÜCHER
WEBERGASSE 5

WINTERTHUR
VOGEL THALIA BÜCHER
MARKTGASSE 41

ZÜRICH
CALLIGRAMME BUCHHANDLUNG
HÄRINGSTRASSE 4
HOWEG BUCHHANDLUNG
WAFFENPLATZ 1
KUNSTGRIFF BUCHHANDLUNG
LIMMATSTRASSE 270
KUNSTHAUS ZÜRICH
HEIMPLATZ 1
ORELL FÜSSLI BUCHHANDLUNG
FÜSSLISTRASSE 4
SPHÈRES
HARDTURMSTRASSE 66

PIERRE HUYGHE
JANUARY 28 — MARCH 12

CRISTINA IGLESIAS
MARCH 22 — APRIL 27

WILLIAM KENTRIDGE
MAY 6 — JUNE 18

MARIAN GOODMAN GALLERY

24 WEST 57TH STREET NEW YORK, NY 10019
TEL: 212-977-7160 FAX: 212-581-5187 WWW.MARIANGOODMAN.COM

Sss ohhoo mmf ah...
slsh ahhh mhn mhn... mhn sssh...
mmm mn mn... ohh mmm aah ahhh...
mmf ohhoo... mn mmm aahgh... slsh ahhh
mhn oho ahhh smak mn slrp mmf ah... mmm mmf...
ahhh mhn mn mmm hmm mn slrp Paul Chan
mhn sssh ohh ahhh mmf mn... ohhoo oooh...
slsh ahhh mn slrp ah slrp ohhoo mmf mmor,...
ohhoo slsh... oho slsh ohhoo sssh slrp hmm slrp mn
slrp mmf ah... mn sssh ahhh... oooh slsh ahhh ahhh...
ahhh yaa ahhh slsh smak slrp mhn ahhh...
mn sssh ahhh slsh ahhh ohhoo oooh ssshit... ohhoo slsh...
mmm hmm slsh slrp mmd ah slrp mmf ah... mn sssh ahhh...
oooh slsh ahhh ahhh mmd ohhoo ohh... ohhoo oooh...
mhn oho ahhh ahhh smak sssh mmor,... ohhoo slsh...
ohhoo Greene Naftali Gallery
oooh... mn sssh ahhh... oho slsh ahhh mhn mhn ssshit...
ohhoo slsh... mn sssh ahhh... slsh slrp ah sssh mn...
ohhoo oooh... mn sssh ahhh... oho... ahhh......
ohhoo oho mn ahhh... oho ahhh mmm smak ahhh
mmm hmm mn ulp...... ohhoo... mmm mhn mhn ahhh ohh
hmm mn ahhh mmor,... mmm mmf mmd... mn ohhoo...
oho ahhh mn slrp mn slrp ohhoo mmf... mn sssh ahhh...
Mnn ohhoo glcch ahhh slsh mmf ohh ahhh mmf mn...
oooh ohhoo slsh... mmm... slsh ahhh mmd Zoo York City
slsh ahhh mhn mhn... ohhoo oooh... ah slsh slrp ahhh glcch
mmm mmf smak ahhh mhn yeess

CARLA ACCARDI
MARK ALEXANDER
BRIAN ALFRED
AHMED ALSOUDANI
RINA BANERJEE
ENRICO CASTELLANI
NATHAN COLEY
THOMAS JOSHUA COOPER
KEITH COVENTRY
LEÓN FERRARI
BILL FONTANA
ADRIAN GHENIE
ANTHONY GOICOLEA
KEVIN FRANCIS GRAY
ISCA GREENFIELD-SANDERS
STUART HAYGARTH
THOMAS HEATHERWICK
JOCHEM HENDRICKS
JITISH KALLAT
ED & NANCY KIENHOLZ
SUSANNE KÜHN
RICHARD LONG
RAFAEL LOZANO-HEMMER
IAN MONROE
SIMON PATTERSON
PATRICIA PICCININI
NICOLAS PROVOST
PETER SAUL
MEEKYOUNG SHIN
CHIHARU SHIOTA
JAMIE SHOVLIN
JESUS RAFAEL SOTO
EVE SUSSMAN
GÜNTHER UECKER
JOANA VASCONCELOS
WIM WENDERS
TOM WESSELMANN
UWE WITTWER

HAUNCH OF VENISON

6 Burlington Gardens
London W1S 3ET
United Kingdom
T +44 (0) 20 7495 5050
F +44 (0) 20 7495 4050
london@haunchofvenison.com

1230 Avenue of the Americas
New York, NY10020
USA
T +1 212 259 0000
F +1 212 259 0001
newyork@haunchofvenison.com

www.haunchofvenison.com

CARL ANDRE

TAUBA AUERBACH

CELESTE BOURSIER-MOUGENOT

SOPHIE CALLE

MARK DI SUVERO

SAM DURANT

WAYNE GONZALES

ROBERT GROSVENOR

HANS HAACKE

DOUGLAS HUEBLER

DONALD JUDD

JULIAN LETHBRIDGE

SHERRIE LEVINE

SOL LEWITT

CHRISTIAN MARCLAY

CLAES OLDENBURG &

COOSJE VAN BRUGGEN

PAUL PFEIFFER

WALID RAAD

RUDOLF STINGEL

JOHN TREMBLAY

KELLEY WALKER

DAN WALSH

MEG WEBSTER

ROBERT WILSON

JACKIE WINSOR

BING WRIGHT

CAREY YOUNG

PAULA COOPER GALLERY

534 W 21st Street • 521 W 21st Street • 465 W 23rd Street, New York 10011
tel. 212.255.1105 • fax 212.255.5156 • www.paulacoopergallery.com

galerie mark müller gessnerallee 36 ch - 8001 zürich t +41 (0) 44 211 81 55

adieu gessnerallee!
opening new location in late spring 2011

art|42|basel 15 - 19 june 2011

www.markmueller.ch

LUCA PANCRAZZI

LANDSCAPES IN MIRROR ARE
CLOSER THAN THEY APPEAR

FEBRUARY 3 – APRIL 30, 2011

GALERIE ANDREA CARATSCH WALDMANNSTRASSE 8 CH-8001 ZÜRICH
TEL +41-44-272 5000 FAX +41-44-272 5001 WWW.GALERIECARATSCH.COM

GALERIA ■ HELGA DE ALVEAR

DR. FOURQUET 12, 28012 MADRID. TEL:(34) 91 468 05 06 FAX:(34) 91 467 51 34
e-mail:galeria@helgadealvear.com www.helgadealvear.com

January 20 – March 5

ELMGREEN & DRAGSET

ÁNGELA DE LA CRUZ

February 16 – 20. **ARCO** Stand 10/D20

March 17 – May 7

SLATER BRADLEY

May 12 – June 30

ISAAC JULIEN

June 15 – 19. **ART BASEL**

CENTRO DE ARTES VISUALES FUNDACIÓN HELGA DE ALVEAR

March – September 2011. Project by Delfim Sardo

October 2011 – April 2012. PHILIPPE PARRENO. Project by H. U. Obrist

In collaboration with Serpentine Gallery, London

CÁCERES, SPAIN

Time/Bank is a platform through which groups and individuals in the field of culture can pool and trade time and skills, rather than acquire goods and services through the use of money. TimeBank is based on the premise that everyone has something to contribute and can take part in developing an alternativeeconomicnetwork that connects unmet needs with untapped resources.

time/bank

e-flux

Time/Bankisane-fluxproject

Moshekwa Langa

Kunsthalle Bern

5.2. - 27.3.2011

Helvetiaplatz 1
CH-3005 Bern
www.kunsthalle-bern.ch

A*

29.1. – 25.4.2011

Im Reich der Zeichnung

Voici un dessin suisse
1990 – 2010

Thomas Hirschhorn
Wirtschaftslandschaft Davos

Manon
Hotel Dolores

14.5. – 31.7.2011

Mai-Thu Perret

Christian Rothacher
Retrospektive

19.8. – 6.11.2011

Dieter Roth
Selbstbildnisse

Marianne Engel
Manor Kunstpreis 2010

***Aargauer Kunsthaus**
Aargauerplatz CH–5001 Aarau
Di–So 10–17 Uhr Do 10–20 Uhr
www.aargauerkunsthaus.ch

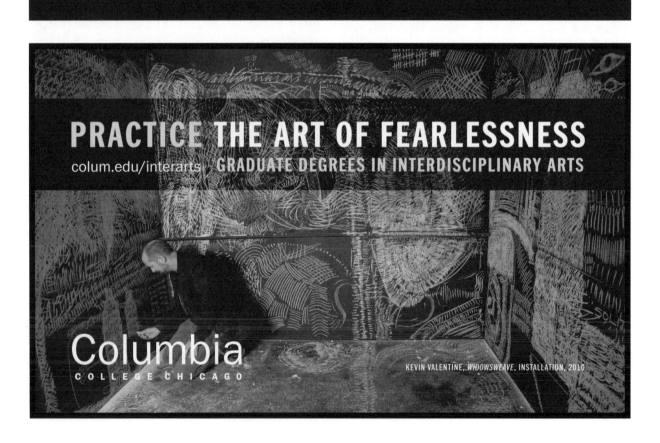

RITA ACKERMANN, FRANCIS ALŸS
MAJA BAJEVIC, HERNAN BAS
MICHAEL BAUER, JOHN COPLANS
WILLIE DOHERTY, BRUNO JAKOB
RAFFI KALENDERIAN, JOCHEN KUHN
ZILLA LEUTENEGGER
JORGE MACCHI, TERESA MARGOLLES
DUNCAN MARQUISS, FABIAN MARTI
CLAUDIA & JULIA MÜLLER
ADRIAN PACI, BERND RIBBECK
MELANIE SMITH, JAVIER TÉLLEZ
TERCERUNQUINTO, ANDRO WEKUA
ARTUR ŻMIJEWSKI

Galerie Peter Kilchmann, Zurich, www.peterkilchmann.com

HEIMO ZOBERNIG
15.1. – 20.3.2011
BRUCE CONNER
2.4. – 29.5.2011
LUCY MCKENZIE
12.7. – 14.8.2011
WALID RAAD
26.8. – 30.8.2011
KERSTIN BRÄTSCH
12.11.2011 – 15.1.2012

KUNSTHALLE
ZÜRICH

TUE/WED/FRI 12–6PM, THUR 12–8PM, SAT/SUN 11AM–5PM
FROM JANUARY 2011 UNTIL JUNE 2012 NEW VISITING ADDRESS:
KUNSTHALLE ZÜRICH AT MUSEUM BÄRENGASSE, BÄRENGASSE 20–22, CH–8001 ZURICH

POSTAL ADDRESS: LIMMATSTRASSE 270, CH–8005 ZURICH /
PACKAGES AND OFFICE ADDRESS: ALBISRIEDERSTRASSE 199A, CH–8047 ZURICH
T +41 44 272 15 15 F +41 44 272 18 88
INFO@KUNSTHALLEZURICH.CH WWW.KUNSTHALLEZURICH.CH

haluk akakçe, philip akkerman, nobuyoshi araki, armen eloyan, anton henning, teresa hubbard/
alexander birchler, peter kamm, edward lipski, lutz & guggisberg, daido moriyama,

galerie bob van orsouw albisriederstrasse 199a ch - 8047 zurich
phone +41 (0)44 273 11 00 mail@bobvanorsouw.ch www.bobvanorsouw.ch

paul morrison, ernesto neto, julian opie, walter pfeiffer, david reed, albrecht schnider, shirana
shahbazi, hannah van bart, marcel van eeden, erik van lieshout, bernard voïta, mario ybarra jr.

february 12
until **the luxury of dirt** curated by michele robecchi
march 26, 2011
bani abidi, armen eloyan, gelitin, jan kempenaers, sarah lucas, paul mccarthy,
aleksandra mir, katrina moorhead

april 7
until **julian opie**
may 14, 2011

may 28
until **anton henning**
july 23, 2011

the armory show, new york march 3–6, 2011
art cologne april 13–17, 2011
art basel june 15–19, 2011

15. APRIL BIS 28. MAI 2011

FRANZ WEST

DER DEFINIERTE RAUM

DOUG AITKEN, EMMANUELLE ANTILLE, MARTIN BOYCE, ANGELA BULLOCH, VALENTIN CARRON, VERNE DAWSON, TRISHA DONNELLY,
MARIA EICHHORN, URS FISCHER, PETER FISCHLI/DAVID WEISS, SYLVIE FLEURY, LIAM GILLICK, DOUGLAS GORDON, AMY GRANAT,
MARK HANDFORTH, CANDIDA HÖFER, KAREN KILIMNIK, ANDREW LORD, RICHARD PRINCE, GERWALD ROCKENSCHAUB, TIM ROLLINS
AND K.O.S., UGO RONDINONE, DIETER ROTH, EVA ROTHSCHILD, JEAN-FRÉDÉRIC SCHNYDER, STEVEN SHEARER, JOSH SMITH,
BEAT STREULI, FRANZ WEST, OSCAR TUAZON, SUE WILLIAMS

GALERIE EVA PRESENHUBER

WWW.PRESENHUBER.COM
TEL: +41 (0) 43 444 70 50 / FAX: +41 (0) 43 444 70 60
MAAGAREAL, GEBÄUDE DIAGONAL
ZAHNRADSTRASSE 21, P.O. BOX, CH-8040 ZURICH
ÖFFNUNGSZEITEN: DI- FR 12-18, SA 11-17

NEUE
ADRESSE

art
forum
berlin

The International
Art Show

30.09.–
02.10.
2011

Berlin Exhibition Grounds, Entrance Masurenallee
Messedamm 22, 14055 Berlin, Germany
T. +49 / 30 / 30 38 20 76, F. +49 / 30 / 30 38 20 60
art@messe-berlin.de, www.art-forum-berlin.com

 Messe Berlin

Art | 42 | Basel | 15–19 | 6 | 11

Vernissage | **14. Juni 2011** | **nur mit Einladung**
Art Basel Conversations | **15. bis 19. Juni 2011** | von 10 bis 11 Uhr
Katalogbestellung | Tel. +49 711 44 05 204, Fax +49 711 44 05 220, www.hatjecantz.de

Follow us on Facebook and Twitter | www.facebook.com/artbasel | www.twitter.com/artbasel

The International Art Show – Die Internationale Kunstmesse
Art 42 Basel, MCH Messe Schweiz (Basel) AG, CH-4005 Basel
Fax +41 58 206 26 86, info@artbasel.com, www.artbasel.com

Kunst

11
Zürich

17–20

17th International Contemporary Art Fair | www.kunstzuerich.ch

NOVEMBER

Thu and Fri 4 pm to 10 pm | Sat 11 am to 7 pm | Sun 11 am to 6 pm

ART COLOGNE
45. INTERNATIONALER
KUNSTMARKT
13. – 17. APRIL 2011

ARGENTINA
CHEZ VAUTIER
IGNACIO LIPRANDI
DANIEL MAMAN
AUSTRIA
JOHANNES FABER
ERNST HILGER
KONZETT
KROBATH
MEYER KAINER
NÄCHST ST. STEPHAN
SALIS & VERTES
ELISABETH & KLAUS THOMAN
BELGIUM
CATHERINE BASTIDE
DEWEER
MSSNDCLRCQ MEESSEN DE CLERCQ
CHRISTIAN NAGEL
GUY PIETERS
CANADA
BLANKET
CHINA
ALEXANDER OCHS
CZECH REPUBLIC
JIRI SVESTKA
DENMARK
MIKAEL ANDERSEN
BO BJERGGAARD
MODERNE
FINLAND
FORSBLOM
FRANCE
CHEZ VALENTIN
KARSTEN GREVE
LAHUMIÈRE
LELONG
MARION MEYER
GUY PIETERS
JOCELYN WOLFF
GERMANY
AANANT + ZOO
ADAMSKI
MIKAEL ANDERSEN
ARNDT
AUSSEREUROPÄISCHE KUNST DIERKING
BAER
GUIDO W. BAUDACH
BAUKUNST
BECK & EGGELING
JÜRGEN BECKER
KLAUS BENDEN
BERINSON
GALERIE BERLIN
ANDREAS BINDER
BOISSERÉE
ISABELLA BORTOLOZZI
BQ
LENA BRÜNING
DANIEL BUCHHOLZ
BUCHMANN
BUGDAHN + KAIMER
LUIS CAMPANA
GISELA CAPITAIN

CARLIER GEBAUER
CONRADI
COSAR HMT
ISABELLA CZARNOWSKA
(FORMERLY KACPRZAK)
DOGENHAUS
CHRISTIAN EHRENTRAUT
EIGEN + ART
FAHNEMANN
FIEBACH, MINNINGER
FIGGE VON ROSEN
FISCHER
MAX WEBER SIX FRIEDRICH
KLAUS GERRIT FRIESE
VERA GLIEM
WOLFGANG GMYREK
BÄRBEL GRÄSSLIN
KARSTEN GREVE
BARBARA GROSS
HAAS
HACHMEISTER
HÄUSLER CONTEMPORARY
HAMMELEHLE UND AHRENS
REINHARD HAUFF
MARIANNE HENNEMANN
ANDREAS HÖHNE
HOFFMANN
HEINZ HOLTMANN
AKIRA IKEDA
FRED JAHN
MICHAEL JANSSEN
JOHNEN
KADEL WILLBORN
MIKE KARSTENS
BEN KAUFMANN
KEWENIG
PARISA KIND
KLEINDIENST
KLEMM'S
BERND KLÜSER
SABINE KNUST
KOCH
KOCH OBERHUBER WOLFF
DR. DOROTHEA VAN DER KOELEN
JOHANN KÖNIG
KROBATH
KUTTNER SIEBERT
L.A. GALERIE
LADEN FUER NICHTS
GALERIE FÜR LANDSCHAFTSKUNST
CHRISTIAN LETHERT
LEVY
LÖHRL
LUDORFF
LINN LÜHN
M29 RICHTER . BRÜCKNER
VITTORIO MANALESE & FILS
MAULBERGER
HANS MAYER
MIRKO MAYER/M-PROJECTS
HUBERTUS MELSHEIMER
METRO
KAI MIDDENDORFF

CHRISTIAN NAGEL
GEORG NOTHELFER
ALEXANDER OCHS
PARROTTA
RUPERT PFAB
KARL PFEFFERLE
PRODUZENTENGALERIE
THOMAS REHBEIN
REMMERT UND BARTH
RIEDER
PETRA RINCK
STEFAN RÖPKE
SAMUELIS BAUMGARTE
MARION SCHARMANN
SCHEFFEL
AUREL SCHEIBLER
BRIGITTE SCHENK
SCHLICHTENMAIER
SCHMIDT & HANDRUP
SCHMIDT MACZOLLEK
SCHÖNEWALD FINE ARTS
RÜDIGER SCHÖTTLE
SCHWARZER
SEPTEMBER
SIES + HÖKE
SIMONIS
SOMMER & KOHL
SPRINGER + WINCKLER
SPRÜTH MAGERS
STAECK
WALTER STORMS
HANS STRELOW
JACKY STRENZ
FLORIAN SUNDHEIMER
JIRI SVESTKA
THOMAS
WILMA TOLKSDORF
UTERMANN
VAN HORN
EDITH WAHLANDT
MICHAEL WERNER
EVA WINKELER
SUSANNE ZANDER
THOMAS ZANDER
GREECE
KALFAYAN
HUNGARY
ERIKA DEÁK
ITALY
FEDERICO BIANCHI
GALLERIA D'ARTE MAGGIORE
GENTILI
GROSSETTI
DR. DOROTHEA VAN DER KOELEN
STUDIO LA CITTÀ
LUCE
JAPAN
BASE
AKIRA IKEDA
TOMIO KOYAMA
NANZUKA UNDERGROUND
SUPER WINDOW PROJECT
TAGUCHI FINE ART

LUXEMBOURG
NOSBAUM REDING
THE NETHERLANDS
DELAIVE
JASKI
ONRUST
MARTIN VAN ZOMEREN
FONS WELTERS
NORWAY
STANDARD
POLAND
RASTER
SPAIN
HEINRICH EHRHARDT
KEWENIG GALERIE
STEFAN RÖPKE
SWEDEN
LARS BOHMAN
MILLIKEN
WETTERLING
SWITZERLAND
BUCHMANN
KARSTEN GREVE
HAAS
HÄUSLER CONTEMPORARY
HAUSER & WIRTH
HENZE & KETTERER
LANGE + PULT
LULLIN + FERRARI
SALIS & VERTES
BOB VAN ORSOUW
TONY WUETHRICH
UNITED KINGDOM
ANCIENT + MODERN
CABINET
HAUSER & WIRTH
HOLLYBUSH GARDENS
ANNELY JUDA FINE ART
SPRÜTH MAGERS
USA
1301PE
AMBACH + RICE
BROADWAY 1602
FOXY PRODUCTION
JACK HANLEY
HAUSER & WIRTH
AKIRA IKEDA
LEO KOENIG
ANDREW KREPS
LELONG
MARGARETE ROEDER
TEAM GALLERY
MICHAEL WERNER

SUBJECT TO CHANGE

koelnmesse

kostengünstig.

Digitaldruck, der begeistert, durch Qualität,
Geschwindigkeit und Preis.

www.digitalprofi.ch

Zürichsee
Druckereien AG

Seestrasse 86 | CH-8712 Stäfa
Telefon 044 928 53 24 | Fax 044 928 53 10
info@zsd.ch | www.zsd.ch

AアR—Tト
아藝ㅌ術
FフAェIアR
博페覽어會
TトOゥKキYョOゥ
도東쿄京

ART FAIR TOKYO
東京
www.artfairtokyo.com

ART FAIR TOKYO 2011 April 1–3 Tokyo International Forum

Dates & Hours: Friday, April 1, 11:00am-9:00pm / Saturday, April 2, 11:00am-8:00pm / Sunday, April 3, 10:30am-5:00pm
Venue: Tokyo International Forum, Exhibition Hall & Lobby Gallery (3-5-1 Marunouchi, Chiyoda-ku, Tokyo 100-0005 Japan)
Tickets: 1,500 yen Advance Tickets: 1,200 yen
First Choice & Opening Preview (Invitees and Press): Thursday, March 31, 2011, 16:00-18:00 / 18:00-21:00
Organizer: ART FAIR TOKYO Committee / ART FAIR TOKYO Co., Ltd.

ART FAIR TOKYO 2011 participates in TOKYO ART WEEK (March 26 – April 3).

New exhibition and storage spaces

Sittertalstrasse 34 · CH-9014 St.Gallen
www.kesselhaus-josephsohn.ch

**KESSELHAUS
JOSEPHSOHN**

Catherine Gfeller. Pulsations

26. 2.–8. 5. 2011

Patricia Bucher. Schlachtenpanorama

26. 2.–1. 5. 2011

Max von Moos. Seen by Peter Roesch,
Christian Kathriner, Robert Estermann

19. 3.–31. 7. 2011

Yves Netzhammer. In collaboration with
Fumetto International Comix-festival

9. 4.–24. 7. 2011

Shansui. Landscape in Chinese Contemporary Art

In collaboration with Sigg Collection & Museum Rietberg Zurich
Curated By Ai Weiwei, Peter Fischer & Uli Sigg

21. 5.–2. 10. 2011

Der Moderne Bund. Arp, Helbig, Lüthy,
Gimmi, Huber, Klee

13. 8.–13. 11. 2011

Charlotte Hug. Hidden Signs

In collaboration with Lucerne Festival

13. 8.–6. 11. 2011

Matthew Day Jackson

22. 10.–Feb. 2012

Kunstmuseum Luzern Museum of Art Lucerne
www.kunstmuseumluzern.ch

Karlheinz Weinberger

Intimate Stranger

February 9 – March 26, 2

Opening Reception
Tuesday, February 8, 201
6 – 8 PM

Under Destruction

A co-operation with Museum Tinguely, Basel

Nina Beier + Marie Lund, Monica Bonvicini, Pavel Büchler, Nina Canell,
Jimmie Durham, Alex Hubbard, Alexander Gutke, Martin Kersels,
Michael Landy, Liz Larner, Christian Marclay, Kris Martin, Ariel Orozco,
Michael Sailstorfer, Arcangelo Sassolino, Jonathan Schipper,
Ariel Schlesinger, Roman Signer, Johannes Vogl

Co-curated by Gianni Jetzer and Chris Sharp

April 6 – June 18, 2011

Opening Reception
Tuesday, April 5, 2011
6 – 8 PM

SI

Swiss Institute / Contemporary Art
495 Broadway, 3rd Floor
New York, NY 10012

prohelvetia

Mamma Andersson
December 10, 2010 – February 6, 2011

Roger Hiorns
December 10, 2010 – February 6, 2011

2010 Turner Prize winner
Susan Philipsz
White Winter Hymnal
December 10, 2010 – February 6, 2011
Trestle Bridge | Snowmass Mountain

Mark Manders
*Parallel Occurrences/
Documented Assignments*
February 18 – May 1, 2011

The Anxiety of Photography
May 13 – July 17, 2011

Cathy Wilkes
May 20 – July 17, 2011

Haegue Yang
2011 Jane and Marc Nathanson
Distinguished Artist in Residence
July 29 – October 9, 2011

Stephen Shore
July 29 – October 9, 2011

aspenartmuseum

590 North Mill Street, Aspen
970.925.8050
aspenartmuseum.org

GALERIE URS MEILE
BEIJING · LUCERNE

BEIJING 29.01.11 – 10.04.11
XIA XING 2007 / 2008 / 2009 / 2010

BEIJING 29.01.11 – 10.04.11
ANDREAS GOLDER I WANNA BE ADORED

BEIJING 07.05.11 – 31.07.11
WIM DELVOYE

THE ARMORY SHOW
NEW YORK
PIER 94, BOOTH 712
03.03.11 – 06.03.11

HONG KONG
INTERNATIONAL ART FAIR
26.05.11 – 29.05.11

ART42BASEL
15.06.11 – 19.06.11

LUCERNE 14.01.11 – 09.04.11
LI GANG A TRANQUIL ORDER

LUCERNE 15.04.11 – 30.07.11
CHEN HUI

ARTISTS
AI WEIWEI - CHEN HUI - DING YI - DU JIE - HE YUNCHANG
(A CHANG) - L/B - LI DAFANG - LI GANG - ANDREAS GOLDER -
LI ZHANYANG - LIU DING - MENG HUANG - CHRISTIAN
SCHOELER - QIU SHIHUA - SHAN FAN - ANATOLY SHURAVLEV -
TRACEY SNELLING - JULIA STEINER - NOT VITAL - WANG
XINGWEI - XIA XIAOWAN - XIA XING - XIE NANXING

Beijing: 104, Caochangdi Cun, Cui Gezhuang Xiang, Chaoyang District, PRC-100015 Beijing/China, phone +86 (0)10 643 333 93, fax +86 (0)10 643 302 03
Lucerne: Rosenberghöhe 4, 6004 Lucerne/Switzerland, phone +41 (0)41 420 33 18, fax +41 (0)41 420 21 69
galerie@galerieursmeile.com, www.galerieursmeile.com

HARUN**FAROCKI**
WAR AT A DISTANCE

22 JANUARY – 26 MARCH 2011

GALERIE THADDAEUS ROPAC
SALZBURG AUSTRIA MIRABELLPLATZ 2 TEL 43 662 881 393 FAX 43 662 881 3939 WWW.ROPAC.NET

GALERIE NÄCHST ST. STEPHAN
ROSEMARIE SCHWARZWÄLDER

MICHAŁ BUDNY

JANUAR - FEBRUAR 2011

ADRIAN SCHIESS

MARCH - APRIL 2011

curated by_vienna 2011

MAY - JUNE 2011

Grünangergasse 1, A-1010 Wien, Tel +43 1 512 12 66
galerie@schwarzwaelder.at, www.schwarzwaelder.at